Whitney Museum of American Art
Handbook of the Collection

00542289

Whitney Museum of American Art
Handbook of the Collection

Edited by
Dana Miller

with an
introduction by
Adam D. Weinberg

Whitney Museum
of American Art,
New York

Distributed by
Yale University
Press, New Haven
and London

Contents

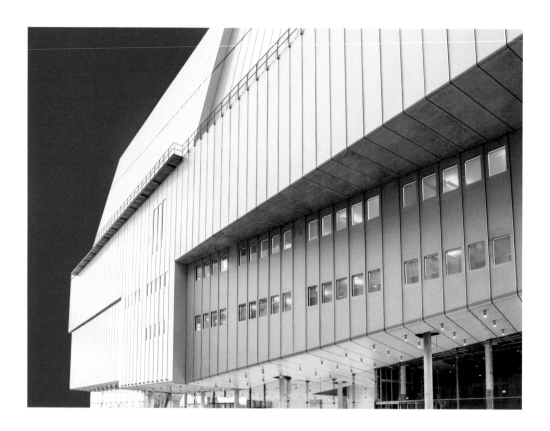

Whitney Museum, looking
northwest from Gansevoort
Street, 2014

Public museums of art, since their
appearance in the eighteenth century, have
attempted to serve a variety of functions:
enlightening and educating the masses
in newly democratic societies, maintaining
national heritages, promoting aesthetic
tastes, and creating art historical narratives.
Few, however, have been dedicated to
advocacy on behalf of artists themselves.
The Whitney Museum of American Art—from
its inception and in its various incarnations
throughout the years—has placed the artist,
and the power and sustenance that work
by artists provides, at the very center of
its vision. The story of how this commitment
arose, and how it has been maintained and
expanded, is a tale of significant individuals,
evolving locations, and ever-present
changes in the culture.

 The Whitney Museum had its origins
in the studio: specifically, the studio of

Gertrude Vanderbilt Whitney. Unlike other artistic institutions that arose in New York in the early decades of the twentieth century, the Whitney did not start as an idea for a museum. That is to say, it did not begin as a collection, or group of collections, made available to the public. Rather, over a period of more than two decades, from 1907 until 1930, what was ultimately to become the Whitney Museum evolved gradually, in unpremeditated fashion, stimulated first by Mrs. Whitney's own struggle for self expression as an artist and as a woman, and subsequently through her desire to aid other artists—personally, socially, economically, and artistically. In time she helped to underwrite a range of independent exhibitions (such as the Exhibition of Independent Artists in 1910 and the Armory Show in 1913), periodicals (including *The Arts*), and organizations (among them the Society of Independent Artists and the Friends of Young Artists). Taken together, these endeavors served to support early twentieth-century progressive American art and artists at a time when few collectors and museums were willing to do so. As the art critic Forbes Watson—a friend to Mrs. Whitney and her trusted secretary, Juliana Force, who would become the Museum's founding director—wrote: "The Whitney Museum of American Art is not the result of a long-lived, slowly developed, logically built up plan. I was present at its birth. It emerged from one curious refusal which climaxed a long series of events sparked into life by the singularly complementary qualities of two sympathetic ladies."[1] But we are getting ahead of the story.

Traveling throughout Europe visiting churches, museums, and historic sites, Mrs. Whitney was inspired and deeply touched by the art she saw. But she was particularly struck by the visit she made to acquire work from the New York studio of the American artist John La Farge in 1898. It was there, in his studio, that the integral connection among artist, creation, and acquisition became linked in her mind and made a deep impression: "I will never forget the feeling of inadequacy combined with pleasure I experienced—not only in possessing the La Farges but in having the privilege of meeting so great a man. From then on, I took an interest in American art. I began to realize the opportunity I had of acquiring."[2] Yet, while Mrs. Whitney recognized the opportunity, she did not fully seize upon it for the purpose of building a collection. Her foremost priority was making art and immersing herself in the community of artists—and, by extension, helping other artists to realize their visions as she sought to realize her own. Until the establishment of the Whitney Museum, the majority of her art purchases were intended simply to provide financial help to artists in whom she believed.

In 1907 Mrs. Whitney moved into her first and only downtown New York studio, at 19 MacDougal Alley, in Greenwich Village. At that time, the Village was a low-rent, bohemian neighborhood that was home to artists, writers, actors, and other nonconformists. It was worlds apart from the uptown society enclave in which this Vanderbilt, daughter of one of America's richest families and now unhappily married to Harry Payne Whitney, scion of another plutocratic dynasty, had been raised according to her birthright. The sculptor James Earle Fraser, one of a succession of Beaux Arts tutors under whom Mrs. Whitney studied, had introduced her to the Alley, where numerous artists of all varieties had studios, including Ernest Lawson, a member of the radical realist group the Eight, whose paintings she acquired early on.

1. This quote is drawn from Forbes Watson's incomplete draft of a text for *Juliana Force and American Art: A Memorial Exhibition* (New York: Whitney Museum of American Art, 1949), which is located in the Frances Mulhall Achilles Library, Archives, Whitney Museum of American Art, New York.

2. B. H. Friedman, *Gertrude Vanderbilt Whitney: A Biography* (Garden City, NY: Doubleday, 1978), 160.

Mrs. Whitney's studio was a refuge, a place where she could develop a brutally honest inner life, separate from the public demands of her social peers. Around this time she began a personal journal of "artistic possibilities," in which she wrote: "[I have] moved into the new studio which abounds in suggestion and inspiration. The ceiling is high and one's ideas soar upward. I felt at once that I must do something large in it. Here one would never putter over little things. The light comes down direct from the sky in all its glory and illumines the human form. Great vistas of possibility open out before one. Life is lived in such a place and eras in one's existence are marked."[3] Mrs. Whitney's desire was clearly to realize something large that arises from a place of ideas and art making, a passion for the human form, and the notion of marking time through art. While the studio was primarily the place where she reflected on "thoughts relating to art, subjects for statues, compositions, symbols, all manner of substance which affects my artistic life," she recognized that here, "every thought or suggestion could be of use."[4] Many of these thoughts were about the potential role of art in America.

Mrs. Whitney's studio served as an informal salon where other artists used to spend time and have discussions after they had finished their work for the day. She also hosted private exhibitions in her studio, which increasingly became a hub of activity as Mrs. Whitney's renown as an artist and patron grew. During this period, as a member of the Committee on Literature and Art at the exclusive women-only Colony Club, she organized several forward-looking exhibitions, featuring, among others, artists aligned with the maverick painter and outspoken anti-academic teacher Robert Henri. Such exhibitions enabled her to introduce contemporary American art to the public while keeping these activities removed from the refuge of her studio.

Most important, Mrs. Whitney made significant purchases at this time, not for the

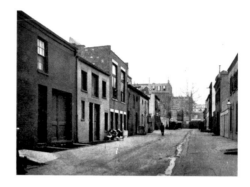

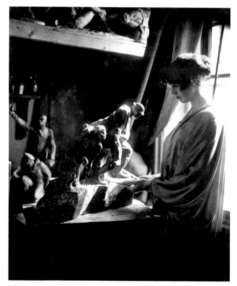

MacDougal Alley, c. 1907

Gertrude Vanderbilt Whitney in her studio on MacDougal Alley, c. 1919

purpose of amassing a private collection but rather to proclaim her support for the unacknowledged artist. As she noted: "First and foremost I buy what I like and because I think the artist has real talent, and what he is doing is worthwhile. Incidentally, it helps the artist, of course, but not only materially. He knows someone wants what he made."[5] At a time when most collectors were still turning to the accepted academic traditions of Europe, some of what Mrs. Whitney chose to acquire and support seemed positively radical. In 1908, for example, she acquired four of the seven paintings sold from the infamous exhibition of the Eight at the Macbeth Gallery. These rough, realist works documenting New York's tenements and street life by Robert Henri, Ernest Lawson, George Luks, and Everett Shinn all reside today in the Whitney Museum's collection. Sloan was cynical about the purchase of these works by a rich artist, but years later he acknowledged: "At that time, to buy such unfashionable pictures was almost as revolutionary as painting them."[6] Certainly to one group of financially unrecognized artists, the gesture of appreciation was stimulus. A purchase by Mrs. Whitney was an affirmation and a sign of belief in an artist's work—an attitude that has shaped the Whitney's acquisition program ever since.

In 1914, Mrs. Whitney established the Whitney Studio, the first public incarnation of her desire to create a place for the presentation of works by living American artists. The name itself notably indicates that she saw the civic role of her newly founded organization as an extension of her studio: the focus was on the creative process, not merely the resulting product. Indeed, the Studio's galleries, which faced onto West Eighth Street, were physically connected to her own studio through the backyard.

The Whitney Studio, overseen by Juliana Force, presented more than thirty exhibitions between 1914 and 1927, demonstrating the varied but pointed interests of the two women. These

included the desire to stimulate an art market for modern American painting, as reflected in the series of exhibitions titled *"To Whom Shall I Go for My Portrait?"* (1916–17); to highlight the art of immigrant artists to the United States, as seen in *Artists of Six Nations* (1916); to promote American art abroad, as implemented in *Overseas Exhibition* (which traveled to Venice, London, Sheffield, and Paris in 1920–21); and most important, to identify key practitioners worthy of "public attention." In this regard, the Whitney Studio presented the first one-person exhibitions of the painters Guy Pène Du Bois and John Sloan, among others. As has been the custom of the Museum since Mrs. Whitney began acquiring works by many of the artists she exhibited, the Whitney's collection is equally an archive that records the history of its exhibitions.

Recognizing that supporting contemporary art was about building a community as well as building acquisitions and creating exhibitions, in 1918 Mrs. Whitney also founded the nonexclusive Whitney Studio Club (the five-dollar membership fee was often waived). As she wrote: "I have often asked artists and students where they went when they were not working, what they did in the evenings and what library they used. The answers opened up a vista of dreariness which appalled me."[7] In response, the Club, which as John Sloan noted was based on "the artists' need for a social and working center" in addition to galleries in which to present their work, offered amenities such as an art library and billiard room.[8] The Club held sketching sessions and notorious parties where drink and

3. Ibid., 245–46.

4. Ibid., 231.

5. Gertrude Vanderbilt Whitney, "I believe in American Art" (c. 1931), 5, microfilm 2372, Gertrude Vanderbilt Whitney Papers: 1851–1975, Archives of American Art, Smithsonian Institution, Washington, DC.

6. Avis Berman, *Rebels on Eighth Street: Juliana Force and the Whitney Museum of American Art* (New York: Atheneum, 1990), 92.

7. Ibid., 155.

food were offered to many a proud but needy artist. It was a gathering place for artists of all stripes: "No attempt was made to impose a creed or style, and all kinds of trends were represented, from abstraction to realism."[9] In 1926, to further a market for modern American art, the Whitney Studio Club shop was opened to sell Club members' works on paper to the public. Annual members' exhibitions were held (these would become the prototype for the Whitney Biennial) as well as one-person exhibitions that often jump-started artists' careers. For example, the first monographic shows of the work of Edward Hopper and Reginald Marsh were hosted by the Studio Club at this time. Whitney and Force, the Club's official director, acquired works from virtually every exhibition, continuing to build a record of their support while nurturing artists in their work. Nevertheless, the idea of starting a museum collection still was not a motivating force. Indeed, with missionary zeal, Mrs. Whitney acquired significant works at this time for other venues—the Art Institute of Chicago, the Brooklyn Museum of Art, the Detroit Institute of Arts, and the Metropolitan Museum of Art—intending to spread her commitment to American art to other institutions.

At its height, the Club boasted four hundred members, including, in addition to Hopper and Marsh, Thomas Hart Benton, Isabel Bishop, Alexander Calder, Stuart Davis, Yasuo Kuniyoshi, and Agnes Pelton (all of whom are included in this volume). The Whitney Museum possesses most of these artists' work in great depth. It is noteworthy that more than a quarter of the Club members were women, a very high percentage given the historical moment. It is such a commitment to the needs and careers of artists of diverse backgrounds and diverse stylistic practices that continues to drive the Whitney Museum's mission and activities.

A substantial waiting list for Club membership as well as the burgeoning market and recognition for American art

eventually signaled the logical end of this cultural community endeavor, and in 1928 it disbanded, stating that "the pioneering work for which the Club was organized has been done; its aim has been successfully attained."[10] Whitney and Force understood that the next step was to showcase the work of the new artists. But how to do so was less evident. Casting around for the next phase in their support of artists, they opened the Whitney Studio Galleries that same year. While their commitment continued to be broad based, the focus was now on one-person exhibitions and, surprisingly, the intention was to run the space as a commercial gallery. The Studio Galleries closed after a mere two years, but the evolution from Studio to Club to Galleries demonstrated the trajectory from creation to community to exhibition. The need for "a collection" and a museum in which to house it thus became abundantly clear to these two daring and restless activists.

The notion of creating an independent museum of American art never occurred to Mrs. Whitney, however. From a psychological point of view, it is fascinating that her first thought was to donate her collection to the Metropolitan Museum of Art, where her father had served as chairman of the executive committee of the Board of Trustees. By this point, she believed that the Studio Club's work had been achieved, and that "the liberal artists have won the battle which they fought so valiantly."[11] For Mrs. Whitney, now more than fifty years of age, the idea of rapprochement with the uptown culture of her father's generation must have been an appealing one. Moreover, fifteen years of running and financing three artist organizations may have left her wanting to focus on her own art, writing, and family. It was not to be. The "one curious

8. Hermon More and Lloyd Goodrich, "Juliana Force and American Art" in *Juliana Force and American Art: A Memorial Exhibition* (New York: Whitney Museum of American Art, 1949), 39.

9. Ibid., 19.

10. Berman, *Rebels on Eighth Street*, 254.

11. Ibid., 254.

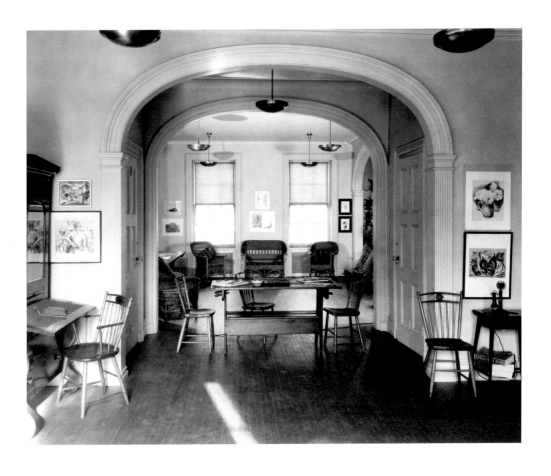

Charles Sheeler, *Office
Interior, Whitney Studio Club,
10 West 8 Street*, c. 1928.
Gelatin silver print, 7½ x 9¼ in.
(19.1 x 23.5 cm). Gift of
Gertrude Vanderbilt Whitney
93.24.2

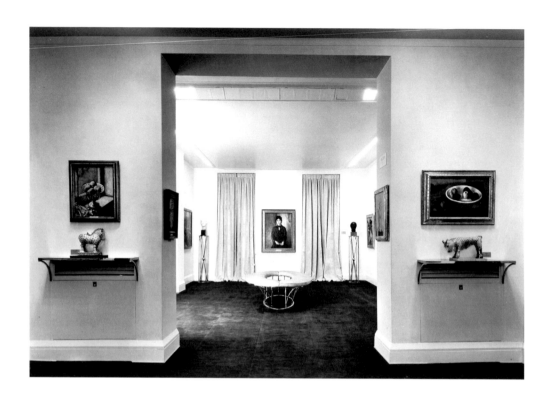

Installation view of *Opening Exhibition—Part 1 of the Permanent Collection (Painting and Sculpture)* (November 18, 1931–January 2, 1932)

Whitney Museum at 10 West 8th Street, c. 1931

Juliana Force (at left) and Gertrude Vanderbilt Whitney surrounded by Mrs. Whitney's sculptures at the Whitney Museum, 1939

refusal" mentioned earlier, of which Forbes Watson wrote, would serendipitously lead to the emergence of the Whitney Museum: Edward Robinson, director of the Metropolitan Museum, refused Mrs. Whitney's offer of the collection outright, saying: "What will we do with them, my dear lady? We have a cellar full of those things already."[12] There was not even the chance to extend the offer to underwrite the costs of building and endowing a new wing for American art. Immediately following this momentous meeting in October 1929, Whitney and Force, in the presence of Watson, had the idea to change "an art exhibition center, half social and half art, into a dynamic museum which is the nearest thing to a museum for artists that this country has developed."[13]

With this as their goal, the Whitney Museum of American Art was announced in January 1930 and opened in November 1931 on Eighth Street, in four adjoining

brownstones redesigned by Noel and Miller architects, steps away from Mrs. Whitney's MacDougal Alley studio. Her collection of some four hundred works was to become the foundation of the institution's holdings and a testament to artists she supported, as well as an implied pact with those yet to be supported. As the critic Henry McBride wrote upon the opening of the Museum: "The freedom and lack of convention that has guided these purchases are the greatest possible auguries for the future liveliness of the Museum. A contemporary museum that is stilted and pedantic is—well, it is not a museum but a morgue."[14]

In fact, Whitney and Force purchased roughly five hundred works to recalibrate the collection and fill in gaps in advance of the Museum's debut, among them masterworks by several artists included in this volume: George Bellows's *Dempsey and Firpo* (1924), Charles Demuth's *My Egypt* (1927), and Edward Hopper's *Early Sunday Morning* (1930). While McBride frankly acknowledged that many of the works, in his opinion, were not yet of museum quality, he nonetheless admitted that "if one were to wait until an artist becomes an acknowledged master there would be no sense in making purchases at all."[15] It is on the horns of this dilemma— acquiring masterworks for a museum and taking risks to support the work of promising artists—that the Whitney was and continues to be challenged. It is this contradiction that makes the Whitney a vibrant museum where art history is not merely reconfirmed but made.

The development of the Whitney into a full-fledged museum was a gradual one. The ethos of the institution, which continues today, derives from the values inculcated by Whitney and Force in its antecedent organizations—above all, the idea that the

artist and the artwork are inalienably linked. This intimate connection was reaffirmed and safeguarded in numerous ways at its founding: with Force as director of the Museum (and serving until 1948), each of the first three curators— Edmund Archer, Karl Free, and Hermon More (who would become the Whitney's second director, 1948–58)—was an artist; at the outset, Biennial exhibitions (later becoming Annuals before reverting again to Biennials) were instituted so that presenting new works by new artists would always be a central mission; a purchase fund to acquire works by Biennial artists was established to support the work of emerging artists; direct consultation with artists

12. Ibid., 263.

13. More and Goodrich, "Juliana Force and American Art," 54.

14. Henry McBride, *The Flow of Art: Essays and Criticisms*, ed. Daniel Catton Rich (New Haven: Yale University Press, 1997), 281.

15. Friedman, *Gertrude Vanderbilt Whitney*, 560.

in the selection and hanging of their art—particularly for the Annuals—became standard operating procedure; and works by living artists were never to be deaccessioned without their permission, so as to protect their reputation and market. (This last practice has become standard in contemporary art museums in the United States today.) As stated at the founding: "It would be presumptuous to point out the road upon which art must travel. We look to the artists to lead the way. . . . As a museum, we conceive it to be our duty to see that he is not hampered in his progress by lack of sympathy and support. It is not our intention to form a 'school'; our chief concern is with the individual artist."[16] The idea of an "artist's museum" had been set firmly in place.

In the years following the opening of the Museum, the Whitney did not present one-person exhibitions of living artists and accepted gifts from only a small group of people—Whitney family members and Juliana Force. The ban on these exhibitions was meant to maximize the number of artists whose work could be presented and to maintain a perceived distance from commercial galleries, which concentrated on one-person shows. Presumably, art donations were limited so as to avoid taking advantage of artists and to maintain absolute independence in the selection of acquisitions. Fortunately, in 1948, both of these policies were reversed. One-person exhibitions were critical vehicles through which the Museum could encourage artists and identify leading practitioners. Indeed, within the next several years, the Whitney hosted some very important retrospectives of artists including Yasuo Kuniyoshi in 1948, Max Weber in 1949, and Edward Hopper in 1950.

The inclusion of donors by the Museum became another factor in the expansion of its mission to support artists. Since 1948, gifts of art have been the life-blood of the Whitney. Despite the generous endowment Mrs. Whitney bequeathed to the institution

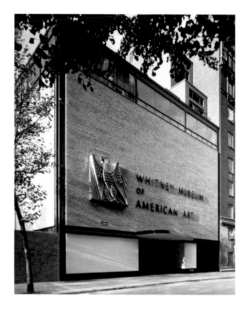

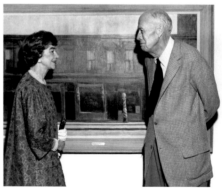

Whitney Museum at 22 West 54th Street, c. 1954

Flora Whitney Miller with Edward Hopper in front of his 1930 painting *Early Sunday Morning*, 1961

at her death in 1942, the Museum began to lack the resources to make acquisitions as it had in the past. It has been especially meaningful and critical for building the collection that so many artists who have had long associations with the Museum—through its Biennials and Annuals, its thematic exhibitions, and its acquisitions—have been extremely generous in making gifts and bequests of their own. Nevertheless, in the continuing spirit of giving support to artists, it is customary today, as it was then, to accept donations only from artists whose work has already been purchased for the Museum—thus underlining the Whitney's initial financial commitment to an artist. Some of the most significant holdings indeed have come from artists and their families. Primary among these was the bequest in 1968 of Edward Hopper's artistic estate of some three thousand works, which has made the Whitney the principal home for the study and display of his art. Arshile Gorky's iconic *The Artist and His Mother* (1926–c. 1936), represented in this volume, was a gift to the Museum on behalf of his daughters in recognition of the Whitney's long-term commitment to the work of this artist, including the first purchase of a Gorky painting by a museum. In all, more than five thousand works have been donated by artists and their estates, including, in this volume alone, objects by Ericka Beckman, Maurizio Cattelan, David Lamelas, Ree Morton, Richard Pousette-Dart, Robert Rauschenberg, Ad Reinhardt, and Theodore Roszak.

Because of the increase in the scale of works in the second half of the twentieth century and the growing number of works in the Museum's collection, in 1954 the Whitney moved to a new location on Fifty-fourth Street, on land adjacent to and generously donated by trustees of the Museum of Modern Art. As with any relocation, this move caused the Whitney to take stock of its vision, collection, and acquisition practices. It became increasingly evident that simply to purchase works

to encourage artists was not enough; a great museum must concentrate on great acquisitions. Furthermore, despite the valiant efforts of Mrs. Whitney's daughter Flora Whitney Miller to support her mother's mission after her death, the Museum was hobbled by a lack of purchase funds. With this in mind, in 1956, with prompting from long-time curator and soon-to-be director Lloyd Goodrich (1958–68), the Friends of the Whitney Museum of American Art was initiated under the able leadership of the collector David Solinger—among the first non-family board members—with the prime purpose of helping to acquire major works that the institution could scarcely afford on its own.

The Friends reaffirmed that "a central aim has always been the prompt recognition of creative ability in the one way that brings prestige, encouragement and material aid to the artists in equal measure—that is, by purchasing his work and exhibiting it as part of the Museum's collection while he is still living."[17] The Friends, comprised largely of the foremost contemporary collectors of the day—among them Seymour Knox, Howard Lipman, Milton Lowenthal, Duncan Phillips, Roy Neuberger, Nelson Rockefeller, and Hudson Walker—nevertheless wisely realized that, in addition to its lack of funds, the Whitney's broad-based collecting policy had in fact remained too narrow, having placed an early emphasis on realist art. Accordingly, the Friends candidly asserted the pressing need "to increase the purchasing funds so that it can fill many serious omissions in the permanent collection and do fuller justice to the vastly expanding field of contemporary American art."[18] Thanks to the Friends, the Whitney recognized that, given the

16. Herman More, *Whitney Museum of Art: Catalogue of the Collection* (New York: Whitney Museum of American Art, 1931), 10–11.

17. Flora Miller Biddle, *The Whitney Women and the Museum They Made: A Family Memoir* (New York: Arcade, 1999), 96.

18. Ibid.

extraordinary proliferation of working American artists, it could not be as inclusive as it had been in the past and that it should focus more on would-be masterpieces, especially works by leading abstract practitioners who, to some degree, had been neglected. The Friends acquired more than one hundred and fifty astonishing works: Willem de Kooning's *Door to the River* (1960), Helen Frankenthaler's *Flood* (1967), Franz Kline's *Mahoning* (1956), Barnett Newman's *Day One* (1951–52), and Andy Warhol's *Green Coca-Cola Bottles* (1962) are all included in this volume.

From the Friends also came many individual donors who, with gusto and generosity, enhanced and transformed the collection: Lawrence Bloedel, whose bequest included works by many artists championed by the Whitney—Charles Demuth, Robert Henri, Georgia O'Keeffe, Charles Sheeler, and John Storrs; David Solinger, who made gifts by his favorite American artists, with works by Hans Hofmann and Willem de Kooning later given in his honor; and Roy Neuberger, who would eventually found

his own museum and who donated two major works by Arthur Dove (one of which is presented herein) as well as Jacob Lawrence's important *War Series* (also represented in this volume), among others. No collectors at the time had a greater impact on the Whitney collection, however, than Howard and Jean Lipman. The former was president and chairman of the Board of Trustees, while the latter was a distinguished specialist in folk art, a writer and curator who served as editor of *Art in America* for thirty years. During their lives, the Lipmans donated more than two hundred works, primarily of modern and contemporary sculpture by artists ranging from Alexander Calder and Isamu Noguchi to Dan Flavin, Nancy Grossman, Louise Nevelson, Robert Smithson, Lucas Samaras, and Edward Kienholz, all of whom are featured here. The Lipmans bought early and boldly, fully embodying the risk-taking spirit of the Whitney. They were the largest and most influential donors since Mrs. Whitney herself, and their generosity continues to this day through

their son and daughter-in-law, Peter and Beverly Lipman, who made a crucial gift of a rare 1964 David Smith *Cubi* sculpture to the Whitney and Storm King Art Center in upstate New York.

This emphasis on acquiring singular works by American masters, begun by the Friends, was pursued by no one more assiduously than director Tom Armstrong (1974–90). In partnership with numerous trustees—particularly Flora Miller (Irving) Biddle (Mrs. Whitney's granddaughter), Howard Lipman, and Leonard A. Lauder—many gems were acquired through purchases and gifts, without which the Whitney's collection would be unthinkable today: Jasper Johns's *Three Flags* (1958), Alexander Calder's *Circus* (1926–31), Robert Rauschenberg's *Satellite* (1955), Elie Nadelman's *Tango* (c. 1920–24), Edward Hopper's *A Woman in the Sun* (1961), David Smith's *Running Daughter* (1956), and dozens of other significant works.

Just as the shifts in organizational structure that occurred in the transition from

Installation view of *The First Five Years: Acquisitions by the Friends of the Whitney Museum of American Art, 1957–1962* (May 16–June 17, 1962)

Installation view of *American Sculpture: Gifts of Howard and Jean Lipman* (April 15–June 15, 1980)

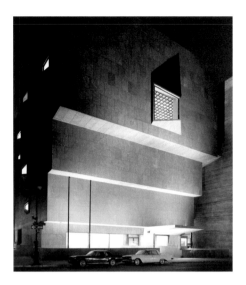

Whitney Museum at 945
Madison Avenue, 1966

Tom Armstrong, Mayor
Edward I. Koch, and
Flora Miller (Irving) Biddle
at the press conference
for the 1982 fundraising
campaign for the purchase
of *Calder's Circus*
(1926–31)

Gilbert Maurer, James
Rosenquist, Leo Castelli,
Robert Rauschenberg,
Roy Lichtenstein, Jasper
Johns, and Leonard A. Lauder
at the opening reception
for *Robert Rauschenberg:
The Silkscreen Paintings, 1962–
1964* (December 6, 1990–
March 17, 1991)

Studio to Club to Galleries to Museum
and in the move from Eighth Street to Fifty-
fourth Street occasioned reassessment
of the vision and amplification of the mission,
so did the 1966 opening of the Whitney's
radical new edifice designed by Marcel
Breuer. That same year, David Solinger was
elected president of the Board. The Friends
Committee, in its original form, was
eventually disbanded in favor of the new
Acquisitions Committee, which, headed by
art critic and writer B. H. Friedman, was
better aligned with the more public evolution
of the institution. Over time, in recognition
of the increasing specialization of collectors
and in a desire to maximize financial
benefit, the Acquisition Committee, under
the leadership of director John I. H. Baur
(1968–74), subdivided, creating the
Committee on the Collection, the precursor
to the Painting and Sculpture Committee in
the early seventies; a Print Committee
was founded in 1969 under Flora Miller
(Irving) Biddle (a great champion of collection
building who served as president and
chairman of the Board and now serves as
honorary chairman). At the behest
of director Tom Armstrong, the Drawing
Committee was established in 1977, with the
renowned art historian Jules Prown at its
helm. Under the succeeding directorship of
David Ross (1991–98), the Photography
Committee was originated by Sondra Gilman
in 1992. The Film and Video Committee
was created in 1999, with George Kaufman,
the leader of Kaufman Astoria Studios,
as its chair (new media became part of this
committee the following decade). The
impact these acquisitions committees have
had on the Whitney's permanent collection
is incalculable. Thousands of works have
been added under their auspices, profoundly
enriching and diversifying our holdings—
only relatively few of which can be seen in
these pages. The enthusiasm generated by
these committees has also encouraged
many members to donate works personally.

During Ross's tenure, he and the
curators recognized that the collection

lacked the cultural diversity that existed in contemporary American art. Throughout its history the Museum had acquired works by African American, Asian American, and to a lesser degree Hispanic American artists (see, for example, works included herein by Charles Henry Alston, Ruth Asawa, Richmond Barthé, Romare Bearden, and Marisol), but it was clear that numerous additions needed to be made. During that period, and continuing to the present, many significant works were acquired to enrich the holdings in all mediums by artists of color. Some of the fine examples purchased in the 1990s and represented in this volume include: Beauford Delaney's *Auto-Portrait* (1965), Ana Mendieta's *Untitled* (Fetish Series, Iowa) (1977), Adrian Piper's *Out of the Corner* (1990), and Gary Simmons's *Ghoster* (1997).

Leonard A. Lauder, who first came to the Museum as a trustee in 1977, was passionate about drawings. He bolstered support of acquisitions in this area and advocated for the first adjunct curator for drawings. In time he would sit on an unprecedented number of acquisitions committees, chairing many, and underwrite curatorial positions for drawings and prints. One of the greatest champions of collection building in the Museum's history, he posited that the quality of the collection and its unique mix of holdings are what draw people to a museum. Indeed, Lauder has been the Whitney's most generous donor of art, having given nearly a thousand objects in all mediums. While he has had an enormous impact on every area of the collection, his particular passion has been for prints, drawings, and paintings. He has acquired for the Museum in-depth collections of work by key twentieth-century printmakers, including Charles Burchfield, Rockwell Kent, Louis Lozowick, and Jasper Johns; his gifts of drawings by Brice Marden, Claes Oldenburg,

and Ed Ruscha are unparalleled; and his donations of paintings by dozens of major American painters, including those presented in this volume by Jasper Johns, Gerald Murphy (given together with Thomas H. Lee and the Modern Painting and Sculpture Committee), Roy Lichtenstein, Agnes Martin (together with the Sondra and Charles Gilman Jr. Foundation), Clyfford Still, and Andy Warhol are among our most cherished works.

Always one to understand the profound effect of an important acquisition, Lauder often acquired works outside his primary areas of personal interest, resulting in the acquisitions of hundreds of Ed Ruscha's original photographic works as well as a body of sculptures and installations by Kiki Smith. In addition to being a discerning collector, Lauder is also a visionary leader, and after the turn of the millennium he headed a drive to dramatically augment masterworks for the collection. The result was the acquisition of eighty-seven works by twenty-three artists—ranging from Helen Frankenthaler, Jackson Pollock, Mark Rothko, and Cy Twombly to Ellsworth Kelly, Sol LeWitt, and Robert Ryman— donated by fifteen trustees, including many from Lauder himself, and presented in the exhibition *An American Legacy, A Gift to New York* in 2002. Other collectors in this

group have had a significant and continuing impact on the Whitney's collection: Joel and Anne Ehrenkranz, Thomas H. Lee and Ann Tenenbaum, and Melva Bucksbaum and Raymond Learsy.

Emily Fisher Landau, another member of this group and a trustee since 1987, was co-chair of the Painting and Sculpture Committee and is one of the most outstanding collectors of American art of our time. Her impeccable eye and fearless attitude, in the spirit of Mrs. Whitney, presciently led her to acquire often difficult works by artists such as Felix Gonzalez-Torres, Nan Goldin, Matthew Barney, and many others that are now of great significance. As she said, "I like the fact that the Whitney isn't afraid to expose the works of young artists before they are accepted."[19] In 2010 Landau pledged 419 works by eighty-six artists to the Whitney Museum. These paintings, sculptures, photographs, prints, drawings, and installations add further depth to the Museum's concentrated holdings of essential artists—among them, in particular, Jasper Johns, Ed Ruscha, Sherrie Levine, and Glenn Ligon—while at the same time providing the Whitney with prime examples of work by such artists as Neil Jenney, Barbara Kruger, and Martin Puryear, all of which are presented herein.

A spectacular and far-reaching donation by Thea Westreich Wagner and Ethan Wagner, like that of Landau, was made in 2011 with the knowledge that the Whitney Museum's Renzo Piano– designed building would provide more opportunities than ever before to display the permanent collection. Westreich Wagner and Wagner, who are among the most perspicacious art advisors of our day, have crafted a challenging and edgy collection of international contemporary artists; most of its works by American artists will

19. Adam D. Weinberg, foreword to *Legacy: The Emily Fisher Landau Collection*, ed. Dana Miller (New York: Whitney Museum of American Art, 2011), 7.

be given to the Whitney. Their collection, representing a cross section of mediums with a distinct emphasis on Conceptual art, is especially critical in enabling the Museum to tell a nuanced and complex story of art in the United States since the 1980s. While the Whitney has long exhibited and supported many of these artists, our limited acquisition funds have meant that most have not been extensively represented in the collection. Objects by Robert Gober, Jeff Koons, and Christopher Wool and photographs by Robert Adams, Lee Friedlander, and Cindy Sherman are among the many treasures that will make it possible to better reveal the contributions of influential contemporary artists.

Sondra Gilman, currently the Whitney's longest serving trustee, gave significant gifts of painting and sculpture by Jasper Johns, Carl Andre, Sol LeWitt, and others to the collection. Together with her husband,

Emily Fisher Landau and Ed Ruscha at his studio in Venice Beach, California, 1985

Installation view of *An American Legacy, A Gift to New York* (October 24, 2002–January 26, 2003)

Whitney Museum, looking
east, 2014

Celso Gonzalez-Falla, she has built
one of the finest collections of twentieth-
century American photography. As the
founder and first chair of the Photography
Committee, she has expertly aided the
Museum in building an excellent collection
of post-1950 American photography,
now numbering more than four thousand
works. Gilman also endowed a curatorship
for photography, named a gallery for
photography in the former Breuer building,
and underwrote the study center for works
on paper in the current facility. Knowing
that price and scarcity made it most difficult
for the Museum to fill gaps in its collection
of images from the first half of the twentieth
century, in 2014 she donated seventy-
five vintage prints by American masters,
including Walker Evans, Helen Levitt, Man
Ray, and Alfred Stieglitz, jointly to the
Whitney and the newly established Gilman

Foundation, with which the Whitney will work closely in the coming years. Glorious pictures by each of these artists as well as photographs by Diane Arbus and Robert Frank from their collection are discussed in this book.

When the Whitney Museum moved into its new home on Gansevoort and Washington Streets in 2015, it signaled yet another evolutionary shift in the organization and its capacity to serve the significant art and artists of our time. The Piano building offers inspirational new spaces for artists, much as Mrs. Whitney's original studio in lower Manhattan had provided a space to inspire her more than a hundred years earlier. Expansive indoor and outdoor galleries, a theater, and a black box, all of which are wired for multimedia presentation and performances, are among the elements that will serve to enhance current and future works in all mediums. The commissioning of the building's four elevators from artist Richard Artschwager—his last major work before his death—at last brings artist and museum together in permanent collaboration; these structures are at the heart and core of the institution, showcasing the compelling nature of the architecture and the Museum's continuing commitment to the essential innovation of artists.

The Whitney's current home, with its commanding prospects of the Hudson River and beyond, as well as more intimate views of New York, serves as a metaphorical bridge between the urban and the wide-open spaces that have inspired America and its art. For the first time in decades, the Museum is able to exhibit in equal measure rotating, temporary exhibitions and its permanent collection. This balance is at the heart of the Whitney ethos—exhibitions that focus on the new, the daring, and the living alongside the collection, which provides historical and aesthetic contexts for those works. But the collection is not a static backdrop; it is an active and ever-changing presentation that positions new artists among their predecessors and peers while offering the next generation encouragement and perspective. As Lloyd Goodrich wrote of Mrs. Whitney's intent in establishing a museum collection: "By its very nature it was not and could never be complete; she asked that it be thought of as an organism 'that would grow as we grow.'"[20] And that it does. The Whitney continues to be democratic in its spirit, catholic in its taste, always risk-taking, and determined to acquire the best art of our time. These imperatives are not mutually exclusive. Our move to Gansevoort Street was a return to downtown, though a radically different one from the bohemian downtown of a hundred years ago that Mrs. Whitney encountered when she first moved to her MacDougal Alley studio. Yet this building—the fourth in our history—standing just a short distance from the original Whitney on Eighth Street, reminds us of our core commitments. As the Whitney's former director Hermon More reaffirmed half a century ago: "A museum's most valuable function is not merely conserving tradition but playing an active part in the creative processes of its time. . . . A museum should always be open to the new, the young, and the experimental; it should never forget that the artist is prime mover in all artistic matters."[21] The Whitney Museum of American Art, in a new century and in a new building, continues to honor the centrality of the artist—it is the priority of the entire staff. To be in the forefront, the Whitney exposes itself to the risk and vulnerability implicit in engaging with radical ideas and unfamiliar paradigms—challenges that artists confront every day.

20. More and Goodrich, "Juliana Force and American Art," 24.

21. Hermon More, *In the Service of American Art* (New York: Whitney Museum of American Art, 1965), n.p.

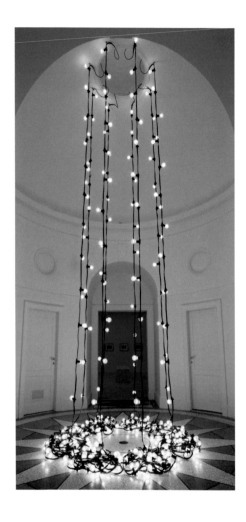

Felix Gonzalez-Torres,
"Untitled" (America), 1994.
Light bulbs, waterproof
rubber light sockets, and
waterproof extension cords,
twelve parts: dimensions
variable. Purchase with
funds from the Contemporary
Painting and Sculpture
Committee 96.74a–l. Installation
view: The United States
Pavilion, Giardini della
Biennale, Venice, Italy, 2007

Given the mandate established for the
Whitney Museum of American Art at its
founding—to focus on the art of this
country—one might fairly assume that the
art works in the Whitney's collection
were made by American artists.[1] Yet the
precise definition of "American art," which
might seem obvious and straightforward
upon first thought, has remained a complex
and unsettled issue for the Museum
throughout its history. Interpretations have
varied across the years, most expressly
as pertains to the unavoidable corollary
questions: "Can only American artists make
American art?" and "By what criteria is
an artist considered American?" More than
seventy of the three hundred fifty artists
included in this collection handbook—over
twenty percent—were born outside the
United States and, of this group, a significant
number were not US citizens when their
work entered the collection; some, indeed,
are not or may never have become citizens.
In assessing the core sample chosen
for this handbook, one might well conclude
that the Whitney Museum of American
Art is not a museum devoted exclusively to
American artists, at least if US citizenship is
the basis by which "American artist" is
defined. The art may be American, but the
artists aren't necessarily so.

Upon further consideration, however,
we might say that the number of artists born
outside the United States in this book
reflects the heterogeneity that has defined
our country since its beginnings. From this
perspective, their inclusion should therefore
come as no surprise. We are a nation
predominantly composed of immigrants, as
we are reminded often in these times, and
artists who have emigrated from abroad
have always been a uniquely creative portion
of the rich mixture of which our society
and culture is composed. The paths taken
to this country by many of the artists
included in these pages follow some of the
more common passages of the nineteenth
and twentieth centuries—like that of
the painter Max Weber, born in the former

Russian Empire, whose family came to the United States in the early 1890s to seek a better future; or of the German artists Josef Albers and George Grosz, who fled Nazi persecution in the years leading up to World War II. The migration has carried on with subsequent generations, though the routes have branched out across the globe in recent decades, bringing artists from African and Asian countries and from Latin America. Younger transplants such as Elad Lassry from Israel, Josephine Meckseper from Germany, and Aleksandra Mir from Poland came to this country expressly to study art and establish their careers. Their stories stand in dramatic contrast to the situation that existed a century ago, when prospects here for artists working outside formal academies were so bleak that, in 1914, Gertrude Vanderbilt Whitney was driven to create the Whitney Studio to bring their work to public attention.

In recognition of the heterogeneity of the artists whose works the Museum has amassed over the years, we have made the seemingly small but significant decision, on the occasion of this publication and the opening of the downtown building, to include for the first time the place of birth and, if applicable, place of death for each artist. Typically, only encyclopedic museums or those with an international mandate include this level of information, and generally it is the nationality of the artist that is listed. We have chosen not to list nationality because it is not a fixed attribute, and because it does not account for the peripatetic and multinational lives that many artists lead in today's global culture. And, as we shall see, citizenship status is not information the Whitney has consistently considered or collected throughout its history. Including this level of biographical information provides a factual counterargument to the cowboy myth of the American artist as exemplified by the Wyoming-born Jackson Pollock, or of the New England Yankee as embodied by Arthur Dove or John Marin.

The "American" art featured in this book was in fact made by three hundred fifty artists who hail from forty-two states, the District of Columbia, and thirty-one other countries. Most important, it provides a more nuanced and textured understanding of the art made in the United States since 1900 and the art being made in this country today.

Even before the Museum first opened its doors in 1931, the leaders of the future institution challenged the term "American" in relation to art. One of the first exhibitions Gertrude Vanderbilt Whitney instigated at the Whitney Studio, in 1915—in the midst of the First World War and at a time marked by massive immigration to this country from Eastern Europe and southern Italy—was titled *The Immigrant in America*. For this presentation, a jury of established artists selected one hundred fifty recent immigrant artists from among four hundred applicants to exhibit their work. Cash prizes were awarded for the best representation of the meaning of America to the immigrant and of the immigrant to America. The show raised several crucial and still relevant questions, as elucidated in the announcement for the exhibition: "Is it true," it asked, "that everything thrown into the melting pot comes out an American product, and, if it does not, is the fault in the product, or in America, who has assumed that the melting pot needs no watching?"[2]

The case of the painter and printmaker Yasuo Kuniyoshi provides an interesting rejoinder to those questions and illuminates the enlightened attitudes that prevailed

1. For the purposes of this essay I use "American" to mean of the United States of America, as this is what was intended by the founders of the Whitney, though today we are all too fully aware that the term "American"encompasses geography and cultures well beyond the United States.

2. Typed report on the exhibition *The Immigrant in America* held at the Whitney Studio in 1915; see Whitney Studio Club and Galleries: Administrative and Exhibition Records, 1907–1930, Frances Mulhall Achilles Library (hereafter FMAL), Archives, Whitney Museum of American Art, New York (hereafter WMAA).

during the earliest years of the Whitney, even as the nationalism that arose after the outbreak of World War I marked a rise in public suspicion of immigrants. Born in Japan, Kuniyoshi had come by himself to this country in 1906, at the age of sixteen, and attended school in Los Angeles. He made his way to New York and studied at the Art Students League, where he became close with many of his teachers and peers and indeed married one of them, Katherine Schmidt, in 1919. Kuniyoshi and Schmidt both exhibited frequently at the Whitney Studio Club in the 1920s, and Kuniyoshi even lent works from his personal collection of American folk art to an exhibition there in 1924, one of the first, if not the first, to focus on that subject. Twelve of his works entered the Museum's collection in 1931 as part of the founding collection, including two paintings purchased that year for the new institution. There could not have been a question at that time about the artist's citizenship status: as a Japanese immigrant, he was prohibited by a variety of laws and exclusion acts from becoming a citizen (in fact, Schmidt had been stripped of her own US citizenship upon her marriage to Kuniyoshi). Although Congress finally lifted the ban in 1952, Kuniyoshi died the following year, his long-awaited application for citizenship still in process. Back in 1931, however, at the very founding of the Whitney Museum of American Art, his work was deemed suitably American to pursue for the collection. The Museum proceeded to purchase additional works of his, including two paintings shown in the Annual Exhibitions of Contemporary American Painting in 1937 and 1938, and others acquired later, in 1948 and 1953.

As the fledgling institution got its bearings, the notion of "American" was interpreted broadly. Hermon More, a member of the original curatorial team and future director of the Whitney, articulated this position in the Museum's first catalogue, in 1931: "In limiting the scope of this Museum to American art, we place the emphasis

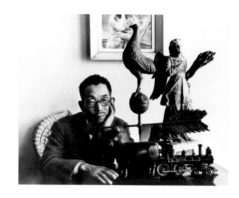

primarily on 'art' and secondarily on 'American.'"[3] Once the founding collection had been conveyed to the institution, however, this openness pertained primarily to the exhibition program. An unofficial but nonetheless persistent dividing line was established between artists who might be allowed to exhibit at the Museum and those whose work it would acquire. Particular care was given to questions of eligibility for artists to participate in the Annual exhibitions, which were specifically devoted to American art. There was much correspondence in those early years with the administrations of other institutions that held annuals or biennials of American art, such as the Carnegie Institute in Pittsburgh (today the Carnegie Museum of Art) or the Pennsylvania Academy of Fine Arts, trying to reach a consensus on particular artists—were they American enough to be considered for inclusion? For the purposes of the collection, however, the Museum classified American art as that made by US citizens, with just a handful of notable exceptions, such as Kuniyoshi.

Arnold Newman, *Yasuo Kuniyoshi, New York City*, 1941. Gelatin silver print, 7¾ x 9⅞ in. (19.7 x 25.1 cm). Gift of Mr. and Mrs. Benjamin Weiss 91.50.5

In 1945 the Whitney organized the exhibition *European Artists in America*, featuring artists who had fled the devastation of war and arrived in the United States after 1938. The show echoed the 1915 endeavor in its open-armed embrace of foreign-born artists, particularly those fleeing war-torn homelands, though it included primarily well-established figures such as Marcel Duchamp, Max Ernst, Piet Mondrian, and Yves Tanguy, none of whom were represented in the collection. No works were acquired directly from that show at the time, and the distinction between qualifications for exhibition and for collection remained. The Whitney strove to represent the full pantheon of artists participating in New York's avant-garde milieu, and to a slightly lesser extent those elsewhere in the country, in its programming, but not all of those artists were considered eligible for the collection. In a 1948 letter, More wrote to a colleague: "Although we are a museum of American art we take a rather liberal view of nationality. We have shown in our exhibitions work by [Chilean Roberto] Matta, [Mexican Rufino] Tamayo, [French Yves] Tanguy, [Russian Pavel] Tchelitchew, [German George] Grosz and others, who have lived and worked in this country for a number of years. We have not inquired as to the status of their citizenship, but are glad to show their paintings if they have been in the United States long enough to become identified with the art of this country, either as long time visitors or as potential permanent residents."[4] The first painting by Tanguy was added to the collection in 1949, the year after he became a US citizen. In a letter representative of the Museum's correspondence at the time, More declined a donation offer of another artist's work in 1950, writing, "We try to interpret American art as liberally as possible as far as exhibitions are concerned, and we have in the past and will continue in the future to show the work of Europeans who live and work in this country. It was felt, however, that the Permanent Collection should be devoted exclusively to the work of American citizens, in order that the purpose with which the Museum was founded would not be meaningless."[5] In 1950 the administrators at the Whitney still felt compelled to fly the banner on behalf of the American-born artist, regarded even then as the stepchild to those with European pedigrees. It would be at least another decade before the epicenter of contemporary art making was generally acknowledged as having shifted from Paris to New York, another fourteen years before Robert Rauschenberg became the first American to win the Golden Lion at the Venice Biennale, and twenty years before Irving Sandler published *The Triumph of American Painting*. Kuniyoshi continued to be the remarkable exception to the Whitney's rules, and he became the first living artist to receive a one-person exhibition at the Museum, in 1948. This came in the wake of World World II, during which the status of Japanese-born residents had been changed from "resident alien" to "enemy alien." Such a public commitment to Kuniyoshi was a deeply political gesture on the part of the Whitney, and one that would set the tone for the Museum in the next decade.

The 1950s was a period of both Cold War conservatism and liberal ideals attached to the burgeoning civil rights movement, and it was further marked by influxes of refugees from war-torn Europe in the wake of World War II and of refugees from behind the Iron Curtain. During this time the Museum's criteria for acquisition softened dramatically under the leadership of curator Lloyd Goodrich, who subsequently

3. Hermon More, "Introduction," in *Whitney Museum of American Art: Catalogue of the Collection* (New York: William Edwin Rudge, 1931), 10.

4. Hermon More to Justus Bier, October 26, 1948. Early Museum History files, Series II, 1940–1949/50, box 7, General Administrative Correspondence, 2.6.4, Correspondence A–Z. FMAL, Archives, WMAA.

5. Hermon More to Gitou Knoop, April 24, 1950. Early Museum History files, Series III, 1950–59/60, box 11, General Administrative Correspondence, 3.18.1, Offers of Works of Art. FMAL, Archives, WMAA.

became director, shifting from citizenship status to residency. The Dutch-born painter Willem de Kooning had come to the United States in 1926 as a stowaway, and would not be naturalized as a US citizen until 1962. Yet the Museum acquired his *Woman and Bicycle* (1952–53), included in this volume, in 1955. De Kooning had been thrown into the metaphorical melting pot that Gertrude Vanderbilt Whitney spoke of in 1915, and in acquiring *Woman and Bicycle* the institution accredited the painting as an "American product," even if the artist did not yet qualify for that designation. De Kooning in fact had acknowledged that his Women paintings were in part his response to American culture and the gender stereotypes he encountered here at mid-century. The high heels, bright lipstick, and grimacing smile of the figure in *Woman and Bicycle* are reminiscent of a 1950s pinup girl or of Hollywood stars such as Marilyn Monroe. De Kooning, like so many immigrant artists in the Whitney's collection—including Robert Frank and Jonas Mekas, to name just two more— were especially attuned to the facets that distinguished American society, and their works provided a lens through which we could see ourselves anew.

A decade later, at the critical moment when the Whitney was moving into its Marcel Breuer–designed building on Madison Avenue in 1966, Goodrich encapsulated this approach, which helped define his tenure, when he wrote: "The art of a nation has a special significance for its people, without chauvinistic implications.... Recognizing the diversity of contemporary art, it should represent all creative tendencies. It should eschew a narrow definition of 'American,' disregarding foreign birth or citizenship, and accepting as American any artist resident in this country."[6] This was also the period during which American art was finally finding acceptance abroad. Perhaps at the moment American artists were beginning to be sought by foreign museums and collectors, the administrators at the Whitney felt less urgency to adhere strictly to their original messianic purpose. During the relatively brief directorship of John I. H. Baur (1968– 74), who had been at the Museum since 1952, as curator and then associate director, the same open attitude prevailed, and the Whitney continued to selectively acquire works by non-citizen artists. These included *Dan Johnson's Surprise* (1969), reproduced in this handbook, by the Guyana-born, British-trained artist Frank Bowling, in 1970. (Bowling, who had moved to New York in 1966, was also given a one-person exhibition at the Museum in 1971.)

When Thomas Armstrong became director in 1974, he led a concerted effort to bring the highest caliber works into the collection. "To my mind," he professed, "a great collection in most cases is determined by its masterpieces rather than its range or depth. Therefore, my primary focus—as Director—must be to acquire great works of art."[7] Indeed, many of the most iconic works in the collection were acquired during his sixteen-year tenure, five astounding examples included in this volume being Alexander Calder's *Circus* (1926– 31), Eva Hesse's no title (1969–70), Jasper Johns's *Three Flags* (1958), Elie Nadelman's *Tango* (c. 1920–24), and Frank Stella's *Die Fahne hoch!* (1959). An acknowledged consequence of this approach, however, was diminished resources for works that did not yet possess canonical status, let alone artists with less established track records. This shift was articulated in the "Report of the Director" from 1980, the year the Museum celebrated its fiftieth anniversary with much fanfare. Armstrong wrote: "The primary goal of the Museum must be to recognize the highest achievements of American artists. We now feel it is important to exercise critical judgment and make selective statements about quality— which changes to a certain extent the historical role of the Museum as the focal point for an overview of the developments in American Art."[8] In conjunction with this

narrowed focus, the Museum began taking a much firmer stance on foreign-born artists, declining to consider works by artists born abroad who had nonetheless been in this country for many years; it was a major reversal of the policies of the Goodrich–Baur years. In 1986 the gallerist André Emmerich wrote to Armstrong regarding one of his artists, the British-born David Hockney. Hockney had lived in California intermittently in the 1960s and had been residing in Malibu since 1978. His paintings of mid-century modern homes with turquoise swimming pools are immediately identifiable for their stylized aesthetic of California suburbia and now stand among the most recognizable portrayals of American domesticity. Yet Armstrong replied to Emmerich: "Good try in your efforts to convince me that David Hockney is an American artist. Unfortunately our criteria is citizenship, not longevity of residency in the United States. In this period of great change, this is one thing that is not destined to be altered, as far as I am concerned."[9]

This narrowing of the definition of American art was tightened further during the period as even works already in the collection by artists born outside the United States came under scrutiny. A drawing by the Chilean-born Roberto Matta had been donated to the Museum by the Kay Sage Estate in 1964. In correspondence with then-director Goodrich and then-curator Baur prior to the acquisition, a representative of the estate wrote of another work to be donated, this one by Yves Tanguy (who had been Sage's husband): "I thought at first of offering you a much earlier work. But when you explained that the Whitney restricts its acquisition to works by foreign-born artists painted after they had settled in this country . . . I ruled out the early picture out."[10] Goodrich and the curators readily accepted both the later Tanguy and the Matta works into the collection, although it seems they had knowledge of neither the date nor title of the Matta piece. The drawing, one of his so-called "inscapes," was identified

by the artist's wife, in response to the standard artist questionnaire (which the Whitney sends to every artist upon their work entering the collection) later that year, as *Endless Nude* and as having been made in New York in 1939, the year Matta arrived for a nearly decade-long stay. And yet, in 1980, *Endless Nude* was deaccessioned from the Whitney's collection with the intent to sell the work at auction. The Executive Committee meeting minutes indicate that "the reason for this action is that Matta is not an American artist and the work was inappropriately accepted for the collection in 1964."[11] Following this same set of guidelines, the questionnaire was amended in 1982. Among the questions added to the document for the first time: "Date of citizenship if born outside the US."[12] Not *if* you are a citizen, but *when* you became one.

The example of Yayoi Kusama proves an emblematic case study for the ways in which the parameters for "American" art have expanded and contracted over the past five decades at the Whitney. Kusama arrived in the United States from Japan in 1957, making an immediate impact on the New York avant-garde art scene and remaining in this country to produce

6. Lloyd Goodrich, "Past, Present and Future," *Art in America* 21 (September–October 1966): 30.

7. Thomas Armstrong to Whitney trustee and Yale University professor of Art History Jules Prown, January 15, 1988. Tom Armstrong Director Files, ctn. 006, Chron. "Rabbit" Files, alphabetical 01/88–06/88. FMAL, Archives, WMAA.

8. Thomas Armstrong, "Report of the Director," *Bulletin of the Whitney Museum of American Art* 2 (Fall 1980): 9.

9. Thomas Armstrong to André Emmerich, July 1, 1986. Tom Armstrong Director Files, ctn. 006, Chron. "Rabbit"

Files, alphabetical 07/86–11/86. FMAL, Archives, WMAA.

10. J. T. Soby to John I. H. Baur, May 11, 1963. Object Files, 63.46, Cataloguing and Documentation Office, WMAA.

11. Executive Committee minutes, WMAA, September 17, 1980.

12. A review of dated artist questionnaires reveals that this question was added in mid-1982, which coincides with an internal reevaluation of the content of the questionnaires. Artist questionnaires are located in the artist files in the Cataloguing and Documentation Office, WMAA.

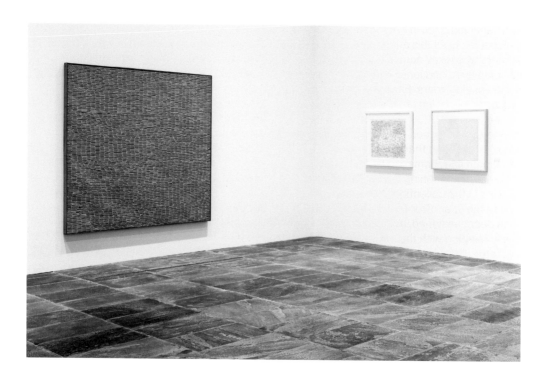

Installation view of *Yayoi
Kusama* (July 12–September
30, 2012) featuring *Air
Mail Stickers* from 1962 at left

some of her most significant work
for another sixteen years. In late 1959 she
corresponded with Goodrich and then-
curator John Gordon, inviting them to see
a gallery exhibition of her work. Gordon
subsequently wrote twice to the Bureau of
Immigration and Naturalization, in 1960 and
again in 1962, as a professional reference
to support Kusama's visa extensions.
She was included in the Whitney's 1961
Annual Exhibition of Contemporary
American Painting, and her 1962 collage
work *Air Mail Stickers* was acquired
by the Museum in 1964. The work, with its
almost maniacal accumulation of red,
white, and blue stickers, echoes elements
of Jasper Johns's flag paintings and
partakes in the burgeoning Pop movement's
appropriation of images and signage
from America's consumer society. But her
choice of materials might equally be read
as the coping mechanism of a young,
foreign-born artist working in this country
and her primary means for communicating

with her loved ones in her homeland. Encapsulating all this and more, *Air Mail Stickers* was a key acquisition and was displayed and lent numerous times in the ensuing years. Fast forward to 1981, long after Goodrich and Gordon had left the Museum: Kusama wrote to the Whitney, then helmed by Armstrong, from Tokyo, suggesting that she might participate in upcoming international group shows and mentioning her work *Air Mail Stickers* in the collection. The letter arrived the year after the Matta drawing had been deaccessioned, and the response was in keeping with that precedent. A curator at the time wrote, "The Whitney Museum can be of no assistance to you as our programs are directed toward exhibiting and collecting the works of citizens of the United States."[13] Within ten days of receiving Kusama's letter, a curatorial memo was sent to Armstrong and others recommending that *Air Mail Stickers* be deaccessioned on the grounds that Kusama was not an American citizen. For reasons not immediately evident in the archival material, the deaccessioning never occurred, and the Museum has continued to frequently exhibit, publish, and lend this work.

In the 1990s under David Ross's directorship, the pendulum swung decisively back toward a more porous and inclusive approach to the concept of American art and has since remained fixed in place. In addition to recognizing a more ethnically and racially diverse group of American-born artists, a significant number of non-citizen artists such as the French-born Marcel Duchamp, Cuban-born Ana Mendieta, and Mexican-born Gabriel Orozco entered the collection for the first time. Ross also wanted to bring greater exposure to the collection abroad and initiated a three-part exhibition, *Views from Abroad*, which invited directors from three major European museums to help organize shows from the collection. Under the directorship of Maxwell Anderson in the late 1990s

and early 2000s, the Whitney acquired two more significant works by Kusama, *Chair Accumulation* (c. 1963), which is reproduced herein, and *Fireflies on the Water* (2003). In 2012 the Museum hosted a retrospective of Kusama's work. All of this is despite the fact that Kusama has resided primarily in Japan since 1973. Indeed, our current collection management policy, last updated in December 2013, references documents from the more open Goodrich era on the question of eligibility for inclusion in the permanent collection:

The Whitney adheres to its 1958 statement of "History, Purpose, and Activities," which says, "Foreign birth and citizenship are not considered: only whether an artist's career has been identified with this country." The criteria for acquiring an artist's work are as follows: An artist may be either an American citizen or may have produced a significant body of work while living in the United States. Eligibility determinations are made on a case-by-case basis by the Museum's Director in consultation with the Curatorial Committee.[14]

Questioning and interpreting the term "American" is part of our institutional DNA. It inflects most all of our internal discussions about the exhibition program, the presentation of the collection in our new home, and—most relevant here—our acquisitions. As the lives of artists become more global and our field of vision more international in scope, new pressures have been placed on the term "American." The increasingly frequent instances of artists from various locales working collaboratively, and the digital era, with the changing art forms and erasure of geopolitical boundaries it entails, are indeed certain to further impact the Museum's interpretation of its collecting principles and its definition of "American art" and "American artist." We welcome these challenges as an

13. Patterson Sims to Yayoi Kusama, February 25, 1981. FMAL, Artist Files, WMAA.

14. WMAA, "Collections Management Policy," last revised December 2013.

essential stimulant to reassess and redefine our directive for many years to come.

With 350 artists and 427 works presented in the following pages, this book represents the broadest coverage of the collection in print to date. It is not meant to identify the highlights or masterpieces of the collection, though many of the works included qualify for those distinctions. Rather, we have aimed to reflect a dynamic cross section of the collection, a combination of acknowledged treasures, singled out for their art historical or aesthetic significance, and works that embody the distinguishing characteristics of the Whitney's collecting sensibilities over the years, including very recent additions. Unlike prior culling processes for similar publications, the current selection has been made at a crucial juncture in the Museum's history, after which the public will have unprecedented access to the Whitney's collection. By the time this book is published, more permanent collection works will be on regular view than ever before in the new downtown location. Additionally, most all of the Museum's collection is now accessible on our website. In anticipation of these two watershed events, we have been emboldened to push even further beyond the usual suspects for our choices than we might otherwise have done. This is in keeping with the Whitney's historically feisty spirit of discovery and reflects the expanded narratives of American art that have been part of our analysis and preparation of the collection for the inauguration of the downtown building.

Limiting the selection of artists for this book to 350 meant that over ninety percent of the more than three thousand artists in the collection have been excluded, and the process was at times excruciating. The selection began with each curator in the department putting forward their choice of seventy-five works for inclusion. The resulting list of most frequently nominated objects served as the central core of this book, numbering around two hundred. Many of these works are by the canonical figures of twentieth-century American art—artists who have become household names, including Alexander Calder, Edward Hopper, Jasper Johns, Georgia O'Keeffe, Jackson Pollock, and Andy Warhol. Among these are works that are generally regarded as some of the greatest achievements of twentieth-century American art. Others are by artists whom the Whitney has supported over the course of several decades and holds in depth: Jay DeFeo, Nan Goldin, Marsden Hartley, Donald Judd, Mike Kelley, Yasuo Kuniyoshi, Glenn Ligon, Christian Marclay, Reginald Marsh, Agnes Martin, Alice Neel, Louise Nevelson, Isamu Noguchi, Claes Oldenburg, Nam June Paik, Ed Ruscha, and Cindy Sherman. Of course, many of the works by the artists in this latter group are also icons of the collection and among those most frequently requested for loan or reproduction.

The remaining selection of artists—and the final list—was fleshed out in an iterative process among the subset of the curatorial department charged with pulling together the inaugural exhibition of the collection in the Renzo Piano–designed building. These discussions took into consideration a multitude of factors beyond the subjective qualities of the works themselves, including the chronological spread of the objects and the balance of mediums represented. The age, gender, and race of the artists were noted but not determinative. We had no quota or target number for any of these identifiers; rather, we wanted the final composition of the book to exhibit the complexity and dimensionality of the artistic community in the United States over the last twelve decades. Finally, at each stage of the selection process the lists of artists and objects were discussed at length with Adam D. Weinberg. As the Museum's director, Weinberg would necessarily have a vested

interest in the selection, but as former curator of the permanent collection at the Whitney and the steward of many of these objects for nearly a decade, he was uniquely well prepared for the task.

Not all of the 282 artists that appeared in the last edition of the Whitney's collection handbook, published in 2001, are included in this volume, and of those who are repeated, many are represented by different works. This is an indication of both the growth of our collection and the ongoing interpretation and reassessment of its contents. While in 2001 the collection contained approximately fourteen thousand objects, we are now approaching twenty-two thousand. This growth is not restricted to the most contemporary art though; a significant number of the historical works featured in this publication have been acquired since the last edition was published, some notable examples being those by Lynda Benglis, Allan D'Arcangelo, Melvin Edwards, Hans Haacke, Roy Lichtenstein, Gordon Matta-Clark, Claes Oldenburg, Ed Ruscha, Nancy Spero, and Clyfford Still. And as the result of even more recent collection-building efforts, works by Asco, Carol Bove, Mary Ellen Bute, Roy DeCarava, Andrea Fraser, Carmen Herrera, On Kawara, Karen Kilimnik, Josephine Meckseper, Jonas Mekas, Toyo Miyatake, Chiura Obata, Laura Owens, Faith Ringgold, and Andrea Zittel are among the thirty-six works in this book acquired by or promised in 2014. Not all of the less familiar works in this book are new to the collection, however; some have been among our holdings from the beginning. Gertrude Vanderbilt Whitney's 1914 sculptural self-portrait *Chinoise*, considered one of her finest works, was part of the founding collection and was included in countless collection exhibitions and publications until the mid-1970s. But it was absent from the collection books produced in 1984 and 2001 and remained unexhibited from 1992 until 2011, when it was included in an exhibition focused on the founding collection. The inclusion of *Chinoise* marks another interval in the continual reassessment and reconsideration of the collection.

The alphabetical arrangement of the handbook provides a neutral means of presentation that avoids any hierarchical sequencing or attempt at either chronologies or taxonomies based on medium specificity. Indeed, many of the artists are represented by multiple works that were made decades apart and employ different mediums. This in itself reflects the all-encompassing composition of the Whitney's collection and the cross-disciplinary structure of its curatorial department, which is not subdivided by artistic medium. And however startling they may seem, the pairings that have occurred on the facing pages of a spread (see Fred Wilson and Garry Winogrand, for example, or Hannah Wilke and Christopher Williams) are entirely serendipitous and demonstrate the productive frisson created by a reshuffling of the collection.

Looking ahead to the next chapter of the Whitney's history, the collection will play a starring role. This handbook is intended to engender a better understanding of the Museum and its holdings by illuminating a small subset of the collection. Certainly the hope is that this volume will persuade readers to see the originals if they have not already visited the Museum, or to return to study new favorites. And perhaps some of the inclusions will provoke discussion about what art, over the last eight decades, has been deemed "American" enough to enter the collection. Examining how and when works have earned entry into the collection and what criteria were used for their acceptance helps to delineate what "American" means to the Whitney now and to consider afresh what the Whitney might mean to America and beyond. But more than anything, the hope is that this book will provide the viewer with the pleasures of viewing the Whitney's collection of American art, in all its multifarious interpretations.

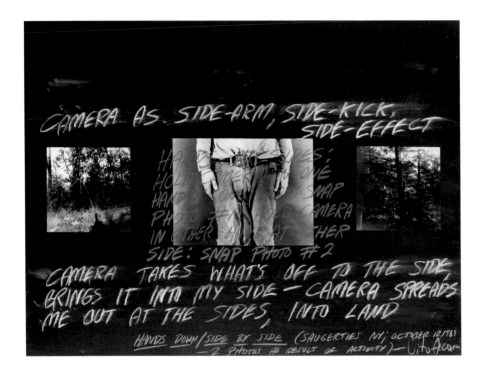

Known for his radical experiments in performance, video, and installation, Vito Acconci began his career as a poet. A preoccupation with space—specifically, how words are contained within the page—led in 1969 to early forays in the visual arts, which he described as "ways to get myself off the page and into real space." Setting up situations based on actions such as jumping, following people, or rubbing his own body, Acconci recorded his activities through text, photographs, and audio- or videotape.

On October 12, 1969, midway through his three-week action *Following Piece*, in which he followed strangers throughout New York to challenge the boundaries of private and public space, Acconci traveled a hundred miles north to Saugerties. There, in the bucolic Hudson River valley that had inspired artists since the nineteenth century, he enacted *Hands Down/Side by Side*. Holding a Kodak Instamatic at one hip with little regard for framing or orientation, he snapped a photo of his surroundings before switching the camera to the opposite hip for a second shot. Far from the carefully composed landscape views associated with this place, Acconci's photographs captured off-handed impressions "not of an activity, but through an activity." Acconci pasted the two photographs on each end of a board, flanking a spliced image of his midsection that locates the origin of the other photographs. In this layout, the artist defines the limits of his body in space, allowing it to expand "into land" as he sketches out his schematic description.

Hands Down/Side by Side, 1969. Four gelatin silver prints and chalk on board, 29⅞ x 40 in. (75.9 x 101.6 cm). Purchase with funds from the Photography Committee 92.12a–d

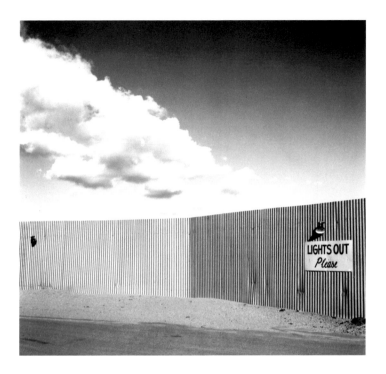

Robert Adams is often identified as a preeminent member of the New Topographics, a label used to describe the work of a group of photographers featured in a 1975 exhibition of that name with the subtitle *Photographs of a Man-Altered Landscape*. These photographers eschewed the picturesque, heroicized aspects of traditional landscape photography for a more sober approach, frequently documenting the transformation—and often, the destruction—of natural environments in the wake of urbanization and industrialization. For the past four decades, Adams's focus has been the changing landscape of the American West. His virtuoso black-and-white images are generally devoid of people but capture the traces and effects of human intervention, implicitly contrasting wilderness with aspects of development and technology. Adams's photographs give the lie to the romance of the West as a frontier of endless promise even as they glorify the

natural beauty that endures there, however precariously.

Like much of Adams's early work picturing suburban areas in Colorado, *Outdoor Theater, Colorado Springs, Colorado* records the incursion of contemporary society—in the form of a section of a fence around a drive-in movie theater—on otherwise unspoiled territory. The spare, striking image exemplifies the artist's feel for compositional harmony: a horizontal band of pavement on the lower edge of the image offsets the vertical fencing, and the diagonal created by a stretch of clouds counterpoises the incline of the top edge of the fence.

Outdoor Theater, Colorado Springs, Colorado, 1968. Gelatin silver print, 5⅝ x 6 in. (14.3 x 15.2 cm). Edition no. 1/3. Promised gift of Thea Westreich Wagner and Ethan Wagner P.2011.5

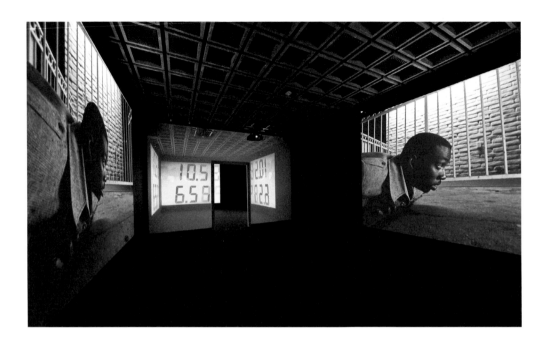

Artist Doug Aitken works across a range of mediums that include single- and multichannel video, film, live performance, sound, photography, and architectural intervention. His projects have engaged diverse geographical and cultural sites, from diamond mines in southwestern Africa to India's Bollywood. Aitken is well known for his large-scale indoor and outdoor video installations that transform physical spaces through complex narratives and viewing experiences. His cinematic project *sleepwalkers* (2007), for example, consisted of five interconnected stories that were displayed as eight projections onto the exterior walls of the Museum of Modern Art in New York and explored the nocturnal urban landscape by following five inhabitants of the city—a bike messenger, a postal worker, an office worker, an electrician, and a businessman.

Aitken's earlier landmark project *electric earth*, which earned him the Golden Lion at the Venice Biennale in 1999, already explored this type of new cinematic form in a multiroom installation. The protagonists of *electric earth* are both the anonymous urban landscape and the lone dancer who traverses it, responding to its rhythms of blinking traffic lights and automatic car windows and fusing psychological and topographical states: "A lot of times I dance so fast that I become what's around me," the protagonist says. *electric earth*'s fusion of dancer and urban wasteland constructs an environment that in turn implicates viewers, who must move through and immerse themselves in it to experience the work. Aitken visually achieves this fusion by expertly merging the vocabularies of narrative cinema, music video, and dance, choreographing a cityscape that is as alienating as it is seductive.

electric earth, 1999. Eight-channel video, color, sound; and architectural environment, dimensions variable. Edition no. 4/4. Purchase with funds from the Painting and Sculpture Committee and the Film and Video Committee 2000.145. Installation view: Whitney Museum, 2009

Throughout his career as an artist, teacher, and writer, Josef Albers investigated the "interdependence" of color and perception. His famous series *Homage to the Square* (1950–76) explores this concept in more than a thousand paintings, drawings, prints, textiles, and murals, each composed of three or four nesting squares and produced in an array of colors. He began the series at the time he joined the faculty at Yale University, after years spent teaching at the Bauhaus and Black Mountain College. His subsequent work in the classroom and studio led to *Interaction of Color* (1963), his influential book on color theory.

Albers created the *Homages* with meticulous consistency. After applying several coats of gesso to a composition board, he penciled one of four set layouts, all symmetrical and weighted toward the bottom edge. He then applied a predetermined palette from the center out, spreading colors straight from the tube with a knife and recording names and manufacturers on the verso (he occasionally mixed paints, including the blue here in the early *"Ascending"*). Such precision was key to demonstrating the mutability of perception, or what he called the difference between "physical fact and psychic effect." Across the series, color combinations alter not only how we see individual hues but also how we perceive space and form. As Albers noted, the squares seem to "move forth and back, in and out, and grow up and down and near and far, as well as enlarged and diminished." In *"Ascending"* squares of yellow, cream, gray, and blue radiate upward. Albers's subtitle references this illusion of movement, while hinting at the potential for metaphysical transformation.

Homage to the Square: "Ascending," 1953.
Oil on composition board, 43½ x 43½ in. (110.5 x 110.5 cm). Purchase 54.34

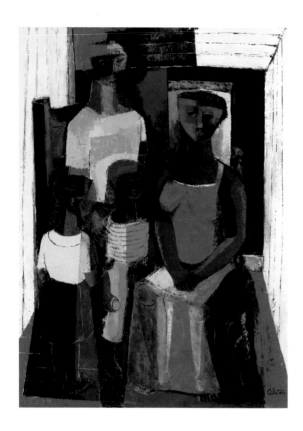

An influential painter, printmaker, sculptor, teacher, and activist, Charles Henry Alston was a central figure of the Harlem Renaissance. Moving with his family to Harlem in 1915, Alston began painting and sculpting as an adolescent before pursuing formal art studies at Columbia University in 1925. During college and after receiving his MA in 1931, Alston taught art at two important Harlem community centers: the Utopia Children's House, where he trained a young Jacob Lawrence, and the Harlem Art Workshop. The experiences led him to establish his own studio workshop in 1934, which quickly became a hub for artists and intellectuals, including Romare Bearden, Ralph Ellison, Langston Hughes, Gwendolyn Knight, and Augusta Savage. This deep engagement with his community is reflected in Alston's art, from the Social Realist scenes of his Harlem Hospital murals to the more painterly compositions of his canvases, both figurative and abstract.

The Family is a portrait of four figures, rendered through bold blocks of color and defined by thin lines created with a palette knife. Calling the family "a recurring theme in my painting," Alston wrote that the work was "an attempt to express the security, stability and human fulfillment which the ideal family represents." His artistic challenge, he explained, was "to find the painterly equivalents for these qualities, as well as [to] tell the story"; he found the solution in "a compact, well-organized design with subtle harmonies and discords and a certain solid, monumental quality."

The Family, 1955. Oil on canvas, 48¼ x 35⅞ in. (122.6 x 91.1 cm). Purchase with funds from the Artists and Students Assistance Fund 55.47

Twenty-Ninth Copper Cardinal,
1975. Copper, twenty-nine
parts: ¼ x 19¾ x 19¾ in.
(0.6 x 50.2 x 50.2 cm) each;
¼ x 19¾ x 580 in. (0.6 x
50.2 x 1,473.2 cm) overall.
Purchase with funds from the
Gilman Foundation Inc.
and the National Endowment
for the Arts 75.55a–cc

In the mid-1960s Carl Andre began making three-dimensional works using materials such as wood, bricks, metal, and precut stone, ordered directly from suppliers. His commitment to utilizing standardized elements and modular, repeating units aligned his practice with Minimalism, yet he preferred to call himself a "post-studio artist" because he conceived and arranged his works on site, in gallery settings, private homes, or public spaces. Instead of viewing the sculptural material as something to be cut into, Andre determined rather to "use the material as the cut in space." He rejected traditional sculpture's vertical orientation and its relationship to upright human bodies. Horizontal works, he argued, "run along the earth," like a road, and indeed his floor works are meant to be walked upon. In fact, the artist once described the road as his "ideal piece of sculpture."

Twenty-Ninth Copper Cardinal is composed of twenty-nine copper plates arranged one after the other, extending outward from the base of a wall in a straight line along the floor. This narrow, flat sculpture belongs to a larger series of *Copper Cardinal* works, begun in 1973. The configuration of each work in the series—either linear, square, or rectangular—depends on the number of units designated for it. Prime numbers of units, such as twenty-nine, are always placed in a line, whereas divisible numbers of units are arranged in rectangles or squares. By allowing spectators to walk on his floor pieces, Andre extends the viewer's perceptual and physical understanding of sculpture. When standing toward the middle of *Twenty-Ninth Copper Cardinal*, the sculpture can appear to fall out of view or to extend beyond its visible boundaries.

Myself—1855, 1977, from
The Angel of Mercy:
The Nightingale Family Album.
Toned gelatin silver print
mounted on paper with ink,
18 x 13 in. (45.7 x 33 cm).
Purchase with funds
from Joanne Leonhardt
Cassullo and the Photography
Committee 95.67.25

Since the late 1960s, Eleanor Antin's work in film, video, performance, and installation art has questioned the immutability of identity. Expanding upon the insistence of the women's movement that traditional gender roles are socially determined rather than innate, in the mid-1970s Antin began to imagine, in art, a range of possible subjectivities for herself. Commenting that the "usual aids to self-definition," such as sex, age, talent, and even time and space, "are merely tyrannical limitations upon my freedom of choice," she slid in and out of a set of archetypal "selves" informed by complex, fictitious narratives, costumes, and makeup.

Myself—1855 resembles a photo-album page, with a handwritten caption in faded ink and a portrait photograph of Antin in the role of Eleanor Nightingale, a fictionalized version of the founder of modern nursing, Florence Nightingale. Working with a group of friends dressed in period costume, Antin staged elaborate scenes from Nightingale's life, which she captured in two suites of photographs, some stained with coffee to lend them a vintage patina. The first, *The Nightingale Family Album*, to which this image belongs, depicts the leisure pursuits of the Victorian aristocracy that Nightingale left behind and her metamorphosis into a caregiver. The second, *My Tour of Duty in the Crimea*, portrays Nightingale's exploits in the Crimean War, the conflict during which she secured her reputation. Together the suites form the series *The Angel of Mercy*. Alternately somber and funny, the project addresses topics from class and gender to charity and cruelty, using Nightingale's life and times as a lens through which to consider identity and subjectivity.

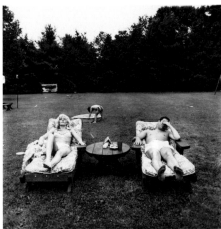

Patriotic Young Man with a Flag, N.Y.C., 1967. Gelatin silver print, 14 ⅞ x 14 ¾ in. (37.8 x 37.5 cm). Promised gift of Sondra Gilman Gonzalez-Falla and Celso Gonzalez-Falla to the Whitney Museum of American Art, New York, and the Gilman and Gonzalez-Falla Arts Foundation P.2014.47

A family on their lawn one Sunday in Westchester, N.Y., 1968 (printed c. 1969–71). Gelatin silver print, 14 ¼ x 14 ⅞ in. (36.2 x 37.8 cm). Purchase with funds from the Mr. and Mrs. Arthur G. Altschul Purchase Fund, Michèle Gerber Klein, and the Photography Committee 95.3

Diane Arbus's photographs convey her unique vision of a time and a place—the period from approximately 1958 to 1971, primarily in and around New York—through intimate portraits of an array of strangers, acquaintances, and relations. Arbus wrote: "For me the subject of the picture is always more important than the picture. And more complicated." The daughter of a wealthy New York family, Arbus became involved in photography with her husband, and the couple established a fashion photography business in 1946. She concurrently pursued her own photographs, but study with the groundbreaking photographer Lisette Model in the late 1950s precipitated a turning point in her work. In 1959 Arbus left her husband, moved to Greenwich Village, and began to concentrate on street photography of people she encountered throughout Manhattan; some of these images, taken with a 35mm camera, were published as photo essays in *Esquire* and *Harper's Bazaar* magazines. Arbus's mature style developed after 1963, when she used a medium-format Rolleiflex camera, which resulted in a distinctive square format, and often a strobe.

In *Patriotic Young Man with a Flag, N.Y.C*, Arbus isolates a demonstrator at a pro–Vietnam War rally in dramatic close-up, the harsh flash capturing his contorted expression, which, juxtaposed with a button declaring "I'm Proud" offers a discomfiting vision of patriotism. In another distinctly American portrait, *A family on their lawn one Sunday in Westchester, N.Y.* presents a suburban family on their lawn; "The parents," Arbus wrote, "seem to be dreaming the child and the child seems to be inventing them." Although she worked for just over a decade (she committed suicide in 1971), Arbus produced some of the most searing images in the pantheon of photography.

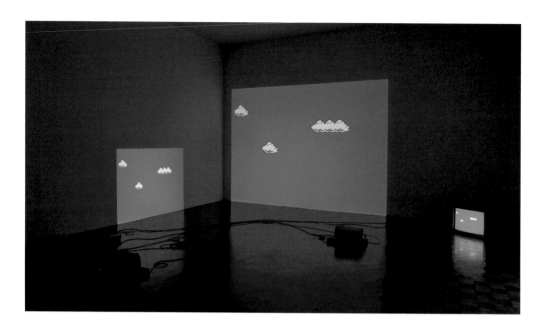

Cory Arcangel's work mines the interplay among digital technologies, Internet culture, and fine art, engaging a range of mediums that include video, installation, performance, print media, musical composition, Internet-based art, and computer games. Arcangel has created several pieces by hacking and reverse-engineering cartridges for the game *Super Mario Brothers*, replacing the chips with his self-manufactured ones. In his iconic *Super Mario Clouds*, he removed everything from the game except for the white clouds and a blue sky.

Super Mario Clouds creates a scenery that effectively fuses and transcends the media from which it borrows—video, computer games, and even "landscape painting"—and seems to evolve into a new manifestation of Pop art. This installation consists of a projection of the clouds as well as their display on a monitor running the Nintendo Entertainment System, the gaming platform supporting the piece. Arcangel lists detailed instructions as well as the code for creating the project on his website, allowing anyone to reproduce the work.

As in many of his video game projects, Arcangel modifies and undermines the experience of play. *Super Mario Clouds* does not allow for interaction but invites viewers to contemplate both their expectations of computer games and these games' inherent aesthetics. The project also reflects the tensions between high-tech and do-it-yourself, as well as pop culture and fine art—themes that have remained prominent in Arcangel's body of work. The appropriation, manipulation, and recontextualization of a mass-produced object, in this case a popular video game, references Marcel Duchamp's concept of the "readymade" and reconsiders established artistic practices through the use of digital technologies.

Super Mario Clouds, 2002. Handmade hacked Super Mario Brothers cartridge and Nintendo NES video game system, dimensions variable. Edition no. 2/5. Purchase with funds from the Painting and Sculpture Committee 2005.10. Installation view, Whitney Museum, 2009

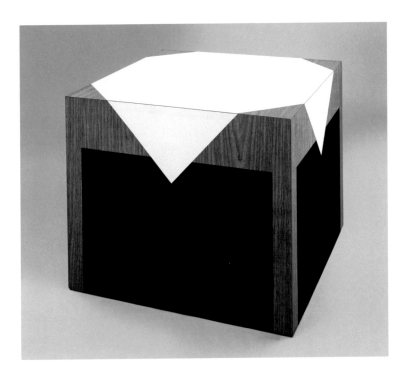

Over the course of six decades Richard Artschwager produced sculptures, paintings, drawings, and architectural interventions that consistently sidestepped the art historical categorizations of their times. During the 1950s Artschwager supported himself as a cabinetmaker, but by the early 1960s he felt increasingly compelled to make what he deemed "useless objects" rather than utilitarian furniture. Artschwager's technical abilities informed his artistic sensibility, and he continued to use wood, and plywood in particular, for his sculptures. But he covered the constructions with melamine laminate (better known by the commercial name Formica), an unlikely medium that he described as "the great ugly material, the horror of the age." More commonly found on luncheonette counters than in museums or art galleries, Formica proved a productive choice for an artist interested in the pictorial qualities of sculpture.

For *Description of Table*, Artschwager fashioned a plywood box and covered the sides with various patterned laminates that approximate wood grain, the negative space between and beneath its legs, and a tablecloth. Its rigid geometries and bilateral symmetry evoke Minimalist sculpture even as the work remains playfully representational. The commercial materials invoke the Pop aesthetic of combining "high" art with "low" mediums and techniques, yet the artist also privileged the trompe l'oeil effects of the synthetic surfaces. By optically mimicking the negative space beneath the table alongside the textures of woven fabric and striated wood on a continuous plane, Artschwager's *Description of Table* is at once an object and a picture of an object.

Description of Table, 1964. Formica on plywood, 26⅛ x 31⅞ x 31⅞ in. (66.4 x 81 x 81 cm). Gift of the Howard and Jean Lipman Foundation Inc. 66.48

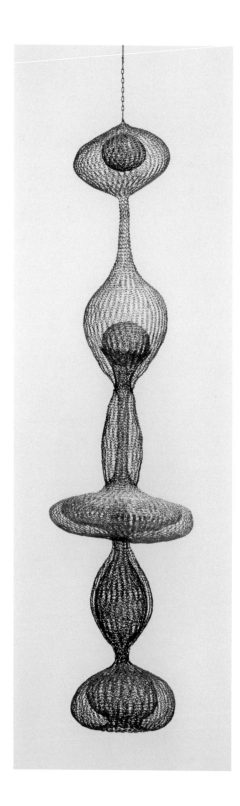

As the child of Japanese immigrants living in California, Ruth Asawa was placed in an internment camp for several years during World War II. Because of lingering discrimination after the war and bleak job prospects, Asawa abandoned her pursuit of a teaching degree and in 1946 she enrolled instead at the experimental, nonaccredited Black Mountain College in North Carolina. She planned to study painting and drawing with the influential artist Josef Albers, but the institution's cross-disciplinary emphasis soon led her to sculpture. This nascent interest flourished after a summer in Toluca, Mexico, where she learned from the local craftspeople how to make the crocheted wire baskets she had admired. The crochet technique requires looping wire around a wooden dowel to produce what the artist described as "a string of e's." By repeating this one motion—with adjustments made for the weight of the material or the space between loops—Asawa created undulating, voluminous forms. "The shape comes out working with the wire," she explained. "You don't think ahead of time, *this is what I want.* . . . You make the line, a two-dimensional line, then you go into space, and you have a three-dimensional piece."

Number 1 – 1955 (which the artist had to re-create in 1958 because of faulty metal in the original), like many of Asawa's abstract wire sculptures, is comprised of an outer, vertical structure, inside of which she nestled smaller shapes, often of a differing metal. Suspended from the ceiling, the biomorphic, semitransparent structure creates a multidimensional play of interior and exterior spaces and a constellation of shadows on the wall. The work, according to Asawa, "does not hide anything . . . and inside and outside are connected. Everything is connected, continuous."

Number 1 – 1955, 1954 (refabricated 1958). Brass and steel wire, 63⅞ x 15 x 15 in. (162.2 x 38.1 x 38.1 cm). Gift of Howard Lipman 63.38

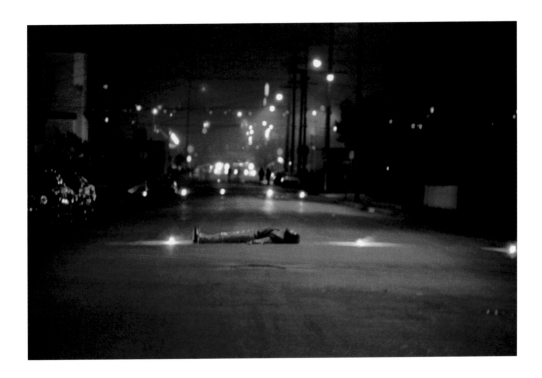

Fueled by the Chicano civil rights movement of the late 1960s and the punk underground of the early 1970s, the collective Asco was founded in East Los Angeles by the artists Harry Gamboa Jr., Gronk, Willie Herrón, and Patssi Valdez, and included other artists over the course of the group's fifteen-year history. Asco means *disgust* or *nausea* in Spanish and aptly expressed the young artists' aversion to America's unjust social and political landscape. The group developed a highly stylized body of work that reflected their avant-garde sensibility and activist impulses. They staged guerilla performances in the streets in protest of mainstream establishments, including the Los Angeles Police Department, the Los Angeles County Museum of Art, the Catholic Church, and Hollywood.

It was LA's all-pervasive movie industry that provided rich source material for Asco's important "No Movie" series, conceptual works that existed as carefully staged photographs, performative actions, published texts, mail art, and media hoaxes. The "No Movies" satirized the Hollywood machine while interrogating both the lack of Chicanos in the media and the stereotypical depictions of them when they were present. For *Decoy Gang War Victim*, Asco mailed a photograph of Gronk posed as a casualty of gang violence to several local press outlets, one of which broadcast it on television as a real incident. The simulated event exposed the media's bias toward East Los Angeles's barrio community and revealed the ways in which the press helped perpetuate not only these racial, social, and economic stereotypes but the violence itself.

Decoy Gang War Victim, 1974 (printed 2011). Chromogenic print, 12¾ x 19 in. (32.2 x 48.3 cm). Edition no. 2/10. Purchase with funds from the Photography Committee 2014.46

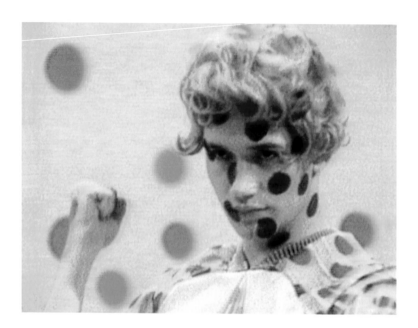

Charles Atlas moved to New York in the early 1970s and soon began to work as assistant stage manager with the Merce Cunningham Dance Company. After experimenting for the first time with video—then still a new technology—he became filmmaker in residence with the company, serving in that capacity from 1974 to 1983. His collaboration with Cunningham, which continued until the choreographer's death in 2009, forged a genre Atlas called "media-dance."

Fusing the techniques of documentary filmmaking with video art, Atlas collaborated with other artists as well, among them Leigh Bowery, Karole Armitage, Marina Abramović, and Yvonne Rainer.

In 1984 Atlas met the young Scottish-born dancer and choreographer Michael Clark, whose newly formed London company channeled the postpunk culture of the era into cutting-edge dance. Atlas collaborated with Clark on *Hail the New Puritan*, a feature-length work structured as "twenty-four hours in the life of a dancer" and peppered with performances and dreamlike sequences, blurring the line between documentary and fiction.

With production design by Leigh Bowery and music by the Fall and Glenn Branca, the work employs cinema-verité techniques to create a narrative that loosely follows Clark as he prepares for a performance titled "New Puritans." Atlas drew inspiration for this surreal performance-portrait from works that had long been important to him, such as 1940s Hollywood musicals, the Beatles' *A Hard Day's Night* (1964), and Andy Warhol's *Chelsea Girls* (1966). As Atlas later said, "It wasn't like finding the truth, it was like doing something fun with the truth."

Still from *Hail the New Puritan*, 1985–86. Video, color, sound; 47 min. Purchase with funds from the Film, Video, and New Media Committee and Catherine Orentreich in honor of Norman Orentreich 2014.284

Tauba Auerbach's "Fold" paintings may initially appear to be photorealistic depictions of new bed sheets freshly removed from their packaging, or pieces of creased paper. To make works such as *Untitled (Fold)*, Auerbach employs the elements essential to painting—canvas, colored pigment, and wooden stretchers—in order to complicate the relationship between representation and reality. She begins by crumpling swathes of canvas, ironing in the folds or pressing them with weights, and leaves the resulting creases to set for several days. She then loosely spreads the canvas out on the studio floor before applying pigment with a house-paint sprayer, holding the device at a raking angle to mimic the effect of natural light falling across a rumpled surface. Afterward, she stretches the fabric taught. As Auerbach has explained, "The resulting flat surface carries a near-perfect record of the canvas's previous three-dimensional self." To determine the final composition, she manipulates the placement and size of the stretcher bars to best capture the effects she has generated.

In its final state *Untitled (Fold)* is a two-dimensional canvas that alludes, through trompe l'oeil techniques, to its past status as a three-dimensional heap of cloth. Auerbach purposely confounds these two senses of time and form in order to "conjure four-dimensional space." In retaining an alluring, lustrous materiality, her depiction of folds also bridges another duality, allowing the viewer's perceptions to oscillate between the aesthetic and the conceptual.

Untitled (Fold), 2010. Acrylic on canvas, 72⅛ x 54⅛ in. (183.2 x 137.5 cm). Purchase with funds from the Painting and Sculpture Committee 2011.12

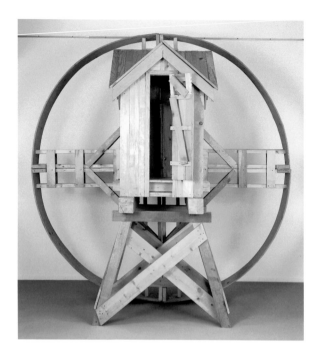

In the early 1970s Alice Aycock found her "muse" in architecture. Her large-scale, Minimalist-inspired work staged encounters inflected with a sense of precariousness, in which spectators navigated mazes, climbed ladders, or crawled through cramped enclosures. *Untitled (Shanty)* marked a shift in Aycock's work toward "nonfunctional architecture"—irrational sculptures entered imaginatively rather than physically. Described by the artist as a "medieval wheel house," *Untitled (Shanty)* is a rudimentarily carpentered wood hut, roof pitched with four gables, front door swung open, propped on a platform, and set against a pair of ladders inscribed within a wheel. While the wheel recalls a primitive mechanism for a watermill or a torture device, its function is not discernable; even if the shack were large enough for a person, it would still be inaccessible, perched several feet above the ground.

The works that followed this piece—frequently public art commissions in steel, aluminum, plastic, and wood—are massive, theatrical pseudo-architectural and mechanical structures, similarly evoking utilitarian forms but not made for practical use. Drawing from a heterogeneous set of architectural, scientific, literary, and occult sources (Thai legends, ancient Egyptian tombs, Bauhaus design, tantric drawings, microchips, and autobiographical experiences), Aycock's repertoire of claustrophobia- and vertigo-inducing forms variously suggests amusement-park rides, turbines, towers, and temples. According to the artist, her syntheses of architectural and symbolic elements investigate the relationship between the way people produce tools—whether arrowheads or rocket ships—and the structure of our minds, plumbing the limits of human imagination and thinking.

Untitled (Shanty), 1978.
Wood, 123⅜ x 107½ x 53⅞ in.
(313.4 x 273.1 x 136.8 cm).
Gift of Raymond J. Learsy
84.711

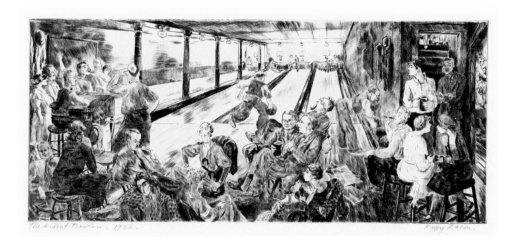

Throughout her work as an artist, illustrator, and writer, Peggy Bacon affectionately satirized the early twentieth-century art world of New York. From 1915 to 1920, she honed her precocious talents at the Art Students League, where her artist parents first met. Influenced by the life drawing classes of John Sloan, who encouraged his students to capture the everyday details around them, she began to sketch caricatures of her artist colleagues—a practice she continued through the 1930s. Though initially trained as a painter, in 1917 Bacon taught herself drypoint, a steel-pen etching technique that would become her primary medium for a decade. She developed a style remarkable for its tonal variation and its use of sketchlike marks such as cross-hatching, and quickly gained prominence as a printmaker (she began showing her prints at the Whitney Studio Club in 1925).

The Ardent Bowlers demonstrates Bacon's drypoint skills and her ability to capture her social milieu with wit and precision. Set in a bowling alley on Third Avenue, the scene depicts a weekly social gathering of artists associated with the Woodstock circle, to which Bacon and her husband belonged. The composition is characteristically crammed with figures;

yet, as Bacon explained of those depicted in her work, "every one of the people was a portrait of a particular individual." Bacon sits center foreground, turned to the right in conversation with another woman; the artist Reginald Marsh is seated at far left. In spite of the dramatic perspectival recession of the bowling lanes beyond, the raucous crowd dominates our field of vision. We, like the bowlers, are drawn into the social dynamics of the group, who are clearly more engaged in one another's company than the sport at hand.

The Ardent Bowlers, 1932.
Drypoint: sheet, 11⅜ x 18⅝ in.
(28.9 x 47.3 cm); plate,
6 x 13⅞ in. (15.2 x 35.2 cm).
Edition of 125. Purchase 32.85

The simplicity of the elements of Jo Baer's *Untitled* belies the complexity of the whole: subtle differences in the weight and shape of the lines draw in the eye, colors vibrate and merge in peripheral vision, and the white edge that extends beyond the black border seems to bleed into space. *Untitled* belongs to a series from 1962–63, later titled the "Korean" paintings, in which Baer repeated this format, varying only the geometry along the upper edge within an otherwise strict template.

This series was Baer's first important statement as a painter and marked her entrance into the emerging discourse of Minimalism. Like other New York artists in the 1960s, Baer made abstract works that engaged the viewer's perceptual experience, often through seriality and geometric form. Yet, while most of her contemporaries began to work with industrial materials, regarding painting as burdened by

illusionism, Baer pursued painting's potential as a radical, nonobjective medium. Her application of paint emphasizes the flatness of the canvas, producing "paintings that picture their own shapes." Baer's commitment to Minimalist painting was informed by gestalt and other theories of perception, which she had studied in the 1950s. The color and shape of *Untitled* produce such optical phenomena as Mach bands (where contrast between a light and dark field heightens the luminosity of both) and retinal glare (in which a white area appears to expand). Baer described her works as "painted light," asserting that they "do not represent light, they are light."

Untitled, 1962. Oil on linen, 71⅞ x 71⅞ in. (182.6 x 182.6 cm). Gift of Arthur Fleischer Jr. 95.217

AN ARTIST IS NOT MERELY THE SLAVISH
ANNOUNCER OF A SERIES OF FACTS.
WHICH IN THIS CASE THE CAMERA HAS
HAD TO ACCEPT AND MECHANICALLY
RECORD.

One of the most notable figures of West Coast conceptual art and an influential teacher, John Baldessari began moving beyond traditional artistic forms in the mid-1960s. His inventive, irreverent art of the past fifty years encompasses painting, photography, prints, film, video, installation, and sculpture. Baldessari's use of found and appropriated imagery has raised important questions about what constitutes authority or authorship; where the boundaries between different mediums lie; what relationships exist between words and pictures; and how images accrue meaning differently depending on context.

This work is one in a series that pairs casual snapshots Baldessari took around the San Diego area with didactic texts and formulaic advice excerpted from art theory or how-to books. The idea of artistic skill and originality is challenged in multiple ways. Baldessari hired a professional sign painter to letter the texts in a nondescript typeface—thus absenting his hand from the creative process— and chose purposefully "bad" images that betray conventions of photography. The traditional hierarchy of mediums, especially the presumed superiority of painting to photography, is no less sacred: by printing his snapshot directly onto an emulsion-coated canvas, Baldessari uses a photographic technique to create a painting. With his signature humor and irony, this work renders Baldessari the "slavish announcer" described in the caption.

An Artist is Not Merely the Slavish Announcer, 1966–68. Photographic emulsion, varnish, and gesso on canvas, 59⅛ x 45 in. (150.2 x 114.3 cm). Purchase with funds from the Painting and Sculpture Committee and gift of an anonymous donor 92.21

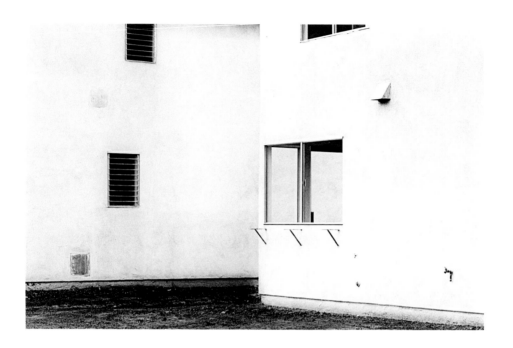

In 1975 work by Lewis Baltz was included in a groundbreaking exhibition at the International Museum of Photography at the George Eastman House in Rochester, New York. *New Topographics: Photographs of a Man-Altered Landscape* featured ten photographers whose work considered the impact of postwar industrialization and urbanization on natural and built environments. Often using large-format cameras, the photographers recorded these developments with an unsentimental approach that aimed for objectivity, forswearing the picturesque scenes and romanticized vistas that historically had dominated the genre of landscape photography. Baltz has produced series of photographs of industrial parks, warehouses, construction sites, recreational areas, and centers of technological and scientific research. He frequently photographs the same subject multiple times over a period of years, the better to register change and transformation.

　　The Tract Houses is a portfolio of twenty-five black-and-white photographs of the exteriors of new homes under construction on the outskirts of Los Angeles. Baltz took the images between 1969 and 1971, during the peak of the exodus from city to suburb, and his photographs document the region's vernacular period architecture in a straightforward, deadpan manner, exposing cheap construction and banal details. Yet the photographs are neither compositionally nor aesthetically neutral: here, for example, the arrangement of windows and air vents creates a loose grid—an abstract pattern that is particularly striking in black and white.

Tract House #22, detail of *The Tract Houses*, 1971. Portfolio of twenty-five gelatin silver prints, dimensions variable. Edition no. 10/12. Purchase with funds from the Wilfred P. and Rose J. Cohen Purchase Fund, the John I. H. Baur Purchase Fund, the Grace Belt Endowed Purchase Fund, and the Photography Committee 93.70a–y

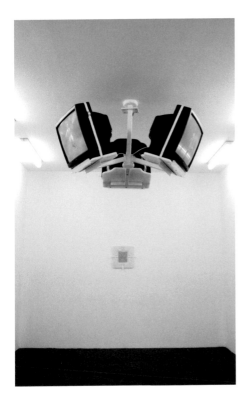

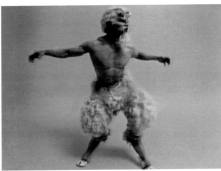

Installation view and still from *DRAWING RESTRAINT 7*, 1993. Three-channel video, color, silent; three monitors; enamel on steel; internally lubricated plastic; and six high-abuse fluorescent lighting fixtures, dimensions variable. Edition no. 2/3 Purchase with funds from the Painting and Sculpture Committee 93.33. Installation view: Whitney Museum, 1993

Since the late 1980s Matthew Barney has employed a range of mediums, including film, video installation, drawing, andsculpture, to address themes such as the limitations of the body, androgyny, eroticism, and ritual. A former athlete, Barney has maintained an interest in bodily transformation that is conveyed through a sophisticated and idiosyncratic visual language. In the earliest works in his *DRAWING RESTRAINT* series, begun in 1987, the artist illustrated the principle of hypertrophy (muscles growing stronger in response to resistance) by fashioning restraints, challenges, and experiments for himself in his studio—"facilities to defeat the facility of drawing," as he put it. As the series progressed, the imagery became increasingly elaborate, from the film sets, narratives, and costuming to the physical feats performed.

For the video installation *DRAWING RESTRAINT 7*, Barney created three horned and cloven-footed satyrs—characters played by two actors and the artist himself wearing sculpted prostheses and professional makeup—whose actions and interactions build in fantastical and libidinal scenes that reference Greco-Roman mythology and the ancient sport of wrestling.

Most of the action takes place within the confines of a limousine bathed in otherworldly neon light, where the satyrs attempt to make images in the condensation on the vehicle's sunroof. In other scenes the two mature satyrs battle to remove each other's horns with strange instruments, while the kid, played by Barney, engages in an endless struggle to catch his own tail. *DRAWING RESTRAINT 7* was included in the 1993 Whitney Biennial and established new approaches to art making at the end of the twentieth century.

Richmond Barthé

b. 1901; Bay St. Louis, MS
d. 1989; Pasadena, CA

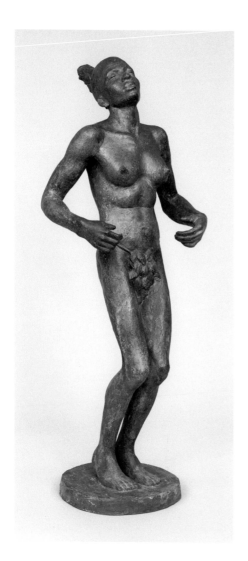

Richmond Barthé sculpted the human body with a sensitivity to movement and expression, earning him acclaim during the 1930s and 1940s. At age fourteen Barthé moved from Mississippi to New Orleans, where patrons encouraged him to pursue the formal study of art. In 1924 he began studies at the Art Institute of Chicago and started to work in sculpture, while also taking private lessons with the painter Archibald Motley Jr. Settling in New York in 1930, Barthé quickly joined the artistic and literary circles of the Harlem Renaissance. Along with fellow African American sculptors Meta Fuller, Elizabeth Catlett, and Augusta Savage, he used figuration and the classical sculptural tradition to depict aspects of black American life and culture, drawing particular inspiration from the worlds of music and dance.

Barthé's painted plaster *African Dancer* presents the tensed body of a woman in the midst of a dance; her head is thrown back and her eyes are closed in a gesture of absorption and, perhaps, spiritual transcendence. Following the aesthetic and political theories of Alain Locke, Barthé, like many black American artists, looked to Africa for subjects and symbols in his work, though with only a generic conception of African ritual and costume. *African Dancer* was Barthé's first female nude, though the muscular body seems somewhat ambiguously gendered; his sculpture most often treated the nude male and celebrated the masculine form, perhaps a tacit acknowledgment of the artist's homosexuality. This quietly forceful sculpture expresses the abiding motivation of his work—"to capture the spiritual quality I see and feel in people."

African Dancer, 1933.
Plaster, 42¾ x 16⅞ x 14¼ in.
(108.6 x 42.9 x 36.2 cm).
Purchase 33.53

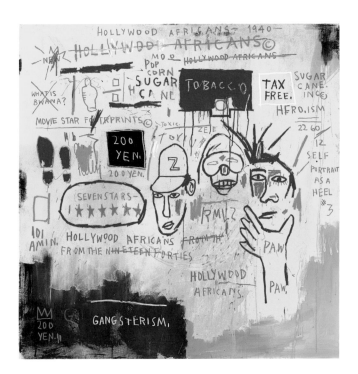

Jean-Michel Basquiat was among a group of young artists in New York who emerged as the worlds of art and music collided and who embraced a new style infused with elements of graffiti and hip-hop culture. He first gained notoriety with cryptic graffiti messages he left across downtown Manhattan, but by 1980 Basquiat was working on canvas, using paint sticks to draw symbols such as crowns, halos, and fragments of the human anatomy.

　　While on an extended visit to California, Basquiat painted *Hollywood Africans* for a spring 1983 show of his work at a Los Angeles gallery. At the center of the canvas is a portrait of the artist with his friends and fellow artist-musicians Toxic and Rammellzee, who had accompanied him to the West Coast. Basquiat is recognizable at the far right by his dreadlocks; the numerals 12, 22, and 60—the date of his birth—are inscribed nearby.

　　With phrases such as "HOLLYWOOD AFRICANS FROM THE NINETEEN FORTIES" and "WHAT IS BWANA?" scrawled across the canvas, Basquiat is questioning the historical depiction of Africans and African Americans in films. (*Bwana* refers to the Swahili word for *master* or *boss*, the term local tribespeople in old Hollywood movies deferentially called the *white safari leaders*.) Yet Basquiat is also referencing himself and his compatriots. Just to the right of his own likeness he wrote "SELF PORTRAIT AS A HEEL #3." Basquiat seems painfully aware of the derogatory manner in which people of African descent have been depicted in Hollywood, and the context that history provided for his own reception and burgeoning presence as an artist visiting Los Angeles.

Hollywood Africans, 1983.
Acrylic and oil stick on canvas.
84 x 84 in. (213.4 x 213.4 cm),
Gift of Douglas S. Cramer
84.23

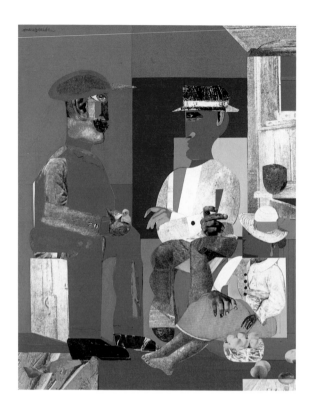

A leading figure of twentieth-century American art, Romare Bearden is best known for his collaged scenes of everyday African American life. As an undergraduate in the early 1930s, Bearden explored his artistic interests and worked as a political cartoonist for college journals and activist publications. After graduating, he enrolled at the Art Students League and began painting under George Grosz, while studying the work of Mexican muralists, American regionalist painters, and seventeenth-century Dutch masters. Traveling under the GI Bill to Paris in 1950, he also studied French, philosophy, and Buddhism.

In the early 1960s, after a notable career experimenting in a variety of abstract idioms, Bearden initiated a dramatic transformation in his art. Returning to figuration, he shifted to an intricate collage technique as his primary medium for the remainder of his prolific career. *Eastern Barn* is composed of photograph and magazine cutouts combined with fragments of colored and textured paper to portray two men and a woman against the flat planes of a barn. Though a location for this scene is not named, Bearden often focused on subjects from the rural South, the locus of the struggle for civil rights in the 1960s. Memories of his native North Carolina and travels to the South inspired a number of the collages he produced in the late 1960s. Describing the way in which compositional structure and meaning were built from the accumulation of disparate elements in these collages, Bearden wrote, "My intention . . . is to reveal through pictorial complexities the richness of a life I know."

Eastern Barn, 1968.
Collage of found paper, fabric,
acrylic, pencil, and ink on
composition board, 55¾ x
44 in. (141.6 x 111.8 cm).
Purchase 69.14

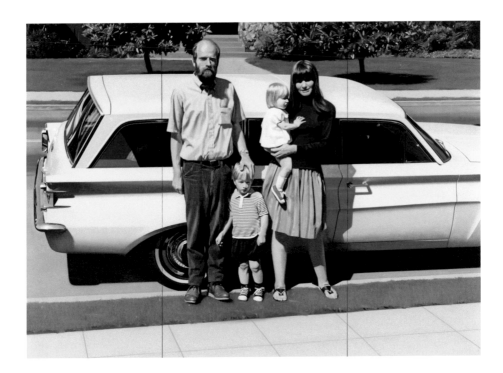

Robert Bechtle began painting realistic imagery in 1963 and by the late 1960s formalized what would become his basic working process—projecting slides and tracing them onto canvas for his Photorealist paintings. Working from snapshots that document everyday life and capture quiet scenes and anonymous situations in his San Francisco Bay Area neighborhood, he was rejecting both Abstract Expressionism and the Bay Area figurative tradition of the preceding generation. Like the Pop artists who incorporated elements of mass culture, Bechtle relied on source materials, but he was not interested in ironic critique. "My interest in these subjects has nothing to do with satire or social comment," he explained. "I paint them because they are part of what I know and as such I have an affection for them; I am interested in their commonness and in the challenge of making art from such ordinary fare."

Mediating his work through photography has allowed Bechtle to impartially present the banal, unglamorous facts of ordinary life, even as the specific moment in time caught by the camera is translated and elevated through painting. It is a dialogue through which he has explored the relationship between the two mediums. In *'61 Pontiac* Bechtle depicts a familiar scene—a family snapshot of himself with his wife and two children posing in front of their station wagon. The painting's light is even, and the setting anonymous. Through the title, Bechtle has nominally made the car—a recurring motif in his paintings—the subject rather than his loved ones.

'61 Pontiac, 1968–69.
Oil on canvas, three panels:
59¾ x 84¼ in. (151.8 x
214 cm) overall. Purchase
with funds from the
Richard and Dorothy Rodgers
Fund 70.16

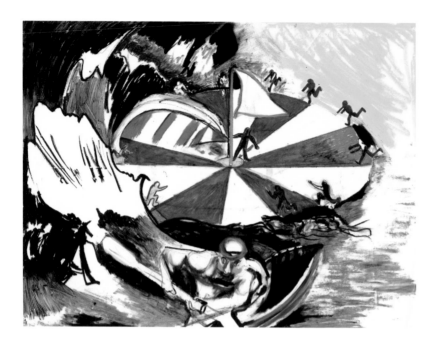

When Ericka Beckman attended California Institute of the Arts in the 1970s, the school was forging a reputation for its rigorous, theory-based curriculum under the leadership of conceptual artist John Baldessari. After graduating, Beckman and fellow alumni Jack Goldstein, David Salle, and Ashley Bickerton relocated to New York, determined to invent new art forms for what they deemed an image-saturated world.

Beckman began to create films with narrative structures that she likened to games or folklore. She shot elaborate performances on crudely constructed sets, adding animation and chantlike music to evoke a fragmented, ambiguous experience. Her techniques were often labor-intensive, with multiple layers of film hand-altered and edited together to make the final piece. Critical response to Beckman's early work was divided: in 1978 one critic called her "easily one of the most interesting young filmmakers around," while her appearance at the 1983 New York Film Festival earned jeers from the audience.

It was at this festival that Beckman debuted *You the Better* (1983), an absurdist meditation on competition in which a cast of two dozen performers, led by Bickerton, competes in a nonsensical gambling game that combines elements of basketball, dodgeball, and roulette (the *Better* of the title is a play on *bettor*). Although the film features childlike primary colors, punchy animated graphics, sports lingo, and an upbeat jingle, Beckman twists these elements until they become menacing.

Power of the Spin is a preparatory study for *You the Better*. Beckman has said that such expressive, freehand drawings "allowed me to work directly from my imagination and try to see if any idea or motif from that realm could be transformed into a performance or prop sequence for a film."

Power of the Spin, 1982.
Oil stick, graphite pencil,
and fiber-tipped pen on paper,
29½ x 39⅜ in. (74.9 x
99.9 cm). Gift of the artist
2014.4

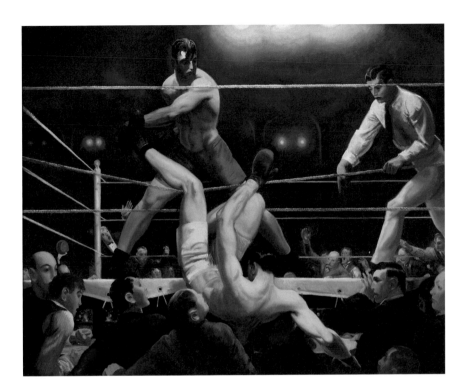

With his depictions of streetscapes, tenements, athletes, and city dwellers, George Bellows became one of the foremost exponents of urban realist painting in the early years of the twentieth century. At the outset of his career, Bellows emulated the loose brushwork of his mentor, leading Ashcan School figure Robert Henri, but by the 1920s he had shifted to a stylized aesthetic of smooth curves and monumental, tubular forms, as in *Dempsey and Firpo*, one his most ambitious late paintings.

To supplement his income as a painter, Bellows worked as a newspaper sports illustrator, and the events he covered often found their way into his art. Here he portrays a pivotal moment in the famous prizefight between American heavyweight champion Jack Dempsey and his Argentine rival, Luis Firpo, on September 14, 1923, at the Polo Grounds in New York. Dempsey was the eventual victor, but Bellows represents the startling moment when

Firpo knocked his opponent out of the ring with a tremendous blow to the jaw. The painting's drama hinges on its underlying compositional structure: Firpo's erect body forms a powerful triangle, the leftward diagonal of his swinging fist providing a forceful counter to Dempsey's overturned body. Bellows was present among the journalists at ringside, and art historians have suggested that either the bald figure at the far left or the man beneath Dempsey, pushing him back up, could have been based on the artist himself. Although Firpo had launched Dempsey out of the ring with his notorious right hook, the artist instead portrayed him swinging with his left. For Bellows, amplifying geometric tension took precedence over anecdotal detail.

Dempsey and Firpo, 1924.
Oil on canvas, 51⅛ x 63¼ in.
(129.9 x 160.7 cm). Purchase
with funds from Gertrude
Vanderbilt Whitney 31.95

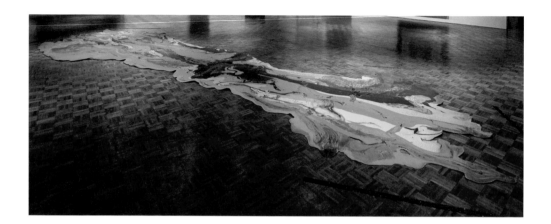

While best known as a sculptor, Lynda Benglis has also worked intermittently in photography, video, and installation art. Her sculptures, although typically abstract, often evoke body parts, organic forms, or the ebb and flow of natural forces: cascades of cast aluminum that cantilever improbably from the wall; knots of plastic and fabric, gaily painted; assemblages of beads and feathers that resemble peacocks. Restlessly experimental, Benglis is as adept with such traditional mediums as metal and ceramic as she is with unconventional materials such as beeswax, chicken wire, and paper.

To make *Contraband*, Benglis poured five hundred pounds each of several colors of pigmented latex onto the floor, allowing the colors to swirl and the material to congeal into a shape she could neither anticipate nor control. A signal work of Process art—in which form emerges in the activity of making and the work becomes a record of its own creation—*Contraband* flouted the rigid geometries and neutral palette of much contemporaneous Minimalist art. In fact, although Benglis planned *Contraband* for inclusion in the Whitney's landmark 1969 exhibition *Anti-Illusion: Procedures/Materials,* she withdrew it in response to curatorial concerns that the work's Day-Glo hues would overwhelm the show's more monochromatic selections. In 2008 Benglis said of *Contraband*,

"I think I'm painting with liquids but making objects that are dimensional, that have a sense of their own space." She followed this piece with other "spill" works—globs of polyurethane foam massed in corners and on walls and floors—and, in the four decades since, has produced a three-dimensional body of work notable for its range and innovation.

Contraband, 1969. Pigmented latex, 3 x 116¼ x 398¼ in. (7.6 x 295.3 x 1,011.6 cm). Purchase with funds from the Painting and Sculpture Committee and partial gift of John Cheim and Howard Read 2008.14

Sadie Benning has produced experimental videos since the late 1980s, beginning with those she shot in her childhood bedroom with a Fisher-Price Pixelvision camera (a gift from her father, the filmmaker James Benning) that illuminate her coming of age and coming out in the Midwest. Benning was still a teenager when her work was first exhibited, and in 1993 she became the youngest artist to be included in a Whitney Biennial. From 1998 to 2000 she was a member of the electronic music group Le Tigre, which projected her drawings as slides during their performances. Since 2006 her work has been focused primarily on painting.

 Play Pause, a two-channel video that Benning produced in collaboration with Solveig Nelson, displays hundreds of the artist's gouache drawings, scanned and sequenced, accompanied by electronic beats and ambient sound recordings she made in Chicago and Milwaukee. The title refers to Benning's self-taught analogue method of sound editing using the "play" and "pause" functions of her cassette recorder— an anachronistic approach that engenders the sense of loss that permeates *Play Pause*. The drawings combine the aesthetics of the Pixelvision camera with Benning's interest in the works of outsider artists like Henry Darger. Unlike most of her earlier videos, however, here there are no recurring characters and no directed storyline.

Benning described the open-endedness of this approach as "a suspended narrative— an intensified narrative—a lack of narrative, to space out, to day dream, a musical feeling, ambience, an open room, jazz we like to listen to, a closed door, a revolving door, people looking, thinking about more than one thing at a time, being together, being alone."

Stills from *Play Pause*, 2006. Two-channel video, black-and-white and color, sound; 29:22 min. Directed by Sadie Benning, in collaboration with Solveig Nelson. Edition no. 1/3, 2 AP. Purchase with funds from the Film, Video, and New Media Committee 2010.78

Thomas Hart Benton studied at the Art Institute of Chicago and lived in Paris and New York, but upon returning to his native Missouri in the mid-1930s he rejected the avant-garde art movements and urban themes of those centers for a folksy, nationalistic realism that he developed in paintings and murals. Together with the painters John Steuart Curry, Joe Jones, and Grant Wood, he became a leading exponent of American Regionalism. The roughened hands of the husband and wife depicted in *The Lord Is My Shepherd* testify to decades of hard work, and a Bible sampler on the wall affirms their faith. The couple assume a symbolic stature in this painting as emblems of a pious, simple life, though they were modeled on two specific individuals, Sabrina and George West. In Chilmark, the town where Benton summered for more than fifty years on Martha's Vineyard, Massachusetts, a particular form of heredity deafness was prevalent and affected the Wests, among many others of Benton's neighbors.

Poker Night (from A Streetcar Named Desire) was a commission from producer David O. Selznick, a surprise gift for his wife, Irene Mayer Selznick, who produced the Tennessee Williams play on Broadway in 1947. The painting portrays a dramatic moment when the refined but fallen Blanche Dubois, holding a mirror and wearing a revealing gown, taunts her drunk, violent brother-in-law, Stanley Kowalski (pictured in a white undershirt). While Benton's figurative style had remained relatively consistent over two decades, his subject here is more provocative and takes narrative liberties. Indeed, Jessica Tandy, who played Dubois onstage opposite Marlon Brando's Kowalski, was offended by her portrayal in this painting—her costumes in the play had been considerably more demure.

The Lord Is My Shepherd, 1926. Tempera and oil on canvas, 33⅜ x 27½ in. (84.8 x 69.9 cm). Purchase 31.100

Poker Night (from A Streetcar Named Desire), 1948. Tempera and oil on linen, 36 x 48 in. (91.4 x 121.9 cm). Mrs. Percy Uris Bequest 85.49.2

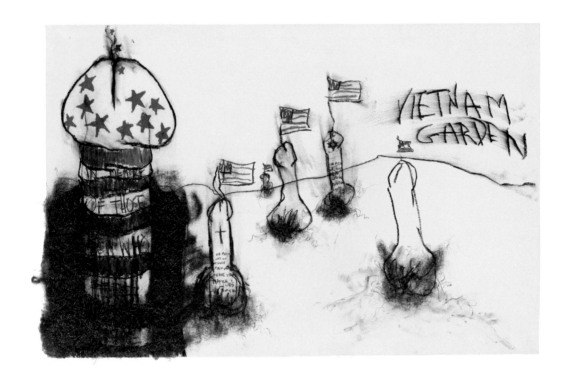

While Judith Bernstein was an art student at Yale University during the Vietnam War, she adopted the image of the phallus as a central motif in her work, based in part on graffiti she found in men's bathrooms on campus. She was attracted to the bold defiance of graffiti and to the masculine pompousness of tagging property with images of genitalia. In her drawings she transformed penises into guns, caped superheroes, giant screws, and flagpoles. In an era when many feminist artists were looking at their own bodies for subject matter, Bernstein's virile, in-your-face phallus drawings were shocking. By forcing the male administration to address and accredit these works, Bernstein challenged the masculine culture that dominated Yale.

Vietnam Garden is one of a series of antiwar drawings that attacked the macho militarism of US foreign policy during the war. A group of erect phalluses capped with American flags rises up from the crest of a hill; a cross on one and a Star of David on another suggest that they are stand-ins for tombstones, with the steel-wool pubic hair covering their bases recalling flowers or plants left by mourners. This oil-stick-and-charcoal drawing retains the informal style and belligerence of the bathroom graffiti. Describing the use of humor in her work to address political issues, Bernstein has said: "When something is funny, you laugh. . . . It's almost like an ejaculation, so you get a release by laughing at it, by laughing with the viewer when you see it; but it's dead serious."

Vietnam Garden, 1967. Charcoal, oil stick, and steel wool on paper, 26⅜ x 40¾ x 2 in. (67 x 103.5 x 5.1 cm). Purchase with funds from the Drawing Committee 2010.80

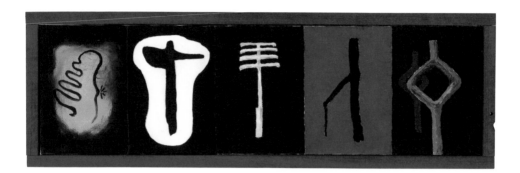

With their diminutive scale and formal economy, Forrest Bess's paintings belie the complex, highly personal symbology from which they emerged. Born and raised in the small East Texas town of Bay City, Bess became fascinated by connections between religion and sexuality while an undergraduate at the University of Texas, where he read widely on subjects such as Greek mythology, Hinduism, and psychoanalysis. After a psychological breakdown led to his discharge from the US Army in 1946, Bess moved permanently to his family's bait-fish camp at Chinquapin, on the Gulf, where he lived a meager, isolated existence for the next twenty years, dividing his time between fishing, painting, and various odd jobs. He nonetheless maintained extensive correspondence with individuals in the outside world, including the dealer Betty Parsons, whose New York gallery represented his work beginning in 1949; the prominent art historian Meyer Schapiro; and even the psychoanalyst Carl Jung.

At Chinquapin, Bess had begun to paint images, or "inward visions" as he called them, based on a language of symbolic forms he saw in his mind as he drifted off to sleep. Upon waking, he would quickly record these forms in sketches, later elaborating them in richly textured oil compositions such as *Drawings*. Like most of Bess's paintings, the work is small in scale and possesses a frame that the artist fabricated from thin strips of found wood, adding to its intimate, handmade quality. By the late 1950s Bess had developed a radical theory that androgyny was the key to eternal life, an idea that pervaded his art and led him to perform surgery on himself with the goal of becoming a hermaphrodite. While Bess identified some of his abstract symbols with specific meanings related to his theory, others, like those in *Drawings*, remain mysterious. Nonetheless, his elemental forms evoke the biomorphic archetypes that suffused avant-garde painting during the postwar years—especially in the work of the Abstract Expressionist painters.

Drawings, 1957. Oil on linen,
with wood frame, 9 x 29¾ in.
(22.9 x 75.6 cm) overall.
Gift of Betty Parsons 82.6a–b

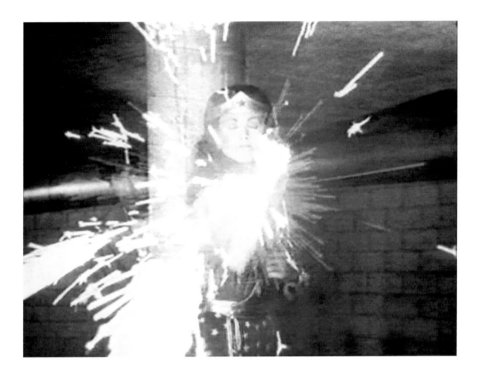

Dara Birnbaum's video art consists of sophisticated deconstructions of American media, especially those of broadcast television. Utilizing appropriated imagery and sound, her works are both formal compositions as well as politicized commentaries on how gender, sexuality, and other social norms are perpetuated through the codes of mainstream media culture. Birnbaum's understanding of the aesthetic underpinnings of social systems grew out of her studies in architecture and urban planning at Carnegie Mellon University and then in painting at the San Francisco Art Institute. She turned to video as a political and aesthetic tool in the mid-1970s.

One of the earliest video works to appropriate broadcast footage, Birnbaum's *Technology/Transformation: Wonder Woman* is a subversive analysis of the popular 1970s television program. By looping scenes of the title character transforming repeatedly from anonymous secretary into superheroine, the artist vividly exposes an instance of female objectification and gender hierarchies: "This is the image of a woman made by men. . . . I did not want to undo the pleasure [of the image], but it was brought to a very strong visceral level. My hope was that . . . it would empty the signification of it." Further articulating the construction of this female archetype, Birnbaum concludes the video with the song "Wonder Woman in Discoland"—its suggestive lyrics scrolling on the screen. In addition to its presentation at the Kitchen and on a monitor in a hair salon window, the video aired in 1979 as a public-access cable program opposite a CBS broadcast of the real *Wonder Woman* show.

Still from *Technology/ Transformation: Wonder Woman*, 1978–79. Video, color, sound; 5:50 min. Purchase with funds from the Film, Video, and New Media Committee 2009.22

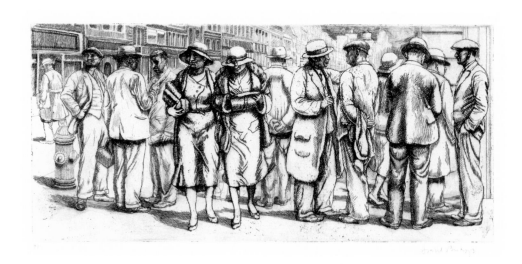

An astute observer of urban life, Isabel Bishop was the only female member of the Fourteenth Street School, a group of Realist painters who depicted New York during the Great Depression. Like her colleagues Reginald Marsh and Edward Laning, Bishop trained at New York's Art Students League under painter Kenneth Hayes Miller, who encouraged his students to join classical forms with contemporary subject matter. In her paintings, drawings, and prints, Bishop captured subjects she encountered in and around Union Square, where she rented a studio from 1926 until 1984. She often favored female figures, especially the new generation of office girls who roamed the neighborhood at lunchtime and the matronly shoppers who frequented the area's thriving department stores. Rather than portraying the chaos and commotion of the city's crowded streets, as some of her contemporaries did, Bishop focused on intimate moments amid the bustle of daily life.

On the Street includes a group of men—probably drawn from the informal community of unemployed working-class males who congregated in Union Square— that serve as a backdrop for a pair of female shoppers lost in thought as they stride toward the viewer. Bishop described etchings such as this as a means for evaluating whether an image had "a nucleus that you could develop" into a painting. Indeed, Bishop subsequently used *On the Street* as the basis for an oil painting. This work exemplifies her distinctive use of geometrically balanced compositions and robust, carefully modeled figures to instill ordinary scenes of modern life with grandeur and monumentality.

On the Street, 1931.
Etching: sheet, 7⅛ x 15 in.
(18.1 x 38.1 cm); plate,
5 x 10⅞ in. (12.7 x 27.6 cm).
Edition no. 11, edition
unknown. Purchase 34.34

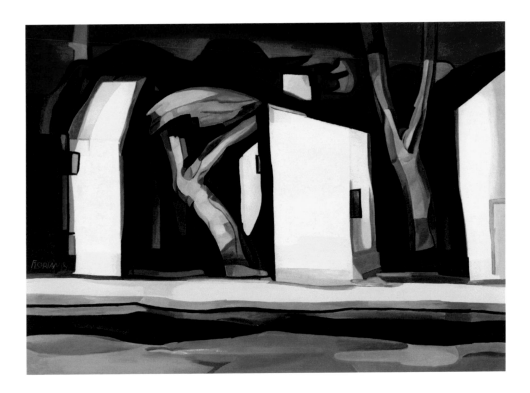

Oscar Bluemner worked as an architect, initially in Germany and later in the United States, before turning to painting full time in 1911. By then he was already a frequent visitor to Alfred Stieglitz's pioneering 291 gallery in New York, and eventually became a member of its inner circle of modern artists. The paintings he debuted in his 1915 inaugural exhibition at 291 married prismatic, architectonic forms with boldly saturated colors that combined his training as an architect with his desire to "bring the colors of things to enormous splendor." His belief that colors could stir feelings and mood, much as music does, led him to develop a system of symbolism that identified specific colors with psychological states.

In *A Situation in Yellow* Bluemner combined predominantly yellow and black colors (identified with light and sorrow, respectively) with images of nature and man-made forms to portray what he believed were the fundamental polarities of body and soul, life and death, and male and female.

By 1930 he was using images of houses and trees as surrogates for what he called the "Ego and the Altera [the other] . . . the Duality in ourselves as well as in Nature." Treating these opposing forces as protagonists, he set the scene in *A Situation in Yellow* as an archetypical drama between "man . . . Ego" (represented by houses) and "she . . . non Ego" (represented by trees). In this work, as in others he made after 1933, Bluemner affirmed his admiration for Northern Renaissance masters by signing his work with the pseudonym Florianus, a Latinized version of the name Bluemner, meaning *flower* or *blossom*.

A Situation in Yellow,
1933. Oil on canvas, 36⅛ x
50⅝ in. (91.8 x 128.6 cm).
Gift of Nancy and Harry L.
Koenigsberg 67.66

Mel Bochner has made conceptually and perceptually driven paintings, sculptures, drawings, photographs, and installations since the mid-1960s, often plumbing the relationships between language, space, objects, and color. He is credited with having kickstarted the Conceptual art movement in a 1966 exhibition for which he photocopied working drawings and other paper materials solicited from artist friends, placed the identically reproduced items in four black binders, then displayed them on pedestals in a gallery. In the late 1960s Bochner began to make site-specific projects consisting of ruled measurements in paint or tape and transfer-type numbers applied directly to gallery walls, turning these seemingly neutral spaces into life-sized diagrams of themselves. Such works challenge conventional notions of abstract thought and perception, testing Bochner's assertion that "outside the spoken word, no thought can exist without a sustaining support." He underscores this thesis in works that invert the representational system of photography. Rather than "using [photography] to look at something," Bochner demonstrates how the medium is itself "something to look at"—an object.

For *Transparent and Opaque*, Bochner hired a professional photographer to produce images of petroleum jelly and shaving cream, differing substances that might illustrate the terms of his title. He stroked or squirted the materials onto glass plates and then had them photographed under various brightly colored lights, in some instances staining the substances with red iodine. The twelve prints confound the relative transparency or opacity of the materials—the semiclear petroleum jelly, for example, casts shadows and reflections that impede its translucence—and suggest how these opposed qualities can be simultaneously present. They also draw attention to the transformative qualities of light and color, pairing images of petroleum jelly lit with pink-toned lights and shaving cream mixed with iodine to create a pink froth. As a result, Bochner challenges the traditional presumption that the camera's "transparent" system precisely mimics the world as seen by the human eye.

Details of *Transparent and Opaque*, 1968 (printed 1998). Twelve silver dye bleach prints (Ilfochrome), 13 x 19⅝ in. (33 x 49.8 cm) each. Edition no. 2/3. Purchase with funds from the Photography Committee 98.61a–l

Lee Bontecou's abstract, wall-mounted sculptures from the late 1950s and 1960s conjure visual associations that range from the mechanical (camera lenses, engines, and gun barrels) to the natural world (rock formations, insect shells, human orifices, wounds, and celestial black holes). To build these intensely physical and ultimately mysterious reliefs, Bontecou began by welding a steel armature onto which she stitched canvas salvaged from the conveyer belts of the laundry beneath her Lower East Side apartment and later incorporated metal scraps and other found materials.

A large hole lined with sharp saw blades grins menacingly from the center of *Untitled, 1961*, like a set of mechanized teeth. Metal spools, washers, and grommets puncture the surface, poised threateningly as if they might expel toxic gas or bullets. The work embodies the anxiety of the Cold War era, foretelling, as Bontecou explained it, what is "to come if we do not learn to handle and face some of the facts of war inside us. It is pessimistic, angry, and full of destruction. . . . It is the negative side of the atomic age. It's war."

Bontecou was the only woman among a roster of notable male artists to be represented by the esteemed Leo Castelli Gallery in the 1960s. Although her work from this period was well received, she withdrew from the New York art world in the early 1970s and moved to rural Pennsylvania, reemerging three decades later to exhibit an abundant body of drawings and sculpture that included large-scale but achingly fragile mobiles made during the 1980s and 1990s.

Untitled, 1961, 1961. Welded steel, canvas, wire, and rope, 72½ x 66 x 24¾ in. (184.2 x 167.6 x 62.9 cm). Purchase 61.41

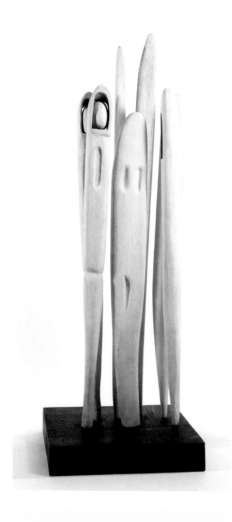

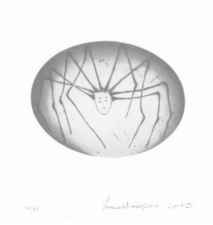

Louise Bourgeois produced an extensive body of sculpture, drawings, and prints over the course a career that spanned seventy-five years. Although the early work *Quarantania* is semiabstract, the elongated pine slabs of which it is made evoke a huddle of human figures. Indeed, Bourgeois described them as effigies of the family members and friends she missed when she moved to the United States in 1938. If this sculpture was partly a means of working through homesickness and guilt, its suggestion of tribal totems and primitive rituals ties it to contemporaneous endeavors by expatriate Surrealists working in New York in the 1940s, a community in which Bourgeois took part. She turned away from Surrealism in the 1950s, however, and also rejected the wholesale abstraction of the New York School painters with whom she often exhibited. Instead, she spent the ensuing six decades honing a three-dimensional practice that utilized various materials (including stone, plaster, fabric, and latex) in a wide range of shapes and scales to plumb the connections between body, psyche, and subjectivity. By turns aggressive and violent, vulnerable and sensual, her biomorphic, erotic forms often seem to symbolize the realization of subconscious drives or the exorcizing of latent desires.

If these are universal themes, other elements of Bourgeois's art are deeply personal. The anthropomorphized arachnid pictured in *Spider Woman* is one of the artist's iconic motifs and was for her a maternal emblem, at once protective and threatening. Bourgeois described her own mother, who helped run the family's tapestry restoration business, as "neat, and as useful as a spider," declaring, "I shall never tire of representing her."

Spider Woman, 2005.
Drypoint: sheet, 13⅝ x 13½ in.
(34.6 x 34.3 cm); plate,
6¾ x 9⅜ in. (34.4 x 23.8 cm).
Edition no. 14/25. Purchase
with funds from the
Print Committee 2006.76

Quarantania, 1941. Painted
wood, 84¾ x 29¼ x 31¼ in.
(215.3 x 74.3 x 79.4 cm). Gift of
an anonymous donor 77.80

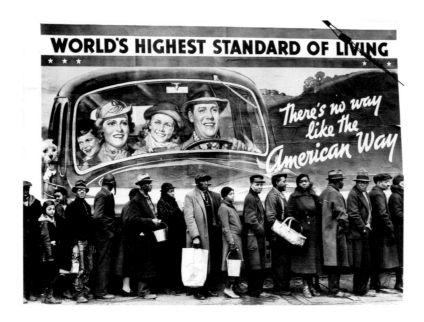

Margaret Bourke-White was among the most significant photographers and photojournalists of the twentieth century. She began her career as a commercial photographer, and her early photographs of steel manufacture demonstrated that modern industry could be a fertile subject for artists. In 1929 the publishing magnate Henry Luce hired her as associate editor and staff photographer for his forthcoming venture, *Fortune* magazine. The publication's expanded interpretation of "modern business" gave Bourke-White an opportunity to travel around the world, recording a diverse array of industrial subjects. Bourke-White's romantic vision of the Machine Age evolved in the mid-1930s into an engagement with more humanistic concerns when she was commissioned to shoot photo essays for Luce's next endeavor, *LIFE* magazine. She pioneered this form with an eye for contemporary social issues, collaborating with the author Erskine Caldwell to document the plight of sharecroppers in the South in the 1937

book *You Have Seen Their Faces.* That same year, Bourke-White was assigned to document the devastation wrought by the massive flooding of the Ohio River valley. *The Louisville Flood*, published in the February 15, 1937, issue of *LIFE*, depicts African American flood victims standing in a relief line with baskets and pails in hand. Behind them looms a massive billboard that portrays a carefree Caucasian family motoring across a pastoral landscape as bold graphics proclaim, "World's Highest Standard of Living" and "There's no way like the American Way." Removed from its original photojournalistic context, this most recognizable of Bourke-White's images has come to represent the nation's racial inequalities and, for many, the inaccessibility of the American Dream the billboard presents.

The Louisville Flood, 1937 (printed c. 1970). Gelatin silver print, 9¾ x 13⅜ in. (24.7 x 34 cm). Gift of Sean Callahan 92.58

In the early 2000s Carol Bove began making understated assemblages of books, magazines, and curios on pedestals, tables, or wood-and-metal shelving units. The meticulous arrangements position the recent past of art and design—minimalist forms and modernist decor—in the context of the social and political upheavals of the 1960s, a decade that looms large in the cultural imagination and in Bove's own self-understanding: she was born at its twilight and raised in Berkeley, California, a mecca for the counterculture, student protests, and leftist politics.

 Adventures in Poetry exhumes an archive of this period in dog-eared volumes culled from thrift shops and garage sales: Lao Tzu's *Tao Te Ching*, Abbie Hoffman's *Revolution for the Hell of It*, Marshall McLuhan and Quentin Fiore's *The Medium Is the Massage* (splayed open on the bottom shelf), books on the activist Angela Davis, LSD, avant-garde art, and communism, as well as Kenneth Anger's *Hollywood Babylon* and a monograph on the abstract painter Nicolas de Staël, cracked open at the far left and sitting atop John Giorno's *Cum* (the installation takes its title from Giorno's publisher, Adventures in Poetry). Bove investigates how these juxtapositions might reveal fissures in the canonized narratives that can be plumbed anew or how they might reanimate the objects' dormant dimensions (for example, the utopianism or sexual emancipation many of them encode), a new poetic meaning emerging from the synthesis. The work's force emerges not just in examining how we receive cultural artifacts from the past but in imagining how future archaeologists will interpret our present thirty years hence.

Adventures in Poetry, 2002. Three wood shelves with metal brackets, twenty-nine books, nine periodicals, and plexiglass cube with paper, 34 x 86 x 10 in. (86.4 x 218.4 x 25.4 cm). Promised gift of David and Monica Zwirner P.2014.1

Frank Bowling began his career in the late 1950s while living in London, where he studied at the Royal College of Art alongside David Hockney and R. B. Kitaj, making figurative paintings that conveyed social and political content. He started making colorful, largely abstract works soon after moving to New York in 1966, having come into contact with the artists Jasper Johns and Larry Rivers whose drive and energy toward creating a new or personal view through their art influenced him tremendously. As Bowling has stated, "After leaving London to live in New York, I broke loose and began to get much more involved in pure painting." These early abstract canvases have often been associated with Color Field painting, given Bowling's use of saturated color and the stained appearance of many compositions.

　　Over time, Bowling found "the most comfortable way of dealing with paint

[was] . . . by leaning on ready-made shapes and photographs." The result was a series of works that referenced maps, including *Dan Johnson's Surprise*, which he made using an opaque projector Rivers had introduced to him. With its blurred forms suggestive of the familiar shape of the South American continent where the artist was raised and a title referencing a friend and fellow artist, this work, which was included in the 1969 Whitney Annual, can be seen as a bridge between Bowling's earlier figurative work and the poured-paint abstractions that he began to make in the 1970s.

Dan Johnson's Surprise, 1969. Acrylic on canvas, 116 x 104⅛ in. (294.6 x 264.5 cm). Purchase with funds from the Friends of the Whitney Museum of American Art 70.14

Mark Bradford works across various mediums, creating paintings, sculpture, installations, video, and prints. In the mid-2000s he began to make collaged paintings that grapple with ideas of urban decay and excavation, as well as with the history of art. Bradford builds up the surfaces of these paintings with materials often found on the street, including advertising posters, billboard paper, newsprint, and permanent-wave end papers, implicitly referencing the economic livelihood of his South Central Los Angeles community and his experience working as a sign maker and hairdresser in his mother's salon. After collaging layers of material onto the canvas, Bradford uses an industrial sander to obliterate and unearth parts of the surface—imparting an effect that is painterly, despite its distance from traditional painting. "What fascinates me about surface," he has explained, "is the way in which paper creates depth, but at the same time it still has its singular form. It's one complete thing on top of another. You are not mixing black and white paint."

Bread and Circuses, measuring eleven feet high and twenty-one feet long, is a monumental composition, more akin to a wall mural. Here, Bradford carefully embedded string amid the collaged layers of found paper, suggesting curvilinear city streets, and later sanded through the material to reveal a textured surface reminiscent of a woodcut. As it explores the topography that results from the juncture between the urban and the natural, the work reads like an intricate, indecipherable map of a congested, city landscape. Building on his interest in Renaissance prints, Bradford's articulated composition, like his earlier work, becomes a reflection on the surrounding world, here constructed through the very detritus of which that world is composed.

Bread and Circuses, 2007. Found paper, metal foil, acrylic, and string on canvas, 133 x 253 in. (337.8 x 642.6 cm). Purchase with funds from Patrick and Mary Scanlan 2008.42

Across his fifty-year filmmaking career, Stan Brakhage produced more than three hundred works while helping to define the language of American avant-garde cinema. His singular approach to the use of color, motion, and light resulted in a uniquely lyrical style that, in the artist's words, sought to depict "birth, sex, death, and the search for God." Brakhage studied art briefly at Dartmouth and the California School of Fine Arts in San Francisco before turning to film and falling in with various circles of poets, artists, and filmmakers in California, Colorado, and New York. Drawn to the works of the Abstract Expressionist painters of the mid-1950s, Brakhage experimented with scraping, painting, and even collaging onto the emulsion surface of his 16mm film while continuing to document his everyday life. In 1964 he settled in a Colorado mining town, where he trained his camera on the wilderness and the simple domestic activities of his wife and five children.

In addition to these first-person impressions of family life, Brakhage also created entirely abstract time-based works, visceral formal investigations of moving shapes and color produced through innovative techniques. *Mothlight*, one of Brakhage's most celebrated abstract films, was produced entirely without a camera by collaging organic detritus between two strips of splicing tape and running this material through a film printer. The projected film casts rhythmic patterns formed by moth wings, flower petals, blades of grass, and dirt flickering across the screen; as Brakhage described, it's "what a moth might see from birth to death if black were white and white were black."

Filmstrips from *Mothlight*,
1963. 16mm film, color, silent;
4 min. Purchase with
funds from the Film and Video
Committee 2000.264

In 1969 AA Bronson cofounded the collaborative group General Idea with fellow Canadian artists Felix Partz and Jorge Zontal. Over the next twenty-five years the trio radically challenged existing structures of identity, mass culture, and art in paintings, sculptures, photographs, videos, prints, books, magazines, and performances. In the 1980s, after Partz and Zontal became HIV-positive, the group began focusing their work on the AIDS crisis. They designed a logo that borrowed from Robert Indiana's iconic *LOVE* image from the 1960s, replacing L-O-V-E with A-I-D-S, and created large-scale installations and sculptures that referenced AZT, the first government-approved drug for treating HIV/AIDS.

Partz and Zontal died in 1994, and Bronson took a photograph of Partz's lifeless body shortly after he passed away. *Felix Partz, June 5, 1994* bears witness to the devastation wrought by the AIDS epidemic. Arranged as if to receive visitors, Partz's body attests to the ravages of the illness. Yet his ashen figure is surrounded by brightly colored bedding and clothing as well as tokens of comfort such as a remote control, cigarettes, and his beloved tape recorder. These personal effects suggest joy and

compassion in the face of a harrowing death, which Bronson memorializes with both unflinching candor and great sensitivity. In printing Partz's portrait in the manner of a commercial billboard, Bronson references their past collaborations while also creating a startling monument that forces us to confront feelings about our own mortality. When first exhibiting the work, Bronson wrote: "Dear Felix, by the act of exhibiting this image I declare that we are no longer of one mind, one body. I return you to General Idea's world of mass media, there to function without me."

Felix Partz, June 5, 1994, 1994 (printed 1999). Inkjet print on vinyl, 84 x 168 in. (213.4 x 426.7 cm). AP, edition of 3. Gift of Mark J. Krayenhoff van de Leur 2003.268

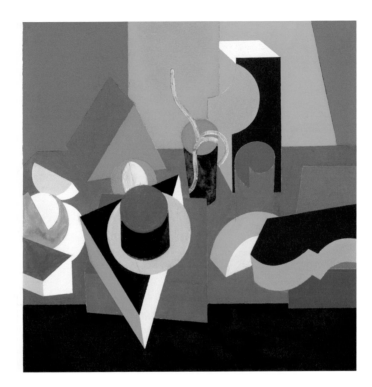

In 1904 Virginia-born Patrick Henry Bruce moved to France, where he would reside for most of his life. Encountering the fractured forms of Cubism there and the color experiments of his friends the Orphist painters Sonia and Robert Delaunay, Bruce soon adopted bold hues and a geometric style. By 1912 he was painting abstracted still lifes, a genre that would occupy him for the rest of his career. Though he was one of the few American artists to be embraced by the Parisian avant-garde of the era, Bruce nonetheless became increasingly disillusioned and reclusive over the course of the 1920s and destroyed much of his work before committing suicide in 1936.

Painting is emblematic of the architectonic style that Bruce developed in his last series of still-life paintings, produced in the years following World War I. Like other works from this period, it focuses exclusively on objects from the private world of the artist's apartment studio. The image is composed of quotidian objects—including a vase, a drinking glass, and a sliced orange—that have been organized into flat planes of color and geometric volumes, formed with the aid of mechanical drawing tools. The white vertical bar on the left-hand side—a device Bruce used frequently in this period—creates the illusion that the objects are set into a deep space, even as it simultaneously calls attention to the flatness of the canvas surface. With its sharply articulated forms and bold, unmodulated color, *Painting* anticipates the hard-edged geometric abstraction adopted by successive generations of American artists in the 1930s and again in the 1950s.

Painting, c. 1921–22.
Oil on canvas, 35 x 45¾ in.
(88.9 x 116.2 cm). Gift of
an anonymous donor 54.20

Charles Burchfield

b. 1893; Ashtabula, OH
d. 1967; West Seneca, NY

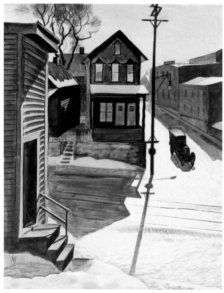

For Charles Burchfield, the American landscape was a source of revelation. Working primarily in watercolor, he captured the vicissitudes of each season at every time of day and change in weather— an infinite variety that, in turn, became a mirror of his own moods and emotions. *Noontide in Late May* belongs to an early group of lyrical nature studies Burchfield made in his boyhood home of Salem, Ohio. Produced during his self-described "golden year," in which he completed his artistic training and embarked on his first mature works, this depiction of a neighbor's backyard conveys the pulsing fecundity of a spring afternoon. Burchfield described the work as "an attempt to interpret a child's impression of noon-tide in late May—The heat of the sun streaming down and rosebushes making the air drowsy with their perfume." Yet while his swelling forms are suffused with a sense of radiant exuberance, they also hint at an underlying disquiet, especially in the writhing thicket of trees at the rear. Indeed, several of the scene's stylized motifs relate to the series of abstract forms Burchfield devised as "Conventions for Abstract Thoughts," evoking threatening emotional states he associated with childhood, such as "Fear," "Menace," and "Dangerous Brooding."

Burchfield's residence in Salem and later Buffalo, New York, distanced him from the New York art world. By the 1930s, however, his emphasis on small-town subject matter and a shift to a darkened palette led to his association with fellow painters of the American Scene, and especially to his friend Edward Hopper. *Ice Glare*, a watercolor from this period, depicts a solitary residential street in Buffalo. The intense contrast between the dilapidated buildings and the brilliant light reflected off the snow reinforces the crisp austerity of this Depression-era scene.

Noontide in Late May, 1917. Opaque and transparent watercolor and graphite pencil on paper, 22 x 18 in. (55.9 x 45.7 cm). Purchase 31.408

Ice Glare, 1933. Watercolor, charcoal, and graphite pencil on paper, 31½ x 25 in. (80 x 63.5 cm). Purchase 33.64

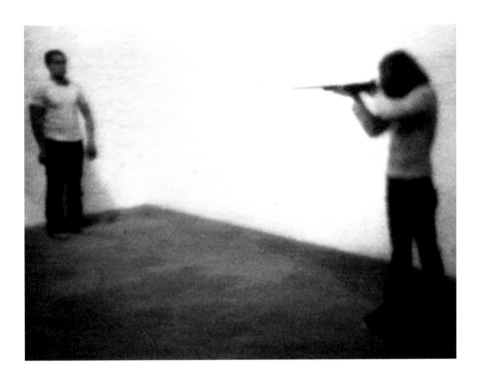

Chris Burden's uncompromising and often controversial performance works from the early 1970s tested the limits of his physical endurance and earned him a reputation as the Evel Knievel of the art world. *Documentation of Selected Works 1971–75* presents visual records of eleven works, performed at locations across Los Angeles and originally recorded on Super 8, 16mm film, and half-inch video, that show the artist's body being subjected to a range of external and internal pressures. The collection includes brief footage of the notorious early performance *Shoot* (1971), in which Burden arranged to be shot in the arm by a friend; *Through the Night Softly* (1973), in which he crawls naked over broken glass; *Deadman* (1972), in which he poses as a dead body in a public street; and *Velvet Water* (1974), in which he attempts to breathe water.

Although Burden's work during this period involved subjecting his body to gunshot, fire, electricity, starvation, isolation, and the risk of drowning (among other trials), he rejected the term *masochism*, stating that "the masochist intends to hurt himself, that is not my intent." Rather, his work explores the complex psychology and energy of anticipation and endurance, issues of identity and masculinity, and the complicated dynamics of the relationship between artist and audience, individual and society. In the compilation, Burden's deadpan voice-over narrative explains the logistics of each work as it reasserts the contingency of performance art that often leads to unexpected outcomes or moments of failure, and the extreme subjectivity of his own experience in the face of mere historical document.

Still from *Documentation of Selected Works 1971–75*, 1971–75. 16mm and Super 8 film transferred to video, black-and-white and color, sound; 34:38 min. Purchase with funds from Randy Slifka 2009.129

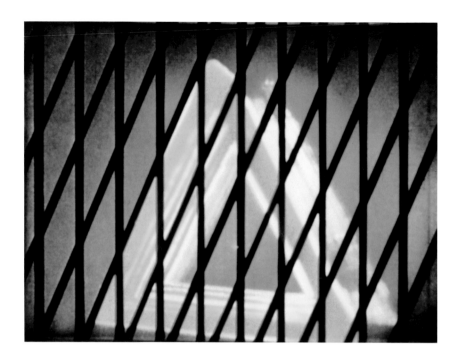

Trained as a painter at the Pennsylvania Academy of the Fine Arts in the 1920s, Mary Ellen Bute identified with the dominant concerns of the modernist avant-garde of that time: an eagerness to move toward abstraction, a desire to capture the frenetic pace of modern life, and an urge to represent movement and duration on canvas. Bute initially sought to express motion and the structures of musical composition in painted abstractions of color and light, but she soon grew disillusioned with painting and turned to film. As she explained: "I felt an overwhelming urge to translate my reactions and ideas into a visual form that would have the ordered sequence of music. . . . Painting was not flexible enough and too confined within its frame."

It was for her "visual symphonies" that Bute ultimately gained both critical and popular acclaim. This work, her first color film, features animated shapes enacting a simple plot against the musical background of J. S. Bach's *Toccata* and *Fugue in D*

Minor. The "hero" of the story is an orange triangle that attempts to escape through a series of scrims—a swirling blue-green plane, black grids that spin and oscillate, and willowy lines that trap the triangle against the blue background. In the final frames, the protagonist escapes the patterned prison and floats balletically into a blue-and-black mist. Bute's formally rigorous yet high-spirited films were exhibited at Radio City Music Hall during the 1930s, making them some of the most widely seen avant-garde films in the United States at the time.

Still from *Synchromy No. 4: Escape*, 1937–38. 16mm film, color, sound; 4 min. Purchase with funds from the Film, Video, and New Media Committee 2014.101

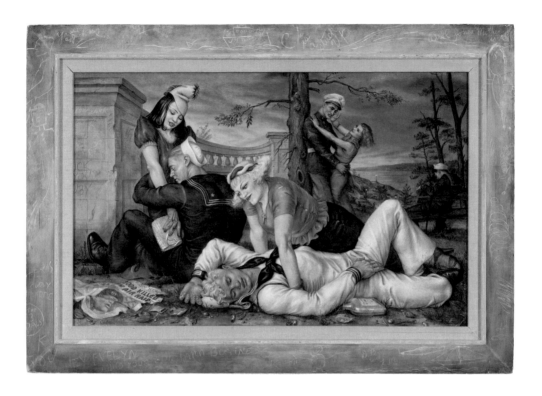

Paul Cadmus gained notoriety in 1934 when Navy officials decried his canvas *The Fleet's In!*, the second in a trilogy of works he made depicting drunken sailors on leave carousing with prostitutes or other men. *Sailors and Floosies*, the third painting in the series, highlights Cadmus's comic sensibility, his frank depiction of sexuality (which often included homoerotic undertones), and his talent for recording modern life with the technical virtuosity of the Italian Renaissance masters. At the composition's center a disarmingly brawny "floosie" is poised over a recumbent sailor, her harsh countenance contrasting with his angelic beauty in an extreme juxtaposition of satire and classicism. Inspired by anatomical studies of the Renaissance, and also drawing on techniques from the Old Masters, Cadmus sculpted the figures' musculature and rendered it visible through their tightly fitted clothing. Like many of his contemporaries, he used the

ancient medium of tempera, a fast-drying combination of egg yolk, pigment, and water that facilitated his graphic style.

Despite these historical influences, *Sailors and Floosies* is firmly situated in modern America. The bawdy scene unfolds in front of the Soldiers and Sailors Monument in New York's Riverside Park, with the graffiti covering the monument extending onto Cadmus's handmade frame. In the left foreground, a cast-off newspaper reports the death toll of a recent air raid in Europe—a reminder of the anxieties that pervaded the late 1930s. *Sailors and Floosies* caused a stir, leading to the painting's temporary removal from the 1940 World's Fair in San Francisco.

Sailors and Floosies, 1938. Oil and tempera on linen, with painted wood frame, 33¾ x 48½ in. (85.7 x 123.2 cm) overall. Gift of Malcolm S. Forbes 64.42a–b

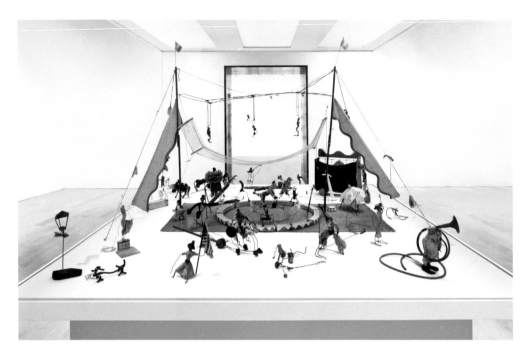

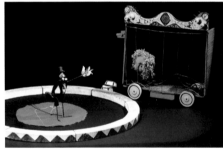

Across the course of more than six decades, Alexander Calder worked with materials ranging from thin pieces of wire to sheets of bolted steel, and experimented with scales and sites that encompassed everything from wearable jewelry to monumental outdoor sculpture. Calder had trained as a mechanical engineer, but he was an aspiring artist by the time he arrived in Paris in 1926, following in the footsteps of his father and grandfather, both well-known sculptors. There he began working on *Calder's Circus*, an ensemble work comprising dozens of small movable figures and accompanying props made from wire as well as readily available, everyday items. Transporting the miniature circus in several suitcases, he gave performances with the creations in his studios and at the homes of friends and art patrons in Paris and New York. The artist served as impresario, narrating the acts in English and French, manipulating the figures, and providing musical accompaniment and sound effects. Adding acts over several years, he fabricated a ringmaster, trapeze artists, clowns, a belly dancer, and a sword swallower—often basing his characters on real circus performers—as well as numerous circus animals, including seals, a kangaroo, and a majestic, bearded lion.

Calder's interest in the circus stemmed from a job he had held at a newspaper in New York, which sent him to illustrate the Ringling Brothers and Barnum and Bailey Circus in 1925. Describing his drawing technique, Calder spoke of his "knack for doing it with a single line," barely lifting

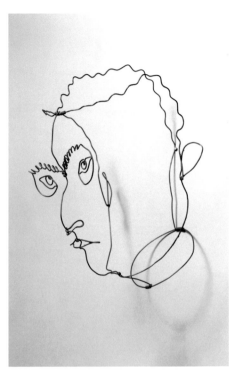

pen from paper. It was a technique he adapted to his small wire circus figures and later to a series of figurative sculptures. Using pliers to bend and contort his preferred medium, Calder created what he called "three-dimensional line drawing" in open wire portrait heads. His subjects included celebrities, politicians, sports stars, and fellow artists. He worked quickly, and while he made preparatory sketches for his portraits, he primarily improvised in the construction of these sculptures. "I think best in wire," he explained. Calder met the French composer Edgard Varèse in 1930 and captured the details of his friend's unique features in *Varèse*, using an economy of materials and gestures.

A formative visit to the Paris studio of the Dutch abstract painter Piet Mondrian, also in 1930, nonetheless convinced Calder to abandon such representational imagery in most of his work. He soon began making abstract paintings as well as sculptural constructions. Due to wartime shortages of metal, Calder's sculptures from the early 1940s are predominantly composed of hand-carved wooden elements. In the Surrealist-

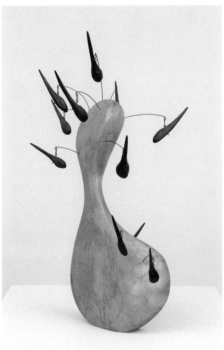

Calder's Circus, 1926–31, and *M. Loyal, the Ringmaster, Lion, and Cage* from *Calder's Circus*. Wire, wood, metal, cloth, yarn, paper, cardboard, leather, string, rubber tubing, corks, buttons, rhinestones, pipe cleaners, and bottle caps, dimensions variable. Purchase with funds from a public fundraising campaign in May 1982. One half the funds were contributed by the Robert Wood Johnson Jr. Charitable Trust. Additional major donations were given by The Lauder Foundation; the Robert Lehman Foundation Inc.; the Howard and Jean Lipman Foundation Inc.; an anonymous donor; The T. M. Evans Foundation Inc.; MacAndrews & Forbes Group, Incorporated; the DeWitt Wallace Fund Inc.; Martin and Agneta Gruss; Anne Phillips; Mr. and Mrs. Laurance S. Rockefeller; the Simon Foundation Inc.;

Marylou Whitney; Bankers Trust Company; Mr. and Mrs. Kenneth N. Dayton; Joel and Anne Ehrenkranz; Irvin and Kenneth Feld; and Flora Whitney Miller. More than 500 individuals from 26 states and abroad also contributed to the campaign 83.36.1–72. Installation view: Whitney Museum, 2010

Varèse, c. 1930. Wire, 15 x 11¾ x 12½ in. (38.1 x 29.8 x 31.8 cm). 50th Anniversary Gift of Mrs. Louise Varèse in honor of Gertrude Vanderbilt Whitney 80.25

Wooden Bottle with Hairs, 1943. Wood, steel wire, and nails, 21¼ x 15¾ x 12⅛ in. (54 x 40 x 30.8 cm). Purchase with funds from the Howard and Jean Lipman Foundation Inc. in honor of the Museum's 50th Anniversary 80.28.2a–l

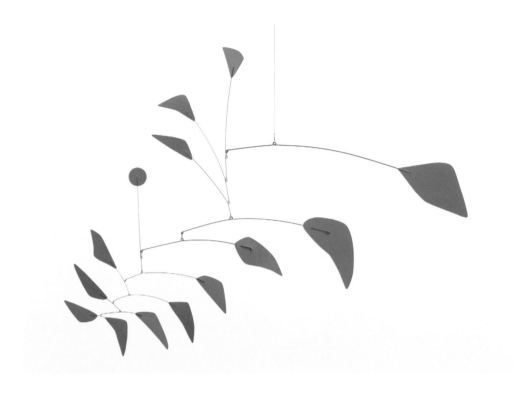

inspired *Wooden Bottle with Hairs*, for example, an abstract piece that nonetheless retains some elements of representation, wood "hairs" dangle from tiny chains attached to wires that protrude from a bulbous wood form; the hairs quiver and vibrate with the slightest shifts in movement.

The sculptural forms for which Calder is best known, however, are his abstract "mobiles"—a term coined by his friend Marcel Duchamp—which were inspired by the kinetic qualities of his earliest pieces. Calder had initially generated movement in these works with manual cranks and motors but soon discovered that natural air currents alone could set the traditionally stationary art form into motion. "Why must art be static?" he famously queried. "The next step in sculpture is motion." For many of his mobiles, including *Big Red*, Calder cut flat, biomorphic shapes from sheet metal, painted the components black, white, or one of the primary colors, and attached the

segments to supporting rods. He secured his mobiles to bases, mounted them to walls, and suspended them from the ceiling, where they would be subject to air currents. Calder controlled the range of movements of his mobiles through carefully calibrated systems of weights and balances. The full composition of *Big Red* spins slowly through 360 degrees, while its subsidiary offshoots rotate independently, resulting in a captivating and unpredictable dynamism.

Big Red, 1959. Sheet metal and steel wire, 74 x 114 in. (188 x 289.6 cm) overall. Purchase with funds from the Friends of the Whitney Museum of American Art and by exchange 61.46a–c

A pioneer of Conceptual art, Luis Camnitzer has embraced his various roles as an artist, educator, critic, and historian. Born in Germany and raised in Uruguay, Camnitzer arrived in New York in 1964 and, together with Liliana Porter and José Guillermo Castillo, founded the New York Graphic Workshop, which explored new directions for the political, conceptual, and formal possibilities of printmaking. Camnitzer's concerns have been the investigation of language; political and social upheavals in Latin America, particularly the atrocities of the Uruguayan dictatorship (1973–85); and the pedagogical functions of art and its display. These subjects follow Camnitzer's belief that art should be a "mechanism . . . for the acquisition of knowledge" rather than "the production of objects."

Camnitzer is particularly critical of the pressure the art market exerts on artists.

In 1971 he conceived of selling his signature itself, priced by the inch—a witty, self-conscious comment on commodification and speculation (the price was set to compound over time). *Sample* includes three versions of the word *sample* accompanied by the price for each, set according to materials and hourly labor. Also given a valuation is the creative act, here defined as the amount of "art" or "concept" involved, as well as the artist's handwriting; itemized values are provided for the entire work and its signature. In doing so, Camnitzer offers a humorous, biting account of the artist's role in contemporary capitalist society.

Sample, 1972. Graphite on paper, 29 7/8 x 22 1/4 in. (75.9 x 56.5 cm). Purchase with funds from the Drawing Committee 2014.70

Elizabeth Catlett

b. 1915; Washington, DC
d. 2012; Cuernavaca, Mexico

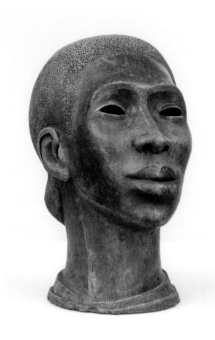

Although Elizabeth Catlett was the granddaughter of former slaves and grew up during a time of severe racial and gender discrimination in the United States, the prints and sculptures she produced during her nearly seven-decade career signal her belief in the dignity of humankind. Catlett credited Grant Wood, with whom she studied painting at the University of Iowa, with encouraging her to focus on the subjects she knew most about. She took his advice to heart and began making depictions of African American women, often in the context of familial relationships or in settings suggesting larger social and political struggles.

After becoming the first woman to receive an MFA from the University of Iowa, in 1940, Catlett studied ceramics at the Art Institute of Chicago. She became a vital figure of the Harlem Renaissance during its waning years in the early 1940s, and in 1946 she received a prestigious grant to travel to Mexico; she established permanent residency there the following year, and eventually became a Mexican citizen. *Head*, one of her first terracotta sculptures, was made there using an ancient coil technique native to the region. The close-cropped hair and slightly abstracted features seen in this serene and stately portrait transcend the particular racial identity of Catlett's subject, suggesting a universal portrayal of the venerable attributes of all women. As Catlett once explained, "I thought of sculpture as something more durable and timeless [than printmaking], and I felt that it had to be more general in the idea that I was trying to express."

Head, 1947. Terracotta,
10¾ x 6½ x 8¾ in. (27.3 x
16.5 x 22.2 cm). Purchase with
funds from the Jack E.
Chachkes Purchase Fund,
the Katherine Schmidt Shubert
Purchase Fund, and the
Wilfred P. and Rose J. Cohen
Purchase Fund in memory
of Cecil Joseph Weekes
2013.103

Truth is more dangerous than falsehood

Maurizio Cattelan has been called a huckster, a prankster, and a firebrand. He began making art at the end of the 1980s, demonstrating a penchant for the performative and talent as an escape artist. (Short of ideas for an exhibition in the early 1990s, he hung a string of knotted sheets from the window of the gallery, the inside of which he left bare.) Since then, Cattelan has developed a body of work consisting mainly of lifelike sculpture, including waxworks and animals reconstructed by taxidermy, and large-scale installations blending social and institutional critique. Interspersed among these—and equally disturbing— are poignant scenarios alluding to themes of innocence and mortality. A quintessential "post-studio" artist, Cattelan produces work on an exhibition-by-exhibition basis, using each scheduled project as a catalyst for new work. As he has said: "I really just take advantage of the exhibition situation. Because I don't have a studio, I use shows as a means to get work produced."

When invited to participate in the Whitney Museum's 2004 Biennial, he proposed a piece that was eventually deemed too controversial to be included in the exhibition. He made *Untitled* in response, using an existing work he created for a project in Kitakyushu, Japan—a sculpture from 2000 in which he depicted himself seated at a table with his head planted in a plate of spaghetti. Cattelan instructed that the piece be sealed in a box and buried in an undisclosed location inside the Whitney's Marcel Breuer building. The work is now re-sited at the Whitney's downtown location, where a wall label is the only indication that it exists. This project— continuing his longstanding interest in institutional critique and public reception— is an implicit burial of his artistic voice beneath the Museum's authority, something further underscored by the epitaph above, accompanying this text.

Epitaph for *Untitled*, 2004. Fiberglass, 15½ x 20⅛ x 14⅝ in. (39.4 x 51.1 x 37.1 cm). Gift of the artist 2013.97

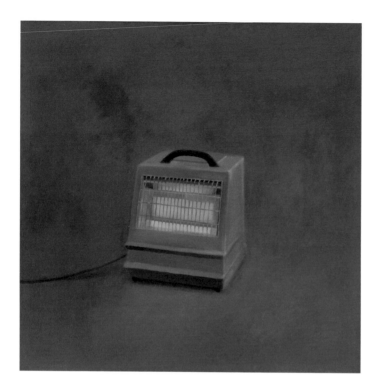

Vija Celmins is known for her painstakingly rendered photorealist paintings and drawings, which examine such subjects as desert and ocean surfaces and nocturnal skies. The still lifes she made in the early 1960s, however, are among the artist's most restrained and introspective works. In a series executed in 1964, while still a graduate student at the University of California, Los Angeles, Celmins painted domestic objects from her Venice, California, studio— a lamp, a hotplate, a fan, a knife resting on a saucer—as an exercise in close looking. Situating these everyday things that relate to the basic necessities of heat, food, and light within fields of gray or brown, she created muted grounds that spurned the slick finishes and bright Pop colors favored by other Southern California artists at that time.

In *Heater,* a characteristic work from this series, a small space heater emits a contained orange glow while its electrical cord trails out of the picture plane, suggesting a larger space beyond the otherwise flattened composition. A tension between the illusion of warmth that radiates from luminous coils of *Heater* and its physical absence from the canvas adds to the painting's unnerving impact. While the subject of this work seems innocuous, its somber, shadowy rendering suggests something more ominous. Indeed, such darker subtexts appear in other, more pointedly political and austere works from this period. Celmins had begun looking to mass media—a *Time* magazine cover depicting the 1965 Watts uprising in Los Angeles, and images of fighter planes on her television—for source material that reflected the turbulence of the 1960s.

Heater, 1964. Oil on canvas, 47⅝ x 48 in. (121 x 121.9 cm). Purchase with funds from the Contemporary Painting and Sculpture Committee 95.19

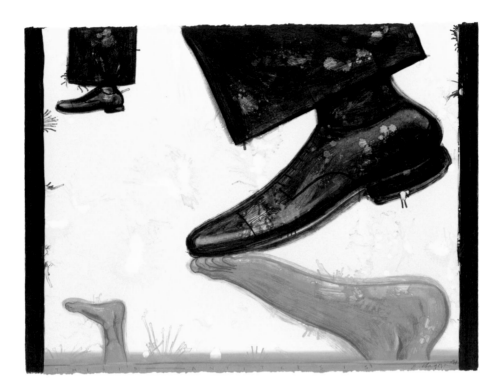

Enrique Chagoya's prints, drawings, collages, and multiples offer critical commentary on the global reach of the United States and its cultural, political, and historical tensions with Latin America. Deconstructing typologies of both the indigenous and modern cultures of the Americas, Chagoya's work draws on a wide range of source material—religious iconography, comic books, sports mascots, folklore, racial stereotypes, Western art history, and other societal artifacts.

The artist has lived and worked in both Mexico and the United States: in the mid-1970s he studied economics at the Universidad Nacional Autónoma de Mexico and became a social activist while working on rural redevelopment projects and drawing cartoons for union and student newspapers; in 1979, he became a permanent resident of the United States and began freelancing as an illustrator and designer before earning degrees

from the San Francisco Art Institute and University of California, Berkeley. In the late 1980s Chagoya was artistic director of Galería de la Raza, an important venue for Chicano and Latino art in San Francisco.

Building upon these political and cultural legacies and his own life experiences, Chagoya's imagery became increasingly reflective of the economic and social realities of the 1990s. *Thesis/Antithesis* explores the dialectics of border relationships, presenting what is perhaps a biting metaphor for the stampede of "big business," represented here by a black wing-tipped shoe, over humanistic concerns, suggested by the bare, burnt-umber foot, or for the colonialist triumph of the modern, industrialized world over a primitive, ancestral past.

Thesis/Antithesis, 1997.
Monotype, 22⅝ x 30⅛ in.
(57.5 x 76.5 cm). Purchase
with funds from the
Print Committee 98.41.1

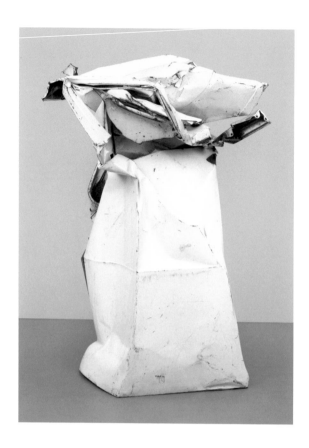

John Chamberlain is best known for the colorful sculptures he made beginning in the late 1950s from found automobile parts that he crushed and welded into compelling new forms. As a result of this practice and its unique use of color and form, his sculptures are routinely associated with the gestural work of Abstract Expressionist artists such as Franz Kline and Willem de Kooning. While Chamberlain's career is undoubtedly anchored within this painterly context, his work is distinguished through its use of found material and the detritus of the everyday—a practice that flourished in the 1960s and 1970s as part of a movement known as Assemblage. As Chamberlain explained, "The early colored sculptures came about when I ran out of iron rod . . . [and] it occurred to me one day that all this material was just lying all over the place."

Despite their cultural associations, Chamberlain selected car parts for their preexisting forms, emphasizing that "a common material with a preformed mythic content shakes off its origins through formal transformation." *Velvet White* comprises two segments of white metal compressed together and lacks his signature use of vibrant color. As such, the sculpture underscores Chamberlain's interest in materiality and the physicality of the body. Here, the work becomes almost anthropomorphic, suggesting the head and body of a figure, shrouded in white.

Velvet White, 1962. Painted
and chromium-plated
steel, 79½ x 52¾ x 58¼ in.
(201.9 x 134 x 148 cm).
Gift of the Albert A. List Family
70.1579a–b

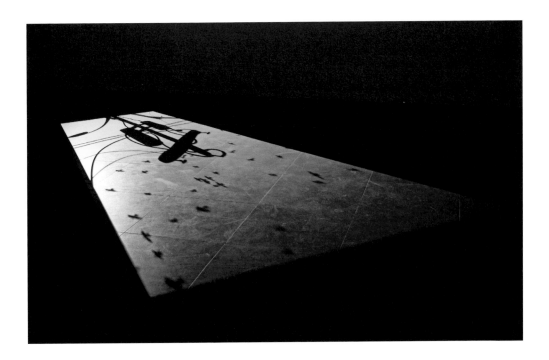

Paul Chan engages philosophy, religion, politics, art, and cultural history in a multivalent practice that has included single-channel videos, charcoal drawings, computer animations, conceptual fonts, and publications of artists' writings. And although he has filmed in Iraq on the eve of war, created an agitprop map for protestors of the 2004 Republican convention in New York, and staged a collaborative post–Hurricane Katrina production of *Waiting for Godot* in New Orleans, Chan distinguishes between the political and the aesthetic in his work. Politics, as he has maintained, requires "collective social power," whereas his art is engaged with "nothing if not the dispersion of power."

The series *The 7 Lights* (2005–7), comprised of seven digitally animated video projections, is among Chan's most acclaimed works. The cycle's initial work, *1st Light*, spills light across the gallery floor like sunlight through an unseen window. As the color of the illumination shifts in a cycle from dawn to dusk, the shadow of a cruciform utility pole tangled with wires appears. The silhouettes of unmoored objects—cell phone, moped, bicycle wheel, sunglasses—and debris begin to ascend slowly and silently through the frame, finally breaking apart in the air. Flocks of birds cross the scene before, suddenly and quickly, bodies begin falling downward, one at a time and then in clusters, recalling the tragic imagery of men and women jumping from the burning World Trade Center towers after the September 11, 2001, terrorist attacks. This narrative makes specific allusions to the story of the Christian Rapture but more broadly envelops us in a meditative environment of reverie shadowed by calamity.

1st Light, 2005. Digital video installation, black-and-white and color, silent; 14 min., dimensions variable. AP 1/3, edition of 5. Purchase with funds from the Film and Video Committee 2007.4

In the late 1970s Sarah Charlesworth began to question the role that photographic images play in shaping perception. This critical standpoint, which she shared with others in a loose-knit group of New York–based artists known as the Pictures Generation, marked a shift in artistic focus away from the linguistic emphasis of Conceptualism and the formal reductions of Minimalism associated with art of the 1960s and 1970s. These artists rather began to draw on, appropriate, and manipulate existing visual content, hoping, as Charlesworth expressed it, to "elucidate a common cultural experience and how it is depicted in the mass media."

Charlesworth's *The Arc of Total Eclipse, February 26, 1979* belongs to her series *Modern History*, which examines how photographic images function within the editorial practices of newspapers. For this particular work, the artist selected as her subject front-page coverage from locales across the path of a solar eclipse over North America. Charlesworth removed all written language except for the mastheads in her actual-sized re-presentations of these twenty-nine newspapers. Although they represent the same spectacle, the images vary somewhat, as do their size and position, depending on the publications'

photographers and editors and on the relative importance of the unseen articles that shared the page. The result is a visual allegory of how varied media perspectives contribute to an understanding of the world. As Charlesworth remarked: "The eclipse interested me metaphysically, because there wasn't any single image that was consistent, or even any single point in time represented. Each town along the eclipse path had its own experience of the same event."

Details of *The Arc of Total Eclipse, February 26, 1979*, 1979, from the series *Modern History*, 1977–2003. Twenty-nine gelatin silver prints, dimensions variable. Edition of 3. Purchase with funds from the Photography Committee 94.60a–cc

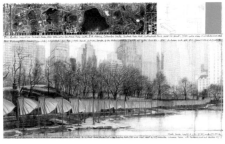

Package on Hand Truck, 1973.
Metal, tarpaulin, wood, and
rope, 50⅞ x 26⅝ x 31¾ in.
(129.2 x 67.6 x 80.6 cm).
Gift of Mr. and Mrs. Albrecht
Saalfield 74.74

*The Gates, Project for Central
Park, New York City*, 2003.
Collage, enamel, fabric,
graphite pencil, charcoal, wax
crayon, pastel, wax, and
tape; and wax crayon, pastel,
wax, charcoal, graphite
pencil, and enamel, two
parts: top, 14⅝ x 96 in. (37.1 x
243.8 cm); bottom, 42 x
96 in. (106.7 x 243.8 cm).
Purchase with funds from
Melva Bucksbaum, Raymond J.
Learsy, and the Martin
Bucksbaum Family Foundation
2004.419a–b

Born in Bulgaria, Christo (Javacheff)
studied fine art in Sofia and then briefly
in Prague and Vienna before moving
to Paris, where he would meet his wife
and longtime collaborator, Jeanne-Claude
(Denat de Guillebon), in 1958. Rejecting
the theoretical emphases of then-current
abstraction for an art grounded in real
objects, Christo began to wrap everyday
items such as tin cans and furniture
in cloth and string, and later in translucent
plastic. *Package on Hand Truck* replaces
the pedestal of traditional, static sculpture
with an ordinary upright moving dolly.
Despite the commonplace materials it
uses—tarpaulin and rope—the work
strikes a mysterious note, as the contents
under wraps remain forever unknown.

For Christo and Jeanne-Claude,
the act of wrapping became an undertaking
of monumental scale and scope, and
for nearly four decades they staged large,
site-specific, temporary interventions
in both natural and built environments.
They wrapped islands, coastlines,
and architectural landmarks (including the
Pont Neuf in Paris and the Reichstag
in Berlin) and installed fences, curtains,
and umbrellas in various locations
all over the world. These bureaucratically
and logistically complex projects, often
years in the making, were conceived
and visualized in preparatory drawings
and collages made by Christo. *The Gates,
Project for Central Park, New York City*
anticipates one of the pair's most ambitious
efforts: the installation, for sixteen days
in February 2005, of seventy-five hundred
square gateways, each sixteen feet
tall and hung with saffron-colored nylon
panels, spread over twenty-three
miles of footpaths in Central Park. First
conceived in 1979, *The Gates* was a
massive endeavor; the collage reveals the
engineering intricacies of a single
gate as well as the extent to which gates
blanketed the park.

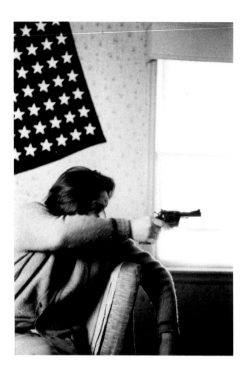

Larry Clark began using a camera in the mid-1950s while working as an assistant to his mother, an itinerant portraitist, and quickly achieved notoriety as a photographer with the publication of his first book, *Tulsa*, in 1971. Shot between 1963 and 1971, the powerful images in the book defiantly document sex, drug use, and violence among teenagers in his hometown, providing a dark counterpoint to the idealized youth culture of the same period. *Tulsa* established Clark as a pioneer in a mode of photography that pushed the boundaries of not only acceptable subject matter but also the relationship between the photographer and his subjects. As Clark noted in the book's short introductory statement, "when i was sixteen i started shooting amphetamine. i shot with my friends everyday for three years and then left town but i've gone back through the years. once the needle goes in it never comes out."

Untitled, an image from *Tulsa*, features a young man pointing a gun at a target off camera, with an American flag hanging askew on the wall in the background. The raw and symbolic content of the image is matched by the harsh light from the window. Clark has noted, "When I'm photographing I always try to shoot against the light . . . the film can't handle this and everything gets burned up, since I'm exposing for the shadows." His haunting photographs similarly reveal the shadows of adolescence in a culture that both glorifies and brutally commodifies youth. Although Clark has gone on to become an acclaimed filmmaker, his intimate and uninhibited approach to photography, epitomized by *Tulsa*, has influenced generations of artists, from Nan Goldin to Ryan McGinley.

Untitled, 1971 (printed 1972), from the portfolio *Tulsa*, 1972. Gelatin silver print, 8½ x 5¾ in. (21.6 x 14.6 cm). Edition no. 35/50. Purchase with funds from the Photography Committee 92.111.4

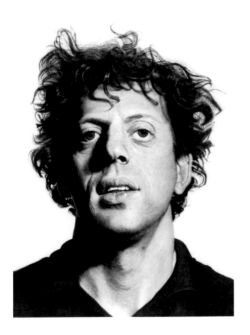

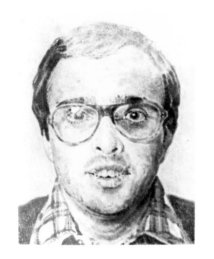

Phil, 1969. Acrylic and graphite
pencil on canvas, 108¼ x
84 in. (275 x 213.4 cm).
Purchase with funds from Mrs.
Robert M. Benjamin 69.102

Mark/Fingerprint, 1983.
Ink on paper, 49⅛ x 38⅛ in.
(124.8 x 96.8 cm). Gift of Anne
and Joel Ehrenkranz 2009.1

Since the late 1960s, Chuck Close has created larger-than-life, photo-based portraits of friends, family members, and fellow artists, which he calls "heads." Prior to that time he painted in an Abstract Expressionist style, but renounced it for a more predetermined way of working: he began tracing grids over photographs of faces and transferred and enlarged them onto canvas, by the quarter-inch unit, using an airbrush filled with black paint. This methodical technique aligns Close's output as much with the systematic rigor of some Minimalist and Conceptual art as with the Photorealism with which it is often linked. *Phil*—derived from a photograph of the composer Philip Glass, on which Close based a number of subsequent works—was among the first of these monumental black-and-white portraits. At the time, Glass was working as an assistant to the artist Richard Serra, and Close professed an interest in making "portraits of people who are in the arts but not famous." Close's images are exacting and dispassionate; they expose every minute facial detail, however unflattering, and yet, unlike conventional portraiture, reveal little about the characters of their subjects.

In 1970 Close started to work in color, adopting the layering processes used in color printing. He covered his surfaces in matrices of small dots, arranged in grids—abstract marks that coalesced into figurative depictions of faces. He began using his hand directly again in 1978, impressing his inked fingerprints on a grid and varying their density in order to convey texture and modeling. *Mark/Fingerprint* pictures Mark Greenwold—an artist Close first depicted in the early 1970s—using his fingerprints and red, yellow, and blue ink. Since the late 1980s, Close's work has expanded beyond painting and prints to include photographs and tapestry portraits.

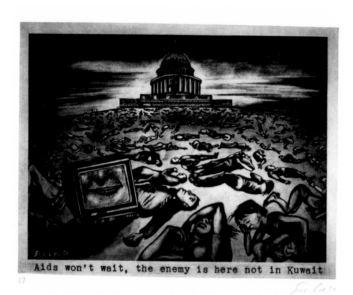

Aids won't wait, the enemy is here not in Kuwait

Sue Coe's message in *Aids and the Federal Government* is grim and unambiguous: the AIDS epidemic—personified in dozens of lifeless bodies sprawled on the ground—was neglected by the country's leaders, symbolized by the US Capitol Building looming at the top of the image, and the cropped, smirking face of an apparent politician or anchorman on a television screen in the foreground. Coe suggests that American military involvement in the Persian Gulf following Iraq's invasion of Kuwait in 1990 came at the expense of addressing the domestic health crisis, which the etching's caption identifies as the true enemy. The image's threatening sky, austere palette, and severe figural renderings reinforce its ominous sentiment, and evoke the charged agendas and stark representational modes of art historical antecedents such as social realism and German Expressionism.

British-born, Coe moved to the United States in 1973 and worked as a freelance newspaper and magazine illustrator at periodicals including the *New York Times* and *Time*, and her art evinces a journalistic concern with truth telling and straightforward communication. Motivated by what she has described as "the idea that art can be used to speak for those that cannot," her paintings, drawings, prints, and mixed-media works involve extensive research and have investigated social and political injustices, such as apartheid, wartime torture, sweatshop labor, and cruelty to animals. Coe's art embodies activism; she hopes that her moving images—often disseminated through publications—will not only provoke emotional responses but also galvanize protest and positive change.

Aids and the Federal Government, 1990. Photoetching: sheet, 13⅛ x 18⅞ in. (33.2 x 47.8 cm); image, 10½ x 13⅝ in. (26.7 x 34.6 cm). Edition no. 27/83. Gift of Kirby Gookin 91.40

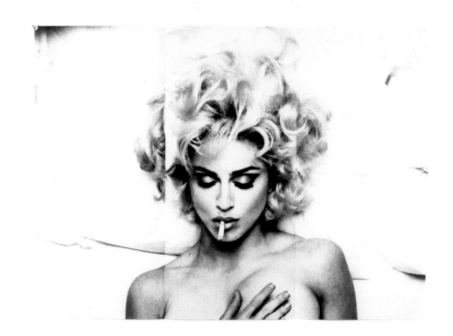

Anne Collier produces sparse still lifes of found objects using a technique of re-photography that is informed as much by West Coast conceptual art practices as by product photography and advertising. She received a BFA in 1993 from the California Institute of the Arts, Valencia, and an MFA in 2001 from the University of California, Los Angeles, studying with Michael Asher, John Baldessari, James Welling, and Christopher Williams. Unlike artists of the earlier Pictures Generation, who appropriated images from contemporary mass media, Collier sources her worn objects from flea markets and eBay and shoots them against an austere white or black background. The resulting photographs return our gaze to artifacts of vision, desire, and power.

Collier frequently focuses on the objectified female subject within pop culture. Here, she has photographed an image of Madonna, in poster format, taken by the fashion photographer Steven Meisel, who later collaborated with the pop star for her controversial 1992 book *Sex*. In this Meisel image, the singer, typically known for her bold reclamation of female sexuality, averts her eyes from the camera and covers her bare breast. Collier complicates the web of power dynamics by re-photographing an image taken by a male photographer and by displaying the wear and tear of the poster, presumably at the hands of a consumer. In an age when most images seem to move in digital form rather than on paper, Collier turns our attention to the physical circulation of images, creases, folds, and all.

*Folded Madonna Poster
(Steven Meisel)*, 2007.
Chromogenic print, 45¾ x
60⅝ in. (116.2 x 153.8 cm).
AP 1/2, edition of 5.
Purchase with funds from
the Photography
Committee 2009.3

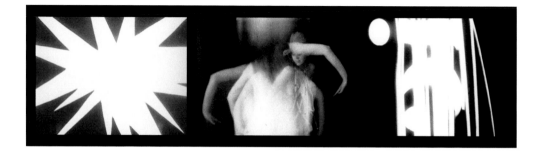

Bruce Conner emerged in the late 1950s as a central figure in the San Francisco Renaissance, a loose association of artists, poets, musicians, and filmmakers who, resisting conformity in both art and life and juxtaposing beauty and ugliness in their work, articulated the cultural and political upheavals of their time. Conner's experimental attitude took a multiplicity of forms, including collage, painting, sculpture, drawing, printmaking, film, and photography. He gained early acclaim for a series of moody, ethereal assemblages that utilized a variety of found objects and scrap materials to form complex meditations on contemporary life.

PORTRAIT OF ALLEN GINSBERG is an unconventional, abstract depiction of the poet that shuns any overtly formal or symbolic references, achieving instead, in Conner's words, "a drama of a characterization." Combining a door or window frame with dangling biomorphic forms (nylon stockings filled with found objects), sinewy stretched fabric, and partially burnt candles, it connotes a state of decay, a forensic scene, or an occult ritual. Equally renowned for his films, Conner originated an influential form of film collage through the meticulous assemblage of found footage—newsreels, countdown leader, film company logos, hand-altered film frames (hole punched, bleached, ink marked)—and his own original material. From the beginning he imagined the possibility of an infinitely looping, multiple projection film environment, and in 1965 he reworked his film COSMIC RAY (1961) into a three-screen 8mm film installation for exhibition at the Rose Art Museum at Brandeis University. Near the end of his life he revisited this work and, with the advance of digital projection, finally realized his vision for an infinite duration, multiscreen work, using this and earlier film materials to create EYE-RAY-FOREVER.

Stills from EVE-RAY-FOREVER, 1965/2006. Three-channel 8mm film transferred to video, black-and-white, silent; 3:42 min., 4:11 min., and 3:45 min., looped, dimensions variable. Edition no. 5/6, 2 AP. Purchase with funds from the Film, Video, and New Media Committee and the Painting and Sculpture Committee 2009.41

PORTRAIT OF ALLEN GINSBERG, 1960. Wood, fabric, wax, metal can, glass, feathers, metal, string, and spray paint, 20 x 11⅜ x 21⅜ in. (50.6 x 28.7 x 54.3 cm). Purchase with funds from the Contemporary Painting and Sculpture Committee 96.48

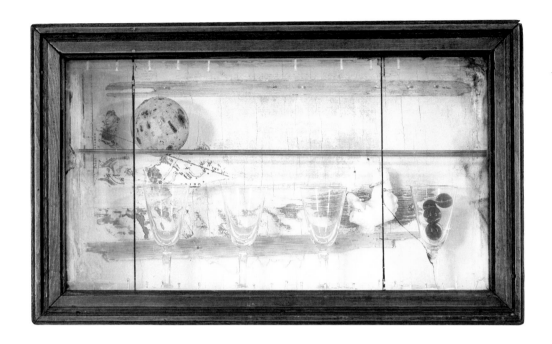

Joseph Cornell was an obsessive collector. He gathered seashells, children's toys, clay pipes, coins, watch faces, and a miscellany of other objects and images and filed them away in the basement of the house in Flushing, Queens, where he lived with his mother and brother. Frequenting New York's bookstores, libraries, galleries, and museums, he also studied scientific diagrams, ancient myths, and children's fairytales. It was in 1931 at the Julien Levy Gallery, an important venue for Surrealist artists, that Cornell encountered collages by Max Ernst, with their improbable pastiches of found imagery. Inspired, Cornell used the raw materials he collected to create the collages and shadow boxes for which he is best known. His boxed assemblages are simultaneously shrines and dioramas—sites for the celebration and examination of the unknown and the fantastical.

 Celestial Navigation contains a blue speckled ball suspended on metal rods above a set of four antique cordial glasses. The four blue marbles in this work can be distributed inside the glasses in various configurations, suggesting the constant movement of the universe. In this arrangement, all four marbles sit inside the glass farthest to the right, like a cluster of planets or stars in a constellation. The fractured plaster head of a boy floats against a backdrop of the night sky like a figurehead on the bow of a ship. He seems to be staring intently at the marbles in the glass, perhaps in contemplation. Cornell had been an avid stargazer since childhood, and astronomy, constellation charts, and celestial navigation—which guided sailors since ancient times in their travels— provided fodder for a number of his elegiac shadow-box works.

Celestial Navigation, c. 1958. Painted wood and printed papers, four glasses, four marbles, plaster head, painted cork ball, metal rods, brad nails, and painted glass, 10 x 16⅜ x 3⅞ in. (25.4 x 41.6 x 9.8 cm). 60th Anniversary Gift of Estée Lauder Inc. 92.24a–e

Miguel Covarrubias

b. 1904; Mexico City, Mexico
d. 1957; Mexico City, Mexico

The artist, writer, and anthropologist Miguel Covarrubias was an important figure in New York's cultural landscape during the Jazz Age. Arriving in 1923 from his native Mexico City, he quickly developed a reputation as a brilliant caricaturist and took up with the city's intellectual and artistic elite. By 1924 he had rented studio space with another young artist, Al Hirschfeld, and began frequenting Harlem nightclubs and associating with key figures of the renaissance underway among the city's African American writers and artists. In March of that year, the Whitney Studio Club presented a show of his drawings, and he began what would become a long association with *Vanity Fair*, which published a number of his illustrations. At the end of the year his work appeared there again, in a spread titled "Enter, The New Negro," in which the young artist interpreted the lively nightclub scene in Harlem.

This drawing was reproduced in that spread, along with seven others by the artist, accompanied by captions from the Afro-Carribean writer Eric Walrond. Covarrubias typically made hundreds of sketches while directly observing Harlem's nightlife, but he clearly labored over this piece carefully in his studio, creating subtle gradations of black and gray washes. Beyond his concise and legible presentation of a Harlem couple out on the town, Covarrubius proves himself a deft master of modernist form. His streamlined figures suggest a nod to the burgeoning Art Deco aesthetic, while the fragmented glass and upturned plane of the table echo elements of Cubism. Covarrubias published a slightly different version of this sheet in his book *Negro Drawings* (1927), a landmark publication capturing the Harlem Renaissance.

Scene: "The Last Jump."
Cabaret on a Saturday Night,
1924. Brush and ink,
ink wash, and graphite on
paper, 14⅜ x 11½ in.
(36.5 x 29.2 cm). Purchase
with funds from the Drawing
Committee 2014.21

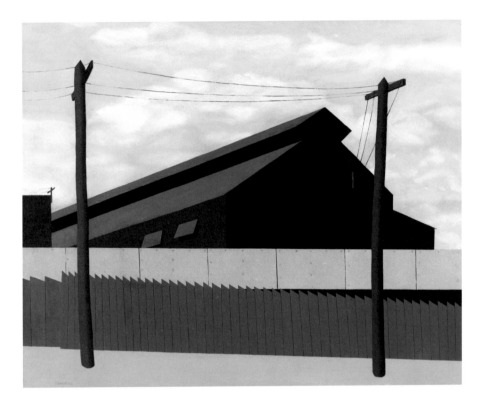

In his early paintings Ralston Crawford sought to develop an aesthetic language suited to the massive industrial expansion of the United States in the decades following World War I. Like his elder colleagues Charles Demuth and Charles Sheeler, Crawford portrayed factories, grain elevators, and mechanical structures using hard-edged geometries, flat planes of color, and crisply articulated lines—a style that came to be known as Precisionism. While many of Crawford's paintings capture the country's optimism about technology and progress, *Steel Foundry, Coatesville, Pa.* presents a more austere vision. The painting depicts a foundry in Coatesville, a center of steel production located forty miles west of Philadelphia. The site had first captivated Crawford during his days as a student at the Pennsylvania Academy of Fine Arts, and by the time he painted this work he was living in nearby Exton, Pennsylvania. With their boldly flattened forms, the building and surroundings depicted in the painting reflect the Machine Age values of order, logic, and purity. At the same time, the dark structure is devoid of human presence and blocked off by a double layer of wooden fencing and concrete wall, its bleak severity countered only by the vivid blue sky and wispy clouds hovering above.

Steel Foundry, Coatesville, Pa.,
1936–37. Oil on canvas,
32⅛ x 40 in. (81.6 x 101.6 cm).
Purchase 37.10

Imogen Cunningham

Recognized as one of the most significant American photographers of the twentieth century, Imogen Cunningham was a pioneer of modernist imagery and technique, producing many of the groundbreaking photographs that helped redefine photography as fine art. She was a key figure in the circle of West Coast photographers—including Dorothea Lange, Edward Weston, and, later, Ansel Adams—who broke away from the painterly, soft-focused style of Pictorialism to create a straightforward, modern aesthetic. Cunningham became renowned in the 1920s for her sharp-focused close-ups of isolated botanical subjects and nudes. The photographs are notable for their contrasting darks and lights, close cropping, abstract composition, and crisp details, imbuing simple subjects with a sense of monumentality.

In 1932 she joined Adams and other photographers from the San Francisco Bay Area to form "Group f.64," which was committed to using the unique properties of the camera to capture images from the world with directness and clarity. Cunningham's experiments with double exposure, a mainstay of her long and distinguished career, include many depictions of artists and musicians. *Martha Graham 2* was created in-camera during a 1931 outdoor photo shoot in Santa Barbara with the famous dancer. The technique involves exposing two different images onto the same frame of film. Two of the ninety photographs shot by Cunningham at that extraordinary session appeared in the December 1931 issue of the original *Vanity Fair*, initiating her freelance work with the magazine, which continued until publication temporarily ceased in 1936. Cunningham would make innovative pictures (including the first known photographs of a nude, pregnant woman) for another four decades, until shortly before her death at age ninety-three.

Martha Graham 2, 1931.
Gelatin silver print, 7⅝ x 5⅞ in.
(19.4 x 14.9 cm). Promised gift
of Sondra Gilman Gonzalez-
Falla and Celso Gonzalez-Falla
to the Whitney Museum of
American Art, New York, and
the Gilman and Gonzalez-Falla
Arts Foundation P.2014.55

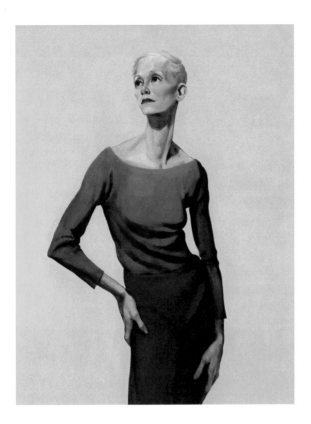

Since beginning to paint in the late 1980s, John Currin has remained exclusively engaged with the practice of figurative painting—specifically portraiture. He came to prominence during the 1990s with a body of work comprised of single and group portraits, frequently containing sexualized, even campy imagery and drawing on influences as varied as Old Master painting and fashion imagery. During this period Currin emerged as part of a larger group of painters, including Luc Tuymans and Elizabeth Peyton, who were revitalizing the practice of figuration and portraiture.

Around 1990 Currin began to make paintings of women depicted alone against monochromatic backgrounds, often basing his portraits on found photographs that he would modify into invented compositions. As the artist has said of these figures, "The people I paint don't exist. The only thing that's real is the painting." For *Skinny Woman*, one of a group of portraits of older women, Currin began with a photograph of a Twyla Tharp dancer, borrowing the figure's dramatic, contrapposto pose but drastically modifying the original image. Currin routinely draws from his immediate surroundings—in this instance incorporating the clothing he was wearing in the studio while working on the painting. He also frequently includes elements of his own body in the portraits, explaining that "I incorporate my face, hands, and backs in the figures. . . . I basically project myself onto everything rather than reveal a lot about other people."

Skinny Woman, 1992.
Oil on linen, 50⅛ x 38⅛ in.
(127.3 x 96.8 cm). Purchase
with funds from The List
Purchase Fund and
the Painting and Sculpture
Committee 92.30

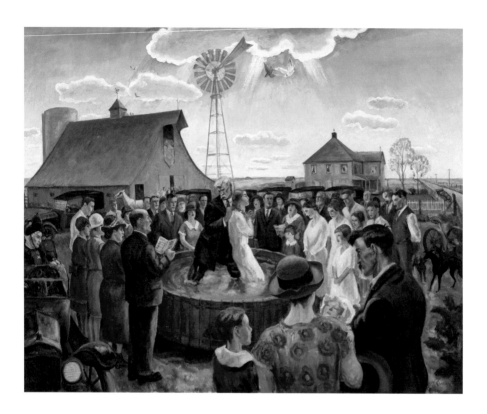

Though John Steuart Curry left his family's farm to pursue a career as a painter on the East Coast, he returned to his Midwestern roots as subjects for his art. *Baptism in Kansas*, his first major painting, portrays two fundamental elements the artist associated with his upbringing: the hardscrabble landscape of his native Kansas and the religious fervor of its inhabitants. (Curry proudly avowed that he was "raised on hard work and the Shorter Catechism.") Based on a baptism Curry witnessed on a neighbor's farm, the painting sets the ceremony around a cattle trough amid several farm buildings, with the stark prairie landscape receding into the background. At the scene's center, surrounded by pious worshippers singing hymns, a young woman is about to be submerged into the water by an ashen-faced preacher. The image is filled with modern details, such as the line of Model-T cars and the cattle trough, a symbol of the deep-water drilling techniques that had made the state farmable. Yet the pair of birds hovering in an aureole of light over the scene—a raven and a dove, the birds Noah released after the Flood—suggests a divine, timeless significance in the survival of these hardy individuals amid their harsh environment.

When *Baptism in Kansas* was first shown in 1928, critics hailed it as a departure from the abstract language and urban themes employed by American modernists. Curry's vision of an idealized American heartland signaled the emergence of Regionalism, a nationalistic, narrative style of painting that glorified rural, homespun values during the hardships of the Great Depression.

Baptism in Kansas, 1928. Oil on canvas, 40¼ x 50¼ in. (102.2 x 127.6 cm). Gift of Gertrude Vanderbilt Whitney 31.159

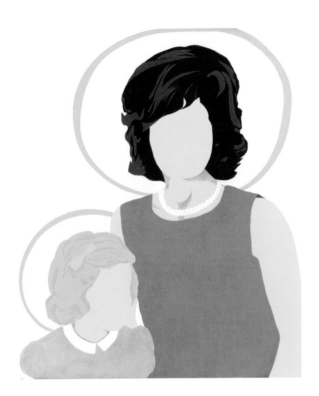

Although Allan D'Arcangelo would become known primarily for his images of US highways, complete with road signs and billboards, he made a number of significant paintings of celebrities, including Marilyn Monroe and Jacqueline Kennedy, the latter pictured in *Madonna and Child* with her toddler daughter. D'Arcangelo worked from a contemporary portrait photograph of the First Lady and Caroline Kennedy to make this graphic take on an age-old religious art-historical subject. Mother and daughter are rendered in bold blocks of unmodulated color, their featureless faces ringed in bright yellow halos that elevate them to the status of contemporary icons and saviors of America.

 D'Arcangelo highlights the Kennedys' brand status in his use of the bold style and limited color palette of commercial design and advertising, epitomized in the subjects' two-tone hair. The image trades on visual legibility: its sitters are recognizable merely by virtue of their signature hair and clothing, and Jackie's string of pearls. With its graphic style and celebrity subjects, *Madonna and Child* relates to works by other Pop artists such as Andy Warhol. Like Warhol's works, this painting points to the more sinister side of celebrity and consumer culture: despite their apparently heavenly status, Jackie and Caroline have been reduced to images to be consumed, devoid of depth, individuality, and voice. The tragic aura of the painting seems particularly poignant given the assassination of President Kennedy just a few months after D'Arcangelo completed this work.

Madonna and Child, 1963. Acrylic and gesso on canvas, 68½ x 60⅛ in. (174 x 152.7 cm). Purchase with funds from the Painting and Sculpture Committee 2013.2

The World's First Collaborative Sentence—commissioned in 1994 by the Lehman College Art Gallery, Bronx, New York, for *InterActions*, a survey exhibition of work by the artist Douglas Davis—is a "classic" of Internet art. Allowing users to contribute to a never-ending online sentence, it presciently anticipated today's blog environments and the ongoing posts on social media platforms. By early 2000 there already were more than 200,000 contributions, in dozens of languages. Any subject may be addressed, but no contribution can end with a period, as the *Sentence* is infinitely expanding. Due to changes over the years in the online environment and Internet browsers, however, several aspects of the work became nonfunctional. In 2012 the Whitney Museum undertook a preservation effort, creating a historic version of the *Sentence* that leaves the code mainly untouched but reconstructs embedded links that had been broken, as well as a new live version that restores the work's functionality and allows visitors to contribute to the piece.

The pioneering online project is a natural extension of explorations that Davis—also a writer and video and performance artist—had been making in participatory media art over the decades. For Documenta 6 in Kassel, Germany, in 1977, he organized a live satellite telecast of artists' work, sent to more than twenty-five countries. In addition to his own performance, it included works by Nam June Paik, Charlotte Moorman, and Joseph Beuys. Davis's contribution, *The Last Nine Minutes*, played with the idea of "breaking through" the confines of the screen and directly communicating with the audience.

Screenshot of *The World's First Collaborative Sentence*, 1994– (conserved 2012). HTML and CGI script. Gift of Barbara Schwartz in honor of Eugene M. Schwartz 95.253. Originally commissioned by the Lehman College Art Gallery, The City University of New York, with the assistance of Gary Welz, Robert Schneider, and Susan Hoeltzel

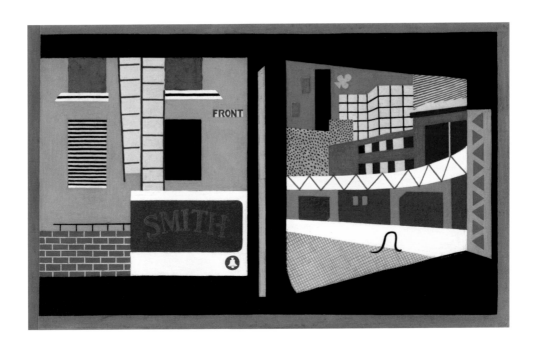

During the 1920s Stuart Davis developed an innovative style that fused the abstracted geometries of European Cubism with subject matter derived from American popular culture, especially advertising, newspapers, and everyday consumer objects. In late 1927 he began a series of four still-life paintings based on a grouping of unlikely items: an eggbeater, an electric fan, and a rubber glove that he had nailed to a table in his studio. During the year he spent

working exclusively on the series, Davis homed in on the most essential formal properties of the objects. "Gradually through this concentration," he remarked, "I focused on the logical elements. . . . The immediate and accidental aspects of the still life took second place." In *Egg Beater No. 1*, the most flat and austere work of the series, Davis transformed his subject into a rhythmic arrangement of geometric forms, reaching a level of abstraction that was unprecedented in his work.

More often during the 1920s and 1930s, Davis's real-world sources were abstracted but still recognizable, as in *House and Street*, which depicts the intersection of Front Street and Coenties Slip in lower Manhattan. The painting's split image suggests the Cubist ambition to portray multiple viewpoints simultaneously, but its distinctively New York subjectmatter,

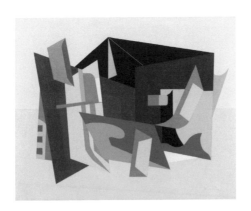

House and Street, 1931. Oil on canvas, 26⅛ x 42⅛ in. (66.4 x 107 cm). Purchase 41.3

Egg Beater No. 1, 1927. Oil on linen, 29¼ x 36¼ in. (74.3 x 92.1 cm). Gift of Gertrude Vanderbilt Whitney 31.169

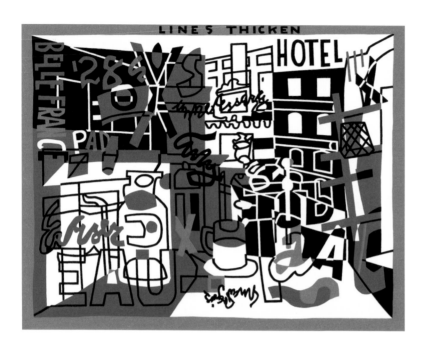

including the Third Avenue elevated train, sets it apart from European precedents. Davis used the urban landscape to explore his fascination with the graphic language of signs and advertisements: the painting includes the word *Front*, for Front Street, the bell icon of the city's telephone company, and the name *Smith*, which likely refers to Alfred E. Smith, the popular governor of New York State who was running for reelection in 1926, the year Davis made the drawing on which this painting was based.

In the final years of his career, Davis frequently used earlier compositions as springboards for new paintings marked by a complex language of unmodulated planar forms and densely woven lines. *The Paris Bit* is based on the canvas *Rue Lipp*, a cafe scene he produced during his Paris sojourn in 1928. With its inclusion of the number twenty-eight and the words *eau*, *Belle France*, and *tabac*, Davis pays homage in *The Paris Bit* to his earlier composition and his seminal experiences in Paris, where he was able to study Cubism firsthand. At the same time, the painting's enlarged

scale and network of calligraphic forms reflect the influence of vanguard American painting in the 1950s, especially Abstract Expressionism. The words "lines thicken," added to the painting's outer border, seem to acknowledge the painting's more solid rendering in comparison with its earlier counterpart.

The Paris Bit, 1959. Oil on canvas, 46⅛ x 60⅛ in. (117.2 x 152.8 cm). Purchase with funds from the Friends of the Whitney Museum of American Art 59.38

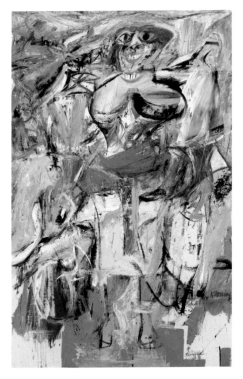

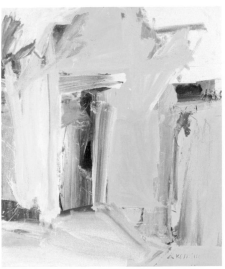

During the course of his prolific career of nearly seven decades, Willem de Kooning expanded the language of painting with a mastery that had few equals in the twentieth century. Along with Jackson Pollock, de Kooning is the painter most closely associated with Abstract Expressionism, the seminal American movement of the postwar era. Some of de Kooning's most celebrated works meld abstraction with figuration and landscape.

Woman and Bicycle belongs to a series of seven paintings of women de Kooning created between 1950 and 1953. With her double mouth, straight-on gaze, and voluptuous figure, rendered in a clashing palette with raw, jagged brushwork, the woman confronts the viewer with an almost visceral force. Although the near-violent energy of his painterly gestures led some to accuse de Kooning of misogyny, for the artist the series was more a reverent, sensual homage to the feminine.

In the late 1950s, motivated in part by a larger studio and a move to the more rural setting of Springs, on New York's Long Island, de Kooning began to paint with greater openness: a "full arm sweep." He mixed his paint with more liquidity and applied it with a speed and force that is especially apparent in *Door to the River*, the apogee of a group of abstracted landscapes inspired by water, light, and motion (and by his many car trips between Manhattan and Springs). De Kooning described the content of these so-called Parkway and Pastoral Landscapes as "emotions . . . landscapes and highways and sensations . . . outside the city— with the feeling of going to the city or coming from it."

Woman and Bicycle, 1952–53. Oil, enamel, and charcoal on linen, 76½ x 49⅛ in. (194.3 x 124.8 cm). Purchase 55.35

Door to the River, 1960. Oil on linen, 80⅛ x 70⅛ in. (203.5 x 178.1 cm). Purchase with funds from the Friends of the Whitney Museum of American Art 60.63

Roy DeCarava

b. 1919; New York, NY
d. 2009; New York, NY

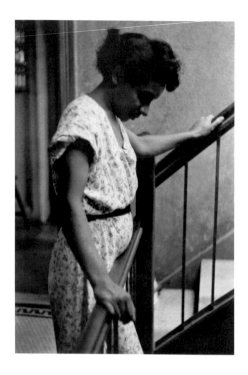

Raised by his mother, who had emigrated from Jamaica, Roy DeCarava studied painting and lithography at New York's Cooper Union from 1938 to 1940 before leaving for the Harlem Art Center and the George Washington Carver School, where he encountered the work of Romare Bearden, Jacob Lawrence, and Langston Hughes. DeCarava began making photographs in the mid-1940s as studies for prints and paintings, and by the end of the decade he had turned his full attention to the medium. In 1952 he became the first African American photographer to receive a Guggenheim fellowship. The award allowed him to continue photographing subjects in Harlem, a project he described as "a creative expression, the kind of penetrating insight and understanding of Negroes which I believe only a Negro photographer can interpret."

Previous studies of Harlem, such as the Photo League's "Harlem Document," undertaken in the late 1930s under the direction of Aaron Siskind, had followed the documentary mode. In marked contrast to such projects, DeCarava poetically recorded everyday life in his own neighborhood. This picture of a woman peering down her apartment building stairwell appeared in his 1955 book *The Sweet Flypaper of Life*, with text by the poet Langston Hughes. The photographer produced a number of pictures in the home of Sam and Shirley Murphy and their two children. DeCarava captured not only moments of intimacy within an African American family but also the subjectivity and introspection of individual members of a community.

Shirley looking down stairwell,
1952. Gelatin silver print,
13 x 8⅞ in. (32.9 x 22.4 cm).
Purchase with funds from
the Photography Committee
2014.136

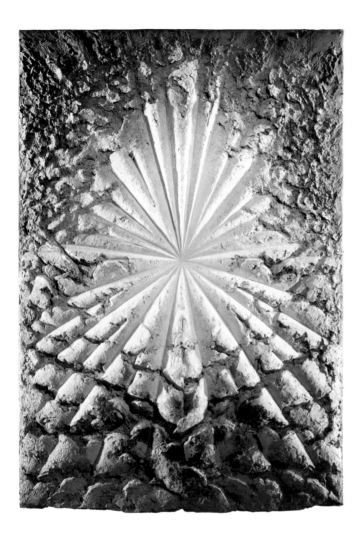

Jay DeFeo came to the fore as part of a vibrant community of avant-garde artists, poets, and musicians active in San Francisco in the mid-1950s, a moment often referred to as the Beat era. A number of significant visual concerns can be traced throughout her forty-year career: a primarily geometric vocabulary of key shapes and symbols; the presence of a centrally located form or image; an emphasis on surface texture; and a tension between compositional order and a sensuous response to her materials.

DeFeo's monumental and now legendary painting *The Rose* simultaneously connotes the centrifugal patterns of flora and the fissures of geologic formations in a stunning composition that has been estimated to weigh more than 1,500 pounds, with the paint measuring as much as

The Rose, 1958–66. Oil with wood and mica on canvas, 128⅞ x 92¼ x 11 in. (327.3 x 234.3 x 27.9 cm). Gift of The Jay DeFeo Trust and purchase with funds from the Contemporary Painting and Sculpture Committee and the Judith Rothschild Foundation 95.170

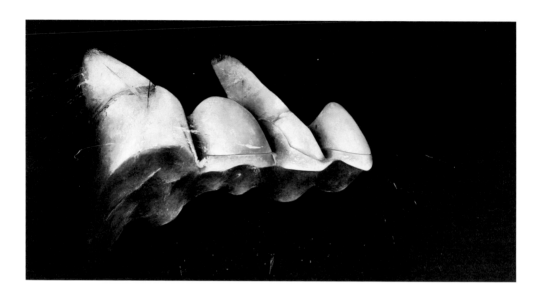

eleven inches thick in places. After spending nearly eight years completing this work, DeFeo took a hiatus from art making. When she resumed her artistic practice in the early 1970s she employed acrylic paint—rather than lead-based oils—and focused on depicting items from her immediate surroundings. *Crescent Bridge II* literally represents a dental bridge composed of her own teeth and replacements for those she had lost to periodontal disease. Courting a sense of mystery, DeFeo rendered the tooth forms in a scale and manner that recall a dramatic mountain range or lunar landscape. Figuratively, this image and its pendant, *Crescent Bridge I*, symbolize a transition period in her career and personal life.

In the early 1970s DeFeo also began experimenting with photography. For her series of pictures made on and titled for the birthday of Salvador Dalí she

worked without the mediation of a lens or a negative, manipulating the photographic chemicals as they ran across the surface of the photographic paper. The resulting images share not just the compositional aspects of her paintings but their spontaneity and expressive volatility as well.

Crescent Bridge II, 1970–72. Acrylic and synthetic resin on plywood, 47 7/8 x 96 in. (121.6 x 243.8 cm). Purchase 2002.329

Untitled (Salvador Dali's Birthday Party), 1973. Gelatin silver print, 10 x 7 7/8 in. (25.4 x 20 cm). Gift of an anonymous donor and The Jay DeFeo Trust in honor of Kim Zorn Caputo 2005.109

Beauford Delaney

b. 1901; Knoxville, TN
d. 1979; Paris, France

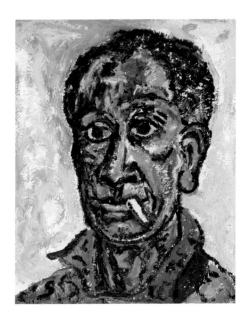

Beauford Delaney studied art in Boston before settling in New York in 1929, drawn by the flourishing Harlem Renaissance. He lived first in Harlem, then Greenwich Village, where he intermingled with the group of downtown artists that included Abstract Expressionist painters Willem de Kooning and Jackson Pollock. Although he remained relatively unknown throughout his career, Delaney also moved among notable literary and musical circles, establishing relationships with the novelists James Baldwin and Henry Miller and depicting Duke Ellington and Louis Armstrong, among other luminaries, in his portraits.

Delaney traveled to Paris in 1953 for a visit and ended up remaining there for a quarter century, until his death. Like many African American artists in the mid-1950s, he found a more hospitable welcome and more open creative community there than in the United States. In *Auto-Portrait* his venturesome feel for color is evident, as is his skillful manipulation of paint to emphasize its tactile qualities. The painting eschews the romanticizing, self-mythologizing proclivities of its genre for an honest, if unsettling, likeness: lines etch Delaney's face, and a sense of vacant sadness predominates. A cigarette hangs from his mouth, and his expression is inward. A background of pink and orange, applied in coarse whorls, intensifies the dramatic tension, while intermittent strokes of electric blue animate the canvas with pulsating energy. Delaney had long been plagued by depression, feeling an acute sense of marginalization throughout his life due to racism, poverty, and homophobia. Shortly before painting *Auto-Portrait*, he suffered a nervous collapse, adding significance to his state of mind as rendered in this work.

Auto-Portrait, 1965.
Oil on canvas, 24 x 19¾ in.
(61 x 50.2 cm). Purchase
with funds from the Wilfred P.
and Rose J. Cohen Purchase
Fund, the Richard and
Dorothy Rodgers Fund, the
Katherine Schmidt Shubert
Purchase Fund, and the
Mrs. Percy Uris Purchase
Fund 95.2

Charles Demuth

b. 1883; Lancaster, PA
d. 1935; Lancaster, PA

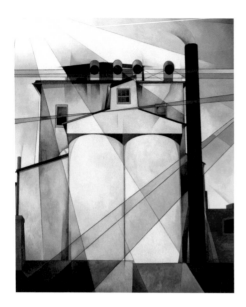

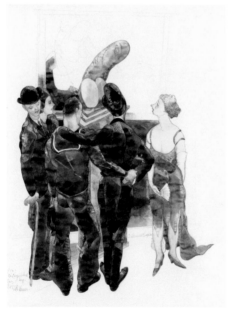

In 1927 Charles Demuth commenced a series of ambitious oil paintings that depict industrial architecture in his native Lancaster, Pennsylvania. In *My Egypt* he portrays the concrete grain elevator of the John W. Eshelman Feed Company, constructed in 1919. Composed using crisp lines and flat planes of color, the painting is an early example of the Precisionist style, which celebrated the expansion of American industry after World War I. The majestic structure, bathed in overlapping shafts of light, epitomizes American achievement—a modern-day equivalent, as the title suggests, of the pyramids of ancient Egypt. While linked to national themes, *My Egypt* is nonetheless infused with personal meaning. Ailing with diabetes, Demuth was increasingly confined to his family's home in Lancaster—far from the sophisticated milieu he had frequently enjoyed in New York. By designating the image *his* Egypt, Demuth links Lancaster to the Biblical connotation of Egypt as a site of involuntary bondage, while also summoning the pyramid's symbolic association with life after death.

 Despite his success working in oil, watercolor was Demuth's favored medium. His watercolors often suggest an underground sexual freedom and licentiousness, subjects that must have had particular resonance for the artist as a homosexual in a largely inhospitable culture. *Distinguished Air*, inspired by a short story by the American writer Robert McAlmon, portrays a woman in a provocative evening dress and two couples, one homosexual and the other heterosexual. All are at an art exhibition, viewing Constantin Brancusi's famous sculpture *Princess X* (1915–16), whose phallic form the artist humorously accentuates.

My Egypt, 1927. Oil, fabricated chalk, and graphite pencil on composition board, 36 x 30 in. (91.4 x 76.2 cm). Purchase with funds from Gertrude Vanderbilt Whitney 31.172

Distinguished Air, 1930. Watercolor and graphite pencil on paper, 16¼ x 12¼ in. (41.3 x 31.1 cm). Purchase with funds from the Friends of the Whitney Museum of American Art and Charles Simon 68.16

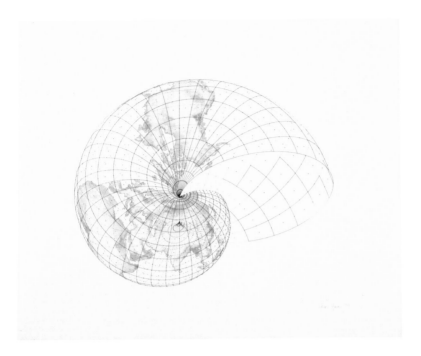

Agnes Denes was among the earliest voices to assert the obligation of artists to address global concerns, ecological ones in particular. Since 1968 she has created site-specific projects that double as acts of environmental remediation. Denes's actions of reforestation, biodiversification, and eco-intervention have included planting a rice field on a contaminated site near the Niagara Gorge; sowing and harvesting a two-acre wheat field over a landfill in lower Manhattan; and making a "tree mountain" of 11,000 firs in Finland, planted by 11,000 volunteers who were given certificates granting them stewardship of the trees.

Isometric Systems in Isotropic Space— Map Projections: The Snail is one in a series of drawings Denes began in 1973 that project images of Earth onto such forms as a pyramid, dodecahedron, cube, egg, lemon, and snail (or nautilus) shell. Unaided by a computer, Denes painstakingly rendered the landmasses, distorting them so that they correspond to their proper longitudinal and latitudinal coordinates. But while

mathematically correct and aligned with cartographic conventions, *The Snail* is equally absurd and—with its seeping washes of watercolor and elegant composition— lyrical. Refashioning the image of our planet as a logarithmic spiral, Denes's unorthodox cartography suggests an alternative conception of humanity's place in the universe—as if a new global consciousness calls for a new globe. As she wrote in 1976: "*Map Projections* creates sculptural form in celestial space and presents analytical propositions in visual form. It is a tantalizing game if one learns to read between coordinates and doesn't mind making sport of the human predicament."

Isometric Systems in Isotropic Space—Map Projections: The Snail, 1979. Watercolor, metallic pigments, and pen and ink on paper with screenprint on plastic overlay, 24 x 30 in. (61 x 76.2 cm). Purchase with funds from Charles Tanenbaum 2001.167

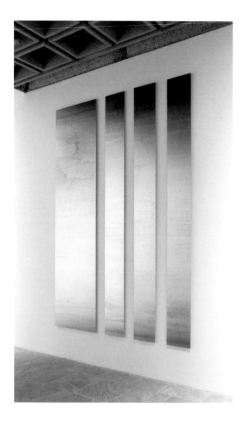

Since the early 1990s, Liz Deschenes has been investigating the histories of photography, film, and, increasingly, architecture and exhibition display. Using a wide range of analogue photography techniques, her often minimal, seemingly abstract photographs act as "the perfect container" for these investigations. Rather than presenting an image of something that happened in the past, Deschenes disrupts "the expectations that are brought to looking at photographic work," asking viewers to reexamine history, context, and their own presumptions.

In recent work Deschenes has made photographs that respond to the sites in which they are initially exhibited. *Untitled*, a four-part photogram made for the 2012 Whitney Biennial, addresses the Museum's Marcel Breuer–designed building, its home from 1966 to 2014. While photograms—a camera-less process in which photosensitive paper is exposed to light and then processed—traditionally have been used by artists such as Man Ray to record the outlines of objects placed directly on the paper, Deschenes's photograms are made by exposing the paper outside at night, recording the subtle variations in available luminescence. The four vertical photograms of *Untitled* echo the stepped facade of the Breuer building as well as the bellows of a large-format view camera, of the type often used for architectural photography. Rather than simply fixedly recording the past, however, the mirrored surfaces of these photographs—which in the present reflect the spaces in which they are displayed—will oxidize over time. As Deschenes has explained, "The photographs simultaneously refer to their history, reflect the present, and will continue to unfold over time."

Untitled, 2012. Four silver-toned gelatin silver prints mounted on aluminum, 120 x 84 in. (304.8 x 213.4 cm). Purchase with funds from the Photography Committee 2012.94a–d

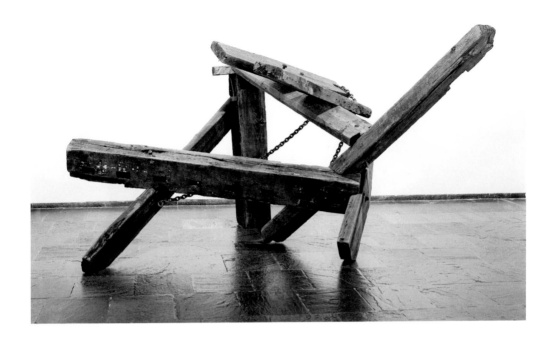

Born in Shanghai to Italian expatriates, Mark di Suvero was raised in San Francisco. He first became interested in sculpture while studying philosophy in college, and started making small constructions of plaster and wax after moving to New York in 1957. The art world was still dominated by Abstract Expressionism, and di Suvero was influenced by painters such as Franz Kline and Clyfford Still, in whose work, as he explained it, "space had some kind of a symbolic value of freedom." He began to transpose their slashing diagonals and kinetic gestures into large sculptures made of wood and scrap metal scavenged from demolition sites. *Hankchampion*, a key work from this period, strikes an uneasy balance between the weightiness of its weathered timbers and their precarious, asymmetric configuration, which animates the surrounding space. Although severely injured at the time in an elevator accident that would leave him paralyzed for several years, he was able to finish the sculpture with the assistance of his younger brother, Hank. The title includes Hank's name as well as that of Champion, the company that provided the chain that girds the construction.

During the course of his rehabilitation, di Suvero learned to operate an electric arc welder and a crane, and since the mid-1960s he has worked primarily in steel. His signature sculptures are composed of I-beams and steel plates that he torques, cuts, and twists into mammoth geometric configurations, often brightly painted and sometimes incorporating kinetic elements. Known for his activism and for his advocacy of fellow artists, di Suvero established the Socrates Sculpture Park in Queens, New York, in 1986.

Hankchampion, 1960. Wood, steel hardware, and chains, 77½ x 152 x 109¼ in. (196.9 x 386.1 x 277.5 cm). Gift of Mr. and Mrs. Robert C. Scull 73.85a–i

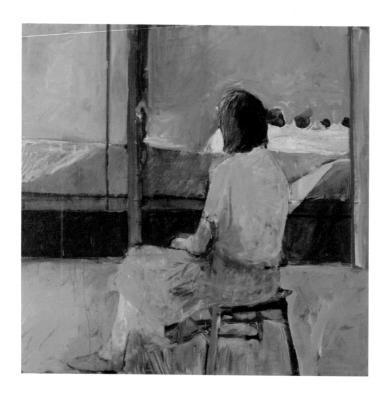

As a member of the Bay Area Figurative movement that arose in the San Francisco Bay region in the mid-1950s, Richard Diebenkorn's gestural style of painting trod the line between abstraction and representation. His work took a more figurative turn in the late 1950s, and his paintings from this period include several depictions of figures in architectural settings and windows opening onto expansive landscapes, among them *Girl Looking at Landscape*. With her back to the viewer, the anonymous girl seems caught in a moment of private reverie, an atmosphere that led the critic Irving Sandler, in a 1961 review, to describe Diebenkorn's figures as "introspective and lonely, affected by the vastness of the settings in which they are placed."

In both its subject and its expressive use of color, *Girl Looking at Landscape* owes a debt to French painters such as Henri Matisse and Pierre Bonnard, whose work Diebenkorn encountered during the 1940s, and additionally indicates the influence of abstract painters such as Clyfford Still and Hassel Smith, who worked in the Bay Area. The geometric frame of the window and the bold blocks of color that delineate the landscape beyond anticipate Diebenkorn's later *Ocean Park* series, in which the modular forms of ground and sky would become more abstract. Throughout his career, impressions are conveyed through the relation of geometry to figuration, the balance of parts being key to Diebenkorn's process. The moment a painting was finished, he explained, was when "the relationship of the figure and the setting seem psychologically right."

Girl Looking at Landscape, 1957. Oil on canvas, 59 x 60½ in. (149.9 x 153.7 cm). Gift of Mr. and Mrs. Alan H. Temple 61.49

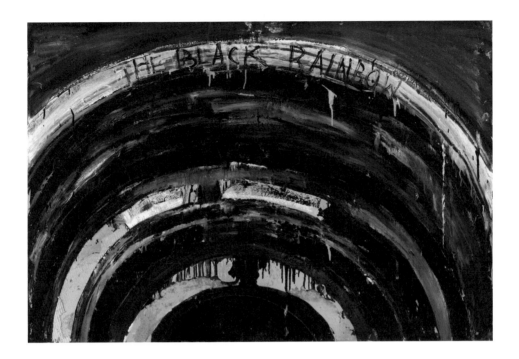

Jim Dine rose to fame in the early 1960s as a leading exponent of Pop art, based on his use of everyday household objects as subject matter. Arriving in New York in 1959, he associated with a group of downtown artists who were challenging the boundaries of art by creating assemblages and environments out of urban debris. In January 1960 he debuted his first environment in a two-person show with Claes Oldenburg at the Judson Gallery, in New York's Greenwich Village. Dine's environment, *The House*, was a dense accretion of paint-splattered rags, paper, found objects, scrawled words, and painted images. A month later he used the environment as the set for his first Happening, a demonic performance lasting slightly more than thirty seconds, in which questions of identity and fear of an unknown yet ever-present danger predominated.

 The Black Rainbow comes from this period and deals with many of the same themes. As with Dine's contemporaneous environments and performances, the work's imagery derived from the artist's dreams and unconscious. "It was me painting out my history," as Dine put it. Substituting cast-off cardboard for canvas, and using the expressive paint handling of the Abstract Expressionists to whom Dine tied himself "like fathers and sons," the work communicates melancholy, human fragility, and foreboding—themes that Dine would continue to explore in his subsequent Pop art works, even as his means for expressing his emotions shifted to manufactured products such as tools, bathroom fixtures, and articles of clothing.

The Black Rainbow,
1959–60. Oil and corrugated cardboard on cardboard, 39⅝ x 59¾ in. (100.7 x 151.8 cm). Gift of Andy Warhol 74.112

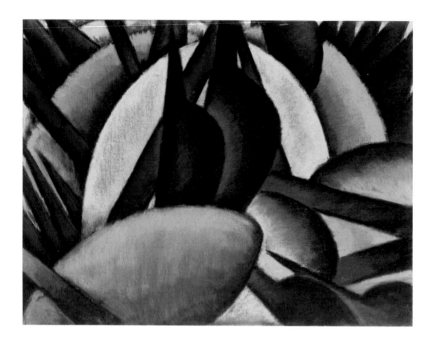

In 1912 Arthur Dove exhibited a radical series of pastel drawings at Alfred Stieglitz's pioneering 291 gallery in New York, making Dove the first American artist to publicly embrace modernist abstraction. Although he had begun his career as a commercial illustrator, an extended stay in Paris between 1907 and 1909 put the artist in touch with European avant-garde developments, including the work of Paul Cézanne, Henri Matisse, and Pablo Picasso. Seeking a nonrepresentational form for his painting, he expressed his desire "to make something that is real in itself, that does not remind anyone of any other thing, and that does not have to be explained—like the letter A for instance."

In his works of this period, Dove announced the rhythmic and resolutely organic formal vocabulary that would occupy him throughout his career. The densely layered composition of *Plant Forms* recalls Cubist precedents, with its abstract pattern of overlapping straight and curvilinear forms. At the same time, Dove's aesthetic language reflected his profound connection to the American landscape. His sensory responses to the natural world are conveyed though the subtle shading of the forms as well as the use of pastel, a medium Dove had turned to the previous year, applying it to canvas rather than paper to create luminous surfaces and an immediacy of color. Calling his technique "extraction," Dove sought to distill the inner essence of his subjects rather than analyze their outward physical form. "I would rather look at nature than to try to imitate it," he remarked.

Plant Forms, c. 1912. Pastel on canvas, 17¼ x 23⅞ in. (43.8 x 60.6 cm). Purchase with funds from Mr. and Mrs. Roy R. Neuberger 51.20

Elsie Driggs

b. 1895; Hartford, CT
d. 1992; New York, NY

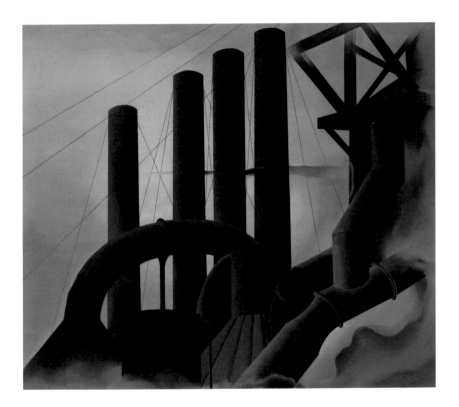

One of few female artists to achieve critical and commercial success in the 1920s, Elsie Driggs was associated with the Precisionists, an influential group of artists, including Charles Demuth and Charles Sheeler, whose paintings used strong geometric forms and precise lines to depict the nation's burgeoning industrial landscape. Driggs studied at the progressive Art Students League in New York and in the early 1920s traveled through Italy to study the masters of the Italian Renaissance. Although she exhibited regularly and in 1932 was included in the Whitney's first Biennial exhibition, she turned to making murals for the WPA and to watercolors after moving to rural New Jersey in 1936. A new generation of artists and scholars rediscovered her work after she began showing mixed-media constructions in the late 1960s.

Pittsburgh grew out of the memory of an evening train ride Driggs had taken as a child past the city's steel mills. Years later, recalling the sulfurous hues emitted from the spewing smokestacks, she returned to make studies for a painting. Since the Bessemer process that created the smoky discharge was no longer being used and her requests to visit inside the factories were denied, she instead sketched the buildings of the Jones and Laughlin mill from a height, lured by what she described as their "great velvet forms." Driggs called the painting her "Piero della Francesca," an atmospheric, devotional image for the twentieth century. It was followed in 1927 by a succession of canvases, such as *Blast Furnaces* and *The Queensborough Bridge,* that similarly sought to capture America's newfound faith in technology and progress.

Pittsburgh, 1927. Oil on canvas, 34¼ x 40¼ in. (87 x 102.2 cm). Gift of Gertrude Vanderbilt Whitney 31.177

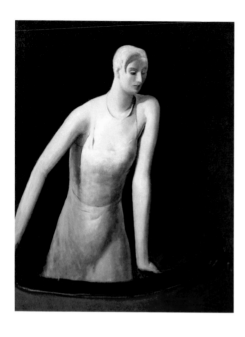

Guy Pène Du Bois studied under the Ashcan School painter Robert Henri, but rather than following his teacher's exhortation to paint ordinary people and places, Du Bois gravitated toward high society. His portraits of chic flappers, elegant matrons, and powerful businessmen capture the glamour, complacency, and disquiet of New York during the Roaring Twenties. With a satirist's eye for social foibles and pretensions, Du Bois depicted the affluent at leisure— at art galleries, racetracks, cafés, and the theater.

Opera Box, a canvas of unprecedented scale and ambition in the artist's oeuvre, takes place at one of his favorite haunts. Du Bois worked for several years as a music critic and frequently attended the opera, where he was captivated as much by the stylish operagoers as by the performances themselves. The statuesque woman featured in the painting, impassive and regal in demeanor, looks down from an upper tier of the house and seems lost in thought, isolated from the audience around her. Her solitude and inaccessibility are reinforced by the monumental, cylindrical forms of her body as well as by the stark contrast of her white skin and dress against the shadowy background. The woman appears almost as if on stage herself, but whether she is consciously posing for the admiration of others or has been caught unawares in a momentary expression of ennui is unclear. With her masklike visage and stylized physique, the graceful protagonist of Opera Box—which Du Bois described as "the most important picture I have ever made"— remains an enigma.

Opera Box, 1926. Oil on linen, 57⅝ x 45⅛ in. (146.4 x 114.6 cm). Purchase 31.184

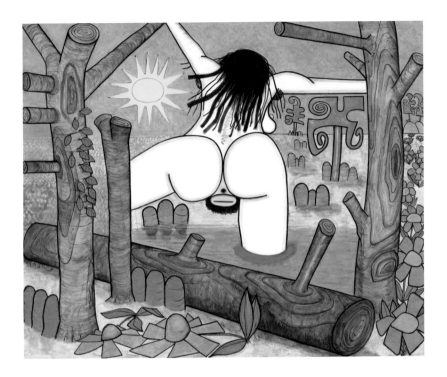

Carroll Dunham has retained a highly personal style of painting across four decades, investigating the pictorial aspects of painting in works that reveal diverse references, including Surrealism, classical landscape painting, and cartoons. Dunham has also looked to art historical figures as varied as Gustav Courbet, Paul Cézanne, Pierre-Auguste Renoir, Pontormo, Tarsila do Amaral, and Sidney Nolan, and to his own earlier works. "Painting responds to painting," Dunham has written.

In recent years Dunham's imagination has been occupied by scenes of bathers, a popular subject among French artists at the turn of the last century. He worked off and on for six years to create *Large Bather (quicksand)*, which eventually became the centerpiece of a series of six paintings. The stark white bather—her visage hidden and each of her four limbs truncated—jarringly divides the landscape into quadrants, placing her genitalia manifestly visible at the center. It is from this point, demarcated with an *X*, that Dunham began the composition, building outward. The organizational point of origin may reflect his initial impulse to create the bathers: as Dunham stated, the paintings had "nothing to do with pornography for me: zero. They really have much more to do with my mother and the kind of universality of that: we all have one." The landscape here initially appears to be a tropical paradise but in fact features felled and severed trees, trampled flowers, and an ominous pool of quicksand—elements that seem to allude to a larger disruption in this natural world.

Large Bather (quicksand), 2006–12. Polyurethane, pigment, and graphite pencil on linen, 96 ⅛ x 119 ¼ in. (244.2 x 302.9 cm). Purchase with funds from the Director's Discretionary Fund, the Painting and Sculpture Committee, and an anonymous donor 2014.40

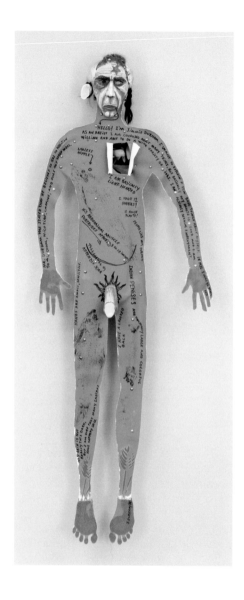

Artist Jimmie Durham, an American of Cherokee heritage, has worked as a sculptor, performer, essayist, and poet for more than thirty years. Durham was a political organizer for the American Indian Movement during the 1970s but by 1987 decided to live in self-imposed exile, settling first in Mexico and then, from 1994, in Europe (or "Eurasia," as he prefers).

Many of Durham's sculptures from the 1980s combine text with found and constructed elements. He implements this approach in *Self-portrait* to reveal how identity, the presumed subject of portraiture, oscillates between an individually determined sense of self and culturally predetermined categorizations. The work's hybrid form features a canvas cutout that follows the contoured outline of the artist's body. Durham painted the raw-edged shape brown and affixed a colorful wood head and penis onto the flat surface. Hung on an armature in front of the wall, the canvas becomes a space on which various handwritten inscriptions commingle. Durham adorns the body with self-affirming phrases ("I am basically light hearted," "People like my poems") and then undermines these with fragmented references to physical imperfections ("useless nipple," "appendix scar"). He also poignantly calls the viewer's attention to stereotyped assumptions about Native Americans ("My skin is not really this dark, but I am sure that many Indians have coppery skin," "Mr. Durham has stated that he believes he has an addiction to alcohol, nicotine, caffeine, and does not sleep well"). While Durham's unconventional self-portrait precludes a single understanding of the artist's identity, it clearly articulates his wry and deeply critical understanding of self-referentiality in art.

Self-portrait, 1986. Canvas, wood, paint, metal, synthetic hair, fur, feathers, shell, and thread, 78 x 30 x 9 in. (198.1 x 76.2 x 22.9 cm). Purchase with funds from the Contemporary Painting and Sculpture Committee 95.118

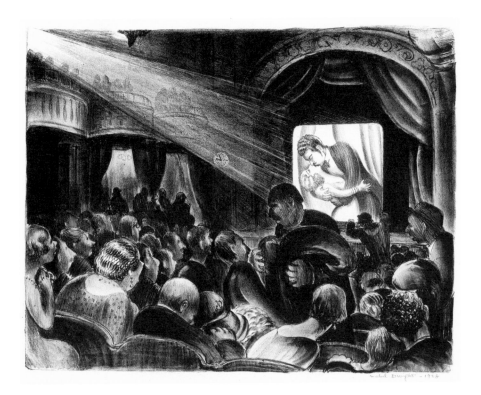

One of the most notable American printmakers of the 1920s and 1930s, Mabel Dwight is best known for her satirical depictions of New York life. Deaf from birth, she first began producing prints in 1927, at the age of fifty-two, and rapidly rose to become a key member of the American Scene movement, which filled a growing demand for realistic art based on the everyday experiences of ordinary Americans. Unlike many of her contemporaries, however, Dwight limited herself exclusively to the medium of lithography, circulating her work to a broad national audience in publications such as *Vanity Fair*. An astute observer of the human comedy, she instilled her scenes of New Yorkers riding the subway, shopping, and visiting parks and other popular entertainments with biting humor as well as compassion.

In *The Clinch, Movie Theatre*, an early print, Dwight portrays one of her favorite subjects: the reactions of spectators at a public event. Here, moviegoers watch as a couple embraces in an on-screen close-up—the "clinch" of the work's title and the conventional ending for romantic films of the period. The scene is filled with amusing details, from the engrossed audience members, who watch openmouthed and with hands clasped, to the man who is awkwardly squeezing through the row, grasping his coat and hat in his arms in such a way as to echo the action on screen. The couple in Dwight's depiction is generic, but may have been inspired by famous on-screen pairs of the period such as Greta Garbo and John Gilbert.

The Clinch, Movie Theatre,
1928. Lithograph: sheet,
11⅝ x 15⅞ in. (29.5 x 40.3 cm);
image, 9⅛ x 11¾ in. (23.2 x
29.8 cm). Edition of 50.
Gift of Gertrude Vanderbilt
Whitney 31.720

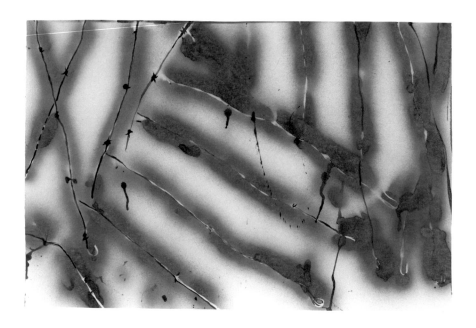

Melvin Edwards's sculptures develop from a sustained exploration of welded steel, a material he began to use as a student at the University of Southern California in Los Angeles. In 1967 Edwards moved to New York, where he exhibited with other African American artists such as Sam Gilliam and William T. Williams. Drawing on the lineage of assemblage and making forceful use of raw materials, Edwards's sculptures incorporate found objects such as chains, barbed wire, and sharp pieces of tools that make implicit reference to violence—as in his best-known series of works, *Lynch Fragments*, which he began making in 1963 during the time of the civil rights movement.

　　In his one-person exhibition at the Whitney in 1970, Edwards presented a group of sculptural installations that used barbed wire and chains as sculptural elements and also as a way of drawing in three dimensions and defining spatial volumes, using strategies of installation that some critics have related to Minimalist and Postminimalist art. Edwards's work inflected these prevailing artistic languages

with political content, drawing on barbed wire's history as both an "obstacle and enclosure." He utilized barbed wire for *Avenue B Wire Vari #1*, spraying paint over the wire, which, when removed, left behind ghostly forms of overlapping striations. Edwards then deepened certain areas with pen. The result is an abstract image that also recalls imagery of imprisonment, violence, and the urban landscape—part of a moment in the late 1960s and 1970s marked by experimentation with materials, abstraction, and the political meanings of art.

Avenue B Wire Vari #1, 1973. Spray paint and ink on paper, 23 x 35 in. (58.4 x 88.9 cm). Purchase with funds from the Drawing Committee 2014.69

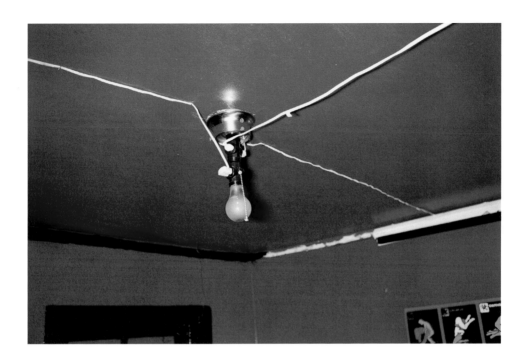

A pioneer in the use of color photography, William Eggleston has been capturing aspects of everyday life in his native South for nearly five decades. His education in the medium came from books on the work of photographers such as Henri Cartier-Bresson, Walker Evans, and Robert Frank. After some early efforts in black and white, Eggleston began working with color in the mid-1960s and came to national attention in 1976 when the Museum of Modern Art in New York mounted a solo exhibition of his work, the first it devoted to an artist working in color photography. His images of commonplace scenes and objects—primarily in and around Memphis, where he has lived since the 1960s, but also from his extensive worldwide travels—possess a snapshot aesthetic: the photographs are not preplanned, and their emotional tenor remains neutral. However, the highly saturated hues of the dye-transfer process employed in their printing, which he began using in the early 1970s, lend the images a perceptible drama.

The red ceiling and walls pictured in *Greenwood, Mississippi*, for example, are startling in their chromatic intensity; the artist has said of the work that it "was like a Bach exercise for me because I knew that red was the most difficult color to work with. . . . The photograph is still powerful. It shocks you every time." The claustrophobic effect of the color combines with the image of the single uncovered light bulb and multiple white electrical cords crisscrossing the ceiling to give the impression that the room is the setting for something untoward, and the fragment of the poster illustrating sexual positions does nothing to dispute this reading.

Greenwood, Mississippi, c. 1971 (printed 1980). Dye transfer print, 11⅝ x 18 in. (29.5 x 45.7 cm). Edition no. 3/12. Gift of Anne and Joel Ehrenkranz 94.111

Nicole Eisenman moved to Brooklyn soon after graduating from the Rhode Island School of Design in 1987. Since coming to prominence in the early 1990s for bold, sexually charged images with feminist themes and abundant references to art history and pop culture, she has remained central to the discourse that has developed around queer and feminist practices.

For one year, starting in August 2011, Eisenman focused exclusively on making works on paper and prints, taking a hiatus from painting. *Untitled* combines a complex mix of mediums, and directly references the history of twentieth-century portraiture. The subject, identifiable by his long-lashed right eye, is Alex, the violent sociopath in Stanley Kubrick's film (adapted from Anthony Burgess's novella) *A Clockwork Orange*. Tightly framed

against a pitch-black, schematically rendered architectural interior, the flattened, cartoonish figure holds a glass of milk and what appears to be a pool cue. The Yankees logo on his floppy hat situates the work in a New York bar—a realm often explored by Eisenman in her recent work. When the economic recession hit in 2008, Eisenman registered its effects on those around her in scenes of barrooms and beer gardens whose occupants appear anything but jovial. Arguably, the figure in *Untitled* constitutes an even darker vision, its sinister reference cloaked in a highly expressive composition.

Untitled, 2011. Monoprint with watercolor, graphite pencil, colored pencil, and tape, 23¾ x 17⅝ in. (60.3 x 44.8 cm). Purchase with funds from the Drawing Committee 2012.33

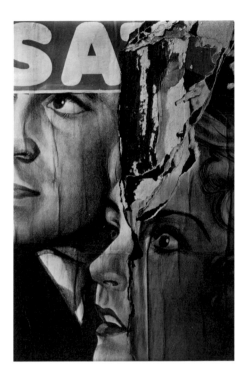

Torn Movie Poster,
1931. Gelatin silver print,
6½ x 4⅜ in. (16.5 x 11.1 cm).
Promised gift of Sondra
Gilman Gonzalez-Falla
and Celso Gonzalez-Falla
to the Whitney Museum
of American Art, New
York, and the Gilman and
Gonzalez-Falla Arts
Foundation P.2014.64

Like many American artists of his generation, Walker Evans made the pilgrimage to Paris, in his case, shortly after dropping out of college in the mid-1920s. When he returned to New York in 1927, Evans all but abandoned his earlier ambition of becoming a writer and instead began photographing his newly adopted city. Over the course of the next decade, he would become one of the most well-known photographers in the United States, establishing a documentary style within a fine arts practice.

Around 1929, Evans became acquainted with Lincoln Kirstein, a brilliant Harvard undergraduate who had already founded the esteemed literary journal *Hound & Horn* and the pioneering Harvard Society for Contemporary Art—Evans's early work would be included in both venues. In 1931 Kirstein commissioned the photographer to document decaying nineteenth-century houses in the Northeast. During a break, Evans spent the month of September in Provincetown and Martha's Vineyard, where he made a series of photographs of weather-beaten posters that Kirstein described as "ripped by the wind and rain, so that they look like some horrible accident." The resulting images, including *Torn Movie Poster*, combine Evans's emerging interests in the American vernacular and Surrealism. By recording the poster head-on and cropping out the surrounding context, Evans ably conflates the surface of the photograph with that of the poster itself and exploits the photographic image's inherent status as a fragment. The couple's terrified faces as they look out at the unidentified menace, along with the torn shreds over the woman's forehead, perfectly allegorize the economic ruin and anxiety of the Great Depression.

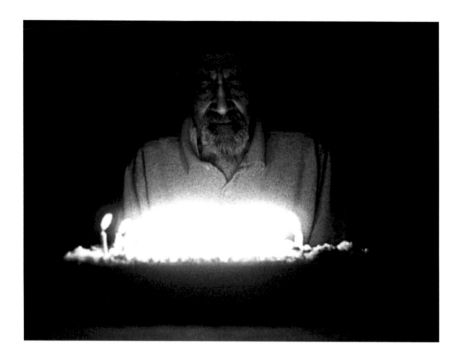

In his feature-length films and dozens of short-form pieces, Kevin Jerome Everson captures moments of everyday life that are by turns quotidian and suffused with significance—often both at once. Everson's camera frequently is trained on working-class African Americans, and his films, made at sites such as a factory and a dry cleaning facility, present what he has described as "things that people take for granted." His use of long, uninterrupted takes and the inclusion of archival footage lend these works a reportorial quality. Yet Everson's films are not documentaries. Instead, he complicates what viewers might assume to be a disinterested or transparent point of view: seeming actuality is interspersed with scripted scenarios, found or archival material is intermixed with contemporary footage, and the mundane is punctuated by drama. Because the line between truth and fabrication is often blurred in Everson's films, viewers are left to disentangle events and connect actions that occur across space and time, distinguishing fact from fiction for themselves.

Ninety-Three is a silent film titled for the age of its subject, an elderly man who is shown trying to blow out ninety-three candles on a large birthday cake and finally succeeding. The elegiac and formal qualities of this work are most apparent when the gallery, illuminated with light from the candles on the screen, goes entirely dark at the conclusion. The man, a relative who has appeared in other of the artist's films, takes on symbolic significance as Everson conjures from the simplest of scenes a meditation on mortality and the passage of time.

Still from *Ninety-Three*, 2008.
16mm film transferred to
video, black-and-white, silent;
3 min. Edition no. 3/15.
Purchase with funds from the
Film, Video, and New Media
Committee 2012.16

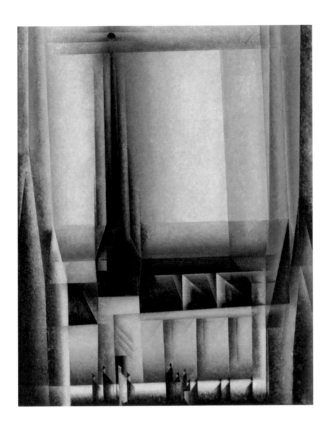

Born in New York to German-American parents, Lyonel Feininger straddled two worlds. He spent much of his career in Germany, where he was a leading member of the avant-garde Expressionist groups Die Brücke and Der Blaue Reiter. But he returned to the United States in 1937 under the threat of Nazi persecution.

One of Feininger's most cherished and enduring subjects throughout his years in Germany was the church at Gelmeroda, a small village on the outskirts of Weimar. The Gothic structure appeared in his work as early as 1908 and he eventually created a series of thirteen monumental oils devoted to the church and its spire that were executed over more than two decades. Painted not long after Feininger began teaching at the nearby Bauhaus, *Gelmeroda, VIII* includes overlapping, prismatic planes of diaphanous color that infuse the modest structure with a sense of epic grandeur. At the composition's lower edge, a group of churchgoers is rendered as a series of semitranslucent triangles, their diminutive size reinforcing the church's monumentality. By portraying the fourteenth-century structure in a language of geometric abstraction, Feininger sought to reconcile modern imperatives with the romantic spirituality of Germany's past. This objective reflected the utopian aspirations expressed by the Bauhaus in its manifesto, which used a woodcut by Feininger of a Gothic cathedral to represent its mission of uniting painting, architecture, and sculpture.

Gelmeroda, VIII, 1921.
Oil on linen, 39½ x 31⅝ in.
(100.3 x 80.3 cm).
Purchase 53.38a–b

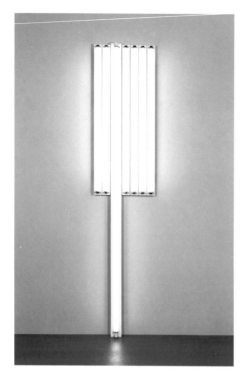

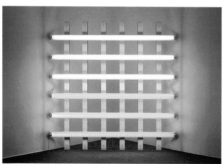

untitled, 1964. Cool white
fluorescent lights, 96⅛ x 21 x
3⅞ in. (244.2 x 53.4 x 9.8 cm).
Gift of Howard and Jean
Lipman 71.214

untitled (for Robert, with fond
regards) 2, 1977. Pink, yellow,
and red fluorescent lights,
96 x 96 x 9 in. (243.8 x 243.8 x
22.9 cm). Purchase with funds
from the Louis and Bessie
Adler Foundation Inc.,
Seymour M. Klein, President;
the Howard and Jean
Lipman Foundation Inc. by
exchange; and gift of Peter M.
Brant, by exchange 78.57

While working as a security guard and elevator operator for New York's American Museum of Natural History in the early 1960s, Dan Flavin filled his uniform pockets with scribbled ideas for "an electric light art." This art initially consisted of wall-hung painted wood boxes with attached incandescent bulbs, but experiments with fluorescent tubes in 1963 led Flavin to the medium he would use for the rest of his career. He selected commercially available materials for his light-based sculptures: fluorescent lamps in standard lengths (two, four, six, or eight feet) and colors (red, yellow, blue, green, pink, ultraviolet, and four intensities of white). Once committed to this visual vocabulary, Flavin manipulated the lights in various orientations and combinations—from diagonal presentations to repeating, freestanding installations—for more than three decades.

Untitled features six four-foot tubes in cool white positioned vertically against the wall and one eight-foot bulb that extends to the floor. Flavin resisted the label of Minimalism for such works, yet they share key concerns with that practice of the mid- and late 1960s. Rejecting the conventions of both painting and sculpture, his projects incorporate industrially fabricated, serial parts and make viewers aware of their own bodily presence in relation to the object and—because the light extends beyond the tubes' physical parameters and into the environment—to the surrounding architecture and ambience.

Flavin dedicated untitled (for Robert, with fond regards) to his studio assistant, Robert Skolnik, formerly an art handler at the Whitney. Flavin arranged the eight-foot fluorescent tubes, facing inward and outward, in a grid pattern to be positioned across the corner of a gallery. The relationship between color, form, and site, as Flavin has explained, creates "an optical interplay . . . all modified by reflected color mixes and shadows of the grid structure itself."

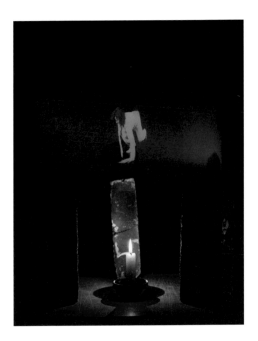

Simone Forti is a dancer, choreographer, and artist whose pioneering work with the body established her as a leading figure among a group of innovators who redefined the language of dance in the 1960s. Following her early work with the choreographers Anna Halprin, Martha Graham, and Merce Cunningham, she became an important presence in the Judson Dance Theater in New York, influencing its direction through her Dance Constructions. Forti's pared-down language of movement paralleled that of the Minimalists with whom she had a close dialogue, engaging the idea of form in iconic performative works such as *Huddle* from 1961. She also created a series of Happenings with Robert Whitman and developed a choreographic language based on the fluid, instinctive movements of children and animals.

In the mid-1970s, Forti made a series of cylindrical holographic sculptures on the curved surfaces of which dance movements appear, animated by viewers moving around them. One of these works,

Striding Crawling, balances an eighteen-inch-high plexiglass cylinder on top of three bricks, in the center of which a small candle burns. This sole source of light illuminates a delicate hologram of Forti, whose single, fluid movement from striding to crawling can be seen only if the viewer circumnavigates the sculpture. The low installation height of the hologram forces the viewer to stoop when circling the cylinder, echoing Forti's own movement, which she derived from t'ai chi and observing animals at the zoo. The light of the candle throws large shadows of the sculpture and the viewer's movements onto the walls of the darkened room, creating a magical environment of movement, light, and shadow in which Forti shifts the viewer's position from that of a passive observer to an active participant in the dance.

Striding Crawling, 1977. Integral hologram (Multiplex), candle, candle dish, and bricks, with plexiglass support, dimensions variable. Purchase with funds from the Film and Video Committee 2003.88

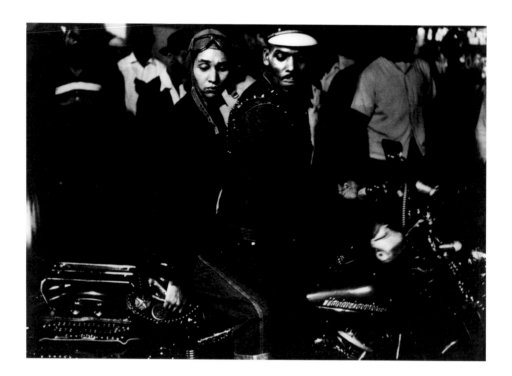

With the publication of *The Americans* in 1958, Robert Frank changed the course of postwar photography. After leaving his native Switzerland in 1953, Frank applied his talent with a handheld camera to present a gritty picture of the United States that was provocatively out of sync with the nation's optimistic sense of itself. In 1955, with a Guggenheim fellowship he received with the support of Walker Evans, Edward Steichen, and *Harper's Bazaar* art director Alexey Brodovitch, Frank purchased a used Ford coupe and crisscrossed the country for nearly a year, taking photographs.

From over seven hundred rolls of film, Frank selected *Indianapolis* as the penultimate of the eighty-three images in *The Americans*. The picture encapsulates the photographer's astute attention to racial and economic inequalities, budding subcultures, and the romanticism of the American road at midcentury. The photograph of a denim-clad African American couple on a motorcycle is at once provocative yet intentionally ambiguous. In the 1950s motorcycling represented a rebellion against middle-class society. In 1953 Marlon Brando played a bad-boy biker in *The Wild One*, a film based on the infamous Hollister riot of 1947. In 1956, the same year as the Montgomery Bus Boycott and the beginnings of the civil rights movement, an image of black motorcyclists might have been discomfiting for many white Americans. In fact, *The Americans* was derided at first by many critics as "un-American" because Frank jettisoned any veils of propriety and captured the people he encountered with blunt candor and unflinching attention.

Indianapolis, 1956, from *The Americans*, 1955–57. Gelatin silver print, 11⅛ x 15⅝ in. (28.3 x 39.7 cm). Promised gift of Sondra Gilman Gonzalez-Falla and Celso Gonzalez-Falla to the Whitney Museum of American Art, New York, and the Gilman and Gonzalez-Falla Arts Foundation P.2014.77

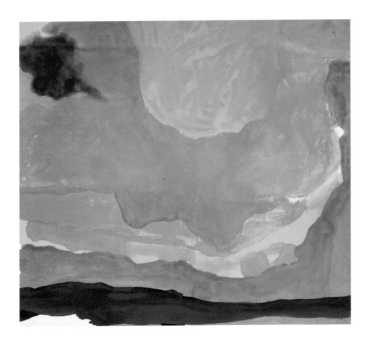

In 1952, near the outset of her career as an abstract painter, Helen Frankenthaler placed canvas onto the floor and poured turpentine-thinned oil paint directly onto the unstretched surface, creating a technique that became known as "stain painting." This innovative procedure was celebrated for its emphasis on the inherent flatness of the two-dimensional medium. The uneven rate of the paint's absorption into the raw, unprimed fabric enabled Frankenthaler to create swathes of densely saturated color or areas of diaphanous pooling.

Jackson Pollock's propulsive dripping and flinging of paint onto horizontally oriented canvases influenced Frankenthaler's chosen method. Frankenthaler, in turn, inspired her fellow second-generation Abstract Expressionists, including Kenneth Noland and Morris Louis, to adopt staining practices. Critics referred to these artists as either Color Field painters, due to their emphasis on free-form stretches of color, or practitioners of Postpainterly Abstraction, terminology that emphasizes the artists' replacement of gestural,

sweeping brushstrokes with directly poured paint.

In the early 1960s Frankenthaler began to incorporate acrylic paints into her process. This synthetic medium would dry before it was able to fully soak into the support, "flooding" the canvas with color and leaving her with brighter results. For works such as *Flood*, she was able to execute forms quickly and create clear delineations between bands of color. If, as she described, "I don't start with a color order but find the color as I go," then in *Flood* she found a deluge of variegation. Despite her abstract working mode, Frankenthaler's paintings recall the natural world. *Flood* demonstrates how nonrepresentational striations can also suggest sky, clouds, water, and earth.

Flood, 1967. Acrylic on canvas, 124¼ x 140½ in. (315.6 x 356.9 cm). Purchase with funds from the Friends of the Whitney Museum of American Art 68.12

Stills from *Untitled*, 2003.
Project and DVD, color,
silent; 60 min. Edition no. 1/5.
Purchase with funds from
the Painting and Sculpture
Committee and partial
gift of an anonymous donor
2014.290

Since the late 1980s Andrea Fraser
has examined the modes of production,
exchange of capital, and display and
circulation of works in the art world,
with often pointed and provocative results.
Bridging the realms of performance,
institutional critique, and video, much
of Fraser's work insists on an engagement
with an audience. Thus in the guise of
a docent in early videotaped performances
such as *Museum Highlights* (1989) and
Welcome to the Wadsworth (1991), she
draws on archival sources to script museum
tours in which she cleverly broaches the
relationship between taste and class,
cultural philanthropy and welfare policy, or
cultural institutions and urban segregation.

Fraser frequently focuses her work
on the relationship between artists and their
patrons. For *Untitled* she proposed
a project in which she would videotape a
sexual encounter between herself and
a collector, who would commission the work,
an arrangement that was facilitated by
her gallery. Shot in a hotel room from a high
camera angle, the silent, unedited video
is but one component of Fraser's project,
which also involves the process of negotiation
and reception of the work, including
detailed agreements setting parameters for
how it may be displayed and circulated.
In *Untitled* both Fraser and her patron are
on display, and the intimate details of their
transaction are laid bare for our examination.
As Fraser has explained, *Untitled* "was
about taking the economic exchange of
buying and selling art and turning it into a
very personal exchange." Number one
in an edition of five, this DVD was acquired
from the participating collector as
a partial gift and partial purchase, an
arrangement negotiated by the artist, and
another step in the sequence of
exchanges that constitute the work.

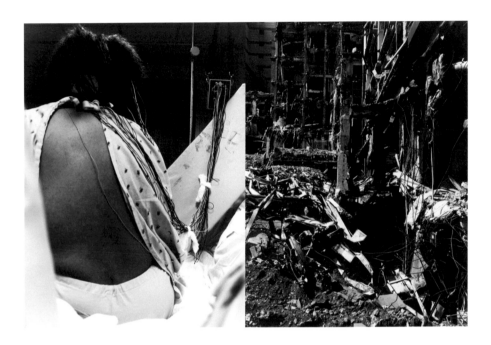

LaToya Ruby Frazier grew up in Braddock, Pennsylvania, a suburb of Pittsburgh that had thrived as home to a steel mill owned by Andrew Carnegie. After the decline of the steel industry in the 1970s, the town faced a period of economic collapse, resulting in widespread poverty and sweeping changes that impacted Frazier's multigenerational family. When she began to make photographs as an undergraduate student, Frazier adopted the documentary aesthetic of Farm Security Administration photographers such as Dorothea Lange, Walker Evans, and Gordon Parks. Instead of training her camera on people and communities foreign to her, as those artists had done, she turned the camera on herself, her family, and the failing town of Braddock.

This project engendered an ongoing series in 2002, *The Notion of Family*, of which the diptych *Landscape of the Body (Epilepsy Test)* is a part. In her unsentimental black-and-white style, Frazier here documents her mother's bare back, framed by an open gown, as she sits on a hospital bed draped in wires. The formal qualities of the portrait are echoed in the accompanying photograph of the UPMC Braddock Hospital, site of her mother's testing, midway through its demolition. Through this pairing, Frazier creates a metaphorical relationship between the human body, damaged by industrial pollutants, and the landscape, similarly ruined by the mills and their closing. "We are in a period of turmoil and industrial collapse," Frazier explained. "We remain steadfast although our bodies are deteriorating along with our land." Throughout her photographic work, Frazier captures such poignant personal moments to enunciate sweeping social and economic issues.

Landscape of the Body (Epilepsy Test), 2011, from the series *The Notion of Family* (2002–). Two gelatin silver prints mounted on board, 30 x 46 in. (76.2 x 116.8 cm) overall. Edition no. 1/6. Purchase with funds from the Henry Nias Foundation 2012.138a–b

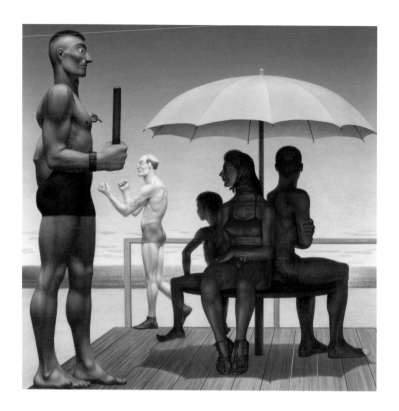

Jared French met fellow artist Paul Cadmus while attending the Art Students League in New York, and both developed a deep interest in life drawing and the idealized human figure as an expressive form. French painted the unsettling *State Park*—with its strangely stylized and isolated figures— at the height of his most innovative period, when he was exploring Surrealist-influenced imagery and portraying static, ideal bodies in minimal, airless landscapes. French, his wife, Margaret, and Cadmus developed a collective photography practice named PaJaMa—a combination of their first names. Using a few props and carefully staged juxtapositions of themselves and friends in the sandy, sunlit summer landscape of Fire Island, the artists created dreamlike tableaux for the camera, which inspired French to paint related scenes. A bleached wood platform similar to the one in *State Park* appears in several PaJaMa photographs.

French's preferred medium was egg tempera, a technique common in early Italian panel painting that allows for precise buildup of form through small brushstrokes; it results in a hard clarity of edge and surface that French masterfully exploits in *State Park*. He carefully contrasts a family unit under an umbrella with two statuesque male figures, clearly inspired by archaic Greek sculpture. This separation likely alludes to the outsider status that he and his circle of friends and lovers—including Cadmus, the painter George Tooker, the photographer George Platt Lynes, and the arts patron Lincoln Kirstein—felt in the bourgeois conventionality of the time.

State Park, 1946. Tempera on composition board, 24½ x 24½ in. (62.2 x 62.2 cm). Gift of Mr. and Mrs. R. H. Donnelley Erdman 65.78

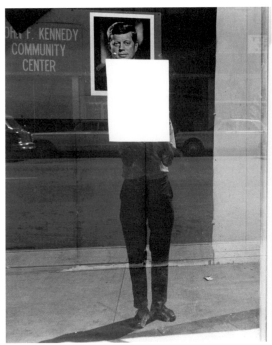

Lee Friedlander developed a passion for photography and jazz as a teenager in the Pacific Northwest. After high school he spent several years in Los Angeles before moving to New York, where he worked from 1955 until the early 1970s as a freelance photographer, traveling and shooting primarily for magazines and the burgeoning record industry. During that time he also produced an independent body of work—a reflection of what he has called the "American social landscape"— that has made him one of the most influential photographers of his generation.

Photographing people, objects, streets, and the landscapes around him, Friedlander often shoots without a preconceived project in mind, later compiling his photographs into books. Among the forty or so such volumes produced thus far, five have been devoted to self-portraits, some of them disarmingly direct and others, such as *Colorado, Self-Portrait with JFK*, notably incorporating only his shadow or reflection. Here, as in many works by Friedlander, it is the unexpected that is most compelling. Friedlander includes subtly disparate and surprising elements in his light-infused, black-and-white photographs. The clarity and directness of his images is reminiscent of Eugène Atget and Walker Evans, and the cool frankness and ironic touch of humor call to mind a Pop aesthetic. Yet it is Friedlander's distinctly personal vision—a rare blend of nonchalance, keen observation, and wit—that makes his work remarkable.

Colorado, Self-Portrait with JFK, 1967 (printed 1978). Gelatin silver print, 7⅝ x 11¼ in. (19.4 x 28.6 cm). Gift of Manny and Skippy Gerard 2003.407

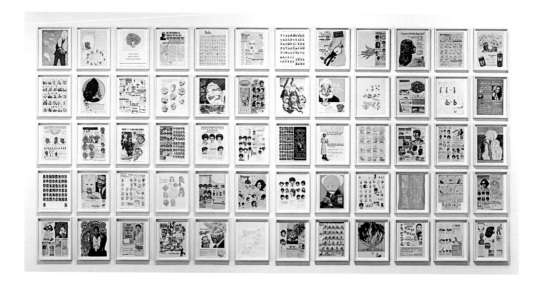

In the mid-1990s, when Ellen Gallagher's work came to widespread attention, many artists were seeking to articulate political positions on race, gender, and sexual identity. Gallagher's paintings, drawings, and prints examine racially charged imagery through the prism of Minimalism and Process art, obsessive workmanship and technical virtuosity. Often combining found imagery and text with highly detailed mark making, Gallagher allows materiality to take the fore, treating political content as a framework for formal exploration.

Gallagher's ambitious portfolio *DeLuxe*, which premiered at the Whitney in 2005, aptly illustrates her fusion of visual play with critique as well as her inventive skill as a printmaker. Comprising a series of sixty works on paper installed in a grid, *DeLuxe* alters reproductions of vintage magazine advertisements for products marketed to African American consumers. In addition to traditional printing methods, including etching, screenprint, and lithography, Gallagher uses mold-making and collage techniques to alter the images, adding yellow plasticine bouffant hairdos, excising sections of the images to leave eyeballs blank, affixing crystals to clothing, and even

employing a tattoo machine. The vintage ads promote aspirational—and strongly assimilationist—values, promising a better life through beauty products and wigs. While the advertising imagery refers to outmoded stereotypes, *DeLuxe* reaffirms the singularity of these individuals at a particular moment in time: their postures, smiles, styles, and desires. Gallagher has said the advertisements "had a kind of urgency and a necessity to them, also a whimsy. . . . It seemed to me to be about identity in the most open sense of that word."

DeLuxe, 2004–5. Photogravure, lithograph, etching, aquatint, drypoint, screenprint, and collage with plasticine, acrylic, pomade, laser-cut papers, metal foil, opaque watercolor, oil, enamel, graphite pencil, velvet, glitter, aluminum powder, and plastic, sixty parts: 84¼ x 175 in. (214 x 444.5 cm) overall. Edition no. 1/20. Purchase 2006.340a–hhh

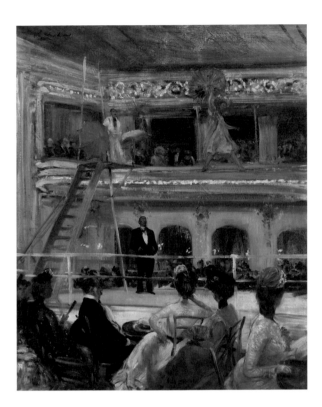

William Glackens was one of a circle of Philadelphia newspaper illustrators who, under the tutelage of the painter Robert Henri, moved to New York at the turn of the century and formed part of the revolutionary group of urban realist painters known as the Ashcan School. Like his colleagues in the group, Glackens rejected the refined themes of genteel society promoted by the conservative art academies, turning instead to street life and pop culture as subjects for his art. Inspired by the proliferation of new entertainment forms during the years before World War I, Glackens used loose, impressionistic brushwork to chronicle an optimistic, democratic world of lighthearted enjoyments.

Hammerstein's Roof Garden portrays an evening at a fashionable New York nightspot—a roof garden used for open-air entertainment when rising summer temperatures forced indoor theaters to close. Opened by theater impresario Oscar Hammerstein on West 42nd Street, Hammerstein's Roof Garden presented vaudeville acts that included exotic Spanish dancers, cycling jugglers, and tightrope walkers. Only at the turn of the century did it become acceptable for respectable women to attend amusements of this sort, and here they sit side by side with men. The arena is lit by a filigreed tangle of electric lights, a recent invention that had made nighttime theater possible. The scene, therefore, is not simply a lively night at the theater but a record of changing social norms and the exhilarating impact of new technology on everyday life.

Hammerstein's Roof Garden, c. 1901. Oil on linen, 29⅞ x 24⅞ in. (75.9 x 63.2 cm). Purchase 53.46

The Ascending Sink, 1985. Plaster, wood, wire lathe, steel, and enamel, two parts: 30 x 33 x 27 in. (76.2 x 83.8 x 68.6 cm) each; 92 x 33 x 27 in. (233.7 x 83.8 x 68.6 cm) overall. Promised gift of Thea Westreich Wagner and Ethan Wagner P.2011.167

Untitled, 1993–94. Beeswax, wood, glassine, and fiber-tipped pen, 9½ x 48 x 40 in. (24.1 x 121.9 x 101.6 cm). Edition of 2. Purchase with funds from Thomas H. Lee and the Contemporary Painting and Sculpture Committee 94.134a–b

The Ascending Sink and *Untitled* are part of a large corpus Robert Gober has made over three decades, including beds, chairs, cribs, newspapers, advertisements, and fruit. Gober's practice can be traced back to the embrace of common items in Cubist collages or Duchampian readymades. His objects differ, however, in that they are fabricated by hand, with artisanal exactitude. Chosen out of the flux of his daily life and his unconscious, the resulting sculptures—quite disparate and often brought together in installations of seemingly unrelated forms—are symbolic, poetic, funny, and political, often at the same time.

Like his contemporaries Jeff Koons and Haim Steinbach, Gober became a leading force in the transformation of sculpture in the 1980s. These artists were invested in the politics of everyday experience, even as they built on Minimalist strategies such as repetition and on the projection of theatricality and humor onto quotidian forms by such forebears as Claes Oldenburg. It was in the early 1980s that Gober began, as he wrote, "to stretch and distort the simple form of the sink," producing a variety of formal permutations—each absent of faucets or drains and each tweaked with individual meaning but sharing allusions to cleanliness and work and, more figuratively, to the body's anatomy. Gober also dealt playfully with their installation, as in the ascension invoked in this example, which recalls a Donald Judd "stack" sculpture as well as a religious tableau.

Gober's sculptures always escape literal interpretation. Typical is *Untitled*, a giant stick of beeswax made to resemble butter and placed on a mat of luminous glassine, a handwritten facsimile of the product's familiar wrapper. The artist leaves us to wonder about possible meanings, or simply to admire the banal beauty of ordinary things.

In the late1970s photographer Nan Goldin began to document her life, recording friends, lovers, relatives, and herself. The resulting color snapshots capture moments of tenderness, pleasure, and intimacy, but these works also chronicle the harsh effects of drug use, squalid living conditions, and the physical traces of abuse. Unlike documentary photographers, who observe communities from an outsider's position, Goldin is deeply entwined with her subjects: "This is my party," she has explained. "This is my family, my history."

Goldin first presented the accumulating photographs as live slide-show performances in downtown New York bars, clubs, and alternative art spaces. Loading her slides into the projector carousel, she conflated public with private by displaying what she called "the diary I let people read." In 1981 she named the still-evolving project *The Ballad of Sexual Dependency* (after the song from Kurt Weill and Bertolt Brecht's *Threepenny Opera*) and arranged the slides into loose categorical groupings—women looking into mirrors, people at clubs, empty interiors. She timed the progression to a soundtrack of pop songs, reggae music, blues, and operatic arias, each underscoring various emotional states that emerge as the narrative opens up to issues of gender, sexuality, and love. Goldin completed the *Ballad* in the mid-1990s, explaining that "stories can be rewritten, memory can't. If each picture is a story, then the accumulation of these pictures comes closer to the experience of memory, a story without end." A deeply personal work, Goldin's *Ballad* nonetheless strikes a universal chord as it demonstrates the human need for connection.

Details of *The Ballad of Sexual Dependency*, 1979–96. 690 35mm slides, color, and sound; 45 min. Edition no. 1/10. Purchase with funds from the Charles Engelhard Foundation, the Mrs. Percy Uris Bequest, the Painting and Sculpture Committee, and the Photography Committee 92.127

Jack Goldstein, a conceptual artist who came to prominence as a member of the Pictures Generation in the 1970s, worked in sculpture, performance, painting, film, and sound recording. His early short films feature close-up shots of simple actions such as hands untying a ballerina's pointe shoe or colored light moving over the reflective surface of a knife blade. Goldstein also appropriated "loaded images" from the culture and then worked to "reduc[e] the symbolism" associated with them. In *Metro-Goldwyn-Mayer*, for example, he altered aspects of the famous studio mascot Leo the Lion, animating it by looping the sound and image. The resulting footage takes on new meaning but, as Goldstein explained, "You're still left with some old meaning . . . in the back of your mind."

Goldstein presents Leo within his familiar circular frame of unspooling celluloid, but excises the MGM name and trademark text. The motto *Ars Gratia Artis* (Art for Art's Sake) remains legible against the added red backdrop, however, signaling the icon's transformation from corporate logo into art object. Instead of maintaining the standard two roars used to announce the coming feature presentation, Goldstein inserts footage of a third roar that plays forward and then backward—an action repeated multiple times for the length of the film. Goldstein's interventions require the viewer to give sustained attention to and actively consider the commercial introduction that typically registers as a fleeting image before the "real" film begins.

Still from *Metro-Goldwyn-Mayer*, 1975. 16mm film, color, sound; 2 min. Edition no. 7/10. Purchase with funds from the Film and Video Committee and the Director's Discretionary Fund 2003.220

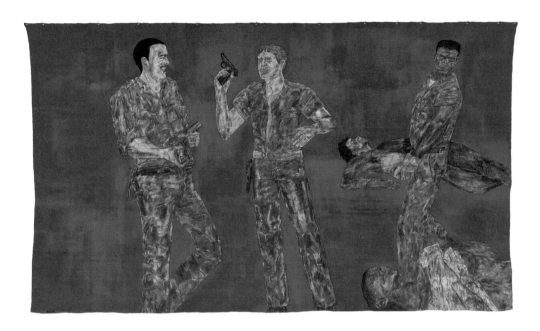

Leon Golub addressed mankind's capacity for brutality in figurative paintings that adopt the monumental scale of traditional history painting. While Golub's 1970s works focused on the war in Vietnam, the eleven paintings that comprise his *White Squad* series, painted between 1982 and 1987, were created in response to the large-scale human rights abuses committed by death squads in politically unstable Central and South American countries.

White Squad I does not present a single discernable event, setting, or narrative, but the figures are based loosely on photographs of the violence wrought by paramilitary gangs that Golub culled from contemporary newspapers and magazines. Here, the viewer's gaze mimics that of the camera, and Golub noted that the flattening effect achieved by the red background and the absence of shadows relates to photography's tendency to fix figures in frozen poses. Golub's painting process paralleled the raw physicality of his subject matter; he built up layers of paint to render the figures and then scraped them down with rubbing alcohol and tools so

that, as he described it, "what you see finally is a paint film which has been in a sense 'smashed back' into the tooth of the canvas." The extreme foreground positioning of a partially undressed female victim brings the violence dramatically into the space of the viewer, who is placed in an uncertain role, caught between accomplice, witness, and voyeur. Golub explained this troubling ambivalence: "I can see myself in, or at least understand, the position of the victim and the victimizer. One could, at different times of one's life—who knows under what circumstances—become either."

White Squad I, 1982. Acrylic on linen with metal grommets, 120 x 210 in. (304.8 x 533.4 cm). Gift of the Eli Broad Family Foundation and purchase with funds from the Painting and Sculpture Committee 94.67

Installations of Felix Gonzalez-Torres's *"Untitled" (America)* can vary: composed of twelve strings of light bulbs, with forty-two low-watt bulbs on each string, the work may be shown inside or outside, in an unlimited range of configurations, including laced above a city street (as in the installation pictured here) or suspended from the ceiling in several lines, and with all the bulbs illuminated or all of them dark. This mutable quality was essential to the work of Gonzalez-Torres, who is known for the sculptures, photographs, and installations he created in New York in the 1980s and 1990s. He conceived of the processes through which art is acquired, presented, encountered, and interpreted as collaborative—an ongoing exchange between the artist and those who owned or viewed his work. Other of his projects whose form and installation vary involve piles of wrapped candies, from which viewers are able to draw, and stacks of sheets of paper, printed with texts or photographs, which also may be taken.

A number of Gonzalez-Torres's works include the word *America* in their title, a choice that might be understood as related to the artist's biography: born in Cuba, he grew up in Puerto Rico and moved to New York in 1979. The light from the bulbs in this work might resonate as cheerful in one context and melancholy in another—indeed the artist's abiding themes included change, impermanence, and loss—leaving viewers to reflect on their ideological or personal associations with the idea of "America."

"Untitled" (America), 1994. Light bulbs, waterproof rubber light sockets, and waterproof extension cords, twelve parts: dimensions variable. Purchase with funds from the Contemporary Painting and Sculpture Committee 96.74a–l. Installation view: Lymington Road, Camden Arts Centre, London, 2000

Arshile Gorky

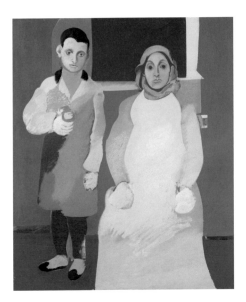

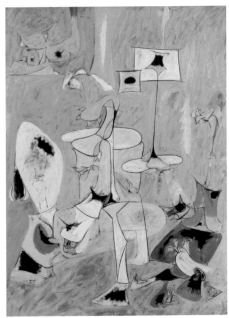

The Artist and His Mother,
1926–c. 1936. Oil on canvas,
60 x 50¼ in. (152.4 x 127.6 cm).
Gift of Julien Levy for Maro
and Natasha Gorky in memory
of their father 50.17

The Betrothal, II, 1947.
Oil and ink on canvas, 50¾ x
38 in. (128.9 x 96.5 cm).
Purchase 50.3

Arshile Gorky played a central role in the shift of American art toward abstraction in the years leading up to the mid-twentieth century. Gorky (born Vosdanig Adoian) immigrated to the United States in 1920, having fled his native country in the wake of the genocide of Armenians by the Ottoman Turks. Among his first major mature works, *The Artist and His Mother* was one of two canvases based on a 1912 photograph of Gorky with his mother, who never recovered after being sent on a death march in 1915 with her two children. When he rediscovered the photograph, the artist created a subdued meditation on loss and trauma that he would rework intermittently over the course of a decade. Rather than mimic the realism of his source, Gorky pared down his composition to a series of loosely brushed passages that presage the abstract path of his later art. The masklike faces of the two figures, their stark gazes, and the unfinished quality of areas such as the hands instill the image with a haunting inaccessibility—a formal analogy, perhaps, for memory itself.

In the 1940s Gorky transitioned to an abstract style that fused the fractured compositions of Cubism with the biomorphic vocabulary of Surrealism. His high-key palette, organic forms, and gestural brushwork would prove formative to the emergence of Abstract Expressionism at the decade's end. *The Betrothal, II* was painted a year before Gorky, beset by a string of personal tragedies, committed suicide. The painting's sinuous forms and lyrical rhythms suggest the themes of union and fecundity evoked by the work's title, and scholars have pointed to works by Marcel Duchamp (specifically, *Bride* [1912]) and the early Renaissance painter Paolo Uccello as sources.

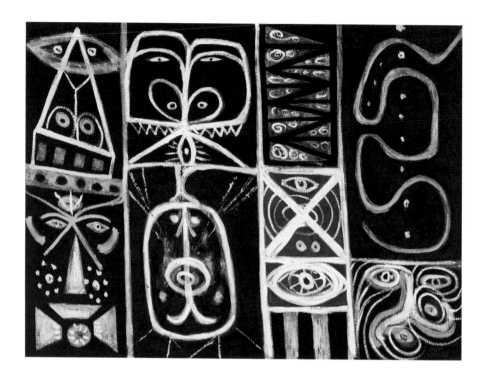

By the late 1930s, Adolph Gottlieb believed that neither American Realism nor European Modernism could adequately address the political and social crises unfolding worldwide. For Gottlieb, who had trained as a Realist painter, such precarious conditions demanded a new art that was universal, open to interpretation, and made up of subject matter that was "tragic and timeless." In developing this new pictorial language, Gottlieb turned to sources as diverse as classical mythology, psychoanalytic theory, and Native American, African, and Oceanic artifacts (which he collected and saw in museums in the United States and abroad).

The *Pictographs* (1941–52), a series of oil paintings, gouache drawings, and prints, borrow loosely from a wide cultural terrain that Gottlieb characterized as "primitive and archaic." In each work a gridded, planar ground is inscribed with an array of fragmented graphic symbols that evoke their varied origins while eschewing specific cultural reference. The series suggests mythic and emotional content without recourse to illusionism, and in this regard anticipates much Abstract Expressionist painting to come.

Vigil, from the *Pictographs*, employs a chaotic mix of eyes, zigzags, squiggles, and masklike faces that jostle within rectangular compartments on a black ground. As with many of the *Pictographs*, the thick layers of paint and roughly sketched lines conjure the prehistoric wall drawings from which the series takes its name. Though some of the forms here resemble designs made by the Northwest Coast Indians, the overall impression is eclectic and cannot be interpreted according to a single cultural system. Gottlieb arranged and selected his pictographs according to free association, and hoped that they would evoke a sense of "ambiguity and mystery."

Vigil, 1948. Oil on canvas,
36⅛ x 48 in. (91.8 x 121.9 cm).
Purchase 49.2

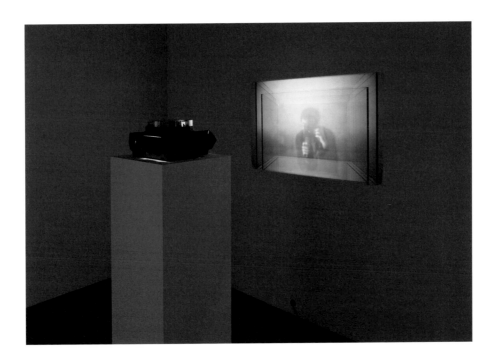

In his sculptural "pavilions" made of two-way mirrors, closed-circuit video systems, and performances, Dan Graham endeavors to break down the barrier between artist and audience. Graham came to art first as a critic; then, in 1964, as the cofounder of a short-lived New York gallery that presented some of the most important artists of the day; and, in 1965, as a conceptual artist, staging works directly in the glossy pages of magazines.

From the beginning, Graham's work pointedly deflected emphasis away from the traditional, static art object and toward spectators' self-conscious, active perception. In 1966 he devised *Project for Slide Projector*, his first exploration of the properties of transparency, reflection, and three-dimensional space; its use of plate-glass surfaces anticipates his architectural pavilions by more than a decade. Moving a camera clockwise around the sides of a small glass box, Graham photographed all four faces, with the focus of each shot moving progressively from the exterior surface to the center. Graham then placed a smaller glass box within the first and repeated the process five times, each time adding a successively smaller box. The carousel projects eighty slides in forward and reverse sequence and then repeats them again. As Graham wrote: "The sculpture is the photographic residue, and effect of projected light. What is seen must be read in terms of the conventions of still photography: two-dimensional objects which appear at once solid and also as transparent, and which function simultaneously in two entirely different planes of reference (two-dimensional and three-dimensional)."

Project for Slide Projector, 1966/2005. Eighty 35mm slides, color, silent. Edition no. 1/5, 1 AP. Purchase with funds from the Film, Video, and New Media Committee and the Painting and Sculpture Committee 2011.2. Installation view: Whitney Museum, 2009

As a teenager, Nancy Grossman assisted at her parents' dress factory in Oneonta, New York, learning to sew and make patterns—skills she would employ in her most notable body of work, known as "Heads." Grossman has worked in a range of two- and three-dimensional mediums but is most identified with these fastidiously crafted, life-sized, leather-covered sculptures of human heads, which she began making in 1968 and continued to produce until the mid-1990s. Each head begins as a block of wood that Grossman carves, sands, and polishes before tautly wrapping it with pieces of leather—sourced from items such as biker jackets and boxing gloves—that are then joined together with nails, stitches, and zippers. Additional adornments might include spikes, horns, and other protrusions; buckles, straps, and chains; noses fashioned from rubber or enamel; dentures; and eyes made of glass or buttons.

The eyes and mouth of *Head 1968*, like those in many of Grossman's head sculptures, are obscured, suggesting a subject who is being silenced or restrained. As the artist wrote in 1969: "This work has to do with the taboos against . . . knowing what you know . . . and what you are not supposed to know even though you do know. . . . We are buckled and bound in our taboos." Created within the context of the social and political upheavals of the late 1960s, including, as Grossman elaborated then, "the second-class citizenship of Blacks, police brutality, corruption in the military, and hunger in America," *Head 1968* today transcends a specific moment, instead symbolizing the individual's encounter with, and refusal or inability to respond to, the injustices that surround us.

Head 1968, 1968. Wood, leather, metal zippers, paint, and metal nails, 16¼ x 6⅝ x 9 in. (41.3 x 16.8 x 22.9 cm). Purchase with funds from the Howard and Jean Lipman Foundation Inc. 68.81a–b

Robert Grosvenor grew up in Rhode Island and Arizona and studied art and design in Europe. In the 1960s he began to make large-scale, abstract geometric sculptures, exhibiting with a group of artists at the pioneering Park Place gallery in New York. His first one-person exhibition was presented there in 1965, and the following year his sculpture was included in the Jewish Museum's landmark *Primary Structures* exhibition, one of the first museum presentations of Minimalist sculpture in the United States.

In 1966 Grosvenor made *Tenerife,* a reflective, maroon sculpture that is cantilevered from the ceiling and projects into the room, hovering like a high-speed vehicle trapped in the confines of an interior space. Titled after one of the Canary Islands, *Tenerife,* like all of Grosvenor's sculpture, has a strong material presence. The pristine form and lacquer-covered fiberglass surface suggest an industrial, machine-crafted object, but this work was actually made by hand. Constructed specifically for the dimensions of the Dwan Gallery in Los Angeles, where it was first shown in 1966, *Tenerife*'s horizontal structure and the relationship it creates

between the ceiling, floor, and viewer are significant formal elements of the work. The perspectival quality of this sculpture is difficult to discern in a photograph; *Tenerife* is experienced most fully in person as one's vantage point shifts within the space. The geometric structure of Grosvenor's early work is often associated with a Minimalist sensibility, and his use of horizontal planes is reminiscent of Frank Lloyd Wright's design concepts. Yet it is the material and structural ambiguity, formal sophistication, and spatially astonishing experience of Grosvenor's sculpture that is most distinctive.

Tenerife, 1966. Fiberglass, plywood, steel, and acrylic lacquer, 63¼ x 276½ x 45⅛ in. (160.7 x 702.3 x 114.6 cm). Purchase with funds from the Howard and Jean Lipman Foundation Inc. 67.51a–b. Installation view: Whitney Museum, 2010

A cofounder of the Berlin Dada movement, George Grosz is primarily known for his work of the 1910s and 1920s, which was motivated by a deep moral commitment to politically engaged art. In drawings, paintings, and printed cartoons, he aimed biting satire at German political classes and bourgeois society, and energetically charted Berlin's sinister underground. Featured centrally in the Nazi's *Degenerate Art* exhibition in 1937, and stripped of his German citizenship in 1938, Grosz watched the Second World War unfold from the United States, to which he had immigrated in 1933.

By 1946, when he began the series of watercolors that includes *The Painter of the Hole*, Grosz's style and attitude had changed considerably. He described the protagonists of the series in a letter to Bertold Brecht: "They consist of thin but firm strokes. They cast no shadow, and are themselves completely grey . . . because everything is grey there." The lanky artist of *The Painter of the Hole* sits among the ruins of the city that in Grosz's earlier works had teemed with chaotic life. The destruction of the city is the setting for a more profound sense of loss, however, and the work is as much about art as it is about the physical devastations of war: where once Grosz had been convinced of the political and social potential of art, *The Painter of the Hole* expresses a weary disillusionment with painting. Despite the numerous attempts piled around his feet, all that the painter can produce is a void in the center of the canvas; its status as garbage is confirmed by the rat nibbling at its corner.

The Painter of the Hole,
1947. Watercolor on paper,
25⅝ x 19 in. (65.1 x
48.3 cm). Purchase 48.8

The Guerrilla Girls collective of female artists came together in the 1980s to condemn the bias that women and people of color faced in the art world. At the time, American museums mounted few exhibitions of female artists and rarely acquired women's art for their collections. Wearing gorilla masks—their trademark— the Guerrilla Girls demonstrated in front of New York museums. They also created posters using statistical research to reveal pervasive sexism and racism in the arts and culture. Their famous poster asking, "Do women have to be naked to get into the Met Museum?" pointed out that while only 5 percent of works in the permanent collection of the Metropolitan Museum of Art were by women artists, 85 percent of the nudes in the collection were female.

The Clocktower Gallery, an alternative art space in lower Manhattan, invited the Guerrilla Girls to mount a response to the 1987 Whitney Biennial. The gallery had noticed that only 24 percent of the works featured were by women artists. In *Guerrilla Girls Review the Whitney*—a poster publicizing the Clocktower show—the female figure in a gorilla mask points a finger at the phallic symbol of a banana in her other hand.

The Guerrilla Girls have continued their work to the present day, employing similar tactics even as their anonymous membership has changed. They have been instrumental in encouraging art museums to rethink established narratives about modern art, and to focus more rigorously on collecting and exhibiting work that more accurately reflects the diversity of artists today.

Guerrilla Girls Review the Whitney, 1987. Offset lithograph, 22 x 17 in. (55.9 x 43.2 cm). Purchase 2000.91

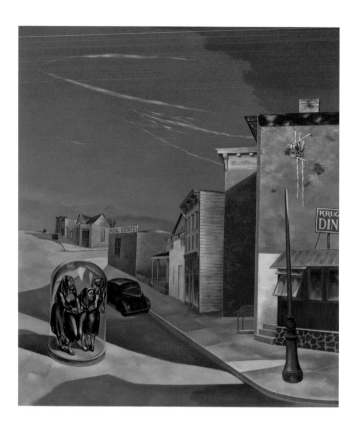

Louis Guglielmi described *Terror in Brooklyn*, one of his best-known canvases, as "a premonition of war and tragedy." The painting reflects the artist's highly personal response to World War II and its impact on the American psyche. Guglielmi, who was born in Egypt to Italian parents and immigrated to the United States as a child, was one of a group of American painters who became known as the Social Surrealists. Along with artists such as Peter Blume and Walter Quirt, Guglielmi utilized the imagery and techniques of European Surrealism to address social and political themes during the 1930s and 1940s.

In *Terror in Brooklyn* Guglielmi envisions a foreboding scene. On a bleak urban street, three nuns are entrapped by a life-sized bell jar; they seem to cower in the presence of a bandaged pelvis that hangs, like a crucifix or relic, from a nearby building. Although painted in a meticulous Realist style, the scene's incongruous details—from the decapitated lamppost to the mirror reflection of the foreground scene in the background—invoke a disjunctive sense of reality. Wispy clouds streak across the sky, like the wake of aircraft, recalling the aerial blitz of London in 1940–41. The source for Guglielmi's image was the intersection of Atlantic and East New York Avenues in Brooklyn, where buildings were being razed as part of an urban renewal project. The ruined buildings may have resembled photographs of the war's devastation elsewhere, inspiring this enigmatic meditation on the looming threat of violence on American soil.

Terror in Brooklyn, 1941. Oil on canvas, 34⅛ x 30¼ in. (86.7 x 76.8 cm). Purchase 42.5

Philip Guston

b. 1913; Montreal, Canada
d. 1980; Woodstock, NY

Philip Guston came to the United States from Canada as a young child in 1919 with his Russian émigré parents, who settled their family in California. In 1927 Guston enrolled in Manual Arts High School in Los Angeles, where, together with his friend and classmate Jackson Pollock, he was soon expelled for producing satirical broadsides. Continuing his artistic and intellectual explorations largely on his own, he began his formal career making figurative art in styles he explored until the late 1940s, including murals made in the 1930s concerned with political and social issues. After his permanent move to New York in 1949, the figures in Guston's work gradually disappeared; his canvases became increasingly textured and his color palette more refined until his signature Abstract Expressionist style emerged.

 Dial displays Guston's confident approach to pure abstraction, and the painting glimmers from the use of gestural yet tempered brushstrokes. It includes the artist's characteristic pinks and reds, with the concentration of color and broader brushwork at the center of the canvas. The composition is structured loosely upon a grid inspired by Piet Mondrian. Guston wrote about the significance of *Dial* to him, "This picture has a special importance for me as it is a culminating point of a certain period of my painting." In the late 1960s Guston would follow a path back to figuration, incorporating a cartoon-inflected iconography into his painting. This transformation, which shocked the art establishment at the time, landed him at the forefront of the Neo-Expressionist movement and a new, postmodern era.

Dial, 1956. Oil on linen,
72 x 76⅜ in. (182.9 x 194 cm).
Purchase 56.44

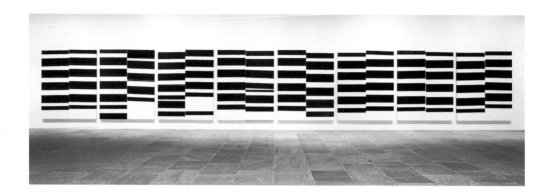

Wade Guyton's polyptych painting *Untitled* spans a monumental fifty feet and was created specifically for the long, narrow proportions of the gallery in Milan where it was first installed. Although made on preprimed linen traditionally used by painters, the work employed neither brush nor paint but was instead produced by a 44-inch-wide inkjet printer (Epson's 9600 UltraChrome model, to be exact). Guyton folded each of eight canvases in half lengthwise and fed them through the machine twice, printing the same TIFF image file—a stack of seven black bands—once on each side; when unfolded and stretched on separate panels that are then hung five inches apart, the canvases merge into a rhythmic, undulating expanse of black and white intervals.

 Untitled extends a practice Guyton initiated in 2002, when he first made "printer drawings" using Microsoft Word and his desktop printer. Though the scale of the printer has increased, he continues to rely on everyday technology and software, exploiting their failures and limitations to productive ends. For Guyton, a new technique often "starts as an accident and then becomes a template for other things, or reproduces itself and generates its own logic until something else intervenes to change it." The repetition of the TIFF file in *Untitled* acts as a yardstick that reveals these incidents of the process: as the fabric jams, the printer clogs or runs dry, or the giant canvases smudge against the studio floor, the initial image produces countless variations. While the resulting painting formally recalls the elegance of high modernist abstraction, Guyton makes a work that also offers a picture of how machines, humans, and images interact haltingly in the early twenty-first century.

Untitled, 2008. Epson UltraChrome inkjet on linen, eight panels: 84 x 69 in. (213.4 x 175.3 cm) each; 84 x 587 in. (213.4 x 1,491 cm) overall. Purchase with funds from the Painting and Sculpture Committee, the Director's Discretionary Fund, Allison and Warren B. Kanders, Andrew and Christine Hall, Donna Rosen, Pamella DeVos, Melva Bucksbaum and Raymond J. Learsy, Ginevra Caltagirone, Miyoung Lee, and Gregory Miller 2011.22a–h

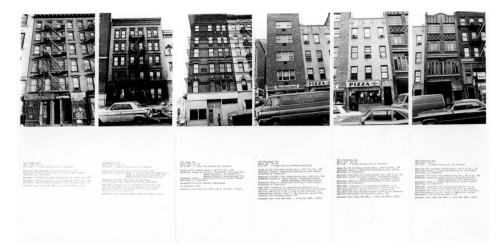

Hans Haacke began his career as an abstract painter and, after joining with the international artist group Zero, turned his attention to works that engaged systems of biological and physical processes. In 1965 Haacke settled in New York, and by 1970 embarked on works that explored what he called "social systems," using a conceptual approach that sought to uncover the often concealed ties that exist between art and the ideological, economic, and political powers that underpin its creation, presentation, and distribution. *Shapolsky et al. Manhattan Real Estate Holdings, a Real-Time Social System, as of May 1, 1971* details two decades of the questionable dealings of Harry Shapolsky, the owner of a vast empire of slum properties in New York. Haacke sourced all of his information from the public record, and the work's components—documentary photographs of

the buildings, maps, typewritten real estate fact sheets—are presented neutrally, leaving viewers to unravel the significance of the data. Still, *Shapolsky et al.* ignited controversy when its inclusion in the planned 1971 solo exhibition of Haacke's work at the Guggenheim Museum led the institution's director to cancel the show abruptly and fire the organizing curator. This act of censorship led to speculation that the web of corporate ties documented in the piece had come too close to the interests of the museum's trustees, though this was never proven.

Since much of Haacke's art reflects on institutions such as museums and galleries—and particularly their connections to corporations, governments, and patrons— it is often labeled "institutional critique"; in the artist's words, his work "bites the hand that feeds it."

Detail and installation view of *Shapolsky et al. Manhattan Real Estate Holdings, a Real-Time Social System, as of May 1, 1971,* 1971. Nine photostats, 142 gelatin silver prints, and 142 photocopies, dimensions variable. Edition no. 2/2.

Purchased jointly by the Whitney Museum of American Art, New York, with funds from the Director's Discretionary Fund and the Painting and Sculpture Committee, and the Fundació Museu d'Art Contemporani de Barcelona 2007.148a–gg

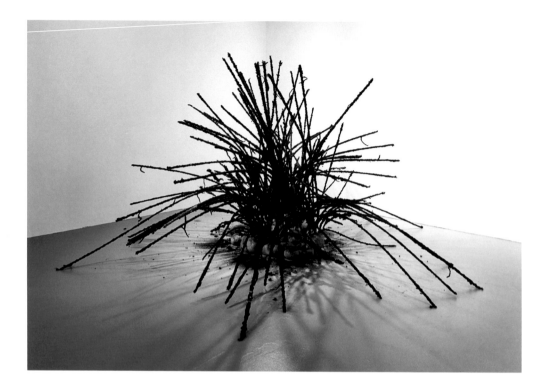

David Hammons's *Untitled* straddles the boundaries between abstraction and representation, organic and inorganic, plant and animal. To make the sculpture, Hammons affixed floor sweepings from barbershops, primarily hair from African Americans, to dozens of copper wires that he then anchored into twenty rocks. Nestled among the rocks are beads, feathers, pantyhose, a hammer, and other items. At first glance, the arrangement evokes a massive insect or an overgrown plant, but the long, hair-covered wires also summon a specific ethnic reference to dreadlocks. Indeed many of Hammons's materials are tied to his heritage and to the streets of New York, where he has lived and worked since 1974. He frequently fashions his sculptures, prints, installations, and performances from ordinary, often ephemeral, objects that have been discarded or are readily at hand. Other projects have featured chicken bones, grease, paper bags, inner tubes, shovels,

basketball hoops, and bottle caps. His work is rarely static, and in the case of *Untitled*, bits of hair inevitably fall off, conjuring up the natural processes of evolution and decay.

Hammons studied in Los Angeles in the late 1960s and early 1970s, and his art has antecedents in both midcentury California assemblage art and the Black Power Movement. The found objects of Marcel Duchamp, the abject materials of Arte Povera, and the pared-down means of Conceptual art are additional, pertinent contexts for Hammons's work, in which art and life intersect to surprising, and often transformative, effect.

Untitled, 1992. Human hair, wire, metallic mylar, sledge hammer, plastic beads, string, metal food tin, pantyhose, leather, tea bags, and feathers, dimensions variable. Purchase with funds from the Mrs. Percy Uris Bequest and the Painting and Sculpture Committee 92.128a–z

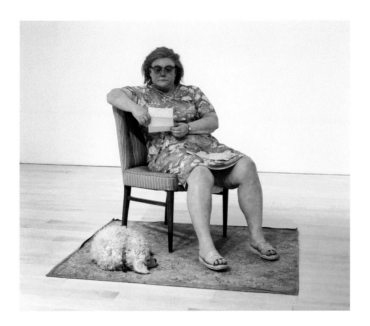

Duane Hanson began casting from live models in 1967 and for several years created expressionist tableaux addressing politically charged subjects such as the race riots of 1968 and the Vietnam War. By the early 1970s he increasingly focused on the individual figure, refining his lifelike sculptures by hand-painting their skin and clothing them with carefully selected garments and props. Depicting archetypes from everyday American life, the hyperreal sculptures are easily mistaken for live people. Hanson is often associated with the Photorealist movement that emerged during this period, but unlike these painters, who meticulously copied photographs, Hanson blended different models, gestures, and expressions for emotional impact. His characters are chosen to highlight the daily lives of lower- and middle-class Americans—construction workers, museum guards, old women, and policemen in forlorn poses. Like Edward Hopper's subjects, they articulate the loneliness and resignation of the individual in modern society.

Representative of Hanson's mature work, *Woman with Dog* portrays an aging, overweight, bespectacled woman on a chair, her dog curled up asleep on a rug beside her. The woman was cast from life and constructed of fiberglass-reinforced resin, meticulously painted. The dog, molded by hand, is adorned with actual canine hair. Hanson's detailed focus adds to the despondency of the scene. "I'm not duplicating life, I'm making a statement about human values," he has explained. "My work deals with people who lead lives of quiet desperation. I show the empty-headedness, the fatigue, the aging, the frustration."

Woman with Dog, 1977. Acrylic and oil on cast polyvinyl with clothing, hair, eyeglasses, watch, shoes, upholstered wood chair, ceramic dog with collar, and woven rug, 46⅛ x 50½ x 48 in. (117.2 x 128.3 x 121.9 cm). Purchase with funds from Frances and Sydney Lewis 78.6a–f

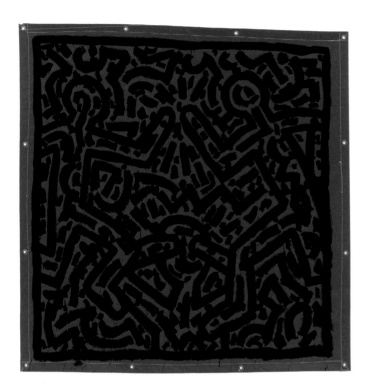

Keith Haring's imagery is familiar worldwide for its trademark black lines, bright colors, and iconography of radiating babies, dancing men, and barking dogs. Haring achieved this recognition and executed his large body of work during the period of twelve years from 1978, when he moved to New York, until his death from AIDS-related causes in 1990. He was a vital part of the burgeoning 1980s New York art scene, from its beginnings in the East Village, amid other young artists such as Kenny Scharf and Jean-Michel Basquiat. New York served not just as inspiration but as the site for much of his art, and it was there that he developed his spontaneous, free-flowing style of graffiti for decorating the surfaces of streets and subways.

In 1981, as Haring's career was gathering momentum, he discovered the vinyl tarps that the city's electrical company used to cover its equipment on the street. Enchanted with this new support, he found a distributor from which to reliably and legally obtain them. Without having to deal with the pressure of being caught by the police, Haring now was able to more carefully arrange his images, as evidenced in this indigo tarp in which three figures—two dancing, one with his eyes covered—are interwoven with the hieroglyphic-like, allover composition. As the decade progressed, Haring became increasingly aware of his role in society and his ability to communicate with a broad public. He strove to create art that was easily accessible and yet addressed the social concerns of his times, including AIDS, racism, and illiteracy.

Untitled, 1981. Vinyl paint on tarpaulin with metal grommets, 73¼ x 72⅛ in. (186.1 x 183.2 cm). Gift of the Lannan Foundation 97.89.2

Rachel Harrison emerged in New York in the 1990s with sculptures and installations whose disparate elements coalesce into insightful, philosophical, and at times comedic networks of meaning. Through their titles, and the combination of carefully painted sculptural forms with appropriated objects, Harrison interrogates what it means to look and identify—whether this takes the form of aesthetic contemplation, anthropological classification, or the absorption of popular culture, history, and entertainment.

Referencing the French social anthropologist's name in its title, *Claude Levi-Strauss* situates a taxidermic rooster and hen atop a pair of sculpted and brightly painted pedestal-like forms. Facing off, the animals simultaneously invoke Lévi-Strauss's concept of binary opposition (the raw and the cooked), a passage or formal entryway, and an unbroken gaze or

Claude Levi-Strauss,
2007. Wood, chicken wire, polystyrene, cement, acrylic, taxidermically preserved silver-laced Wyandotte hen and Black Minorca rooster with attached label and mount, USPS Priority Mail cardboard box, and Sharp UX-B20 Fax machine cardboard box, dimensions variable. Purchase with funds from Warren and Allison Kanders 2008.15a–f

Untitled, 2011. Colored pencil on paper, 19 x 24 in. (48.3 x 61 cm). Purchase with funds from the Drawing Committee, 2012.81

standoff across a divide. The notion of sending and receiving is further expressed, as each sculptural form rests on a cardboard box—one a USPS Priority Mail and the other a Sharp fax machine. At once flat-footed and esoteric, the work demonstrates the potential for figurative sculpture or statuary to employ language, found objects, abstract forms, and precise choreography to renew its communicative potential.

In a series of colored-pencil drawings featuring the singer-songwriter Amy Winehouse, then recently deceased, Harrison graphically juxtaposed her image with renderings of female figures or self-portraits by artists such as Marcel Duchamp, Pablo Picasso, and Martin Kippenberger. The series reminds us that identity and personification as a creative act occur across the widest spectrum of art history and popular culture.

Harrison's *Voyage of the Beagle, Two* similarly pairs art historical statuary with vernacular representations such as mannequins, a Barbie doll, figurative roadside attractions, and stuffed animals. The work references Charles Darwin's 1839 travel memoir, which recounted his five years of exploration in the southern hemisphere aboard the *H.M.S. Beagle*, an expedition that resulted in the English

naturalist's theory of evolution. Just as Darwin's observations led him to conclude that all species are descended from common ancestors, Harrison's collected photographs suggest a taxonomic study of anthropomorphic representation and its development over time and across cultures.

Beginning with the simple question "What does a sculpture look like?" Harrison carried an off-the-shelf digital camera with her for a year, documenting found objects and working within the technical limits of point-and-shoot photography. She then made a selection of fifty-eight images that are exhibited together in six subsets. "The order was very specific," she explained. "I was interested in the linear aspect of a photo frieze, in which narrative is implied, but also in the fact that you can't see them all at once. That's where memory comes in, from image to image sequentially, but also across the work as a whole."

Details of *Voyage of the Beagle, Two*, 2008. Fifty-eight inkjet prints, 16 x 12 in. (40.6 x 30.5 cm) each. Edition no. 1/6. Purchase with funds from the Painting and Sculpture Committee 2008.17a–fff

Among the most important practitioners of American Modernism in the first decades of the twentieth century, Marsden Hartley combined an understanding of advanced European practices with a deeply spiritual sense of the American landscape to create a daring and wide-ranging body of work in both abstract and realist styles. Trained first at the Cleveland School of Art and then in New York under William Merritt Chase and at the National Academy of Design, Hartley caught the attention of the photographer and gallerist Alfred Stieglitz with landscapes he had painted in his native Maine. The work earned him a solo exhibition in 1909 at Stieglitz's famed 291 gallery, which also promoted the early Modernists Charles Demuth, Arthur Dove, and John Marin.

Hartley first visited Europe in 1912, where he traveled to Paris and then Berlin, encountering French Cubist work and meeting German Blaue Reiter artists Wassily Kandinsky and Franz Marc. Enthralled by Berlin's thronging crowds and military pageantry, and having also fallen in love with Karl von Freyburg, a handsome German Royal Guard officer, Hartley returned to the city in 1914 for an extended stay. Shortly after World War I broke out, von Freyburg was killed. Devastated by Freyburg's death, Hartley created a series of abstract portraits of the officer that included

Painting, Number 5, 1914–15.
Oil on linen, 39¼ x 32 in.
(99.7 x 81.3 cm). Gift of an
anonymous donor 58.65

The Old Bars, Dogtown,
1936. Oil on composition
board, 18 x 24 in. (45.7 x
61 cm). Purchase 37.26

Madawaska, Acadian
Light-Heavy, Third
Arrangement, 1940.
Oil on composition board,
27⅞ x 21¾ in. (70.8 x
55.2 cm). Gift of Nina and
Herman Schneider, Gertrude
Vanderbilt Whitney, and
Dr. Meyer A. Pearlman
by exchange; purchase by
exchange; and purchase
with funds from the
Director's Discretionary
Fund 2005.89

overlapping images of German imperial flags, military emblems, and fragments of the Royal Guards' uniforms. The paintings— known as the "War Motifs"—were shown in New York in 1916, at the height of anti-German sentiment prior to the American entry into the war, and were greeted with lukewarm indifference. Today they are revered as icons of American art, masterful fusions of Synthetic Cubist structure and German Expressionist color and brushwork.

Hartley spent the next fifteen years traveling throughout America and Europe. During this time he discovered Dogtown, a stark Ice Age moraine outside Gloucester, Massachusetts, with a craggy, archaic landscape that he captured in paintings such as The Old Bars, Dogtown. In Hartley's words, "A sense of eeriness pervades all the place . . . [which] is forsaken and majestically lovely as if nature had at last found one spot where she can live for herself alone. . . . [A] cross between Easter Island and Stonehenge—essentially druidic in its appearance—it gives the feeling that an ancient race might turn up at any moment and renew an ageless rite there."

In 1937 Hartley returned to his native Maine, where he used a vocabulary of simplified forms and deep, rich color to portray what he viewed as the state's solemn grandeur and began to experiment with figuration in a series of iconic, frontal portraits. In Madawaska, Acadian Light-Heavy, Third Arrangement Hartley depicts a French-Canadian boxer he knew with a series of massive, sculptural shapes delineated by loose brushstrokes and rich areas of color. The final composition conveys a raw immediacy and the sensuous intensity of male desire.

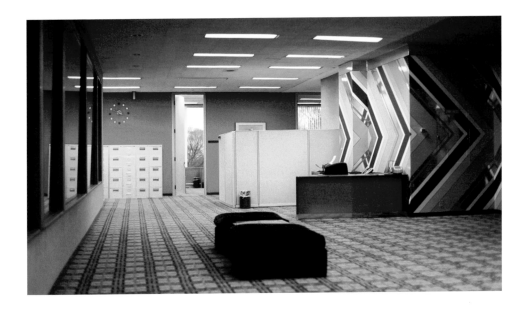

David Hartt has worked primarily in photography and, for more recent projects, incorporated elements of sculpture and video. Probing themes at once universal and particular, each of his bodies of work focuses on a location or architectural site, examining what he has described as "the built environment as a vehicle for the layering of history" and "space as a container for a specific ideology."

Stray Light, a body of work that includes a video, photographs, and an installation, focuses on the 1971 Johnson Publishing Company headquarters building in Chicago, designed by architect John Moutoussamy and interior designer Arthur Elrod in the company's heyday as publisher of magazines such as *Ebony* and *Jet*. Elrod's luxurious interior décor, accompanied by the Johnsons' collection of African American and African art, was intended to express a black, modernist aesthetic that reinforced the ideology of the corporation and its publications. The video (shot shortly before the building was sold) is composed of a series of long, static shots. An employee quietly works away, a curtain flutters in the air-conditioned breeze, a clock hand ticks, and at times nothing happens at all. The sound track, composed by avant-garde jazz flutist Nicole Mitchell, provides a sense of narrative progression and pacing to these otherwise silent scenes. Hartt's camera captures the new technology— Apple computers, industrial printers, network servers—occupying these otherwise unchanged spaces and ends with glimpses of the company's archives, suggesting its historical legacy. As Hartt has stated, "I'm interested in the space between failure and success, as these individually are written on the space. It's not one or the other; it's a relationship."

Still from *Stray Light*, 2011.
Video, color, sound;
12:12 min. Edition no. 2/6,
1 AP. Purchase with funds
from the Film, Video,
and New Media Committee
2013.80

In the video installation *Symbionese Liberation Army (SLA) Screeds #13, 16, 20 & 29*, we see Sharon Hayes's face looking straight ahead, closely framed against a white backdrop. Hayes recites four of the audiotaped messages recorded by heiress Patty Hearst to her parents and broadcast in the media after her kidnapping in 1974 by the Symbionese Liberation Army, a left-wing revolutionary group. On occasion Hayes's memory falters, and off-screen participants correct or prompt her with lines from the original transcript before the monologue resumes. The tone of Hearst's communiqués shifted over the months between the first and the last, as she began collaborating with the SLA, but Hayes's voice remains affectless, imparting no position on what remains a contested episode in American history.

The *SLA Screeds* is one of a number of Hayes's performances, videos, and video installations that take social or political documents from the past as their point of departure. She also has "respoken" addresses by Ronald Reagan and appeared with protest signs from various eras in locations around New York and other international centers. This citing of the past in the present not only draws renewed attention to old sources but also highlights the mechanisms of a text's transmission, reception, and interpretation over time, and often testifies to stasis as much as change when her sources take on contemporary reverberations and relevance. Equally important, Hayes's work underscores the performative dimension of public activism and political speech, demonstrating how much of what a message means is determined by how, when, and where it is conveyed.

Still from *Symbionese Liberation Army (SLA) Screeds #13, 16, 20 & 29*, 2003. Four-channel video, color, sound; 9, 10, 20, and 15 min., looped. Edition no. 1/5, 2 AP. Purchase with funds from the Film, Video, and New Media Committee 2012.135

Mary Heilmann's decision to become a painter in 1970 in New York was, according to the artist, a contrarian move: "I chose it as a practice in order to have arguments with people like Robert Smithson." After training in ceramics with the avant-garde ceramicist Peter Voulkos at Berkeley, she had moved to New York in 1968 and was making large-scale sculpture similar to work by artists she admired, like Smithson. When Heilmann turned to painting, she approached it as a sculptural medium, building up semitransparent layers of paint like a ceramic glaze, and emphasizing the painting as an object by embracing imperfectly stretched canvases and by painting the canvas edges. More than four decades later, these continue to be hallmark features of her work. While Heilmann draws on the traditions of modernist and minimalist painting, she pushes the limits of geometric abstraction by imbuing her compositions with

references to everyday objects or experiences. "Behind my choices of color, surface, and scale," she has said, "there is always a memory of a place or event."

Made up of overlapping shapes in primary colors, *French Screen* is emblematic of Heilmann's 1970s work, in which she was exploring the conceptual attributes of painting. The blue and yellow drips on the red field and the rough edges between shapes invite the viewer to imagine her process and the sequence of the application of paint. The title of the painting playfully challenges the ideal of flatness associated with high-Modernist abstraction, suggesting the three-dimensionality and familiarity of a domestic object.

French Screen, 1978. Acrylic
on canvas, 60 x 73½ in.
(152.4 x 186.7 cm). Gift of
Will Pilcher 95.220

Robert Heinecken was a pioneer of conceptual photography, although he rarely stepped behind a camera. Famously referring to himself as a "para-photographer," Heinecken differentiated himself from a traditional practitioner, preferring to "pay homage to the medium," as he explained it, "but not to be a photographer." A printmaker by training, Heinecken was first drawn to photographs as material he could incorporate into his etchings. Inspired by the radical inventions of the Dada movement, he experimented widely with collage, montage, and various exposure techniques during the early 1960s, later moving into photo-sculpture and installations. Images were treated as objects, matter to be manipulated in myriad ways and to various ends.

Found material from magazines, advertising, and television served as key sources for Heinecken's critical investigations of the increasingly media-saturated landscape around him. *Inaugural Excerpt Videograms*, composed of twenty-four images, captures scenes from the televised events surrounding Ronald Reagan's 1981 presidential inauguration. Heinecken produced these "videograms" by pressing Cibachrome paper onto a television screen, exposing the sensitized paper with a flash of the screen's electronic glow— an unpredictable technique that produced elusive, ghostlike images of the participants (including the president, Nancy Reagan, Frank Sinatra, and Jimmy Stewart). Further confounding the inclination to read the pictured events as documentation, he randomly assigned a short phrase from the inaugural speech to each image, penciling it below; he also gave the series no predetermined order, unmooring it from any chronological significance. Exposing the media's classic tools of manipulation, Heinecken challenges us to take an active role in our interpretation of his work, reminding us that we can't believe everything we see.

Details of *Inaugural Excerpt Videograms*, 1981. Twenty-four silver dye bleach prints (Cibachrome), 10⅞ x 14 in. (27.6 x 35.6 cm) each. Purchase with funds from the Photography Committee 2003.94a–x

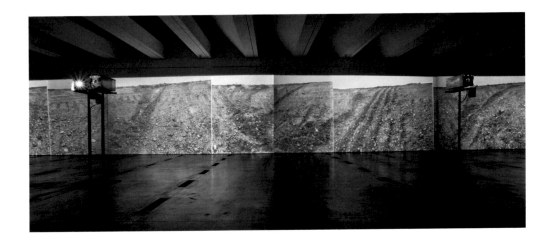

Since the late 1960s, sculptor and Land art pioneer Michael Heizer has produced large-scale works that engage with the natural environment, either in sculptural form or through acts of carving and displacing earth. For his first prominent earthwork, *Double Negative* (1969), he gouged deep trenches into Mormon Mesa, near Overton, Nevada, displacing more than 240,000 tons of rock into a gap at the mesa's edge. The work consists of these negative spaces, both natural and man-made.

Heizer's *Actual Size: Munich Rotary* is a mediated, "screened" version of another of his 1969 earthworks, *Munich Depression*, in which he removed 1,000 tons of earth in a massive conical shape near Munich, Germany. Using six custom-made steel projectors, each holding a black-and-white photographic positive on a glass plate, Heizer projects documented imagery of the Munich excavation as a continuous, panoramic landscape at a 1:1 scale, displacing the original earthwork into the gallery space and placing the viewer inside the depression, where every detail appears life-sized. The materiality of the installation's heavy steel projection equipment references construction machinery and the act of excavating the original site. Yet *Actual Size: Munich Rotary* consists of what is not physically there— what has been displaced. The visual experience of the installation amplifies this displacement, since the imagery becomes increasingly blurry as the viewer approaches it. Heizer's work has consistently reflected on the relationships between the natural and technological and their transformations and displacements. As the artist has put it: "We live in a world that's technological and primordial simultaneously. I guess the idea is to make art that reflects this premise."

Actual Size: Munich Rotary, 1970. Six custom-made aluminum projectors with steel stands and six black-and-white slides mounted between glass, dimensions variable. Gift of Virginia Dwan 96.137. Installation view: Los Angeles County Museum of Art, 2012

Robert Henri

b. 1865; Cincinnati, OH
d. 1929; New York, NY

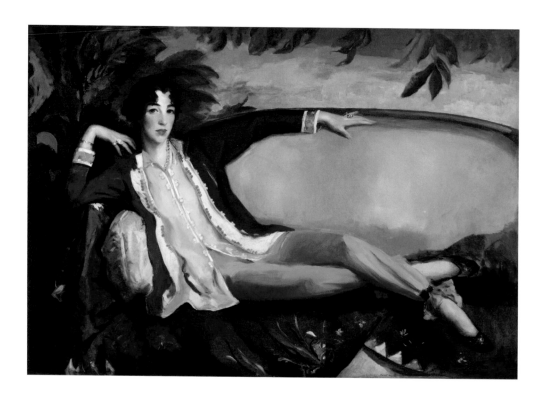

Leader of the renegade circle of artists known as the Eight and father of the Ashcan School, Robert Henri was one of the most influential figures in American art at the turn of the twentieth century. With a group of colleagues that included John Sloan, Everett Shinn, and William Glackens, Henri rebelled against the accepted subject matter and formal strictures of the conservative art academies of the time, which exerted almost complete control over the prospects of young artists. Henri encouraged his followers to paint everyday urban life in a loose gestural style and dramatic palette inspired by Spanish painting. During his long tenure as a teacher, he nurtured the budding careers of a generation of American artists, including Edward Hopper, George Bellows, and Stuart Davis.

In his own work Henri favored portraiture over the urban landscapes of his cohorts. "Human faces," he remarked, "are incentive to great adventures. . . . The picture

is the trace of the adventure." This portrait of Gertrude Vanderbilt Whitney was commissioned by the subject herself— one of Henri's most important patrons, who by 1916 had founded the Whitney Studio, an organization devoted to supporting American artists. Through the self-assured, reclining pose and silk lounging pajamas, the painting captures Mrs. Whitney's unconventional spirit, casting her as a thoroughly modern woman. Although it was exhibited at the Whitney Studio the year it was completed, Mrs. Whitney's husband was scandalized by the image of his wife wearing pants and refused to display it in their Fifth Avenue mansion. She subsequently hung it in her Greenwich Village studio, which in 1931 became the first home of the Whitney Museum.

Gertrude Vanderbilt Whitney,
1916. Oil on canvas, 50 x 72 in.
(127 x 182.9 cm). Gift of
Flora Whitney Miller 86.70.3

Carmen Herrera was educated in Paris and Havana and studied at the Art Students League of New York before moving with her American husband to Paris, where she lived from 1948 to 1953. During that time she showed regularly with the Salon des Réalités Nouvelles, an international group of artists focused primarily on abstraction, and developed what would become her signature style: a form of geometric, hard-edge abstraction featuring no more than two or three colors in each composition.

Upon returning to New York in 1954 Herrera found an art world dominated by Abstract Expressionism. Yet she continued to make works in her uniquely distilled style, and until the early 1990s she had few public showings and received little critical attention. *Blanco y Verde* is part of a long-running series of paintings she composed in white and green. The broad expanses of white in these works extend to the surrounding walls, so that the green triangles—rendered in various sizes and positions—appear to be cuts into space. In diptychs such as this one, the seam between the canvases presents yet another form of division. Here the union of forms and surfaces conveys a structural tension that pushes beyond Herrera's investigation of line and color to explore the boundaries between two- and three-dimensional space.

Blanco y Verde, 1959. Acrylic on canvas, two parts: 68⅛ x 60½ in. (173 x 153.7 cm) overall. Purchase with funds from the Painting and Sculpture Committee 2014.63

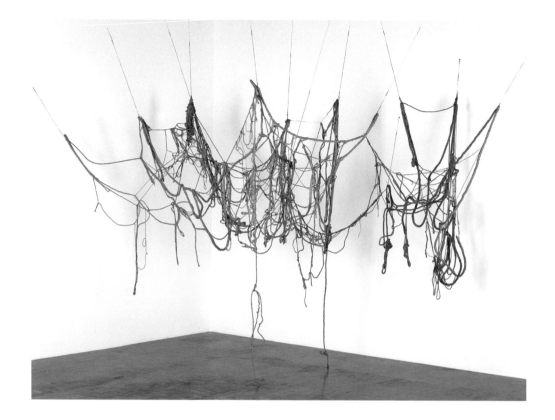

No title, 1969–70. Latex, rope, string, and wire, dimensions variable. Purchase with funds from Eli and Edythe L. Broad, the Mrs. Percy Uris Purchase Fund, and the Painting and Sculpture Committee 88.17a–b. Installation view: Whitney Museum, 1990

Between 1965 and 1970, Eva Hesse worked with diverse and sometimes unusual materials—from oil paint and graphite to latex and fiberglass—to create a body of abstract paintings, drawings, and sculptures that aimed, as she described it, to "go beyond what I know and what I can know." In 1966, she executed drawings featuring grayscale circles placed within gridded boxes or rectangular borders. For her 1966 untitled drawing, Hesse used a compass to draft concentric rings and then filled the sections with ink wash to create the subtle gradation and cadences in the composition.

The amorphous compositions and tactile surfaces of her sculptural works allude to organic sources and reveal the artist's working processes. To create *Sans II*, Hesse collaborated with a plastics manufacturer to cast sixty box-shaped units in resin and fiberglass. She combined

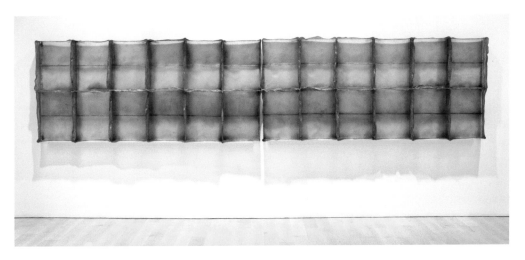

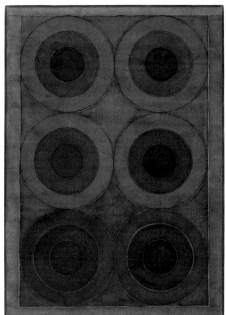

these elements into five groups of twelve boxes (the Whitney owns two of these) and positioned them in a row. Despite the rigidity of the untraditional materials, the boxes appear malleable and retain the incongruities of their making.

In the untitled 1969–70 scultpure, one of the last works she made before her death from cancer at the age of thirty-four, mutability itself operates as a key medium. To create this suspended work, Hesse had knotted ropes dipped into buckets of latex. When hung up to dry—an act that becomes part of the work's process of construction and informs its presentation— the viscous liquid either adhered to the twisted ropes' surfaces or dripped off, resulting in sections of tangled gnarls and sweeping loops. Hesse signaled her interest in such unpredictability in notes she made on a preparatory drawing: "hung irregularly tying knots as connections really letting it go as it will. Allowing it to determine more of the way it completes its self."

Sans II, 1968. Polyester resin and fiberglass, two parts: 38⅝ x 173 x 7½ in. (98.1 x 439.4 x 19.1 cm) overall. Purchase with funds from Ethelyn and Lester J. Honig and the Albert A. List Family 69.105a–b

No title, 1966. Ink wash on board, 9¾ x 7 in. (24.8 x 17.8 cm). Purchase with funds from David J. Supino in honor of his parents, Muriel and Renato Supino 87.51

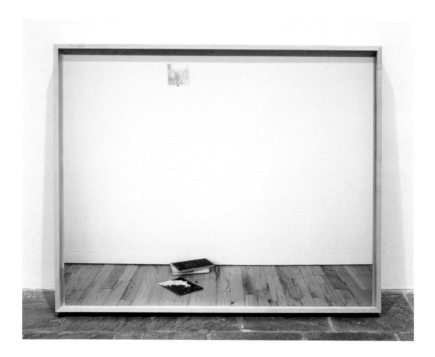

Leslie Hewitt's photographs and sculptures employ personal items and found objects to address notions of time, history, memory, and identity. Influenced by the French New Wave and Latin American Third Cinema movements of the 1960s and 1970s, she emphasizes personal narrative as a means to expose social and political issues, pointing to the techniques these filmmakers used to create a revolutionary visual language. Hewitt similarly pushes the boundaries of photography, questioning the structure of the medium and delving into its sculptural possibilities. "It's important to remind ourselves that photographic meaning isn't something that's produced by the artist or inherent in the subject," she has noted. "We're all actively involved in its negotiation, all the time."

One of seven photographs that comprise the *Blue Skies, Warm Sunlight* series, *Untitled (Myriad)* depicts a casual arrangement of books and a faded family snapshot pinned to the white wall. Barely discernable is a tattered copy of

Jerome H. Skolnick's *The Politics of Protest*—a 1969 report on protest movements that explored the role law enforcement played in the escalation of violence. She emphasizes the large-scale photograph's physical presence by exhibiting it in a wooden frame that rests on the floor and leans against a wall. Suggesting the ways in which personal and collective memories coexist, the image points to a specific time of social change in American culture while documenting a present moment; each photo in this series was taken in her studio as the light subtly changed over time.

Untitled (Myriad), 2011, from the series *Blue Skies, Warm Sunlight*. Chromogenic print, with wood frame, 52⅝ x 66⅜ x 5 in. (133.7 x 168.6 x 12.7 cm). Edition no. 2/3, 1 AP. Purchase with funds from the Photography Committee and the Painting and Sculpture Committee 2013.1a–b

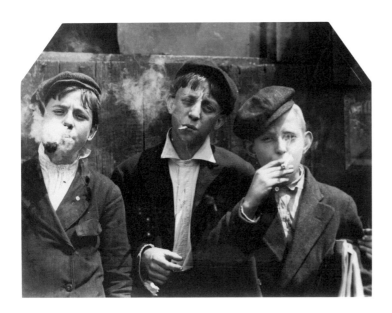

In the early years of the twentieth century, Lewis Hine explored the intersection of sociology, pedagogy, and photography. Following in the footsteps of the Danish journalist Jacob Riis, whose 1890 book *How the Other Half Lives* documented the conditions in New York slums in words and pictures, Hine believed photography to be a powerful tool for reform and the democratization of knowledge.

After studying sociology and education at the University of Chicago and Columbia University, Hine taught at New York's Ethical Culture School. In 1904 he began to document immigrants arriving at Ellis Island in photographs that demonstrate their common humanity. He soon became a photographer for numerous charity and social work agencies, as well as for the Pittsburgh Survey, a pioneering sociological investigation of an American industrial city.

In 1908 Hine became a photographer for the National Child Labor Committee (NCLC), founded in 1904 to promote legislative reform. The issue of industrialized labor was important to Hine, who had worked twelve-hour days at an upholstery factory before attending the University of Chicago. He spent more than a decade working for the NCLC, traveling the eastern United States photographing children working in mills and factories. He also frequently documented the newsboys, or "newsies," who sold papers in the street, often from the predawn hours until late into the night. Hine recorded this image on a weekday morning, indicating that these children are most likely not in school—which could lead, as the photograph of three smoking boys demonstrates, to the dangers and adult vices of the harsh city environment.

Newsies at Skeeters Branch, St. Louis, Missouri, c. 1910. Gelatin silver print, 3⅜ x 4⅜ in. (8.4 x 11 cm). Gift of Barbara Schwartz in memory of Eugene Schwartz 98.77.1

Jenny Holzer is widely known for the large-scale public displays of written language she creates in the form of illuminated electronic signs, posters, billboard advertisements, and projections on buildings. Like her contemporary Barbara Krueger, Holzer has explored multiple ways of disseminating commentary and ideas as visual objects in public spaces. Among her first public works were the *Truisms*, one-line aphorisms she wrote between 1977 and 1979 that originally took the form of posters wheat-pasted to buildings and walls around Manhattan. These thought-provoking, often contradictory statements distilled readings Holzer encountered as a student at the Whitney Independent Study Program. They were later printed on T-shirts and stickers, carved in granite benches, or remixed as part of the Internet art project *Please Change Beliefs*, started in 1995.

UNEX Sign #1 (Selections from The Survival Series) was among the first of Holzer's works to present such texts with LED (light-emitting diode) technology, a state-of-the-art means of public communication for government and institutional agencies in 1983. At that time,

the piece might have been mistaken for an electronic signboard transmitting ads, instructions, or public announcements. But the work's fifty-four statements and messages—simultaneously disturbing, cynical, and humorous—instead communicate private thoughts normally deemed inappropriate for public discourse, drawing attention to societal problems such as homelessness or issuing commands to viewers. In a media-saturated world in which news and ads flash by for passive viewers, Holzer uses this instrument of communication to call the viewer to attention, asking for a vigilant response and a close reading of cultural values, societal structures, and tensions between the public and private.

Statements from *UNEX Sign #1 (Selections from The Survival Series)*, 1983 (refabricated 2012). LED sign in powder-coated aluminum housing, 31⅛ x 106 x 12 in. (79.1 x 269.2 x 30.5 cm). Edition no. 1/3, 1 AP. Purchase with funds from the Louis and Bessie Adler Foundation Inc., Seymour M. Klein, President 84.8

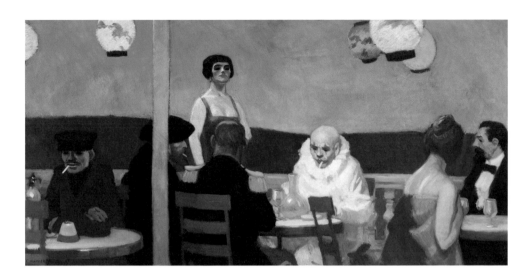

Edward Hopper was a keen observer of the everyday, which he transformed through his imagination into works of art that bear his signature tense, ambiguous atmospheres. A reflective and solitary man, he was deeply empathetic to the human condition and attuned to the relationship of the self to the world. Hopper was frequently inspired by the two locations in which he spent most of his time: downtown New York, where he lived and worked in the same rented apartment on Washington Square for most of his life; and Cape Cod, where, beginning in 1934, he maintained a second home and studio.

Hopper studied for several years at the turn of the twentieth century at the New York School of Art, most notably with the painter Robert Henri. Afterward, in 1906, he traveled to Paris for an extended stay and returned twice more, in 1909 and 1910; the city's culture exerted a strong and lasting influence on the artist. Hopper's early painting *Soir Bleu* reflects this influence, as well as his sophisticated and deep interest in art history: in this case Japanese prints, caricature, Impressionism, and Post-Impressionism. Though the characters here—including a well-dressed couple, a beret-clad man, a uniformed official, and a clown—are derived from sketches the artist made in Parisian cafes, their sense of alienation and disconnectedness is a quality Hopper made his own.

Back in New York, Hopper established his career as a chronicler of the modern urban experience. *New York Interior*, one such urban study, places the viewer in an odd position: just outside the window of an apartment, looking in at a woman who sits

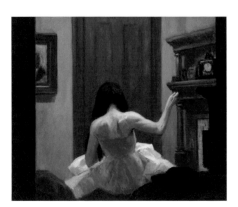

Soir Bleu, 1914. Oil on canvas, 36⅛ x 72 in. (91.8 x 182.9 cm). Josephine N. Hopper Bequest 70.1208

New York Interior, c. 1921. Oil on canvas, 24⅜ x 29⅜ in. (61.9 x 74.6 cm). Josephine N. Hopper Bequest 70.1200

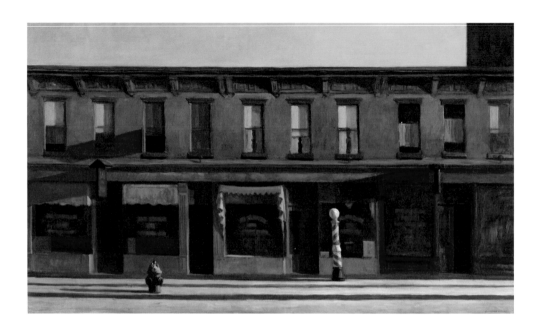

on her bed sewing with her back to us, unaware of our gaze. This unconventional view is both impersonal and yet unexpectedly intimate, reflecting the condition of life in densely inhabited spaces. The tension inherent in this voyeuristic perspective was likely inspired by the experience of riding the city's elevated train lines, a vantage point Hopper appreciated and used for inspiration in other works.

Hopper's earliest important exhibitions were held at the Whitney Studio Club, and his ties to the Whitney Museum deepened over the course of his career. Indeed, his masterpiece *Early Sunday Morning,* acquired just a few months after it was finished, would become part of the Museum's founding collection. The Seventh Avenue building on which the painting was based was a short walk from Hopper's studio. Although he described the composition as "almost a literal translation" of a specific two-story building, he nonetheless changed some of its features. In compressing the doorways and spacing the windows with subtle irregularity, he bestowed the scene with a tension it lacked in reality. In addition he obscured the

letters printed on the first-floor shop windows to the point of illegibility, a decision that purposefully undermines the viewer's ability to identify the businesses. Hopper's keen interest in the quality of sunlight is also evident here in the play of shadows across the surfaces of the building, street, and sidewalk. Demonstrating a potent force of its own, the light even seems to tilt the sidewalk barber's pole off its vertical axis.

Painted more than a decade later, Hopper's most acclaimed composition, *Nighthawks* (1942), also references his downtown neighborhood. Indeed, the same building type that Hopper featured in *Early Sunday Morning* reappears in the background of this work. The Whitney

Study for Nighthawks, 1941 or 1942. Fabricated chalk and charcoal on paper, 11⅛ x 15 in. (28.3 x 38.1 cm). Purchase and gift of Josephine N. Hopper by exchange 2011.65

Early Sunday Morning, 1930. Oil on canvas, 35¼ x 60 in. (89.5 x 152.4 cm). Purchase with funds from Gertrude Vanderbilt Whitney 31.426

Seven A.M., 1948. Oil on canvas, 30¼ x 40⅛ in. (76.8 x 101.9 cm). Purchase and exchange 50.8

owns seventeen of the nineteen known studies for *Nighthawks*, including this finished drawing that includes all the main elements of the final painting but places the spectator in a slightly lower viewing position. This famous fictional diner was partly inspired by a series of corners on Greenwich Avenue—past which the artist frequently walked—where diagonal streets meet in triangles.

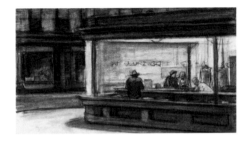

Hopper's well-known interest in capturing the mood and characteristics of light has justifiably become one of the most celebrated attributes of his art and is especially apparent in his Cape Cod works. In *Seven A.M.*, the artist invented the painting's subject based on his familiarity with the local landscape, creating this surreal pairing of foreboding, silent woods and a nearly empty storefront. Hopper carefully synthesized what he saw in life to create his uncanny paintings, where memory itself is often the underlying subject. The artist was also a master of narrative ambiguity—it is unclear what kind of store this is or what might be sold there. He intentionally left the subjects of his paintings unresolved, even as he remained sensitive to the nuances of implication.

In one of his last paintings, *A Woman in the Sun*, Hopper omitted many visual

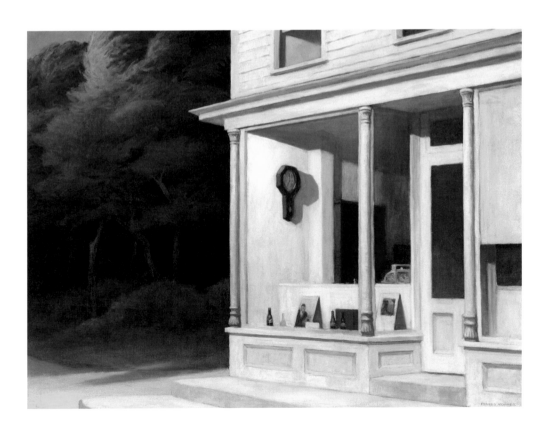

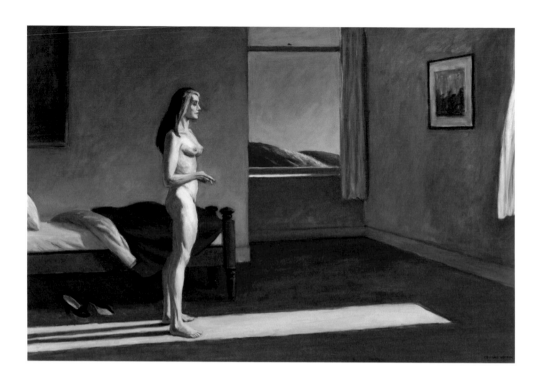

A Woman in the Sun, 1961.
Oil on linen, 40⅛ x 60¼ in.
(101.9 x 153 cm). 50th
Anniversary Gift of Mr. and
Mrs. Albert Hackett in
honor of Edith and Lloyd
Goodrich 84.31

details and focused instead on the psychological reality of his subject. A nude woman stands smoking a cigarette in a sparsely decorated bedroom. The voyeuristic, almost cinematic imagery suggests a narrative, enticing the viewer to imagine the events that may have occurred prior to the scene pictured and also to wonder what will happen next. Hopper's wife, Josephine Nivison Hopper, served as the model for this figure, as she did for many of the women depicted in his compositions. She was seventy-eight at the time this work was created, but rather than faithfully adhering to realistic detail Hopper transformed her— just as he altered details of the work's Cape Cod setting—according to his own internal vision. Standing in the raking afternoon light that floods the room, her naked body meets the rays as if seeking purification, redemption, or absolution.

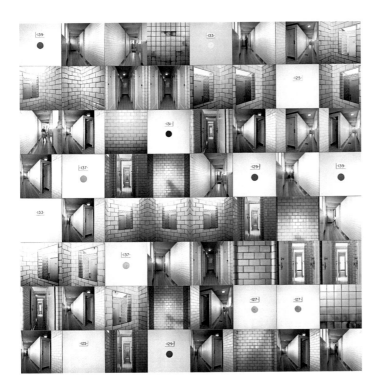

Since the mid-1970s, Roni Horn has produced a visually rich body of work that includes sculpture, drawing, photography, and artist's books—a diverse corpus that often proves difficult to categorize. Geometric sculptures cast in metal, plastic, or glass echo the rigorous, abstract forms and industrial fabrication processes associated with Minimalism. Yet Horn is also concerned with how objects respond to each other and to their sites of display, and is significantly more invested in the affective qualities of her subjects than were many of her predecessors in the late 1960s.

The sixty-four individual photographs that comprise *Ellipsis (II)* record the mazelike spaces inside the changing rooms of an indoor public pool in Reykjavík, Iceland, a country Horn has visited regularly since 1975. The large-scale grid of black-and-white photographs juxtaposes cropped views of the space's tiled walls, which curve around corners to form continuous surfaces; deep vistas of its receding corridors, on occasion occupied by a towel-wrapped swimmer; and close-ups of its numbered doorways. Oversized peepholes in the doors and reflections in mirrors of the edgeless tiles add to the work's sense of voyeurism. No single print could describe the locker room's labyrinthine design. Rather, as Horn explained, "In *Ellipsis* you don't really see what you're looking at until you've seen it all, until you've looked at all of the sixty-four photographs. In the cumulative differences and similarities of the images and in the search it poses—the experience of the original space unfolds."

Ellipsis (II), 1998. Sixty-four inkjet prints, 12 x 12 in. (30.5 x 30.5 cm) each; 96 x 96 in. (243.8 x 243.8 cm) overall. Purchase with funds from the Photography Committee, Anne and Joel Ehrenkranz, and the Contemporary Painting and Sculpture Committee 2001.13a–lll

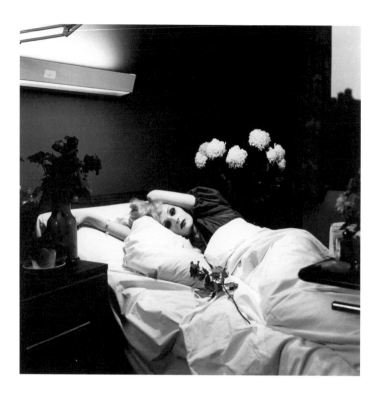

During the period from the early 1970s, when he left the field of commercial photography in which he had worked for two decades, until his death, Peter Hujar produced a poignant body of black-and-white photographic work. His themes encompassed landscapes, interiors, and still lifes, but he is best known for his portraiture. In his East Village loft, Hujar documented the artists, writers, musicians, and performers of the era's demimonde in moments of repose and candor. Some subjects are unknown, and others eminent—among them Andy Warhol, Susan Sontag, William Burroughs, and Hujar's partner, the artist David Wojnarowicz. Without a trace of pretense or artifice, Hujar captures something of each sitter's essence or personality. This intimacy is rendered all the more affecting by the elegant formal precision of his compositions, which often evoke classical sources.

Candy Darling on Her Death Bed pictures the transgender actress Candy Darling, a downtown denizen and member of Andy Warhol's coterie who was a muse to artists and musicians. Hujar shot this photograph of Darling in bed at a Manhattan hospital shortly before her death in 1974, at the age of twenty-nine, from Hodgkin's lymphoma. Ringed by flowers, she appears at once resigned and serene, her fragile beauty still intact; as the philosopher of art Arthur Danto wrote, Hujar "has photographed her the way she would have wanted to be shown." Mortality and death would become more explicit concerns in Hujar's work in the 1980s as many of his friends and fellow artists suffered from HIV; in 1987 he died of an AIDS-related illness.

Candy Darling on Her Deathbed, 1973. Gelatin silver print, 14¾ x 14¾ in. (37.5 x 37.5 cm). Purchase with funds from the Photography Committee 93.75

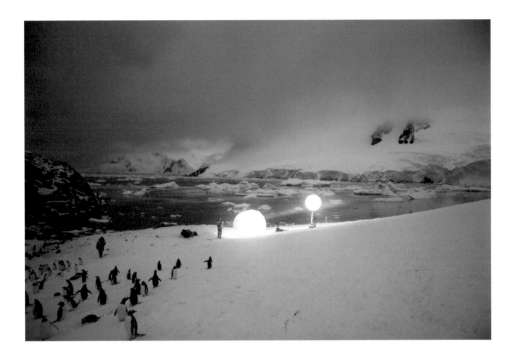

Pierre Huyghe rose to prominence during the 1990s, when many conceptual artists were exploring relational aesthetics, an approach that emphasized the creation of participatory experiences rather than the production of discrete art objects. Huyghe constructs situations that draw attention to the human condition and our place in the world in work that often exists simultaneously in multiple forms, including research projects, staged events, and film or video documentation.

Many of Huyghe's narratives blur the distinctions between reality and fantasy. His *A Journey That Wasn't*, which premiered at the 2006 Whitney Biennial, is part documentary film and part reenactment. Slipping nimbly between fact and fiction, it represents the artist's journey to Antarctica and his search for a species of albino penguin rumored to exist on a glacial island. While in the antarctic Huyghe encountered islands of ice that had detached from the main continent due to global warming and he translated this shifting topography into pulsing signals of light based on Morse code. These signals were later used by the composer Joshua Cody as the basis for an original orchestral piece performed at an ice skating rink in New York's Central Park. In the resulting film, scenes from the musical performance punctuate documentary footage of the artist's voyage resulting in a series of poetic juxtapositions and a film that plumbs the translation from experience to documentation and documentation to artistic form.

Still from *A Journey That Wasn't*, 2005. Super 16mm film and high-definition video transferred to high-definition video, color, sound; 21:41 min. Edition no. 2/7, 2 AP. Purchased jointly by the Whitney Museum of American Art, New York, with funds from the Painting and Sculpture Committee; and Walker Art Center, Minneapolis, T. B. Walker Acquisition Fund, 2006 2006.349

Like many of his Pop art contemporaries in the early 1960s, Robert Indiana turned to advertising and consumer culture as subjects for his art. Growing up in small-town Indiana, the artist became fascinated by Americana and unabashedly embraced his homespun Midwestern roots—even changing his given surname, Clark, to that of his home state in 1958. In his dynamic, brilliantly colored paintings, Indiana drew on the language of highway signs, restaurant billboards, and roadside entertainments.

The X-5, composed as an X-shaped structure reminiscent of the warning signs found at railroad crossings, was one of five works that comprised the fifth suite of Indiana's series of American Dream paintings. In this suite, Indiana paid homage to an earlier painting: Charles Demuth's I Saw the Figure 5 in Gold (1928). Demuth's image, itself inspired by a poem by Williams Carlos Williams, records the impression of

seeing a fire engine inscribed with the numeral 5 racing down a New York street. Demuth's bold decision to use the enlarged, crisply articulated figure 5 as the centerpiece of his composition represented, for Indiana, a "modern step" that presaged his own experiments with words and numbers. In The X-5 Indiana creates a complex geometric configuration by layering Demuth's 5 over other forms that allude to the number 5—stars and pentagons—and by repeating the image on five panels that are joined together. The X-5 is Indiana's first canvas composed exclusively in grisaille tones, which he would continue to employ on future occasions as an alternative to his normally vibrant palette.

The X-5, 1963. Oil on linen,
five panels: 101¾ x 102 in.
(258.4 x 259.1 cm) overall.
Purchase 64.9a–e

In the 1960s Robert Irwin set about creating works of art that explored the physical experience of looking. Like many of his Los Angeles peers in what came to be known as the Light and Space movement, he had become increasingly interested in optical effects and the mechanics of perception as well as in the use of industrial and technological processes as a means to investigate these phenomena. Irwin's series of untitled "disc" works, begun in 1966, continued the project of his earlier perceptual "dot" paintings. Both series represented a radical desire to "eliminate imagery in favor of physicality" and an attempt to escape the limitations set by the rectangular frame of painting.

 In this untitled work, a circular, convex aluminum disc, sprayed with matte acrylic paint in barely perceptible concentric rings and attached to an armature, appears to hover in space about twenty inches from the wall. Four precisely positioned spotlights cast circular, overlapping shadows that expand the area of the work by appearing to dissolve the boundary between the disc and the wall behind it. "The key," Irwin explained, "was for the edge to become lost in its own shadows." In effect, the wall becomes part of the work, which in turn "does not begin and end at an edge but rather starts to take in and become involved with the space or environment around it." Irwin's interest in expanding the parameters of the artwork through perceptual and sensory experiments would continue to develop with environmental installations that employ natural light filtered through delicate fabric scrims and what he has called "site-conditioned" landscape works.

No title, 1966–67. Acrylic on aluminum, with four lights, dimensions variable. Purchase with funds from the Howard and Jean Lipman Foundation Inc. 68.42a–e

In the New York art world of the late 1960s, Neil Jenney, who began his career making sculpture, faced a scene dominated by the austerity of Minimalism and the slick, post-Pop imagery of Photorealism. Wishing to challenge the classicizing aesthetics of the latter, which he considered "a bad idea done pretty," Jenney abandoned his work in sculpture and turned to figurative painting. *Threat and Sanctuary* is part of a series of paintings that Jenney completed in the late 1960s and early 1970s for which he made deliberate use of thinly applied, visible brushstrokes of pigment, underscoring the artist's desire to "never avoid the realization that I was using paint . . . I wanted to emphasize it." He described his new works as "good ideas done badly," heralding what would later be referred to as "Bad Painting"—a category that included Jenney's work as well as that of artists such as Joan Brown and William Wegman.

His paintings frequently addressed contradictory ideas or relationships; in *Threat and Sanctuary* a lone figure swims toward a life raft amid three encroaching predatory sharks. Jenney's composition is painfully humorous in its paradox though he has stated he is interested in the relationships between objects rather than narrative, because, as he explained, "I think that is what realism deals with—objects relating to other objects." Jenney crafted deep black frames for his paintings to enhance their illusionism and added their titles to the wooden component, usually two nouns conjoined by the word "and." The associations prompted by the combination of words and image hints at Jenney's connection to Conceptual approaches.

After 1970, Jenney turned to making his so called "good paintings"—finely wrought studies of the natural world that suggest a wry allegorical commentary on humankind's interaction with the environment.

Threat and Sanctuary, 1969. Oil on canvas, with wood frame, 61 x 123¼ x 3¼ in. (154.9 x 313.1 x 8.3 cm). Gift from the Emily Fisher Landau Collection 2012.175a–b

A San Francisco Bay Area artist who came to prominence working alongside artists and writers of the Beat Generation in the 1950s, Jess (Collins) created figurative paintings with a literary sensibility. Trained as a chemist, he worked on producing plutonium for the Manhattan Project during World War II before dropping his surname and enrolling at the California School of Fine Arts (now the San Francisco Art Institute), where he studied under painters Clyfford Still, Hassel Smith, Elmer Bischoff, and David Park. His long-term romantic partnership with Beat poet Robert Duncan, whom he met in 1951, served as great artistic inspiration; the two often collaborated, with Jess's artwork accompanying Duncan's poems.

Jess is known for his collages, which he referred to as "paste-ups," a term that references the media and advertising culture of the time. *Tricky Cad, Case 1*, in which individual panels from Chester Gould's *Dick Tracy* comic strips have been cut up and rearranged, is an early paste-up that references Pop art, Dada collage, and the experimental cut-up poetry that William Burroughs would produce later in the 1950s. Jess reordered the plots and relettered the dialogue of the comics, but made no additions. As the original narrative breaks down, a strange poetry emerges. In an introduction to the series, Jess referred to the project as "a demonstration of a hermetic critique self-contained in popular art." This critique, however, is infused with a playful sensibility. Jess transforms the deconstructed comic strip into a riddle that demonstrates the unexpected potential for poetics in pop culture.

Detail of *Tricky Cad, Case 1*, 1954. Twelve collages mounted on pages of found notebook, with handwritten title page and blank end pages, 10¼ x 9⅜ in. (26 x 23.8 cm) each. Purchase with funds from the Contemporary Painting and Sculpture Committee, the Drawing Committee, and the Tom Armstrong Purchase Fund 95.20

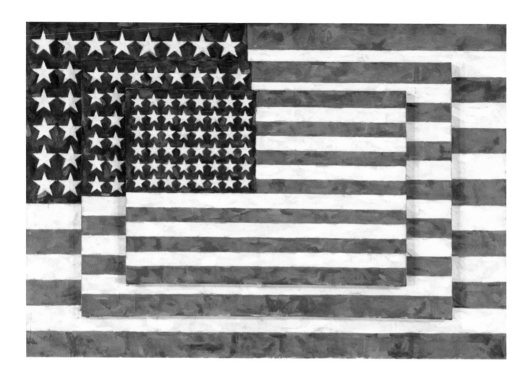

In the mid-1950s, Jasper Johns began making paintings of recognizable objects and images, including the American flag, targets, and numbers. As the artist explained, these subjects are "things the mind already knows," things that are "seen but not looked at, not examined." In 1954, Johns had a dream that he painted the American flag. He carried out the idea for the first time a year later, and in 1958 he completed *Three Flags*, arranging three canvases in a concentric stack. He used encaustic, a fast-drying mixture of pigment suspended in warm wax, to accumulate brushstrokes and achieve an agitated, textured surface. Projecting almost five inches from the wall, the work signals, as Johns asserted, that "the painting of a flag is . . . no more about a flag than about a brushstroke, or about the physicality of paint," or, he might have added, about the painting's physicality as an object.

Johns often reworks motifs in various mediums—a prime example of this is a

Savarin, 1982. Lithograph and monotype: sheet, 50 x 38⅛ in. (127 x 96.8 cm); image, 41 x 29½ in. (104.1 x 74.9 cm). Edition no. 1/3. Gift of The American Contemporary Art Foundation Inc., Leonard A. Lauder, President 2002.231

Racing Thoughts, 1983. Encaustic, screenprint, and wax crayon on collaged cotton and linen, 48⅛ x 75¼ in. (122.2 x 191.1 cm). Purchase with funds from the Burroughs Wellcome Purchase Fund; Leo Castelli; the Wilfred P. and Rose J. Cohen Purchase Fund; the Julia B. Engel Purchase Fund; the Equitable Life Assurance Society of the United States Purchase Fund; The Sondra and Charles Gilman Jr. Foundation Inc.; S. Sidney Kahn; The Lauder Foundation, Leonard and Evelyn Lauder Fund; the Sara Roby Foundation; and the Painting and Sculpture Committee 84.6

Three Flags, 1958. Encaustic on canvas, 30⅝ x 45½ x 4⅝ in. (77.8 x 115.6 x 11.7 cm). Purchase with funds from the Gilman Foundation Inc., The Lauder Foundation, A. Alfred Taubman, Laura-Lee Whittier Woods, Howard Lipman, and Ed Downe in honor of the Museum's 50th Anniversary 80.32

a haunting self-portrait by Edvard Munch in which Munch depicted his face and shoulders hovering above a skeletal arm. Johns added the initials *E. M.*, incorporated an imprint of an arm, likely his own, and deployed the brush-filled can as his visage. Eleven of the impressions rejected from the 1981 edition were then used by Johns as the basis for a new series of monotypes— among them, the Whitney's *Savarin*.

In the early 1980s Johns started to render perspectival space in his paintings. For *Racing Thoughts*, Johns used trompe-l'oeil illusionism to "tack" and "tape" personal mementos, both depicted and actual, to the painting's surface. The complex layering of imagery is set in the bathroom at his former home (note the faucet at bottom right and the khaki pants hanging at left). Like the flags and numbers, these new motifs— Johns calls them "fragments of thoughts"— such as a lithograph by Barnett Newman, a pot by the ceramicist George Ohr, and a jigsaw puzzle portrait of his dealer Leo Castelli, would recur in subsequent works.

paintbrush-filled Savarin coffee can from his studio. An image of the can was used by Johns in a lithograph announcing his 1977 retrospective at the Whitney, and then in 1981 he adjusted the composition to invoke

William H. Johnson

b. 1901; Florence, SC
d. 1970; Central Islip, NY

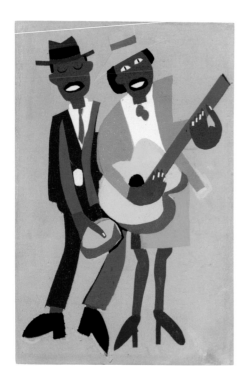

William H. Johnson used the language of modernist abstraction to create images of African American life in the 1930s and 1940s. Moving from his native South Carolina to New York in 1918, at the age of seventeen, Johnson settled in the city's flourishing Harlem neighborhood. After studying at the National Academy of Design from 1921 to 1926, Johnson spent more than a decade living in Europe—first in France, followed by Denmark and Norway—where he felt he could achieve greater success as an African American artist. During these years, he assimilated the lessons of avant-garde European modernism and began working in a bold expressionist style. Johnson returned to New York in 1938 and began teaching at the Harlem Community Art Center, which was a focal point for the burgeoning art scene in Harlem during the 1930s. In the Center's print studio, Johnson learned how to make screenprints, a medium that encouraged him to move away from his expressionist style toward a pared-down, planar language rooted in folk traditions.

An example of this new approach, *Blind Singer* utilizes flattened planes of vibrant, unmodulated color to capture the rhythms of daily life in Harlem. Here, Johnson portrays one of his favored subjects of this period: the lively musicians and dancers he encountered on the city streets. Such subjects also reflect Johnson's interest in the writings of his friend Alain Locke, the philosophical leader of the Harlem Renaissance, who exhorted African American artists to find inspiration in the life and culture of their own people.

Blind Singer, c. 1942.
Screenprint, 17½ x 11⅝ in.
(44.5 x 29.5 cm). Purchase
with funds from the
Print Committee 95.53

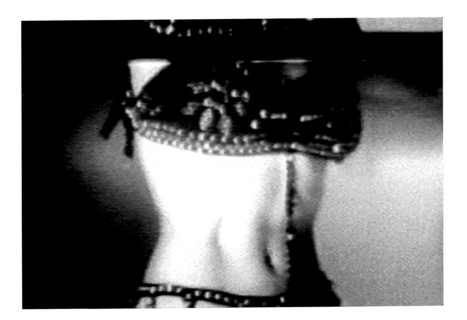

In the experimental climate of the late 1960s and early 1970s, artists used the moving image to extend their sculptural practice into a time-based form, using film, video, and performance. Joan Jonas produced some of the most important works of the period in these mediums, among them *Vertical Roll*, widely considered a seminal work of single-channel video.

In *Vertical Roll*, Jonas videotapes a television monitor, which plays a video of her performing in front of the camera. The image of the performance is disrupted by the black bar of the video monitor's vertical hold scrolling down in a staccato motion, repeatedly detaching the image for a fraction of a second, in a relentless rhythm that evokes the act of blinking. Each "blink" offers a fleeting glimpse of Jonas's body as she performs a series of gestures in front of the camera, wearing a mask, a feathered headdress, a belly dancer's costume, or nothing at all. Legs, fabric, mask, face, and arms appear in a series of tantalizing flashes, constructing a body that continuously slips away from our visual grasp.

The rhythm of the images is further punctuated by the sound of Jonas banging a silver spoon on a mirror and then clapping two blocks of wood together repeatedly, in a reference to Japanese Kabuki theater. At the end of the video, the artist moves her head in front of the persistently blinking image, revealing that the camera is recording not only Jonas, but also the monitor on which her performance appears. She uses the properties of the video camera to present herself and the process of recording as a sequence of fragments, suggesting the impossibility of reading identity as something singular and unified.

Still from *Vertical Roll*, 1972. Video, black-and-white, sound; 19:38 min. Purchase with funds from the Film and Video Committee 2000.189

Donald Judd

b. 1928; Excelsior Springs, MO
d. 1994; New York, NY

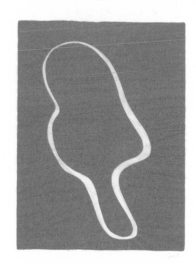

In groundbreaking critical and theoretical writings he published in the early 1960s, Donald Judd was an early and articulate advocate for what would become known as Minimalism, though he preferred the term "Specific Objects" to convey that the primary significance of this new work was its physical existence, not any external reference. Judd studied philosophy, art, and art history at the Art Students League and at Columbia University, and his earliest works, including paintings and woodcuts such as *Untitled (S.22)*, were simplified abstractions. But by late 1961 Judd gave up painting for sculpture— or, rather, unified the two mediums in a new hybrid: rectangular structures of painted wood or metal that hung on the wall and projected into space.

Soon he arrived at his signature modular form: a cantilevered, vertical stack of boxes or series of brackets, set like the rungs of a ladder, that project from the wall, or horizontal progressions of boxes

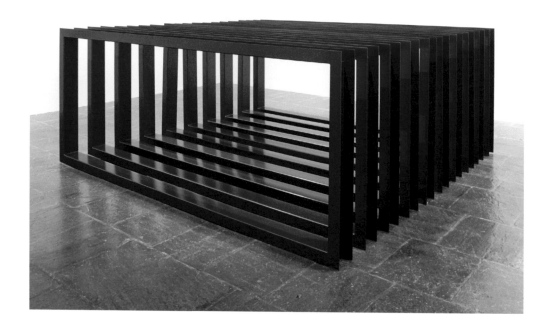

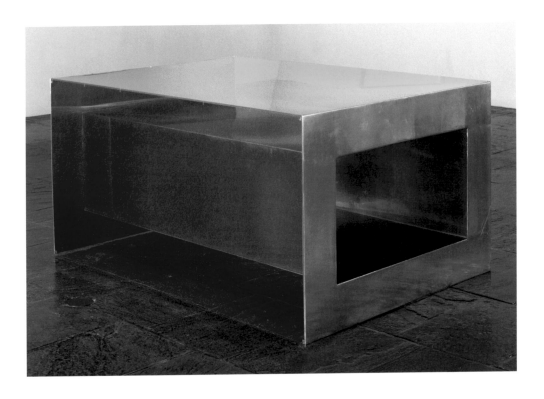

attached to a beam and arranged according to mathematical principles. Rejecting the illusionism of traditional painting, Judd explained that "actual space is intrinsically more powerful and specific than paint on a flat surface."

Most of Judd's output after 1964, and much of the work of other Minimalists such as Carl Andre, Robert Morris, and Dan Flavin, was industrially fabricated, absenting any trace of the artist's hand and, with it, the notion of singularity. Judd worked with a range of materials, including steel, iron, brass, and copper, and often placed his sculptures directly on the floor to better engage the space—and the people—around them.

The deep cerulean hue and large-scale installation of the ten identical, open steel rectangles that constitute *Untitled* (1966) command spectatorial attention. As with this sculpture, Judd often staggered the intervals between his geometric units with precise spacing in order to emphasize

what he called "the thing as a whole" rather than the constituent parts.

The Day-Glo orange plexiglass sides and top of *Untitled* (1968) reflect surrounding lights, creating a dramatic contrast to the dark hollow of its stainless steel interior. Whereas in traditional sculpture we are left to imagine what fills an interior, in Judd's work what he called "actual space" is directly visible, both that of the enclosed volumes and the hollow inside.

Untitled (S.22), 1960–61 (printed 1978). Woodcut with watercolor: sheet, 25⅞ x 20⅞ in. (65.7 x 53 cm); image, 21 x 16 in. (53.3 x 40.6 cm). Edition no. 3/25. Purchase with funds from the Print Committee 98.41.2

Untitled, 1966. Painted steel, ten parts: 48 x 120 x 6½ in. (121.9 x 304.8 x 16.5 cm) each; 48 x 120 x 120 in. (121.9 x 304.8 x 304.8 cm) overall. Gift of Howard and Jean Lipman 72.7a–j

Untitled, 1968. Stainless steel and plexiglass, 33 x 68 x 48 in. (83.8 x 172.7 x 121.9 cm). Purchase with funds from the Howard and Jean Lipman Foundation Inc. 68.36

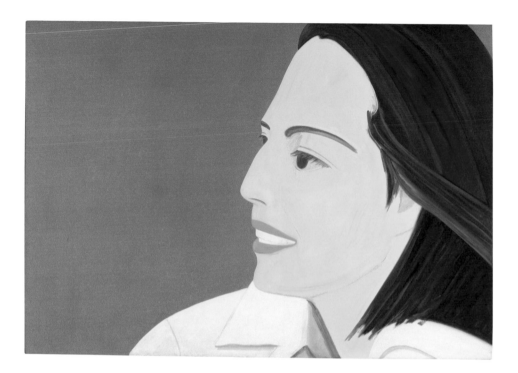

For more than sixty years Alex Katz has remained dedicated to figurative art in his paintings, sculptures, and works on paper, despite the influence—and, at times, dominance—of abstraction since the postwar era. In 1957 Katz met Ada Del Moro; they married the following year, and she became one of the most frequent subjects of his paintings. Their relationship began during a period of artistic transition for Katz following several years of making small-scale collages. He has recalled how he came to abandon these works for what would become his signature painting style: "I said that if I enlarged them to six feet then I could be very successful, but it was much more interesting to try to paint a contemporary portrait."

Prior to beginning the large-scale work *The Red Smile*, Katz made several preparatory drawings as well as smaller versions of the painting. This drafting process and its results recall the work of the "Old Masters" of Renaissance and Baroque art rather than the spontaneous, abstract compositions of many of Katz's peers. As Katz himself has explained, he also shares with his fifteenth- and sixteenth-century artistic predecessors a desire to "search for beauty" in the visible world around him.

Evocative of a billboard advertisement or a film still, *The Red Smile* is a tightly cropped portrait of the head and shoulders of Ada, clad in a white shirt and blue headscarf. Her broadly smiling profile fills half of the horizontally oriented composition. With her distinctive fair skin and dark hair and eyebrows, she is as recognizable across Katz's many paintings of her as are his signature expanses of flat, crisply delineated color.

The Red Smile, 1963. Oil on canvas, 78⅞ x 115 in. (200.3 x 292.1 cm). Purchase with funds from the Painting and Sculpture Committee 83.3

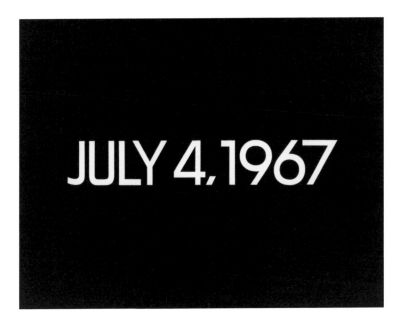

Conceptual artist On Kawara's practice is marked by a preoccupation with the measurement of time as an illustration of human existence. In the mid-1960s Kawara initiated a number of temporal and diarizing projects, including a series of telegrams and postcards sent from his travels to associates confirming "I Am Still Alive" and "I Got Up."

The earliest and longest-running such project was the *Today* series, also called the *Date Paintings*, which Kawara began in January 1966 and continued until late 2013. He made thousands of these paintings—each taking eight or nine hours to complete—by creating a dense surface of acrylic paint and hand-drawing letters and numbers to spell out a single date that constitutes the title of the work. Kawara's self-prescribed rules dictated that each painting be completed within a single day or destroyed, and established parameters for the size, orientation, color palette, and text. Each work also includes a handmade storage box, which since late 1966 the artist has lined with news clippings for that date from the city in which he made the

painting. Such simple and rigid formulas belie the complexity and physical intensity of the task Kawara set out for himself, cataloging his days through his own mechanical labor.

July 4, 1967 is an early example from the series, aptly subtitled by the artist "Independence Day." Yet what we learn through the clippings from a New York tabloid is simply the quotidian news of births, deaths, and sports scores. That these everyday events exist within the subjects of his paintings—days, months, and years— hold up Kawara's project and repetitive process as a meditation on living and dying.

JULY 4, 1967, 1967, from the series *Today*, 1966–2013. Acrylic on canvas, 13 x 17 in. (33 x 43.2 cm). Purchase with funds from the Painting and Sculpture Committee 2014.150

Mike Kelley

b. 1954; Detroit, MI
d. 2012; South Pasadena, CA

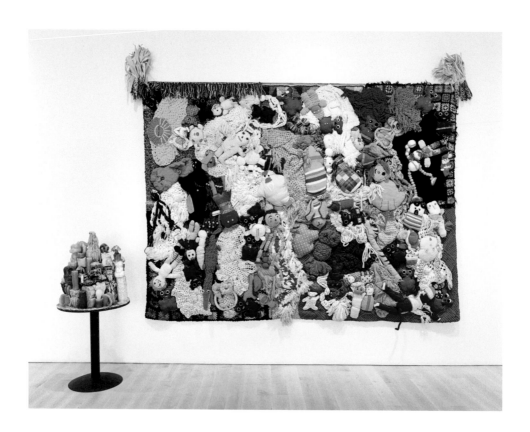

More Love Hours Than Can Ever Be Repaid and *The Wages of Sin*, 1987. Stuffed fabric toys and afghans on canvas with dried corn and wax candles on wood and metal base, 120¾ x 151¾ x 31¾ in. (306.7 x 385.4 x 80.6 cm) overall. Purchase with funds from the Painting and Sculpture Committee 89.13a–d

Educational Complex, 1995. Acrylic, latex, foam core, fiberglass, and wood, 57¾ x 192¼ x 96⅛ in. (146.7 x 488.3 x 244.2 cm). Purchase with funds from the Contemporary Painting and Sculpture Committee 96.50

Mike Kelley produced some of the most influential art of the late twentieth century, developing radical content and hybrid forms across a range of artistic mediums. Kelley's art draws from elements of his teenage years in working-class Detroit in the late 1960s—the politics of hippies and feminists, Catholicism, rock and roll, and underground comics—and later, while a student at the University of Michigan in the early 1970s, from the local music scene of poet Jon Sinclair of the MC-5s, and Iggy Pop. To these cultural influences was added the conceptually oriented training he encountered after relocating to Southern California in 1976 to study at the California Institute of the Arts. The resulting amalgam is a distinctive body of work appropriated from high and low American culture—at once subjective, intellectual, poetic, funny, and highly transgressive.

A complex, subversive, and moving commentary on art and human relations, *More Love Hours Than Can Ever Be Repaid* is a wall sculpture composed of crocheted dolls and stuffed animals sewn into old afghan blankets that are in turn attached to canvas. It is accompanied by the sculpture *The Wages of Sin*, a shrinelike arrangement of half-burned candles resting on a café table. Scavenging his materials from Los Angeles thrift stores, Kelley saw these objects as an expression of the relational economy between adults and children, in which the child becomes an innocent recipient of an adult's overdetermined actions. Extending the metaphor to art itself, the colorful, allover composition of the assemblage further refers to the drip paintings of the Abstract Expressionists. Here, however, Kelley has replaced the professed male existential energy of such work with a feminine alternative, exemplified by pattern-based craft materials and the fetishized objects of childhood and domesticity.

Educational Complex is a tongue-in-cheek reflection on the artist's academic background; a seemingly rational-looking architectural model, the sculpture purports to be a re-creation of all the places Kelley studied, beginning with his Catholic elementary school. In fact, the artist couldn't remember the spatial configuration of some of those places, and so turned to the pop-psychology theory of repressed memory to suggest that the lapses were due to traumatic events that had occurred there. The model's blank spaces indicate where these imagined traumas might have transpired.

Using a pared-down vocabulary and a deeply honed instinct for perceptual nuance, Ellsworth Kelly has continuously explored the tensions and balances he can cull from edge, shape, line, and color. He studied at the Pratt Institute in New York and, after a stint in the Army, at the School of the Museum of Fine Arts, Boston. Kelly developed his approach to abstraction while living in Paris from 1948 to 1954. His large-scale paintings and sculptures question the boundaries between the two categories. Using flat, unmodulated expanses of solid color, black, or white, Kelly explores the taut relationships that arise among space, architecture, and form within his distilled play of edges.

Kelly's art is almost always a retranslation of what he has found by looking carefully at the world. "All my work comes from perceiving," he has said. He painted the monumentally scaled *Atlantic* in New York and derived its curving,

wavelike rhythm from a sketchbook in which he traced and filled in the shadows that moved across its pages while he was seated on a bus. The facing pages of the book and its central fold are mirrored in the painting's diptych structure, although Kelly has rendered the shadows as white forms against a black ground. Perhaps the artist's greatest mastery lies in his ability to recognize in the seemingly slight events the world presents him a potential for shifting and refining qualities of formal weights and balances into striking and powerful abstractions.

Atlantic, 1956. Oil on canvas, two panels: 80⅛ x 115⅜ in. (203.5 x 293.1 cm) overall. Purchase 57.9a–b

A Sister of the Immaculate Heart of Mary, Corita Kent graduated from Los Angeles's Immaculate Heart College in 1941 and received a MFA in art history from the University of Southern California in 1951. From 1964 to 1968 she headed the art department at Immaculate Heart College, garnering a progressive reputation for the program. In vibrant serigraphs and screenprints produced during the 1960s and 1970s, Kent demonstrated a deep political and social engagement: a strong antiwar sentiment and equally strong support of the civil rights movement, but also a belief in effective communication and creative pedagogy. Many works from this period incorporate quotations and slogans collected from a range of literary, biblical, and pop culture sources.

Works such as *HA* demonstrate an interest not only in the meaning of words but in their sound and their shape on the page. *HA* includes the word *LIFE*, appropriated from the masthead of the magazine but rendered upside down and in reverse, while the rest of the letters appear distorted. The letters hover between their appearance as abstract shapes and their resolution into recognizable signifiers. Kent cited the modernist architect and designer Charles Eames and the nonfigurative possibilities of Abstract Expressionist painters such as Mark Rothko as influences. The legibility of her prints attracted an audience looking for accessible meaning, Kent explained, but her graphic and colorful style would also introduce them to ideas about form and encourage them to understand the visual message.

HA, 1966. Screenprint: sheet, 29¾ x 36⅛ in. (75.6 x 91.8 cm); image, 22⅛ x 36⅛ in. (56.2 x 91.8 cm). Purchase with funds from the Print Committee 2007.44

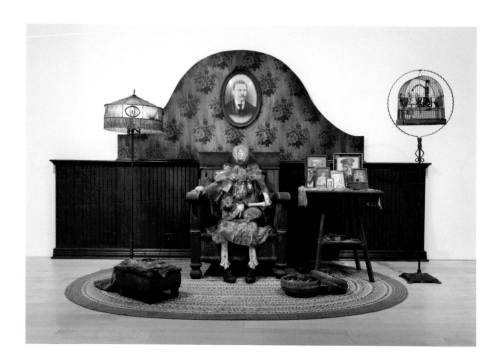

In 1953 Edward Kienholz moved to Los Angeles, where he was instrumental in the development of the city's burgeoning art scene and helped to found the Ferus Gallery, a crucial venue for the nurturing of West Coast assemblage, funk, and Pop art. Kienholz's early work from the 1950s consisted of relief paintings made by nailing scraps of wood to a support and spreading industrial paint across their surfaces with a broom. By 1958 these developed into freestanding, three-dimensional assemblages and, by 1961, into the large-scale, life-sized sculptural installations he called "tableaux," for which he is best known. The components of these tableaux were mainly found or discarded materials that the artist scavenged from the street, junk stores, and flea markets—commonplace, even down-at-the-heels elements that nonetheless combined to provide commentary on such significant issues as war, crime, sexuality, religion, and racism.

 The Wait, one of Kienholz's most affecting and morbid tableaux, addresses the subject of aging and the loneliness and decay that can accompany it. Its centerpiece is the figure of an elderly woman, her body shaped from cow bones and her face replaced by a glass jar sporting a photograph of a young visage on the front and an animal skull inside. Photographs on a nearby table and mementos encased in a necklace of glass canning jars offer poignant reminders of earlier, happier times, while the chirping of a live, caged parakeet underscores the decrepitude of the rest of the scene. The woman is alone with her sewing basket and a taxidermic cat; "the wait" named in Kienholz's title is an anticipation of death.

The Wait, 1964–65. Tableau: wood, fabric, polyester resin, flock, metal, bones, glass, paper, leather, varnish, gelatin silver prints, taxidermic cat, live parakeet, wicker, and plastic, 80 x 160 x 84 in. (203.2 x 406.4 x 213.4 cm) overall. Gift of the Howard and Jean Lipman Foundation Inc. 66.49a–m

Karen Kilimnik's witty, fantasy-driven, celebrity-obsessed work encompasses painting, drawing, video, photography, and installation. Her paintings cast movie stars and models as actors in gothic fairy tales and European history; contemporary icons such as Leonardo DiCaprio or Kate Moss may populate scenes from a Russian ballet or Marie Antoinette's castle.

The Hellfire Club episode of the Avengers is an early example of what came to be known as "scatter art," a loosely defined approach to installation in which artists arranged photographs, found objects, and ephemera in a way that seemed casual, almost accidental. Kilimnik's title refers to the popular 1960s British television show, with characters Emma Peel and John Steed as crime-fighting spies. References to the show in several of Kilmnik's works unite many of her key themes: upper-class culture, female glamour, disguises, the threat of violence, and fantasy. This episode of

The Avengers, where the show's protagonists infiltrate a modern-day version of the sadomasochist Hellfire Club, was banned in the United States.

Some elements in the installation—a tall boot, a candelabra—could be props from the show, while others, such as photocopied images of the actors, might be found in the bedroom of a teenage fan. Kilimnik sets it all to a soundtrack that includes the show's theme song as well as other popular late-eighties music.

The Hellfire Club episode of the Avengers, 1989. Fabric, photocopies, candelabra, toy swords, mirror, gilded frames, costume jewelry, boot, fake cobwebs, silver tankard, audio media player, and dried pea, dimensions variable. Gift of Peter M. Brant, courtesy The Brant Foundation 2014.106. Installation view: Nicole Klagsbrun, 1989

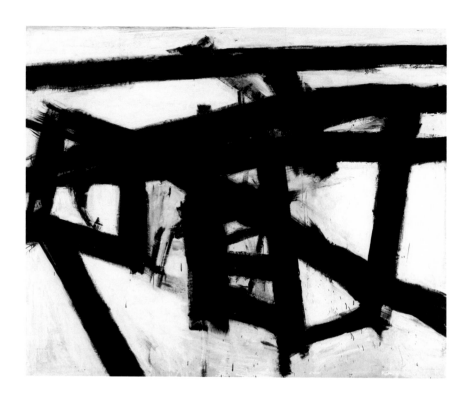

Although Franz Kline is best known for the abstract paintings he created between 1949 and 1961, he began his career making figurative works, many of which contained Social Realist–inspired references to the concerns of the urban lower classes. In 1950, however, Kline showed a group of paintings at New York's Egan Gallery that established him as one of the preeminent practitioners of Abstract Expressionism. Over the next twelve years he painted with large-scale gestural strokes, frequently using a limited palette of black and white paint, to create such vigorous works as *Mahoning*.

Despite its majestic dynamism, *Mahoning* was based on a small, quickly brushed ink study (also owned by the Whitney) that Kline had made several years earlier on a page from a telephone book. He carefully translated the drawing into a larger-scale painting with the aid of a Bell-Opticon projector, a magnification tool introduced to him by friend and fellow artist Willem de Kooning. As Kline noted: "Some of the pictures I work on a long time and . . . there are other pictures that come off right away. The immediacy can be accomplished in a picture that's been worked on for a long time just as well as if it's been done rapidly." Although many critics compared these monochromatic works with the gestures of Eastern calligraphy, Kline insisted that he was not writing with paint, for he painted as much with white as with black. The tension between light and dark creates the monumental forces of dynamic movement and taut architectural structure that make *Mahoning* an emblematic work of action painting.

Mahoning, 1956. Oil and paper on canvas, 80⅜ x 100½ in. (204.2 x 255.3 cm). Purchase with funds from the Friends of the Whitney Museum of American Art 57.10

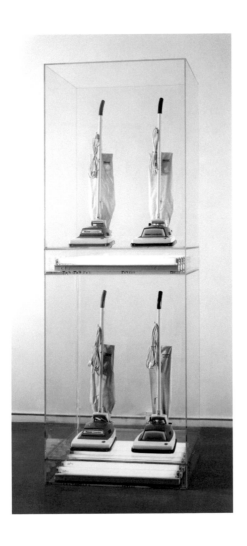

New Hoover Convertibles,
Green, Blue, New Hoover
Convertibles Green, Blue
Doubledecker, 1981–87.
Four vacuum cleaners, acrylic,
and fluorescent lights, 116 x
41 x 28 in. (294.6 x 104.1 x
71.1 cm). Purchase with funds
from The Sondra and Charles
Gilman Jr. Foundation Inc.
and the Painting and Sculpture
Committee 89.30a–v

Since the early 1980s, Jeff Koons has tested the boundaries between contemporary art and key aspects of American society, including marketing and the media, religion and popular entertainment, and technological innovation. Koons emerged among the first generation of artists reared on television and pop culture, influences that led them to pointedly mine and analyze the gloss and fervent consumer culture associated with the Ronald Reagan era. His breakthrough series *The New* serves as a meditation on the obsession with novelty that underpins both the avant-garde and the market economy, each of which depends on fresh offerings to whet appetites and drive sales.

In sculptures such as *New Hoover Convertibles Green, Blue New Hoover Convertibles Green, Blue Doubledecker*, Koons presents the then latest-model vacuum cleaners as pristine, even virginal, symbols of newness. He chose the appliance in part for its anthropomorphic air intake and because he felt it epitomized middle-class domesticity, whether through the image of his homemaker mother or of the "Hoover man" peddling products door-to-door. Befitting this interest in salesmanship, Koons also plays with conventions of display, which he learned firsthand in his father's home decorating store. Artworks, like consumer goods, often depend on lighting and cases to heighten their allure. By bathing these humble vacuums in an otherworldly glow, Koons recaptures the ardent desire and almost religious excitement that the newest products—and artworks— can inspire. Yet, almost paradoxically, these perfectly preserved specimens have inevitably grown dated, suggesting that the inexorable quest for the "new and improved" is inherently shadowed by obsolescence.

Joseph Kosuth is a pioneer of Conceptualism whose work untethers art from the strictly visual to draw attention to its theoretical framework. As he wrote in his influential treatise "Art After Philosophy" (1969), "A work of art is a kind of *proposition* presented within the context of art as a comment on art." *Five Words in Green Neon* predates this declaration but elegantly illustrates its idea. Like much of Kosuth's art, the work describes itself: here, five words are rendered literally in the titled material, collapsing language and image. A self-reflexive commentary on its own making, this is an early example of an artwork that calls attention to its context and presentation.

Influenced by Minimalism's dematerialization of the art object, Kosuth sought to demystify the act of creation and diminish the intervention of the artist's hand by having the work fabricated in neon. Many of Kosuth's contemporaries—including Bruce Nauman and Dan Flavin—worked in this material, which invoked the language of commercial advertising and referred the viewer to the work's surrounding architecture. Neon, for Kosuth, was neutral and legible, and he emphasizes these qualities by leaving visible the wires, transformer, and power source. Made as part of a series of language-based pieces in colored neon, *Five Words in Green Neon* and other early works by Kosuth sought to transform theory into practice, visually rendering semantic propositions that shift art, along with the viewer, away from painting toward the realm of ideas.

Five Words in Green Neon,
1965. Neon, 62⅛ x 80⅝ x 6 in.
(157.8 x 204.8 x 15.2 cm).
Purchase with funds from
Leonard A. Lauder 93.42a–b

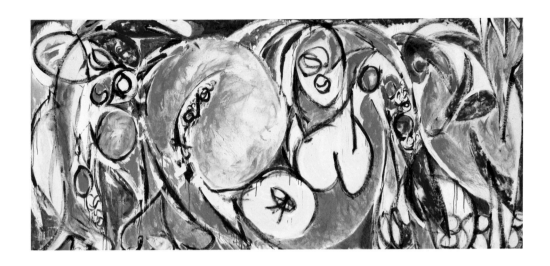

In the mid and late 1940s, Lee Krasner, one of the few women associated with Abstract Expressionism's first generation, developed compositions comprised of small, interconnected boxes with symbols that she described as hieroglyphic. Using a limited palette and paint applied in thick, controlled drips, Krasner achieved the nonhierarchical, allover format that she and her Abstract Expressionists peers favored.

Yet the diminutive scale of Krasner's early work was in part a consequence of her studio space. Krasner completed many of these canvases in an upstairs bedroom of the Long Island home she shared with her husband, Jackson Pollock. After she recovered from the shock of Pollock's death in a car accident in 1956, Krasner began to paint in the barn on their property that had previously been his studio. She made the most of the increased space: nearly seventeen feet wide and more than seven feet in height, *The Seasons* was the largest work she had attempted up to that point.

The composition, a signal example of a group of late 1950s paintings often referred to as the *Earth Green* series, interweaves sweeping black brushstrokes with swaths of pink, bulbous shapes in off-white, and sections of lush green. Her energetic markings evoke the female body and botanical forms, organic elements tied to growth and the inevitable cycles of nature. Krasner explained that in the wake of the sudden loss of her husband, "the question came up whether one would continue painting at all, and I guess this was my answer."

The Seasons, 1957. Oil and house paint on canvas, 92¾ x 203⅞ in. (235.6 x 517.8 cm). Purchase with funds from Frances and Sydney Lewis by exchange, the Mrs. Percy Uris Purchase Fund, and the Painting and Sculpture Committee 87.7

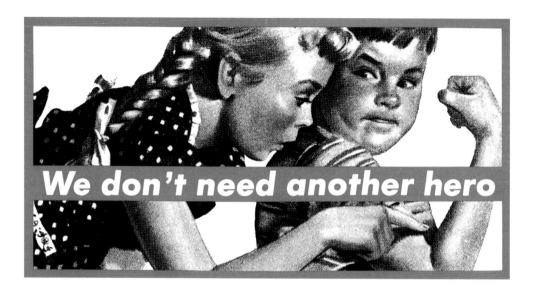

Barbara Kruger studied at Syracuse University and then Parsons School of Design, where her instructors included the photographer Diane Arbus and the graphic designer Marvin Israel, art director at the fashion magazine *Harper's Bazaar* at the time. She began her career in commercial art, designing book covers and working as an editorial designer at Condé Nast on publications such as *Mademoiselle*. After initiating her fine art practice with abstract paintings and woven wall hangings, Kruger arrived at her signature aesthetic by the early 1980s—the juxtaposition of provocative catchphrases (slogans she appropriates or formulates herself), printed in bold blocks of text, with found and often vintage photographic imagery. These graphic combinations of text and image, often bordered in red, dramatize— and call into question—the effect of the contemporary mass media in shaping identity, desire, and structures of power. Kruger implicates her audience through the use of neutral pronouns such as *you* and *we*, and viewers must work to untangle the often ambiguous relationship between her texts and images. *Untitled*

(We Don't Need Another Hero) pairs the lyric from a 1985 Tina Turner song with a photograph of children performing stereotypical adult gender roles: the boy flexes his bicep and makes a macho expression while the girl, in her dress and pigtails, is his eager admirer.

Kruger works in a range of scales and across diverse media, including unconventional contexts for art; her photomontages might be encountered as billboards, on T-shirts, or as posters. Since the 1990s, her practice has expanded to encompass large-scale installations that feature video and audio components in addition to photos and text, as well as public art projects.

Untitled (We Don't Need Another Hero), 1987. Photoscreenprint on vinyl, 108⅞ x 209¼ in. (276.5 x 531.5 cm). Gift from the Emily Fisher Landau Collection 2012.180

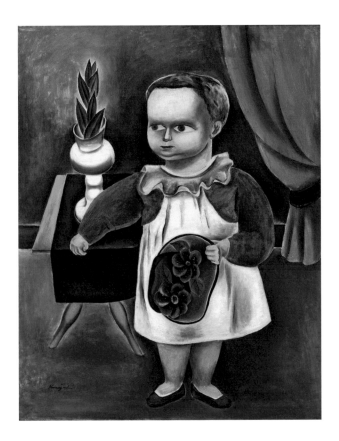

Yasuo Kuniyoshi emigrated from Japan to the United States in 1906, moving to California and then in 1910 to New York. There he studied at the Art Students League and became an active participant in the Whitney Studio Club and a prominent figure in American art during the first half of the century. Kuniyoshi and others in his circle, in particular his friend and teacher Hamilton Easter Field, were fascinated by American folk art and adopted a faux-naïf style for some of their work of the 1920s. Kuniyoshi combined this sensibility with sophisticated undercurrents culled from traditional Japanese painting and symbolism and stylistic elements from European modernism. *Child* is representative of his painting from this period, with the flattening of the space and the tilting of the table revealing an acute awareness of Cubism as well as Japanese printmaking. The influence of Colonial American arts, including the decorative arts, is also evident in the clothes and furniture and in the wide-eyed, stiff pose of the child.

Kuniyoshi often depicted women, children, and female circus performers, drawn from both his memory and imagination, in poses with mysterious objects that create enigmatic narratives. In 1948 Kuniyoshi was the subject of the Whitney Museum's first retrospective of a living artist, despite his having been legally barred, because of his national origins, from receiving US citizenship.

Child, 1923. Oil on linen, 30⅛ x 24¼ in. (76.5 x 61.6 cm). Gift of Mrs. Edith Gregor Halpert 55.1

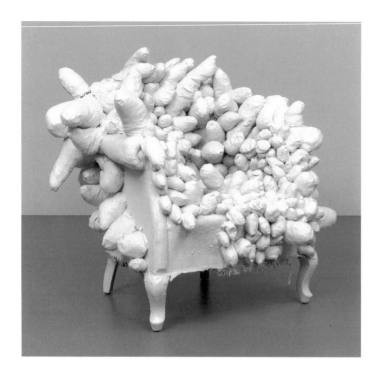

Best known for her obsessive use of pattern and her immersive, large-scale environments, Yayoi Kusama has produced a diverse and distinctive body of work that encompasses painting, sculpture, drawing, collage, performance, film, and installation art. Kusama moved to the United States from her native Japan in 1957, and her series of *Infinity Net* paintings—large canvases with endlessly repeated brushstrokes that anticipated the serial techniques of Minimalism and Conceptual art—catapulted her to the forefront of the 1960s New York avant-garde. Out of this practice grew a series of sculptures that feature everyday items she covered with similarly obsessional proliferations of repeated forms—what she called her "Accumulations," or sometimes "Compulsion Furniture." Although often exhibited alongside works by artists such as Andy Warhol and Claes Oldenburg, these sculptures distinguished themselves from their Pop art counterparts through

their otherworldly quality and their connection with the artist's childhood traumas and hallucinatory visions.

For the "Accumulation" sculptures she began in 1961, Kusama roamed the streets of New York collecting outcast items—a sofa, a ladder, shoes, even a baby carriage and ironing board—that she covered with cotton-stuffed, white fabric forms she unabashedly identified as penises. The mass of soft-sculpture phallic forms that cover the curvaceous white-painted armchair in *Accumulation*, at once alarming and absurd, reflects Kusama's efforts to face her sexual anxieties, creating a kind of self-induced exposure therapy: "Reproducing the objects, again and again," she has said, "was my way of conquering the fear."

Accumulation, c. 1963. Sewn and stuffed fabric, wood chair frame, and paint, 34⅜ x 39 x 36⅜ in. (87.3 x 99.1 x 92.4 cm). Purchase 2001.342

Southern California in the 1970s was home to a strong feminist art movement, with many of the area's art schools and universities becoming focal points of radical art. Suzanne Lacy first encountered the movement as an activist and psychology student at Fresno State University, where she studied with the feminist artist Judy Chicago. She continued working with Chicago at California Institute of the Arts, where she also studied with Allan Kaprow and explored the transformative possibilities of performance art. Calling upon viewers to participate in her work, Lacy was a pioneer in what would come to be known as Social Practice art. Her performances, videos, and social interventions addressed a broad spectrum of women's issues, including rape, poverty, abuse, and class inequality.

Learn Where the Meat Comes From is part of Lacy's *Anatomy Lessons* series. The title was taken from a cooking show by Julia Child, who exhorted her audience, "Taking the time to learn where the meat comes from will ensure your constant success." Lacy follows to absurd and disturbing extremes Child's instructions to imitate a lamb's movements, becoming more animal-like as the video progresses.

Meat had featured in several of Lacy's earlier works, and her own body was a recurring subject as well: the diagram of cuts of meat in the background of *Learn Where the Meat Comes From* recalls the beef kidneys that Lacy nailed to the walls in her 1972 *Ablutions* performance as well as the legal contract she devised for selling her own body parts in *Body Contract*, the inaugural piece in the *Anatomy Lessons* series.

Still from *Learn Where the Meat Comes From*, 1976, from the series *Anatomy Lessons*, 1974–77. Video, color, sound; 14:20 min. Purchase with funds from the Film, Video, and New Media Committee 2014.142

Born in Buenos Aires and educated in London, artist David Lamelas redirected his practice from sculpture to conceptual explorations of media-based forms in the late 1960s. Working in Los Angeles in the early months of 1974, he made *The Desert People*, a film he describes as a "fake documentary"—the purported story of five people who, crossing the desert by car, discuss their experiences at a Native American reservation in Arizona. Typical road-movie scenes of the journey are intercut with passages of the talking heads: four researchers provide varied accounts of their time spent on the reservation and impressions of the Papago tribe, while the fifth passenger, a member of the tribe, speaks English, Spanish, and Papago by turns. While these interview-like segments seem convincing, other aspects of the film betray the influence of the formulaic television talk shows and spectacular Hollywood films that Lamelas studied after arriving in Los Angeles. In fact, the film's dramatic conclusion calls into question all that has come before and confounds the very genre of which it initially seems a part.

This disruption of conventional structures of narrative and categories of representation—indeed, of truth and fiction—characterizes much of Lamelas's art, which comprises painting, photography, sculpture, installation, and performance in addition to film, and resonates with Minimalism, Conceptual art, and Land art, among other contexts. Although often of modest means, his projects engage complex themes, plumbing and testing the limits of temporal and spatial experience.

Still from *The Desert People*, 1974. 16mm film, color, sound; 52 min.
Gift of the artist 2001.238

Dorothea Lange spent many years making photographs for New Deal government agencies. Yet she arrived at this enterprise only after a lucrative career as a high-society portrait photographer in San Francisco, where she skillfully deployed the Pictorialist training she had received from the legendary photographer Clarence White. Even before the stock market crash in 1929, however, Lange had become dissatisfied with commercial portraiture, and in the ensuing years she turned her attention to documenting the effects of the Depression.

In 1935 Lange began working for the California State Emergency Relief Administration, where she met her husband and future collaborator, economist Paul Schuster Taylor. Later that year she transferred to the Resettlement Administration, set up to assist migrating agricultural workers, and produced some of her most famous images. This picture, taken on a highway in California,

captures two girls who have been displaced with their family. One child stands without shoes and the other with the aid of crutches. The caption in the Farm Security Administration archives reads: "Children of Oklahoma drought refugees on highway near Bakersfield, California. Family of six; no shelter, no food, no money and almost no gasoline. The child has bone tuberculosis." Lange had a limp from contracting polio as a young girl, which perhaps helped her capture subjects with greater empathy. The photograph does not reduce these children to mere facts or statistics. Rather, Lange dares viewers to look at the human consequences of unregulated capitalism and environmental ruination.

Child of Migrant Family Suffering from Tuberculosis of the Bone, California, 1935. Gelatin silver print, 7½ x 7⅝ in. (19.1 x 19.2 cm). Purchase with funds from the Photography Committee 2012.49

In explorations of what she calls "basic sculptural ideas," Liz Larner makes works from a range of connotative materials: mirrors, living trees, aluminum, rope, false eyelashes, surgical gauze, ceramic, plexiglass, and leather, arranging them in large-scale, frequently colorful, abstract compositions of grids, solid forms, tangles, chains, and weavings. On the one hand, Larner's mature body of work, begun in the late 1980s, accedes to the traditional modernist attitude that sculpture's proper domain is space; on the other hand, Larner refuses historical protocols of formal purity. Take the wobbly, uncanny shape of *Two or Three or Something*: twelve approximately equal sections of steel rod, each wrapped in paper washed with yellow watercolor, would form the edges of a cube were they straightened out and set at perpendicular angles, yet the sculpture, poised unstably on the ground on three corners, appears to have shimmied itself out of the confines of that ideal geometry. It also manages to establish volume without mass or density, existing on the pressure point between presence and absence, or between the implied space it demarcates and the larger space in which it exists and which is shared by the viewer. The mixed-media work evokes drawing through its linearity and the artist's use of paper, while the bright watercolor suggests the painting tradition. It challenges the requirement that artwork occupy either two or three dimensions. The viewer's movement around the piece maps a terrain of perception in which boundaries are permeable and implied volumes shift, and thus delivers the "something" named in its title.

Two or Three or Something, 1998–99. Steel, paper, and watercolor, 105⅜ x 64⅞ x 64½ in. (267.7 x 164.8 x 163.8 cm). Purchase with funds from the Contemporary Painting and Sculpture Committee 2001.31

Elad Lassry "reactivates" images in his art, which includes film, photography, drawing, sculpture, and performance. "I am especially interested in finding pictures that have fallen between the cracks, that have been destabilized, misplaced, or rejected," he has explained. Based in Los Angeles, Lassry is heir to the Pictures Generation artists, who appropriated preexisting imagery in exploring how images are produced, disseminated, and interpreted. In Lassry's work, the distinction between a found picture and a staged one is often difficult to discern. His meticulously crafted, glossy photographs play havoc with traditions such as still life and portraiture, in turn disrupting customs of framing, display, and installation. Drawings become films, and photographs register as sculptures as the very boundary between object and image grows increasingly fluid.

Lassry's silent film *Untitled* employs reconstructions of photographs illustrating principles of perspective, which the artist found in a textbook from the 1970s. To these seemingly straightforward enactments of diagrams he has added actors, who interact with the spaces. The work's long takes and fixed camera positions recall structural films of the 1960s and 1970s, in which the materials and overall structure of film are the subject. As *Untitled* progresses, however, one notices mismatches between the constructed, illusory tableaux and the individuals in the film, who seem to inhabit a separate space and obey different codes of representation. Footage of two people having an inaudible conversation intensifies the film's disorienting effect and shifts its emphasis from the nature of perception to the workings of individual subjectivity.

Still from *Untitled*, 2008. 16mm film, color, silent; 9:20 min. Purchase with funds from the Film, Video, and New Media Committee 2009.76

Part of the Pictures Generation, Louise Lawler has used photography since the early 1980s to examine the conditions under which art is seen and the networks through which it is circulated, displayed, and sold. Exploring how such changes of context not only engender different experiences of art but produce different meanings, Lawler uncovers the various, often conflicting, interests that underpin the sites in which art is encountered and commodified: galleries, museums, art fairs, collectors' homes, auction houses, and art storage facilities. Her photographs have captured items such as wall labels, packing and shipping materials, and exhibition vitrines—ancillary elements, usually unremarked upon or unseen, that nonetheless affect an artwork's reception and meaning.

Salon Hodler, Lawler's image of the living room of a Swiss art collector, demonstrates the centrality of context in the experience of viewing art. It features two large fin-de-siècle paintings by the Swiss artist Ferdinand Hodler that hang on adjacent walls. In this room the paintings function as status symbols, taking their place alongside other emblems of wealth and taste such as an ornate chandelier and antique furnishings—an elegant décor that seems to neutralize Hodler's vibrant palette and even temper the eroticism of his embracing couples. Lawler relies here on photography's presumptions of objectivity—the image, like those in many of her works, has a clinical, detached feel—even as she exploits the aesthetic possibilities of her medium through the use of large-scale, glossy prints that document her prepossessing subjects.

Salon Hodler, 1992 (printed 1993). Silver dye bleach print (Ilfochrome), 47⅛ x 56¾ in. (119.7 x 144.1 cm). Edition no. 2/5, 1 AP. Purchase with funds from the Photography Committee 94.23

Jacob Lawrence used his art to tell the epic story of African Americans' struggle for freedom and justice. Growing up in Harlem during the 1930s, Lawrence was exposed to leading artists of the Harlem Renaissance, who inspired him to delve into the history of his community. By the decade's end he had developed his signature approach: series of works in multiple panels centered on a single theme. With this format, Lawrence sought to instill his narratives with pictorial grandeur and to address complex histories he felt could not be effectively portrayed in a single image.

In 1946, with funding from the Guggenheim Foundation, Lawrence began work on the *War Series*, the first of his multipart works to document both a personal and historical experience—his service in World War II, during which he was stationed on the first racially integrated naval ship in United States history. Although he conceived of the project during the war and based the series of fourteen panels on his own memories, each also reflects broadly on the experience of war—from the drudgery of a nighttime patrol or the cramped quarters of a ship's hold to the terror of being detained as a prisoner of war. Lawrence rendered these scenes using his characteristic flattened planes and silhouetted figures, eschewing modeling and perspective in favor of bold, semiabstracted forms. *Victory*, the last work in the series, contains none of the exuberance one might expect from its title. Rather, the image's subdued palette and solitary soldier—hunched over, his expression inaccessible—present a somber vision of the war's end.

War Series: The Letter, 1946. Tempera on compostiion board, 20¼ x 16⅛ in. (51.4 x 41 cm). Gift of Mr. and Mrs. Roy R. Neuberger 51.11

War Series: Victory, 1947. Tempera on compostiion board, 20¼ x 16¼ in. (51.4 x 41.3 cm). Gift of Mr. and Mrs. Roy R. Neuberger 51.19

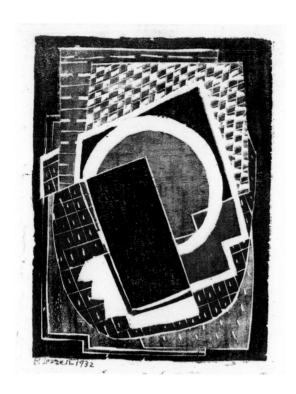

Blanche Lazzell, one of the first abstract artists in the United States, combined an interest in European Modernism with innovative techniques to create a rich body of prints, paintings, and designs. After studies at the Art Students League with William Merritt Chase (alongside Georgia O'Keeffe), and a stint at the art academies in Paris, in 1915 she joined a group of artists in Provincetown, Massachusetts, who were pioneering a new woodcut technique. The "white-line color woodcut," made using a single, deeply incised block, allowed the artist to vary color and composition, both while carving and across impressions. Drawn to this capacity for innovation, Lazzell went on to produce a groundbreaking body of woodcuts, printing 550 impressions from 138 blocks between 1916 and 1956. She printed most in editions of five or fewer, using French watercolor pigment on traditional Japanese paper to create dynamic, vibrant abstractions and still lifes.

In Lazzell's *Untitled (Abstraction)*, simple shapes overlap and tilt to build a composition of layered depth and rhythmic rotation. Incised grids contrast with the organic grain of the wood, while irregular lines and vivid colors disrupt the strict geometry. The work reflects the formative impact of a second stay in France, from 1923 to 1925, when Lazzell encountered the teachings of Albert Gleizes, Fernand Léger, and André Lhote. In subsequent work she combined their Cubist interest in planar geometry and shape relationships with her own Fauvist-inspired commitment to color and expression. As Lazzell explained, "I am working for color values, form relationships, rhythm of movement, interplay of space and sincere expression."

Untitled (Abstraction), 1932.
Woodcut: image, 5⅝ x 4¼ in.
(14.3 x 10.8 cm); sheet,
9⅛ x 5⅜ in. (23.2 x 13.7 cm).
Purchase with funds from
the Print Committee 2000.41

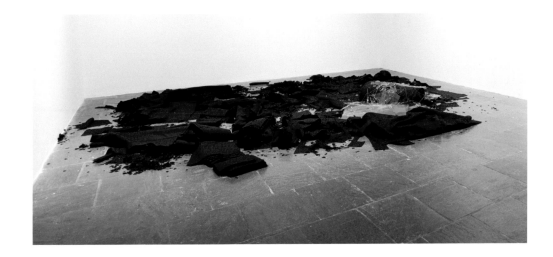

Barry Le Va's groundbreaking early works were important examples of an artistic approach that emerged in the mid-1960s, when artists began placing emphasis on the processes and ideas of their art making rather than on finished objects. His *Continuous and Related Activities; Discontinued by the Act of Dropping* is a sculptural work, yet because it is contingent on the instructions and actions by which it is created, it challenges the very notion of what a sculpture is. The work consists of two hundred yards of maroon felt that the artist disperses in an almost performative fashion; working around a single large bolt of felt placed on the floor, Le Va tosses, folds, and positions variously sized pieces of felt to create a scattered but thoughtfully composed array across the gallery space. Four sheets of glass—each thirty-six inches square and a quarter-inch thick—are then held, one at a time, above the bolt at the center and dropped. The artist allows the shattered glass to remain wherever it falls. Le Va often created detailed, score-like drawings as starting points for such actions. For other of his "distribution" pieces from this era, the artist employed a range of materials including powdered cement, chalk, sand, ball bearings, and wood. In each instance, the viewer is confronted by an installation that exists as a kind of chance effect of the artist's deliberate actions, the aftermath of the activity. As Le Va explained about his work from this period, "I became intrigued by the idea of visual clues, the way Sherlock Holmes managed to reconstruct a plot from obscure visual evidence. What I'm trying to do now is set up situations in which audiences have to use their minds to piece elements back together."

Continuous and Related Activities; Discontinued by the Act of Dropping, 1967. Felt and glass, dimensions variable. Purchase with funds from the Painting and Sculpture Committee 90.8a–b. Installation view: Whitney Museum, 2006

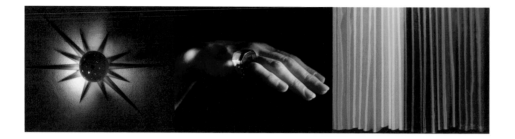

William Leavitt arrived in Los Angeles as a graduate student in 1965 and joined a circle of young Conceptual artists, such as Bas Jan Ader, Allen Ruppersberg, and John Baldessari, who were then experimenting with performance and narrative formats. Leavitt developed a polyvalent practice that encompasses sculpture, music, installation, writing, drawing, painting, theater, and photography. Many, and occasionally all, of these elements are present in the stage sets for which he is most widely recognized and which he started making in the early 1970s, as his fascination with the culture and artifice of the film and television industries of Hollywood took hold.

Leavitt conceived of the sets not as vehicles for live performances but as static installations revealing his interest in "the edge between . . . illusion and how it's supported." Using a handful of "props"—ersatz contemporary furnishings accessorized with plastic plants and his own oil paintings—Leavitt constructed fictional fragments of suburban LA interiors modeled on those memorialized in countless mid-twentieth-century Hollywood productions, evoking a vapidity that is both familiar and unnerving. On the exposed backs of the stage flats that serve as the sets' walls, he wrote short texts conjuring opening scenes from fictionalized soap operas.

Later in the decade, Leavitt wrote, directed, and created sets for two plays and embraced the opportunity to generate multiple images of individual props in design drawings, storyboards, and performance photographs. The photomontage *Spectral Analysis* is related to the same-titled one-act play written by Leavitt and first performed upon a stage set built by him in 1977. The photograph juxtaposes three eerily lit images whose narrative links are obscure: a midcentury starburst light fixture, a woman's hand bearing a large cocktail ring, and a rainbow-hued curtain. With a layout reminiscent of a filmstrip or storyboard, the photograph begs the viewer to make sense of these disparate images, yet Leavitt never delivers on this promise. With its scientific title, *Spectral Analysis* merges Leavitt's interests in the domestic soap opera and the fantastical science fiction, without presenting a consequential plot or action.

Spectral Analysis, 1977 (printed 2011). Three chromogenic prints mounted on plastic, 16⅛ x 60⅛ x ⅛ in. (40.8 x 152.7 x 0.3 cm) overall. Edition no. 2/3, 2 AP. Purchase with funds from the Photography Committee 2014.2

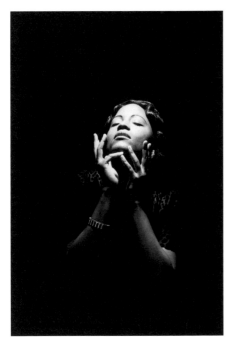

Zoe Leonard's work has ranged from explorations of the natural landscape and the urban environment to issues of gender and the global circulation of goods. Whether in her early aerial photographs of cities, her observations of trees, a survey of New York storefronts, or recent images of the sun, Leonard has tended to amass multiple pictures into works as she investigates the relationship between the photograph and the natural or constructed world.

Such an archival impulse is reflected in *The Fae Richards Photo Archive*, a group of eighty-two photographs Leonard made in collaboration with the filmmaker Cheryl Dunye for the latter's 1996 film *Watermelon Woman*. The film's protagonist encounters the fictional character of Richards in an old film and is driven to research the African American lesbian actress's life and career. For the *Archive*, Leonard hired actors to play Richards and her costars, lovers, family, and acquaintances in staged photographs that drew upon Dunye's family photographs as well as existing images of black performers of the era. Leonard printed each image using historically appropriate processes, lending visual authenticity to the archive, and added detailed, typewritten captions for each. The narrative tracks the imaginary Richards's life as a teenager and then as a Hollywood screen star, through the civil rights era, when her film career was obstructed by racism, and finally to her old age as a forgotten figure. Fae Richards had to be constructed because, as Leonard said, "certain histories are so vastly, wildly, crazily underrepresented" that even if she had lived "we probably wouldn't have known about her."

Installation view and detail of *The Fae Richards Photo Archive*, 1993–96. Seventy-eight gelatin silver prints, four chromogenic prints, and notebook of seven pages of typescript on paper, dimensions variable.

Edition no. 2/5. Purchase with funds from the Contemporary Painting and Sculpture Committee and the Photography Committee 97.51a–dddd. Installation view: Whitney Museum, 2010

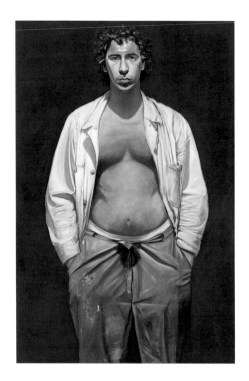

Alfred Leslie was an established Abstract Expressionist painter when, in 1962, he embarked on a pivotal series of large-scale portraits of friends and colleagues. Though a dramatic departure from his earlier painting, Leslie's interest in figuration was already demonstrated in an earlier series of Polaroid "mug shots" of studio visitors, as well as in his experimental films and writing. For this new mode of painting, which Leslie called "confrontational art," he sought to emphasize elements such as scale, frontality, and accuracy while eliminating color, space, light, and composition. The resulting grisaille portraits present monumental, three-quarter-length views of figures standing against planar gray grounds. Each is painted from separate eye-level views of the sitter's head, chest, torso, and hands, a composite technique intended to "democratize" all parts of the body and allow them to be viewed simultaneously. Through these larger-than-life portraits, Leslie sought to create paintings that "demanded the recognition of individual and specific people . . . straightforward, unequivocal, and with a persuasive moral, even didactic, tone."

In 1966 a fire in Leslie's New York studio destroyed most of his work. This self-portrait, one of only four grisailles completed after the fire, is a rare surviving representative of his style from the early 1960s. Here, Leslie shows himself in his "worst light," wearing a dour stare, a stained, rumpled shirt, and paint-splattered pants cinched below a protruding belly. This unflinching self-presentation and straightforward style have made the work an icon both of self-portraiture and the new realism of the early 1960s.

Alfred Leslie/1966–67,
1966–67. Oil on canvas,
108⅛ x 72⅛ in. (274.6 x
183.2 cm). Purchase
with funds from the Friends
of the Whitney Museum
of American Art 67.30

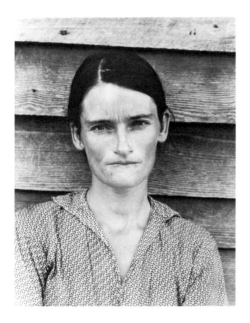

After Walker Evans: 4, 1981. Gelatin silver print, 9½ x 7½ in. (24.1 x 19 cm). Purchase with funds from the Photography Committee 96.2

La Fortune (After Man Ray): 4, 1990. Mahogany, felt, and billiard balls, 33 x 110 x 60 in. (83.8 x 279.4 x 152.4 cm). Purchase with funds from Joanne Leonhardt Cassullo, Beth Rudin DeWoody, Eugene Schwartz, and Robert Sosnick 92.1a–h

To make *After Walker Evans: 4*, one her best-known works and a key example of what is termed Postmodern art, Sherrie Levine rephotographed one of Evans's most iconic Depression-era pictures from a reproduction in an exhibition catalogue, presenting the image as her own. This work, from the series *After Walker Evans*— along with copies of images by other established masters of photography such as Edward Weston and Eliot Porter that she executed in the 1980s—exemplified the artistic strategy of appropriation, in which existing images, including those by other artists, are employed as the basis of one's own production. Appropriation challenged values enshrined in the practice and theory of Modern art: namely, the imperatives that an artwork be authentic, unique, and original. It also subverted the authority of a patriarchal canon of art history and underscored the centrality of authorship and historical context in our understanding of artworks.

Levine took the subject of *La Fortune (After Man Ray): 4* from a 1938 Man Ray painting titled *La Fortune*, also in the Whitney's collection, which features a pool table set beneath a sky filled with brightly colored clouds. By producing a three-dimensional object based on a two-dimensional representation made decades earlier, and by giving physical reality to something that in Man Ray's painting is shown in a Surrealist manner at an impossibly oblique angle and with seemingly attenuated proportions, Levine again demonstrates that the same subject, re-created in a different medium and era, assumes new meaning for new audiences. Her longstanding sensitivity to the contexts of image production and circulation has taken on even greater relevance in our increasingly digital age.

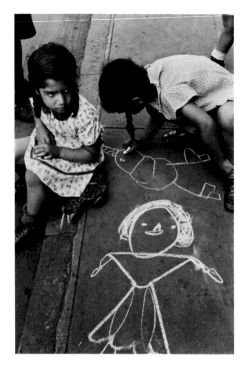

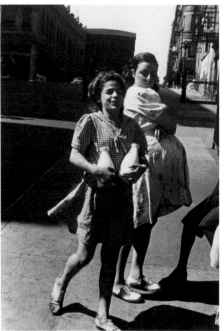

After dropping out of high school, Helen Levitt took a job assisting in the darkroom of a commercial portrait photographer. She soon acquired her own camera, and by the late 1930s she had met and gained the support of the esteemed photographers Henri Cartier-Bresson and Walker Evans as well as the writer James Agee. In Levitt's photographs of the late 1930s and 1940s, shot mainly in the streets of New York, two modes of artistic production often considered antithetical intersect: documentary realism, with its emphasis on vernacular subjects and social issues, and Surrealism, particularly as it engages found objects and chance meetings.

Levitt often trained her lens on children, in whose lack of inhibition she identified a freedom from the usual social strictures. *Street Drawing* shows a pair of girls, one of whom is creating the kind of sidewalk chalk drawing that attracted Levitt and served as the subject for dozens of her photographs. The echoing of the girls' forms in the pair of chalk figures exemplifies Levitt's talent for capturing lyrical moments of happenstance amid urban life, a facility also evident in *New York*. Here the exuberance of the young woman pictured frontally is offset by the scornful look of the pregnant woman shown in profile behind her. The two milk bottles the former hugs to her chest seem to foretell the birth of the child of the latter—a whimsically humorous, Surrealist coincidence.

New York, c. 1945. Gelatin silver print, 9½ x 6⅝ in. (24.1 x 16.8 cm). Promised gift of Sondra Gilman Gonzalez-Falla and Celso Gonzalez-Falla to the Whitney Museum of American Art, New York, and the Gilman and Gonzalez-Falla Arts Foundation P.2014.88

Street Drawing, c. 1940. Gelatin silver print, 10⅞ x 7⅜ in. (27.6 x 18.7 cm). Gift of Lilyan S. and Toby Miller 94.167

Over the course of five decades, Sol LeWitt explored a variety of mediums and scales while continually mining ideas he first developed in the early 1960s. Seeking to distinguish himself from the Abstract Expressionists, LeWitt determined that the initial concept, not the finished object, was the work of art. In a series of 1967 statements that outlined parameters for Conceptual art, the artist argued, "The idea becomes a machine that makes the art."

In 1968 LeWitt sought to make a work that was "as two-dimensional as possible," and he achieved this flatness literally by sketching directly onto a gallery wall. During the next forty years he conceived of more than 1,200 wall drawings. Accompanying instructions allow other artists and even amateurs to execute the works in different locations. LeWitt saw the wall drawings as the equivalent of musical scores that could be realized by any number of people in any location, and his instructions often allow for subtle interpretive differences. For *Wall Drawing #289*, the artist instructs drafters to draw lines in white crayon charted on a six-inch graphite grid that overlays one to four painted black walls.

LeWitt's three-dimensional works, or "structures," are based on the unit of an open rather than solid cube, peeling away what he perceived as the decorative skin on traditional sculpture. Though he created these structures in a range of scales, LeWitt maintained the ratio 1:8.5 for each unit (the empty space is 8.5 times the width of the wood or metal edge). *Five Towers*, a later, more complex structure, rises more than seven feet in height, culminating in four towers on each edge of its square form, with a fifth tower in the center.

Fourth wall from *Wall Drawing #289*, 1976. Wax crayon, graphite pencil, and paint on four walls, dimensions variable. Purchase with funds from the Gilman Foundation Inc. 78.1.4. Installation view: Whitney Museum, 1983

Five Towers, 1986. Bass wood with alkyd enamel paint, 86⅝ x 86⅝ x 86⅝ in. (220 x 220 x 220 cm). Purchase with funds from the Louis and Bessie Adler Foundation Inc., Seymour M. Klein, President; the John I. H. Baur Purchase Fund; the Grace Belt Endowed Purchase Fund; The Sondra and Charles Gilman Jr. Foundation Inc.; The List Purchase Fund; and the Painting and Sculpture Committee 88.7a–h

Roy Lichtenstein

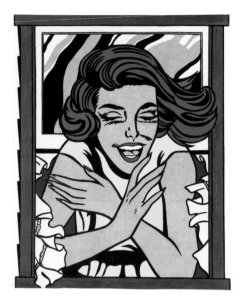

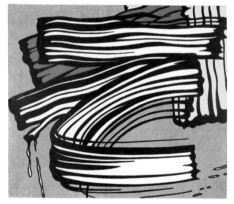

*Girl in Window (Study
for World's Fair Mural)*, 1963.
Oil and acrylic on canvas,
68⅛ x 56 in. (173 x 142.2 cm).
Gift of The American
Contemporary Art Foundation
Inc., Leonard A. Lauder,
President 2002.254

Little Big Painting, 1965.
Oil and acrylic on canvas,
68 x 80 in. (172.7 x 203.2 cm).
Purchase with funds from
the Friends of the Whitney
Museum of American Art 66.2

Alongside Andy Warhol and James Rosenquist, Roy Lichtenstein was a key figure of Pop art, a movement that emerged in the early 1960s and was distinguished by subject matter derived from pop culture and the use, or imitation, of mechanical reproduction techniques such as screenprinting. Lichtenstein studied art briefly with the Social Realist painter Reginald Marsh at the Art Students League in New York and then at Ohio State University, from which he received undergraduate and MFA degrees. In 1961 he arrived at his signature aesthetic: works whose subjects were loosely derived from comic strips, cartoons, or advertisements, painted in a style that mimicked commercial printing.

In *Girl in Window*, a study for a mural commissioned by the architect Philip Johnson for the New York State Pavilion at the 1964 World's Fair, Lichtenstein represented the half figure of a comely female through a combination of simplified passages of solid color, bold black outlines, and areas of gridded dots. Yet his technique is more labor intensive, and manual, than his coolly detached surfaces—and their allusion to industrial reproduction—suggest. His process involved first sketching his selected subject, then projecting the drawing using an opaque projector, tracing the image onto canvas and, finally, filling in the outline with contours and dots, which were applied with a stencil to emulate the Benday dots of halftone printing processes.

In the mid-1960s Lichtenstein began to take the artist's mark itself as a motif: *Little Big Painting* pictures the slashing brushwork and drippy runoff that characterized many an Abstract Expressionist canvas. Lichtenstein parodies this means of improvisatory mark making, and its associations with spontaneity and freedom, by rendering the strokes as if stylized and premeditated—substituting the look of anonymous commercial production for the uniqueness of the artist's gesture.

Untitled (I Do Not Always
Feel Colored), 1990. Oil stick
and oil on wood, 80 x 30 in.
(203.2 x 76.2 cm). Gift of The
Bohen Foundation in honor
of Thomas N. Armstrong III
2001.275

Glenn Ligon uses borrowed texts and
images as the basis for evocative works that
reflect on American history, literature,
and society as well as the fundamental
nature of art making and perception.
As a college student he painted gestural
canvases indebted to Abstract
Expressionism; however, his engagement
with more conceptual modes of art
making during a stint at the Whitney's
Independent Study Program in the
mid-1980s led him to confront the limits of
abstraction. "I had a crisis of sorts," he
recalled, "when I realized that there was too
much of a gap between what I wanted
to say and the means I had to say it with."

For Ligon, the way through this
impasse was to introduce language directly
into his work. In the first of his seminal
"Door Paintings," he covered wooden doors
with phrases from Zora Neale Hurston's
1928 essay, "How It Feels to Be Colored Me,"
in which the African American writer
explains how she saw herself as "colored"
only after leaving the protective black
community in which she was raised.
The phrase "I do not always feel colored"
repeated in this work suggests the mutability
and contingency of Hurston's—and perhaps
anyone's—sense of self. Ligon subtly
conveys this condition through his stenciling
technique. The letters at the top of the
door sit crisply on the surface, but as
he works his way down the stencil becomes
covered with oil and smudges the words
into darkness and unintelligibility.

Since 2004, Ligon's use of text and
his formal and metaphorical play with light
and dark has continued in a series of
luminous neon wall reliefs, often partially
coated in black paint. In several examples,
such as Rückenfigur, Ligon reconfigured
the word America to reflect on the
ambivalent status of a country that, in his
words, is both a "shining beacon" and
"dark star." "I was thinking about Dickens's
'the best of times, the worst of times,'"
he remarked. "We can elect Barack Obama,
and we're still torturing people in prisons

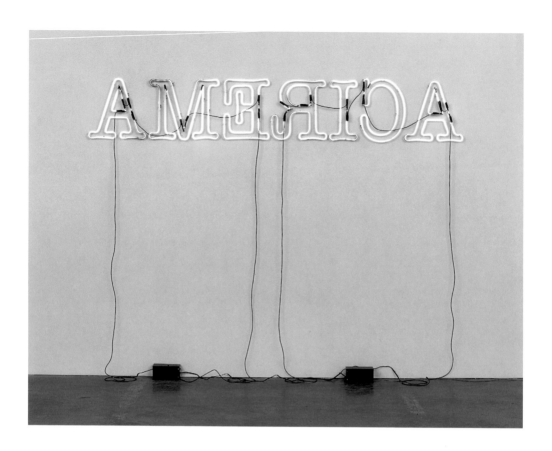

Rückenfigur, 2009. Neon and paint, 24 x 145½ x 5 in. (61 x 369.6 x 12.7 cm). Purchase with funds from the Painting and Sculpture Committee 2011.3a–i

in Cuba. Those things are going on at the same time. Of course, because the piece is a black covering over white neon, it gets read as black America/white America, and those kind of binaries, which is a part of it. I'm not denying that. But I think that maybe if the piece has a kind of richness, it is because of the ambiguity."

The title *Rückenfigur* is an art-historical term describing a figure seen from behind, and, accordingly, each of its letters is rotated toward the wall. Yet because the *A*, *M*, and *I* are bilaterally symmetrical they appear to face forward, so that the word uncannily addresses us and turns away at the same time. In this regard, Ligon's glowing sign poetically captures the twinned sense of identification and alienation the country so often inspires. A sense of gleaming promise is haunted by a shadow of doubt.

Encompassing performance, video, music, writing, and directing, Kalup Linzy's art probes the socioeconomic structures of high and low culture with equal parts earnestness, resourcefulness, and wit. After studying at the University of South Florida and the Skowhegan School of Painting and Sculpture, in 2002 Linzy began producing *Conversations Wit de Churen*, an episodic video series that continued for over a decade. The work focuses on the emotional lives of a host of female characters, all played by the artist in drag. These narratives play with the trope of daytime television soap opera—with its melodrama, plot twists, and cliffhanger endings—and make reference to the long-running soap operas *All My Children* and *As the World Turns*. The story is set in the American South, and each character speaks with a distinct dialect in a voice-over that is slowed down or sped up to create masculine and feminine tones. The multiple layers of Linzy's performance—histrionic acting, affected speech,

blonde wigs, and tight dresses—result in direct commentaries on gender, race, sexuality, and class.

Conversations Wit de Churen V: As da Art World Might Turn follows a promising young painter, "Katonya" (played by Linzy), as she stages her first solo gallery exhibition. Made shortly after Linzy himself experienced his first art-world successes, the video parodies the rise, fall, and ultimate return of a hopeful emerging artist. Linzy's subsequent videos and performance have investigated the structures of celebrity and pop culture and include collaborations with personas such as musician Michael Stipe and actor James Franco, among others.

Still from *Conversations Wit de Churen V: As da Art World Might Turn*, 2006. Video, color, sound; 12:09 min. Edition no. 3/5. Purchase with funds from the Film, Video, and New Media Committee 2009.134

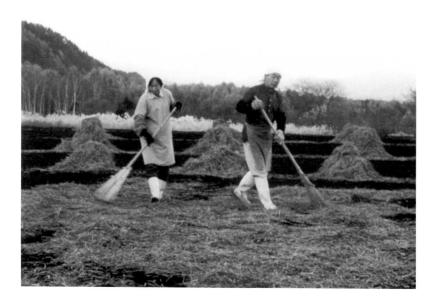

Since the mid-1990s, Los Angeles–based artist Sharon Lockhart has become known for her conceptually and formally rigorous films and photographs. As a student at the Art Center College of Design in Pasadena, California, she was exposed to the work of James Benning, Hollis Frampton, Yvonne Rainer, Michael Snow, and Andy Warhol, artists who frequently explored the relationship between the still photographic image and its moving cinematic counterpart. Lockhart's films, indebted to both the history of art and a critical history of cinema, similarly investigate the durational possibilities of the camera and the extended act of looking. The artist often focuses on seemingly candid yet elaborately staged everyday moments that are the result of extensive collaboration with her subjects.

Lockhart's film *NŌ* records the meticulous mulching work of a Japanese husband and wife. Within the static frame of the artist's camera, the film resembles a moving landscape, as the farmers pile hay and then slowly spread it across an empty field. With the same deliberate choreography of her previous films, the artist uses the lighting, colors of the landscape, depth of field, and the seemingly detached camera angle to investigate the underlying principles of photography and cinematography. The film, however, becomes more than a structuralist exercise. The title refers not only to the Japanese calligraphy character for farming and NŌ-no ikebana, a more radical form of ikebana flower arranging, but also to Noh, a popular form of theater in Japan. Through metaphor and metonymy, Lockhart creates layers of meaning embedded in time.

Still from *NŌ*, 2003. 16mm film, color, sound; 32:30 min. Edition no. 3/5. Purchase with funds from the Film and Video Committee 2005.22

Conceptual artist Mark Lombardi's delicate pencil drawings chart the webs of power and influence that interweave governments, individuals, and corporations, as well as various crime and conspiracy networks. In the early 1990s Lombardi began researching scandals of the time in the financial and political realms, from the Vatican Bank and Savings and Loan crises to Harken Energy and Iran Contra, as well as the vast network of intrigues surrounding BCCI (Bank of Credit and Commerce International), which had come under the scrutiny of financial regulators and intelligence agencies and was ultimately found to be involved in massive money laundering.

BCCI-ICIC & FAB, 1972–91 (4th Version) visually traces the bank's web of financial connections, which had far-reaching political implications. While he was inspired by the information design of statistician and political scientist Edward Tufte, Lombardi's maps—which he called "narrative structures"—do not function as examples of data visualization per se. Rather than simplifying, the drawings add complexity to the understanding of interconnected networks, and their visually compelling arcs and looping lines have caused them to be compared to celestial or navigation charts. Solid or dotted lines create abstract fields of connection suggested by information found in newspaper or television accounts, while verifiable information culled from court judgments typically appears in red. Notable for both their formal structure and conceptual potency, the drawings have also attracted official attention: in the wake of the September 11, 2001, attacks, the FBI contacted the Whitney regarding *BCCI-ICIC & FAB, 1972–91 (4th Version)*, in which information regarding the financial networks of Osama bin Laden appears.

BCCI-ICIC & FAB, 1972–91 (4th Version), 1996–2000. Graphite pencil and colored pencil on paper, 51⅛ x 137¾ in. (129.9 x 349.9 cm). Purchase with funds from the Drawing Committee and the Contemporary Painting and Sculpture Committee 2000.250.1

BCCI-ICIC & FAB, 1972–91 (4th Version), 1996–2000 (detail)

Influenced by the drip painting technique of Jackson Pollock, a group of American artists in the 1950s began to experiment with the effects of diluting and pouring synthetic paints onto unprimed canvas, allowing the paint to spread and bleed, and creating flat areas of color. Chief among them were Helen Frankenthaler in New York and Morris Louis in Washington, DC. Louis visited Frankenthaler's studio in 1953, and after seeing her recent "stain" paintings he devoted himself to exploring the technique and expanding the style for the next nine years. Louis's mature paintings are often divided into three series, each numbering over one hundred works, in which he experimented with different compositions: the broad, irregular swaths of often overlapping color of the *Veils* (1954, 1958–59); the brightly colored, poured ribbons that uncoil over the bottom edges of the *Unfurleds* (1960–61); and the multicolor bands that overlap and extend horizontally or vertically across the *Stripes* (1961–62).

 Addition II, one of the *Veils*, differs from earlier paintings in the series with its distinct separation of the broad plumes of color. Louis, like many of the Color Field painters, often left large areas of canvas blank, and the open space in the center of *Addition II* directs attention outward to the irregular clouds of blue, red, green, and black paint that emanate from the four edges. Critic and friend Clement Greenberg observed that Louis's staining technique "conveys a sense not only of color as somehow disembodied, and therefore more purely optical, but also of color as a thing that opens and expands the picture plane."

Addition II, 1959. Acrylic on canvas, 99¼ x 135¼ in. (252.1 x 343.5 cm). Gift of the Marcella Brenner Revocable Trust 2011.52

The title of Al Loving's *Septahedron 34*
describes the open, seven-faced object that
he painted onto a shaped canvas. Loving
began working in the late 1960s with
geometric shapes, which provided him with
what he described as "a sort of mundane
form that could be very, very dull unless
a great deal was done with it." The young
painter used this structure as an arena
for experimentation, a way to uncover his
particular colorist sensibility. Loving enlivens
his subject here by juxtaposing Day-Glo
pigments that recede or advance relative to
one another. The resulting composition
toggles between three-dimensional illusion
and painterly flatness. His paintings
garnered significant attention, and in 1969
he became the first African American
artist to receive a one-person show at the
Whitney Museum.

The shaped canvases and geometric
forms depicted in Loving's paintings
from the late 1960s and early 1970s align
with the emphasis on rigorous abstraction
and repetition championed by many of

his Minimalist contemporaries. However,
the mid-1960s also saw the rise of the
Black Arts Movement and other activist
groups whose members asserted the
urgent need for art reflective of African
Americans' everyday struggles. While
Loving's abstractions eschew the figurative
content often associated with activist
art, he was politically engaged in his
life outside the studio and believed that
"art is about needs that have not been met."
Indeed, his claim that "even a box can
be a self-portrait" prompts the viewer to
consider how *Septahedron 34*, a thoroughly
nonrepresentational painting, can also
reveal the personal.

Septehedron 34, 1970.
Acrylic on shaped canvas,
88⅝ x 102½ in. (225.1 x
260.4 cm). Gift of William
Zierler Inc. in honor
of John I. H. Baur 74.65

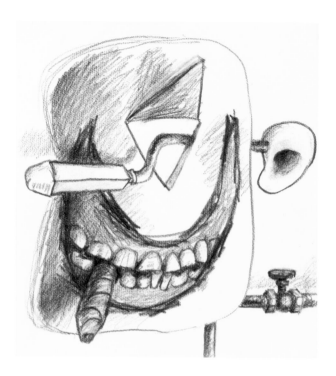

In Lee Lozano's early 1960s graphite drawing, inanimate objects protrude from a rectangular, grinning face. Its crooked teeth grip a cigar or crayon, yet other accessories defy bodily logic: instead of a neck, a pipe and faucet extend from the disembodied head; instead of eyes, a triangular opening is pierced by the crank of a brace drill, positioned so that its handle serves as ear while its jaws become a phallic nose. The inconsistency of graphite marks, which range from subtle chiaroscuro to violent scribbles, enhances the strangeness of the scene. This grotesque, Surrealist collision of human and mechanical forms is one of many Lozano produced in the years immediately following her move to New York around 1960. Made in pencil, wax crayon, pastel, and paint, these drawings stage disturbing, humorous, and perverse encounters between body parts—especially breasts, phalluses, and orifices—and a variety of handheld tools and household objects.

Lozano's artistic career was cut short by a self-imposed exile from the art world in 1972, but during the nearly dozen years she spent in New York she produced a complex and provocative body of work. Her charged, mechanomorphic drawings can be seen as a comment on a turn to industrial techniques of art making, while also anticipating the gender politics of the late 1960s. A subsequent series of large-scale paintings and drawings depicts tools in a more hard-edged style that nonetheless retains suggestive anthropomorphism, while her language-based works of the late 1960s place her at the vanguard of Conceptualism.

Untitled (Grinning Face with Ear/Crank), c. 1962. Graphite pencil on paper, 9¼ x 8⅝ in. (23.5 x 21.9 cm). Gift of Susan Lorence 2008.247

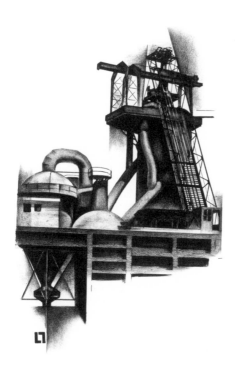

Louis Lozowick worked predominantly in the print medium and was most prolific during the 1920s and 1930s, when he recorded the social reform and industrial growth that took place in America between the world wars. Born in the former Russian Empire (now Ukraine), Lozowick immigrated to the United States in 1906, where he studied drawing and pursued a liberal arts education. During a year spent in the Army Medical Corps, in 1918, he was able to travel cross-country, sketching the industrial structures that would later become the central subject of the prints and paintings of his mature style. Lozowick moved to Europe the following year and, during time spent in Paris, Moscow, and Berlin, absorbed the ideas and techniques of artists of the European avant-garde, especially the Constructivists. "Almost everyone evinced an immediate interest in America," he later recalled, "not, however, its art but its machines." Upon his return to the United States in 1924, he would incorporate their views into his vision of industrial America.

Lozowick's attraction to the geometry of the American industrial landscape is evident in *Corner of Steel Plant*. The angle of the image, looking up at the steel mill, highlights the power of its presence and the rational order of its structure—the parallel lines of the scaffolding, the grid of the vent, the curves of the pipes. While Lozowick's lithographs from the 1910s and 1920s depict industrial structures and machine parts, during the Depression his prints became more overtly political and explored themes of labor, strikes, homelessness, and racial inequality.

Corner of Steel Plant, 1929. Lithograph: sheet, 13⅜ x 9⅜ in. (34 x 23.8 cm); image, 11½ x 7⅞ in. (29.2 x 20 cm). Edition of 25. Purchase with funds from The Lauder Foundation, Leonard and Evelyn Lauder Fund 96.68.202

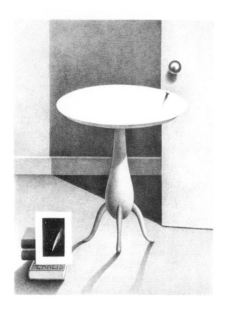

To accompany an exhibition of their paintings in 1934, Helen Lundeberg and her teacher (and later husband) Lorter Feitelson published an artistic manifesto that called their style "Postsurrealism." At a time when French Surrealist painters were gaining prominence in New York, Lundeberg's paintings presented a different take on the movement. Like Surrealism, her paintings represented the inner workings of the mind through pictorial allegory, but instead of privileging the often-chaotic unconscious, she focused on the rational and scientific mind. With their poetic use of symbols, her paintings pose intellectual puzzles. The unexpected presence of flat, abstracted geometric forms within three-dimensional perspectival space lends her work a sense of visual mystery and a distinct style that would later garner the term "hard-edge" painting.

In *Planets*, a monochromatic print Lundeberg made under the auspices of the Federal Art Project, a circular table sits in the center of a room with a door open behind. A marble rests near the edge of the table, adjacent to a rounded doorknob, and together these spherical forms resemble celestial bodies in orbit. In the foreground an image of a comet is propped atop a stack of books, the word *PLANETS* visible on the cover of the bottommost one. The stark contrast of light and dark turns swaths of illumination or shadow into spatial planes. This image is a mystical interplay between two- and three-dimensional space, abstraction, and representation. Evidently modeled after Lundeberg's painting *The Red Planet* from 1934, the composition is nearly identical but is a mirror reflection, with the stack of books and door on opposite sides of the image.

Planets, 1937. Lithograph: sheet, 16 x 12½ in. (40.6 x 31.8 cm); image, 12 x 9 in. (30.3 x 22.9 cm). Edition unknown. Purchase with funds from the M. Anthony Fisher Purchase Fund 81.17

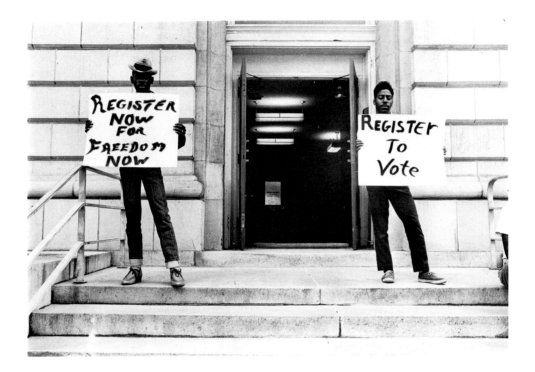

The son of European émigrés, self-taught photographer Danny Lyon traveled south to join the Student Nonviolent Coordinating Committee (SNCC) in Selma, Alabama, in 1962. Working with the civil rights organization for two years, he became its first staff photographer and documented its activities, including sit-ins and marches, as they campaigned across the South for racial equality. In images that combine the unflinching realism of street photographers such as Robert Frank with the intertwining of reporter and participant that marked New Journalism, Lyon helped publicize the group's efforts and, in the process, produced a visual record of a crucial period in the history of the civil rights movement.

Two SNCC Workers, Selma (which was published in a 1964 documentary book about the movement) pictures a pair of SNCC workers encouraging voter registration, which had been made difficult for African Americans in the South by obstacles such as literacy tests and · administrative delays. The imperatives of the men's signs, the visual rhythm created by their matching stances, and the striking tonal contrasts in the image make for a dramatic composition. Indeed, the moment Lyon captured was a tense one: soon after this shot was taken, the workers were arrested—an incident that Lyon also caught on camera.

After leaving SNCC in 1964, Lyon shifted his focus to documenting Chicago motorcycle gangs; subsequent projects have taken as their subject the Texas prison system, industrial workers in China, and the Occupy Wall Street movement. Lyon's photographs, often published as books, stand beside his notable work as a writer and a filmmaker.

Two SNCC Workers, Selma, 1963. Gelatin silver print, 7¼ x 10⅝ in. (18.4 x 27 cm). Purchase with funds from the Photography Committee 95.6

In 1913 Stanton Macdonald-Wright established himself as a pioneer of Modernist abstraction. That year, he debuted an abstract, kaleidoscopic method of painting that he had developed together with his colleague Morgan Russell while living in Paris. They called their movement Synchromism, a term that means *with color*. Rooted in various color theories, particularly those of Macdonald-Wright and Russell's teacher, the Canadian artist Ernest Percyval Tudor-Hart, Synchromism identified color as the generating element of form, volume, and movement. For both artists, color was an abstract tool for conveying mood and emotion; as with musical scales, a spectrum of colors could be combined to achieve a harmonious arrangement. Macdonald-Wright and Russell earned critical acclaim following their landmark Synchromist exhibitions in Paris and Munich in 1913, but the advent of World War I led to the end of their partnership.

By 1916, Macdonald-Wright was back in the United States, where he eschewed his earlier nonobjective style in favor of semiabstract, vibrantly hued compositions with suggestions of figurative imagery, such as *Oriental – Synchromy in Blue-green*. Years later, the artist recalled that this painting was based on a group of figures smoking opium, a subject related to his incipient interest in Eastern aesthetics and philosophy (he would spend the later decades of his career teaching these subjects at the University of California, Los Angeles). As in a hazy, drug-induced reverie, the hints of figurative imagery—a face, an arm, a thigh—seem to appear momentarily before dissolving into the layered, shifting planes of form and gently feathered hues.

Oriental – Synchromy in Blue-green, 1918. Oil on linen, 36⅛ x 50 in. (91.8 x 127 cm). Purchase 52.8

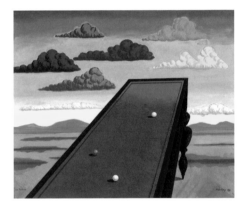

Man Ray was the only American artist to play a leading role in the Dada and Surrealist movements, spending much of his career in Europe. The son of Russian-Jewish immigrants, he was born Emmanuel Radnitzky and adopted the pseudonym Man Ray at the outset of his career. After collaborating in New York with French Dadaists Marcel Duchamp and Francis Picabia, Man Ray moved to Paris in 1921. During the following decade, he focused on photography, using the medium to portray members of his avant-garde Parisian milieu as well as to transform everyday objects into strange and disconcerting Surrealist compositions, as in this untitled photograph of a mannequin's hand.

He shifted to painting in the 1930s, creating Surrealist canvases such as *La Fortune*, which he produced shortly before fleeing Nazi-occupied Paris for Los Angeles. The composition is dominated by an oversized pool table, which looms over an uninhabited landscape and a sky filled with rainbow-hued clouds. Man Ray described the painting in relation to a string of personal associations: "I distorted the perspective of that table on purpose, I wanted it to look as big as a lawn. I could have had two people playing tennis on it." The pool table also alludes to the Surrealist fascination with games and chance as creative springboards, while the spectrum of clouds evokes a painter's palette, suggesting an allegory of artistic creation. The table's lack of pockets indicates that the game, like all Surrealist propositions, will not follow rational rules or logic—but the painting's title, meaning *wealth* or *luck*, seems to augur rewarding possibilities.

Untitled, 1931. Gelatin silver print, 6⅜ x 8½ in. (16.2 x 21.6 cm). Promised gift of Sondra Gilman Gonzalez-Falla and Celso Gonzalez-Falla to the Whitney Musum of American Art, New York, and the Gilman and Gonzalez-Falla Arts Foundation P.2014.93

La Fortune, 1938. Oil on linen, 23¾ x 28⅞ in. (60.3 x 73.3 cm). Purchase with funds from the Simon Foundation Inc. 72.129

Manila – Neutral Area is one of Robert Mangold's *Walls and Areas* works of the mid-1960s. Although nonrepresentational, the series has roots in reality, as it was inspired by the architecture of lower Manhattan, where the artist moved in 1962. The notch in the left panel evokes a roof overhang, the division between the two panels suggests the borderline between two adjacent buildings, and the scale of the work—roughly eight by eight feet—is architectonic. "Shape is the first element in my work . . . everything starts there," Mangold has stated. While the artist used the mechanical method of spraying paint on composition board, the work's gentle gradations of color from buff to ivory conjure handmade effects.

Mangold was part of the generation of artists who came to prominence in New York in the 1960s under the rubric of Minimalism. Like Robert Ryman and Sol LeWitt, Mangold was interested in the perceptual possibilities engendered by small permutations within a limited set of formal variables. For Mangold, these elements were line, shape, and color, which he has combined over the course of a long career in varying, and frequently unexpected, ways. Most of his paintings and wooden constructions involve large, spare geometric units that are often parceled into smaller internal divisions. By limiting his pictorial means, the artist trains our attention on subtleties of form and composition. One takes in a Mangold work all at once, rather intuitively, but its perceptual nuances invite sustained contemplation.

Manila – Neutral Area, 1965–67. Oil on composition board, two panels: 96¼ x 96⅜ in. (244.5 x 244.6 cm) overall. Gift of Philip Johnson 72.41a–b

Although its subject appears ordinary— a section of floor and wall in a room— Sylvia Plimack Mangold's *Floor with Horizontal Mirror* effects a canny play on the conventions of representation and the mechanics of vision. In depicting not only an expanse of wood flooring but its reflection in a mirror propped up against the wall, the artist stages a perspectival conundrum: the mirror at once creates a sense of depth and directs our attention to the surface of the picture plane. "I want the viewer to . . . enter the painting, and then come back to the surface," she has stated. The mirror also makes a literal pun on the idea of a painting being a window onto the world, and asserts Mangold's photorealistic abilities: every color shift and striation in the wood flooring's strips has been faithfully recorded, appearing just as they do in the mirror.

After studying at the Cooper Union and Yale University, Mangold first experimented with Cubist-like modes of painting, arriving at her signature theme in the mid-1960s: the floors, corners, baseboards, wainscoting, and walls of her New York apartment and studio. Often, these works incorporated trompe l'oeil images of masking tape and rulers, which self-reflexively referenced both her painting process and the confines of the work. In 1971 Mangold and her family moved to upstate New York, and most of the paintings, drawings, and prints she has produced since that time are landscapes featuring the trees around their home.

Floor with Horizontal Mirror, 1974. Acrylic and fabricated chalk on canvas, 51¼ x 67⅝ in. (130.2 x 171.8 cm). Purchase with funds from Mr. and Mrs. William A. Marsteller 74.42

Robert Mapplethorpe

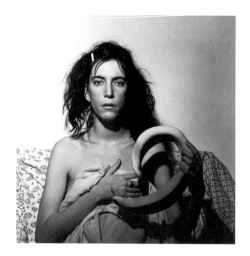

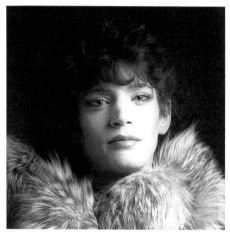

Patti Smith, 1978. Gelatin silver print, 13⅞ x 13⅞ in. (35.2 x 35.2 cm). Edition no. 2/10. Jack E. Chachkes Bequest 95.146

Self Portrait, 1980. Gelatin silver print, 13½ x 13¾ in. (34.3 x 34.9 cm). Edition no. 7/15. Purchase with funds from The Sondra and Charles Gilman Jr. Foundation Inc. and partial gift of The Robert Mapplethorpe Foundation Inc. 2002.322

Having studied a variety of fine-art mediums at the Pratt Institute, Robert Mapplethorpe turned to photography in the early 1970s. He first used a Polaroid and then various medium- and large-format cameras, working predominantly in black and white. His subjects comprised nudes, still lifes, and portraits—of himself and of friends, lovers, and fellow artists. *Patti Smith* pictures the musician and artist with whom Mapplethorpe shared a close relationship for many years (an earlier image he made of Smith graced the cover of her 1975 debut album, *Horses*). The portrait conveys an unguarded, frank intimacy: Smith, with her androgynous beauty, stares at the camera, covering her naked torso with a sheet as if she has been caught unawares. Other signs, however, suggest that this image was deliberately arranged: the curled neck brace Smith holds (remnant of an injury) echoes the shape of her head, and her bent elbows create a carefully composed visual rhythm.

Mapplethorpe's work was marked by rigorous attention to the principles of classical composition, and his coolly elegant images were deftly staged and carefully printed. If some of his motifs—most notably, his still lifes of flowers—had long pedigrees in the history of art, others marked his work as pioneering. His photographs of sadomasochistic acts became a lightning rod for controversies about public arts funding in the 1980s. One of Mapplethorpe's abiding concerns was the idea of gender and sexuality as social constructs, a theme he explored not only in portraits of members of the S & M scene but also in self-portraits in which he assumed various personas. *Self Portrait* shows the artist in drag, wearing makeup and a boa. As in the photograph of Smith, Mapplethorpe's expression is at once confrontational and indecipherable, hinting at private narratives.

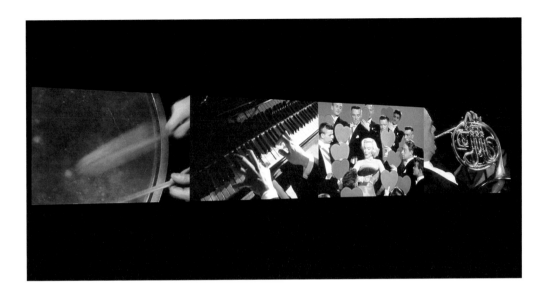

Since the late 1970s Christian Marclay has explored the interplay of sound, noise, music, and image in a body of work that ranges across sculpture, installation, film, and musical performance. He has collaborated with musicians such as Sonic Youth and the Kronos Quartet and is one of the pioneers of "turntablism"—the use of vinyl records and turntables as musical instruments—and of the remix as a cultural form. In *Video Quartet*, a visual and auditory collage consisting of four synchronized videos that form one contiguous image-and-sound work, Marclay creates a seventeen-minute symphony that assembles and musically choreographs hundreds of clips from iconic Hollywood feature films from the 1920s to the early twenty-first century. The film scenes, which themselves relate a cultural history of the movies, feature people playing musical instruments or singing as well as other soundtrack elements: shouts, screams, objects generating noise, and moments of cinematic silence.

Video Quartet is a meticulously edited composition that at the same time maintains an improvisational atmosphere, the clips creating moments of synchrony or seeming spontaneously to respond to each other as if performed live. The project anticipates genres such as the "supercut," a video montage highlighting a single theme that has become a popular form on YouTube. Marclay continued his exploration of montage in *The Clock* (2011)—winner of the Golden Lion at the 2011 Venice Biennale—a film that chronicles a twenty-four-hour period by combining thousands of film excerpts featuring clocks, watches, and timekeeping mechanisms, commenting on cinematic time as it unfolds in real time on the screen and through cinema's history.

Video Quartet, 2002. Four-channel video installation, black-and-white and color, sound; 17 min.; 96 x 480 in. (243.8 x 1,219.2 cm) overall. Purchase with funds from the Painting and Sculpture Committee 2005.171

By the time he finished his MFA at Yale University in 1963, Brice Marden had begun to develop what would become a vital concern of his early work: the use of monochrome abstraction to conjure expressionistic effects. In 1964 his exposure to the art of Jasper Johns—while employed as a guard at the Jewish Museum in New York during an important Johns exhibition—fostered his dedication to geometric formats; Mark Rothko, Robert Ryman, and Robert Rauschenberg, for whom he worked as an assistant in the mid-1960s, were other notable influences. Minimalism was then the dominant idiom, and while Marden borrowed its formal rigor and muted palette, he did so to expressive ends. In his words, his art is "highly emotional."

Marden created *Summer Table* using a combination of melted beeswax and oil paint, a mixture he developed in the mid-1960s in order to endow the surface of his canvases with a luminescent tactility. Comprising three panels of equal size, the work seems to pulse with chromatic tension. The artist applied the paint with a spatula, producing a dense, matte surface devoid of brushstrokes. Traces of his process remain, however, in the narrow strip of paint drips and spatters at the bottom of each panel. And although *Summer Table* is wholly nonrepresentational, Marden has identified it as rooted in nature and experience. The work's palette evokes the sun, land, and sea of the Mediterranean, and was directly inspired by the memory of a table set with glasses of lemonade and Coca-Cola that the artist saw on the Greek island of Hydra, where he has spent time since 1971.

Summer Table, 1972–73.
Oil and wax on canvas, 60¼ x 105⅜ in. (153 x 267.7 cm).
Purchase with funds from the National Endowment for the Arts 73.30

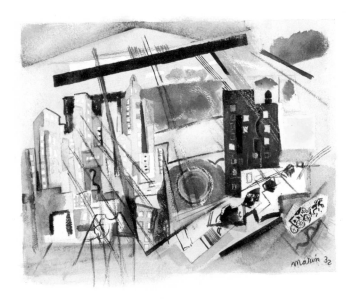

One of the most revered watercolorists in the history of American art, John Marin was a central member of the vanguard group of modern artists associated in the early decades of the twentieth century with Alfred Stieglitz and his New York galleries. Dividing his time between his native New Jersey and the New England coast, especially his beloved Maine, Marin focused on painting the urban and rural American landscape. The architecture of lower Manhattan occupied him especially at the outset of his career, after he returned in 1911 from a prolonged European sojourn. In the soaring structures of New York—especially landmarks like the Woolworth Building and the Brooklyn Bridge—Marin found the excitement and optimistic promise of modernity. Using Cubist geometries and expressionist brushwork, he portrayed the city as a living entity, an organic, rhythmic being governed by spatial tensions that he described as "warring, pushing, pulling forces."

Region of Brooklyn Bridge Fantasy, a later meditation on the subject of the Brooklyn Bridge, continues to emphasize the city's energetic dynamism. Yet the composition shifts away from Marin's early graphic style toward a weightier handling of paint and a greater stress on underlying structure—developments that may reflect his contemporaneous experiments with oil paint, which he began using in 1925, as well as his response to the dramatic architectural transformations New York was undergoing in the 1930s. By juxtaposing the dense band of skyline and radiant sun with the bridge's delicate cables, which fan out in staggered diagonals across the composition, Marin here transforms the bridge into an ethereal presence—the icon of an earlier world.

Region of Brooklyn Bridge Fantasy, 1932. Watercolor, colored pencil, and graphite pencil on paper, 22 x 28¼ in. (55.9 x 71.8 cm). Purchase 49.8

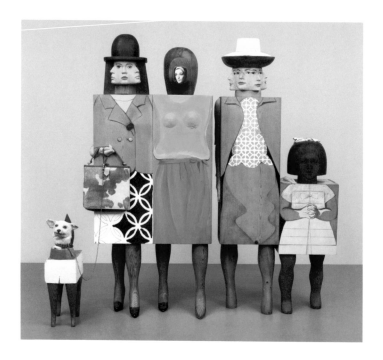

Born Maria Sol Escobar in Paris to Venezuelan parents, the artist Marisol moved to Los Angeles at age fifteen and studied for a time with the painter Hans Hofmann in New York. Rebelling against the dominance of Abstract Expressionist painting in the mid-1950s, she turned to sculpture, forging a distinctive approach that combined elements of Surrealism, Pop art, assemblage, and even folk art in her arrangements of large-scale figures. Marisol frequently used her own image—drawn, painted, sculpted, photographed, and carved—for both the male and female figures of her tableaux, which have depicted everything from monstrous, oversized children to John Wayne on horseback, a dinner date, women at a cocktail party, a wedding, and the Last Supper.

Each of the four life-sized blocky female figures in the sculptural assemblage *Women and Dog* is a self-portrait of the artist, carved from wood and painted. One of the figures incorporates a black-and-white photograph of Marisol; the multiple faces on two of the others were cast in plaster directly from the artist herself; while the small figure is a representation of Marisol as a child. Each sports a fashionable outfit of the period, accessorized with found objects that include a real purse and hair bow. Although the work explores variations on the generic midcentury American woman, Marisol, commenting on the piece in 1964, claimed to have been "inspired by the dog." Indeed, the stuffed dog head—which the artist purchased from a taxidermist—is a central element of the piece; the animal, tethered by a leash, becomes another kind of accessory to these well-heeled ladies.

Women and Dog, 1963–64. Wood, plaster, acrylic, taxidermic dog head, and found objects, 73⅝ x 76⅝ x 26¾ in. (187 x 194.6 x 67.9 cm) overall. Purchase with funds from the Friends of the Whitney Museum of American Art 64.17a–g

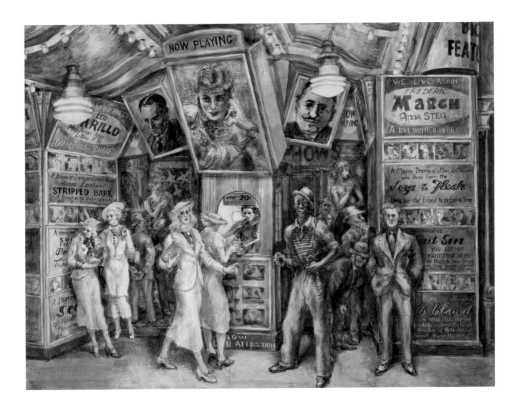

With his staccato brushwork and densely packed compositions, Reginald Marsh captured the vitality of New York in the 1930s. Though born into a wealthy family, Marsh set out to portray everyday urban dwellers—pedestrians, subway riders, Coney Island bathers, burlesque performers, and dance-hall workers. *Twenty Cent Movie*, like many of his compositions, relies on authentic details—here, the precise imagery, wording, and typeface of the movie marketing campaigns—to activate a sense of realism. A prolific and inveterate sketcher, Marsh made extensive drawings for the composition of this painting, which he based on the facade of the Lyric Theater on Third Avenue and Thirteenth Street, not far from his studio on Union Square. The meticulously replicated theater exterior that serves as the painting's backdrop resembles a stage set, in front of which the scene's figures are poised

for action. The women mimic the fashionable styles of Hollywood actresses, while the man on the far right adopts a self-assured posture in the type of flamboyant suit sported by the gangsters of 1930s cinema. In an era when Hollywood movie stars became national celebrities, Marsh's characters reflect the bright aspirations projected on the silver screen, but the scene is not without reference to the period's economic turbulence. The painting's title, *Twenty Cent Movie*, reiterated on the box-office sign, alludes to the drop in ticket prices at some theaters to entice an audience during the Great Depression.

Twenty Cent Movie, 1936.
Carbon pencil, ink, and
oil on composition board,
30 x 40 in. (76.2 x 101.6 cm).
Purchase 37.43a–b

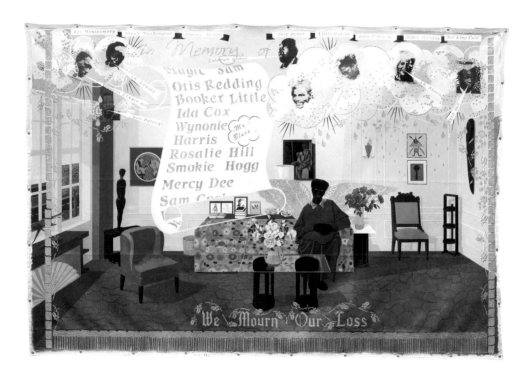

Kerry James Marshall gained prominence in the 1990s for works that invoke the grand traditions of history painting and yet pointedly defy the genre. Throughout his already four-decade-long career, Marshall has often depicted African American subjects—long omitted from traditional narratives of art history—in everyday settings that exude an otherworldly aura. During the rise of identity politics in the 1980s and 1990s, when photography and conceptually based art were primarily addressing these issues, Marshall employed the more traditional form of figurative painting to investigate notions of identity.

Marshall studied at the Otis Art Institute in Los Angeles, and the influence of his drawing instructor Charles White, an artist known for his social realist murals, can be seen in Marshall's conjunction of expert draftsmanship with unconventional materials and Old Master techniques such as grisaille. In 1998 he created a suite of four monumental paintings for *Mementos*, his multimedia installation at the Renaissance Society in Chicago. The four *Souvenir* paintings commemorate African American icons who made invaluable contributions to American culture and died in the 1960s. Set in a middle-class domestic interior, *Souvenir IV* memorializes musical pioneers, including John Coltrane and Billie Holiday, whose faces appear as celestial presences above the black-and-white living room. A lone woman sits on the sofa below, bearing a set of brilliant angel's wings as she gazes directly at the viewer—an invitation to join in the remembrance of those "key African Americans and their creative legacies."

Souvenir IV, 1998. Acrylic, glitter, and screenprint on paper and tarpaulin, with metal grommets, 107⅝ x 157½ in. (273.4 x 400.1 cm). Purchase with funds from the Painting and Sculpture Committee 98.56

Throughout the more than five decades of her career, Agnes Martin made works using a spare, formal vocabulary and a delicate, subtly variegated palette. Martin was among a vibrant group of artists—including Ellsworth Kelly, Robert Indiana, and James Rosenquist—who settled in the Coenties Slip neighborhood of Manhattan in the late 1950s. Martin established her reputation as one of the foremost abstract artists of the postwar era with six-foot-square canvases delineated with overall grid patterns; in 1967, however, she moved to Taos, New Mexico, and ceased painting until 1974. When she began working again she shifted to compositions of horizontal bands of color defined by graphite lines, a body of work exemplified by *The Islands*.

From a distance or in photographs, the twelve pale, identically sized paintings of *The Islands* appear indistinguishable. As with most of Martin's works, they are almost impossible to capture accurately in reproduction; the experience of viewing them in person is essential to appreciating and understanding her art. Only then can the variances in the faint graphite markings and the ethereal, horizontal washes of color that differentiate the twelve canvases

be noted. Among her most ambitious and monumental works, *The Islands* envelops viewers in a contemplative environment in which they can become attuned to the sublime qualities of light and atmosphere as well as to their own reactions to the work. While Martin's commitment to nonobjective painting and her disavowal of ego in art have sometimes led to her association with Minimalism, her work is hardly devoid of expression and emotion. "Everything," she said, "is about feeling."

The Islands, 1979. Acrylic and graphite pencil on linen, twelve panels: 72 x 72 in. (182.9 x 182.9) each. Purchase with funds from The Sondra and Charles Gilman Jr. Foundation Inc. and Evelyn and Leonard Lauder 93.110a–l

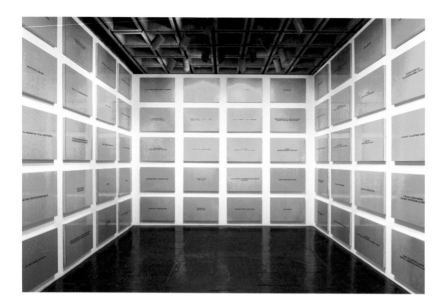

Daniel Joseph Martinez has implemented nearly every available artistic medium—text, photography, painting, sculpture, video, performance, and even motorized animatronic self-portraits—in works that examine individual and collective identity and reveal tensions between political activism and personal culpability. Martinez developed *Divine Violence* from a research project aimed at cataloguing every twentieth- and twenty-first-century organization that sanctions the use of violence for political ends. Ninety-two hand-lettered names appear on two-by-three-foot wooden panels coated with gold automotive paint. Martinez selected the color for its associations, which range, as he has explained, from "the Renaissance and religion to precious mineral and economic considerations." Presented floor to ceiling in an installation that fills a room, *Divine Violence* immerses the viewer in a gridded, gilded environment.

Martinez implements a "flattening out of political ideologies" in the project, whereby a globe-spanning range of resistance movements and state-run agencies appear side by side. Included are groups as seemingly disparate as the Vigorous Burmese Student Warriors and the Central Intelligence Agency. Yet, every organization on his ongoing list "claims the same thing: to be right, to be moral, to be ethical, and . . . to be fighting in the name of God." The artist derived the installation's title from Walter Benjamin's 1921 essay "Critique of Violence," a text in which the philosopher considers circumstances under which violence is acceptable. While Martinez boldly advocates for "the end of useful politics, as we know it," he remains optimistic. *Divine Violence* prompts viewers to consider embracing what he envisions as "an intertextual and intercultural society," one that might move humanity forward toward an "unimagined future."

Divine Violence, 2007. Automotive paint on wood, ninety-two panels: 24 x 36 in. (61 x 91.4 cm) each. Purchase with funds from the Painting and Sculpture Committee, with additional funds from Neil Bluhm, Melva Bucksbaum, Philip Geier Jr., Nicki Harris, Allison Kanders, and Pamela Sanders 2008.289a–nnnn. Installation view: Whitney Museum, 2008

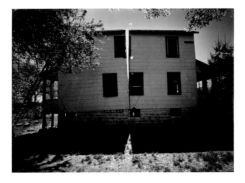

Of all the innovative site-specific works that were made during the 1970s, Gordon Matta-Clark's were among the most imaginative, socially conscious, and sculpturally remarkable. A son of the Chilean painter Roberto Matta, Matta-Clark trained as an architect at Cornell University before abandoning the practice to create conceptual interventions in urban space. In 1971 he began making what he termed "anarchitecture"—ephemeral transformations and perceptual shifts of the physical and social environment. In some instances this meant carving directly into the built environment, typically within overlooked urban neighborhoods and into derelict or soon-to-be-demolished buildings (an approach that eschewed the remote locations and geologic scale of the Land art and earthworks of contemporaries such as Michael Heizer and Robert Smithson). These "cuttings" merged the formal language of sculpture (line, volume, light, surface) with the cultural concerns of the 1970s—namely, the rupturing of established societal codes. To capture his process, Matta-Clark created a series of objects, photographs, books, drawings, and films that document his radical sculptural practice.

Untitled (1973) corresponds to the project *A W-Hole House*, an intervention Matta-Clark had made earlier that year in a small house in Genoa, Italy. Simulating a wall of the house with a stack of paper, he used a handsaw to cut the same minimal rhomboid shape he had incised into the architecture.

The film *Splitting* documents a celebrated work of Matta-Clark's, in which, over a period of months, the artist and a friend literally divided an abandoned house in suburban New Jersey, in half. In the film we see the men cut into the house with power tools and subtract chunks of its foundation until it cracks open, revealing unexpected shafts of light, astonishing interior views, and a strange sense of equilibrium.

Untitled, 1973. Stack of gessoed paper, cut, mounted on board, 26½ x 38½ x 2 in. (67.3 x 97.8 x 5.1 cm). Purchase with funds from the Painting and Sculpture Committee, the Director's Discretionary Fund, the Photography Committee, and the Drawing Committee 2008.215

Still from *Splitting*, 1974. Super 8 film transferred to video, black-and-white and color, silent; 10:50 min. Purchase with funds from the Film and Video Committee 2000.161

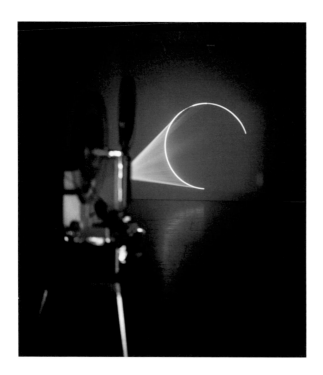

Since the early 1970s, Anthony McCall has taken a revolutionary approach toward experimental filmmaking through his ongoing series of projected light installations that are poised at the intersection of film, sculpture, drawing, and performance. His series *Solid Light* deconstructs the basic components of cinematic space—projection, light, darkness, duration—that require a phenomenological encounter with the work as opposed to the passive viewing of conventional narrative film. McCall completed his studies in graphic design at the Ravensbourne College of Art and Design in London in the mid-1960s and became an active member of the avant-garde artist collective the London Filmmakers Cooperative. He began using film to document his outdoor performance works and soon became fascinated with the medium itself, exploring its possibilities and limitations.

Made shortly after moving to New York in 1973, *Line Describing a Cone* is McCall's first *Solid Light* film. When projected in a room filled with mist generated by a fog machine, the 16mm film creates a physical beam of light that slowly traces a circle until a single conical plane exits as a volume of light piercing the room. As viewers walk through the installation, their bodies interrupt the geometric volume of light. To McCall the film deals directly with projected light, "one of the irreducible, necessary conditions of film," and "is the first film to exist solely in real, three-dimensional, space." The film led to further explorations of projected forms such as ellipses, waves, planes, and lines that contract, expand, fade, and reappear.

Line Describing a Cone, 1973. 16mm film, black-and-white, silent; 31 min. Purchase with funds from the Film and Video Committee 2001.248

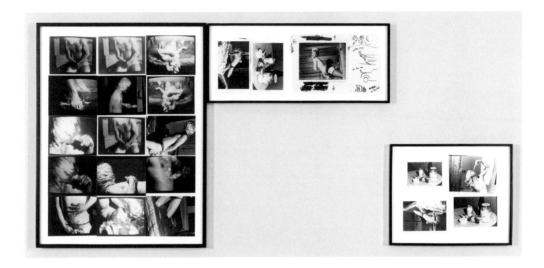

In the groundbreaking performances that form a significant part of his artistic output, Paul McCarthy creates graphic and disturbing scenarios that imagine the dark underbelly of American popular culture and family life. As he once noted, "I've always had an interest in repression, guilt, sex, and shit." McCarthy's performances of the late 1960s and early 1970s announced the thematic preoccupations and unfettered physicality that the artist would develop in his transgressive later works. Some of his best-known actions were documented on video and in photographs; such imagery forms the basis of his *Combination Photographs*, a series of unique collages.

Sailor's Meat and Sailor's Meat, Europe Raw and Sailor's Meat and Tubbing is a document of two well-known performances, *Sailor's Meat* and *Tubbing*, which McCarthy loosely based on Russ Meyer's soft-core film *Europe in the Raw!* (1963). In these works, the artist, wearing a blonde wig and black lingerie, smeared his body with ketchup and performed movements suggestive of copulation on a soiled bed and in a bathtub. Employing a range of props—including raw meat, skin cream, and bodily fluids—McCarthy delivered a pointed attack

on commercial entertainment, consumption, and social conventions. Although such body-based actions characterized much of the video and performance work of the 1970s, the spectacular and often grotesque extremes to which McCarthy extends these gestures set his work apart from that of his contemporaries and continue to challenge viewers who encounter his art today.

Sailor's Meat and Sailor's Meat, Europe Raw and Sailor's Meat and Tubbing, 1975, from *Combination Photographs*, 1970–80. Fifteen gelatin silver and chromogenic prints; three gelatin silver prints with manila folder, fiber-tipped pen, tape, ink, and paint; and four gelatin silver prints, dimensions variable. Purchase with funds from the Contemporary Painting and Sculpture Committee and Norah Sharpe Stone 2001.138.5a–c

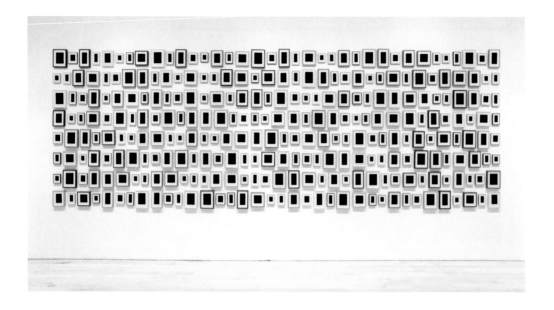

Allan McCollum, who began exhibiting in Los Angeles in the late 1960s, sought to escape the legacy of formalism—the theory that helped make Abstract Expressionism and Color Field painting the dominant styles of postwar American art. Inspired by the performative and conceptual aspects of movements like Fluxus, and by the standardization and modularity of industrial production, he attempted to make an object that would embody only the idea of painting. McCollum wanted to show that cultural conventions and contexts, rather than any qualities inherent in the work itself, made a painting what it was.

In 1978 McCollum assembled the first of his "surrogates" from wood and mat board, then painted the center of this picture-like object black. He went on to make many of these surrogates, initially crafting each one by hand; in 1982 he began casting them in plaster, which allowed for a larger production volume. For his 1983 exhibition at the Marian Goodman Gallery in New York, he filled the walls with hundreds of plaster surrogates. The exhibition perfectly illustrated the participation of art in a system of cultural rules dictating how it is made, displayed, viewed, and sold. Fabricated by McCollum and his assistants, works such as *Collection of Two Hundred and Eighty-eight Plaster Surrogates* represent a type of labor that is not "artistic" on its face but anonymous and communal. McCollum has said that "a painting is what it is because it is a convention. It exists precisely because the culture makes a place for it."

Collection of Two Hundred and Eighty-eight Plaster Surrogates, 1982–89. Enamel on solid-cast Hydrostone, dimensions variable. Gift of Joan and Jerome Serchuck 2000.190a–h

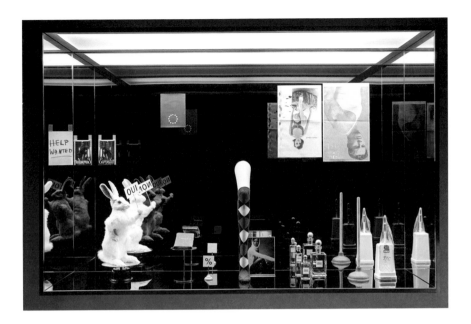

Josephine Meckseper left Germany in 1990 to attend the California Institute of the Arts and moved to New York, where she is still based, in 1992. Her stay in Southern California had a profound impact on the development of her practice, which examines links between politics, corporate capitalism, and consumerism. The shopping malls, car culture, and social unrest that were part of Meckseper's experience in Los Angeles inform the content of her photographs, films, videos, installations, paintings, and sculpture. She is perhaps best known for her displays of invented shopping vitrines that she began in 2000 and that she frequently exhibits alongside imagery of political demonstrations, suggesting scenarios of cause and effect. As Meckseeper has unequivocally explained, "The basic foundation of my work is a critique of capitalism."

For *The Complete History of Postcontemporary Art*, Meckseper assembled a discordant array of commercial products and political symbols. (One of the latter, held by a stuffed and rotating rabbit, alludes to France's 2005 referendum on the EU constitution.) The stylized display references both a department store window and an ethnographic museum, presenting a range of juxtapositions—what she referred to as the "contradictions and absurdities" of the objects exhibited. Her critique foregrounds the persistent conflation of consumption, politics, and art—a point underscored by the work's title. *The Complete History of Postcontemporary Art* asserts that consumer manipulation extends to recent art, articulating the artist's belief that "Contemporary art today tends to be complicit in the prevailing rapacious market economy."

The Complete History of Postcontemporary Art, 2005. Taxidermic rabbit on revolving display stand; mixed media on paper; and mixed-media objects in wall-inserted mirror, glass, acrylic sheeting, and wood vitrine with aluminum frame and fluorescent lights, 63 x 98½ x 23⅝ in. (160 x 250.2 x 60 cm). Purchase with funds from the Painting and Sculpture Committee 2014.65a–p

Julie Mehretu has been known since the late 1990s for her large-scale, dynamic paintings that capture the chaos and flux of urban experience, globalization, and contemporary politics. Her distinctive cartographic vocabulary derives from a wide range of sources, including maps, diagrams, and photographs; history and mural painting; and the abstractions of the historical avant-garde. Although influenced by her own migration—from Addis Ababa to New York, by way of Senegal, Michigan, Texas, and Rhode Island—Mehretu's work does not represent specific locations but rather takes up the radical possibilities of abstraction. Through a palimpsest of diverse imagery, perspective, and scale, she creates what she has described as "spaces of subterfuge, control, and power turning in on themselves."

Mehretu builds up the luminous depth of her paintings using ink, pigment, and thin acrylic sheets that are overlayed and sanded down. With *Untitled*, her first formal edition, Mehretu tackled the problem of achieving this effect in the medium of print.

Working with master printer Gregory Burnet, she employed a complex range of techniques, including etched lines and chine- collé, which allowed her to embed and superimpose imagery in thin layers of paper. The resulting composition suggests the intercirculation of populations, natural forces, and the built environment. Clusters of curving lines swirl around an architectonic knot, where the central, perspectival recession is disrupted by scattered structures and colored ribbons. The techniques of layering and image making demanded by print have prompted innovation in subsequent drawings and paintings; as Mehretu has explained, it is "in the printmaking that new things are invented."

Untitled, 2000, from *twoandthreezeros: Exit Art Portfolio*. Etching, aquatint, engraving, and drypoint with chine-collé and stencil: sheet, 22 x 29⅞ in. (55.9 x 75.9 cm); plate, 17¾ x 21⅞ in. (45.1 x 55.6 cm). Edition no. 1/50. Purchase with funds from the Director's Discretionary Fund 2012.147.6

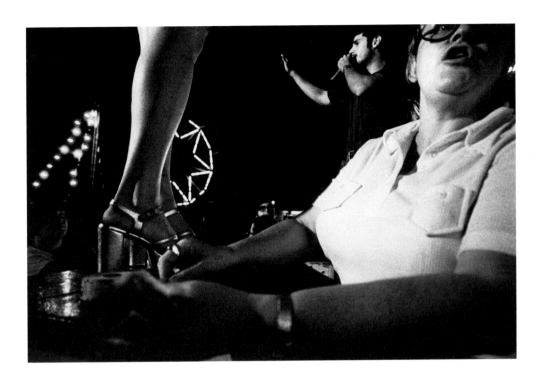

While studying at Harvard University in the early 1970s, Susan Meiselas began photographing neighbors in her Cambridge boardinghouse. Ever since, the acclaimed photographer has adopted a direct approach to the documentary tradition, often immersing herself within diverse populations for sustained periods of time. "The camera is an excuse to be someplace you otherwise don't belong. It gives me both a point of connection and a point of separation," she has remarked.

Meiselas's first major project, *Carnival Strippers*, was published as a book in 1976. Made at the time of the women's liberation movement, this feminist work is the result of the photographer's engagement with women working as strippers in carnivals and fairs between 1972 and 1975, primarily in New England. Using a small Leica camera without zoom lenses or a flash, she could shoot unobtrusively, capturing the full spectrum of carnival-stripper culture with unflinching immediacy. Attuned to the minutiae of human encounters, Meiselas depicts not only the overtly sexual performances but also the managers, bouncers, and "talkers" who lure clients, as well as the spectators, whose expressions vary from fascination to aggressive leering. Often shot from backstage or the edge of the stage, these candid photographs are as intriguing for their human insight as they are unsettling. Extensive transcriptions from tape-recorded interviews accompany these images and provide a more complex representation of the participants. Much like her contemporaries Danny Lyon and Larry Clark, Meiselas brings into full view a layered slice of America from its half-hidden fringes.

Patty's Show, Tunbridge, Vermont, 1974, from *Carnival Strippers*, 1972–75. Gelatin silver print, 7⅝ x 11½ in. (19.4 x 29.2 cm). Purchase with funds from the Photography Committee 2000.32

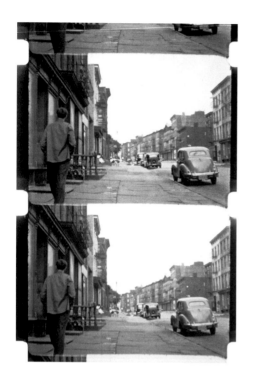

Experimental filmmaker Jonas Mekas has made more than one hundred films and has played an active role in New York's avant-garde film community for more than fifty years. He started the journal *Film Culture* in 1954; began writing criticism for the *Village Voice* in 1958; and, in 1969, cofounded Anthology Film Archives, a screening space, museum, and library in New York.

During World War II the Lithuanian-born Mekas was imprisoned in a Nazi labor camp because of his Slavic heritage; he managed to escape, but ended up living in refugee camps in Germany for four years. His time spent watching films in the camps fostered a lifelong interest in cinema. When Mekas arrived in New York in 1949, he began making a documentary about the experience of being displaced by war. Although he never fully realized the project, his footage points to the loneliness of his immigrant status. His subject matter soon expanded to include unscripted records of his personal life and the New York art scene, as well as poetic and fantastical sequences. To assemble the six-reel opus *Lost Lost Lost*, Mekas selected passages from hours of material shot between 1949 and 1963, including his earliest documentary-style material. The resulting film constitutes a journey of artistic and personal self-discovery; in successive reels a gestural and expressive style emerges, and by the end the air of loneliness begins to ease. As the artist has explained, "By reel six one cannot say that I feel lost anymore; paradise has been regained though cinema."

Frames from *Lost Lost Lost*, 1976. 16mm film, black-and-white and color, sound; 178 min. Purchase with funds from the Film, Video, and New Media Committee 2014.248

Ana Mendieta

b. 1948; Havana, Cuba
d. 1985; New York, NY

The earthworks, body art, performances, photography, and films Ana Mendieta made in the 1970s and early 1980s reveal an artist deeply connected to nature through the prisms of gender, identity, ritual, and cultural belief. At the age of twelve, Mendieta was sent with her older sister to the United States to escape the Castro regime in Cuba. The girls were resettled in orphanages and foster homes in Dubuque, Iowa—a profound dislocation that would surface in the artist's mature work. Although she studied painting, Mendieta abandoned the medium in 1972, stating that it wasn't "real enough. . . . I wanted my images to have power, to be magic." Her subsequent performative actions, such as wiping her blood-covered arms down a wall in a graceful sweeping gesture, and what she termed earth-body works— for example, placing an effigy into the dirt and lighting it on fire—were attempts to return her body to a more elemental state, one that symbolized sacrifice, regeneration, healing, the feminine, and the entropic cycle of life.

Untitled (Fetish Series, Iowa) documents an ephemeral earth-body work created at Old Man's Creek, in Iowa City. Mendieta used natural materials, mud and water, to create a figure; pierced with sticks, the form recalls the iconography of martyred Catholic saints, ethnoreligious fetish objects thought to contain supernatural powers, and simple burial mounds. The form would eventually wash back into the creek bed, but for Mendieta the simple act of building it was a way of "reasserting my ties with the earth . . . the reactivation of primeval beliefs . . . [in] an omnipresent female force."

Untitled (Fetish Series, Iowa), 1977. Chromogenic print, 20 x 13¼ in. (50.8 x 33.7 cm). Edition no. 2/2. Purchase with funds from the Photography Committee 92.112

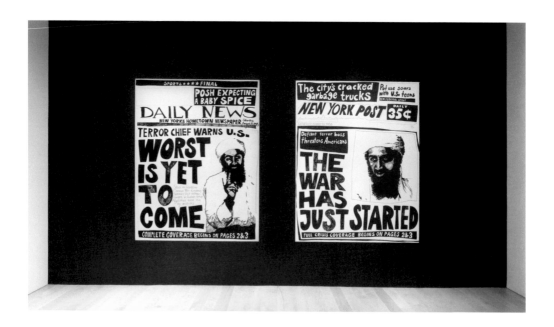

Through drawings and films that incorporate a do-it-yourself aesthetic and various forms of performance, Aleksandra Mir's socially engaged practice reflects her background in publishing and graphic design, as well as her study of cultural anthropology. The pair of drawings that constitute *Osama* were part of an ambitious collaborative project—*Newsroom 1986–2000*—that transformed Mary Boone Gallery in New York into an imitation newsroom, gathering space, and artist's studio. Over a period of six weeks in 2007, Mir worked with a group of artists to translate approximately two hundred covers culled from a fifteeen-year span of the *New York Post* and *New York Daily News* into large-scale drawings that covered the gallery walls in rotating installations.

In selecting which covers to work from and conceptualizing the installation of the *Newsroom* drawings, Mir aimed to dissociate the featured headlines from any particular chronologies or events. This is especially evident in the *Osama* drawings. By the time these works were shown in 2007, Osama bin Laden was well-known for masterminding the terrorist attacks of September 11, 2001, but the drawings are based on cover stories from 1998. The headlines "Worst Is Yet To Come" and "The War Has Just Started" quote the Al Qaeda leader's threats to avenge US attacks in Afghanistan and Sudan. Today, in light of the 9/11 attacks, the wars in Iraq and Afghanistan, and bin Laden's assassination by US military forces, his words seem chillingly prophetic. By giving permanence to daily tabloids, Mir undercuts the ephemerality of the news and highlights the cyclical nature of the narratives it both reports and shapes.

Osama, 2007. Fiber-tipped pen on paper, two parts: 75 x 59 in. (190.5 x 149.9 cm) each. Purchase with funds from the Drawing Committee 2010.170a–b. Installation view: Whitney Museum, 2011

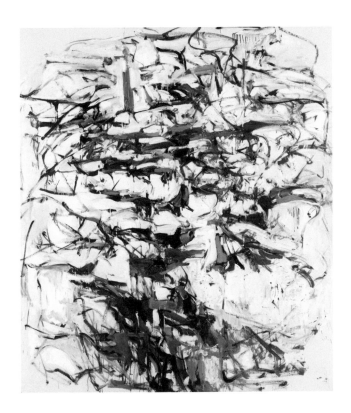

Joan Mitchell's exposure to art began at an early age: her father was an amateur artist, and her mother was an associate editor at *Poetry* magazine. Mitchell studied at Smith College and Columbia University, and earned degrees from the School of the Art Institute of Chicago. Influenced by the work of Franz Kline and Willem de Kooning, Mitchell began working in an abstract mode in the early 1950s, becoming one of the few women—in addition to Helen Frankenthaler and Lee Krasner—to gain notice as an Abstract Expressionist. Mitchell's paintings are characterized by boldly expressive, varied brushwork; an adventurous feel for color; and a dynamic, often unresolved tension between figure and ground. If such qualities aligned her works with the New York School, their lingering, if tenuous, connection to the outside world, specifically in their evocation of natural sensations such as light and movement, set them apart.

The title *Hemlock* (an allusion to a Wallace Stevens poem), for example, promotes a reading of the work's imagery as a tree, and indeed the tight central cluster, composed of verdant calligraphic spikes, supports such an interpretation. The color white functions in this work as both foreground and background, flatness and relief, creating an effect of atmospheric lyricism and contributing to the sense that *Hemlock* is as much about the experience of seeing as it is about the thing seen.

Mitchell left New York for France in 1959 and remained committed to painting abstract takes on landscape throughout the 1960s and 1970s, calling herself "the last Abstract Expressionist."

Hemlock, 1956. Oil on canvas, 91 x 80 in. (231.1 x 203.2 cm). Purchase with funds from the Friends of the Whitney Museum of American Art 58.20

Toyo Miyatake began his photography career in 1909, shortly after immigrating to Los Angeles from Japan. He first studied under pictorial photographer Harry Shigeta and later Edward Weston, with whom he developed a close friendship. Miyatake shared with Weston an interest in Japanese woodblock printing and European Modernism—sources that would influence his approach toward form and composition. In 1923 Miyatake established his own studio and began making portraits in the Little Tokyo section of Los Angeles, capturing figures such as the painter and poet Yumeji Takehisa, novelist Thomas Mann, and modern dancer Michio Ito, who made Miyatake his company photographer. The artist's photographs from this period range from intimate portraits of the dancer to abstract studies of motion, light, and shadow.

In 1942, following Pearl Harbor and the US declaration of war on Japan, more than 100,000 Japanese Americans were relocated to internment camps. Miyatake and his family were forced from their home and taken to a camp in Manzanar, California, a remote outpost in the desert. As photography was outlawed in the camp, Miyatake smuggled in a lens, built a makeshift box camera, and began surreptitiously documenting life at Manzanar. He was eventually discovered but allowed to continue shooting, in part because of support from his friend Ansel Adams, who had photographed the camp as a visitor. Miyatake's photos are among the most poignant traces of this historical episode; the little girl pictured in *Untitled (Memorial Service at Memorial Monument, Manzanar)*, for example, captures a deep human longing, while the adults around her stoically carry on in the face of unjust circumstances.

Untitled (Memorial Service at Memorial Monument, Manzanar), c. 1945. Gelatin silver print, 6⅝ x 8¾ in. (16.8 x 22.2 cm). Purchase with funds from the Photography Committee 2014.245

After years of music training, Lisette Model took up photography before moving from Europe to the United States in 1938. Living in New York, she set out to capture the city's bustling streets and nightlife. Like other street photographers who emerged during this period, Model took advantage of the recent invention of portable handheld cameras, pursuing what she called "the art of the split second." With their candid, unaffected style, Model's images evoke the qualities of a snapshot. She gravitated not to scenes of elegance and refinement, but to the operatic dramas and comedies of ordinary life, especially the seedy but alluring underbelly of nocturnal New York.

One of Model's favorite locales was Sammy's Bowery Follies, a nightclub located among the flophouses and missions of the Bowery in downtown Manhattan.

Sammy's featured colorful performers and attracted both downtown personalities and thrill-seeking members of the uptown elite—all of whom became targets of Model's lens. In *Sammy's, New York*, Model captures a private moment amid the club's action. A sailor and a woman engage in an intense but mysterious exchange, the sexual heat between them accentuated by the low camera angle, dramatic lighting, and closely cropped composition. After this shot and others from Sammy's were featured in *Harper's Bazaar*, where Model worked from 1941 to 1955, her images of the nightclub became one of her best-known series.

Sammy's, New York, c. 1940–44 (printed 1950s). Gelatin silver print, 13¾ x 10⅞ in. (34.9 x 27.6 cm). Purchase with funds from the Photography Committee 97.98.12

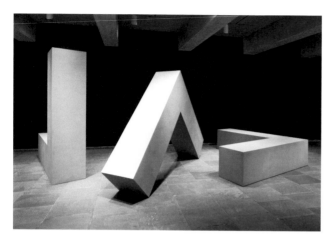

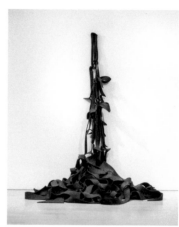

Robert Morris began his career as a painter in the late 1950s but turned to sculpture in 1961 and emerged as a central figure in the burgeoning movement of Minimal art. Relying on reductive geometric forms and industrially fabricated objects, Morris's work from the 1960s explores the perceptual and experiential effects of three-dimensionality. *Untitled (3 Ls)* consists of three large L-shaped stainless steel beams, each placed in one of three possible configurations: upright, flat on its side, or balanced to form an inverted "V." These units have identical dimensions, but Morris allows them to be reconfigured for each location in which they are displayed and viewers can move around and between the three elements. The varied orientations and configurations of the components can have dramatically different effects on viewers. As Morris once explained, "Simplicity of shape does not necessarily equate with simplicity of experience." The sculpture prompts spectators to consider how they share space with the work and what it means to perceive objects, both optically and physically.

By the late 1960s Morris had begun to move away from Minimalism's rigid, industrial forms and was experimenting with rope, rags, and felt to create sculptures whose shapes were largely determined by chance and gravity. In *Felt* Morris created a regular pattern of incisions in a large rectangular sheet of felt. When hung from the wall, however, this precise geometry dissolves as the pliable material settles into tangle of strips.

Each time it is installed, the work's configuration relies on the wall from which it hangs, the floor on which it rests, and the physical manipulations of the installers. Through such sculptures, and through writings such as his influential 1968 essay "Anti-Form," Morris signaled the beginnings of Postminimal art.

Untitled (3 Ls), 1965 (refabricated 1970). Stainless steel, three parts: 24 x 96 x 96 in. (61 x 243.8 x 243.8 cm) each; overall dimensions variable. Edition of 3. Gift of Howard and Jean Lipman 76.29a–c. Installation view: Whitney Museum, 2011

Felt, 1967–68. Felt, dimensions variable. Purchase with funds from the Howard and Jean Lipman Foundation Inc. 69.23a–b

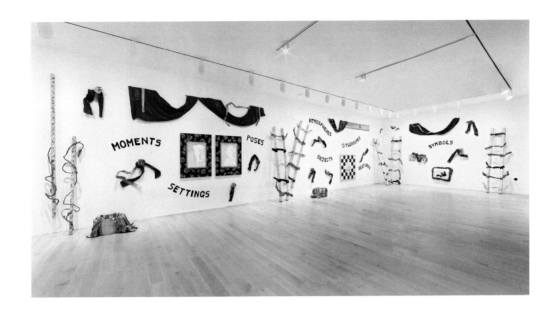

During a prolific career that ended prematurely in a fatal car accident, Ree Morton produced a significant body of work that adds complexity to Postminimal art of the 1970s. Her deeply personal sculpture and installations played with space, language, decoration, feminine tropes, metaphor, and color. Morton began her art studies in 1966, after training to be a nurse, marrying a naval officer, and becoming a mother to three children. She received a BFA in 1968 from the University of Rhode Island and an MFA from the Tyler School of Art at Temple University in 1970. Emboldened by the growing feminist movement, she explored the possibilities of what she termed a "female sensibility," both embracing and skewering the trappings of conventional womanhood. The imagery, palette, and objects in *Signs of Love*, perhaps her most significant work, are unapologetically sentimental and lighthearted. The work's decorative ribbons, garlands, and banners—key motifs in her art—were crafted from Celastic, a plastic material that becomes pliable like fabric for a brief period when wet but hardens upon drying. Although the work reflects the influence of artists such as Florine Stettheimer, Claes Oldenburg, and Eva Hesse, it also retains a distinctive originality through its free-association involving form, poetry, and symbolism. Morton once said, "A work of art has a unique quality . . . of clarifying and concentrating meaning contained in scattered and weakened ways the material of other experience." *Signs of Love* was included in the Whitney Biennial in 1977, the year of Morton's death.

Signs of Love, 1976. Acrylic, oil, colored pencil, watercolor, and pastel on nitrocellulose-impregnated canvas; wood; canvas, and felt, dimensions variable. Gift of the Ree Morton Estate 90.2a–n. Installation view: Whitney Museum, 2010

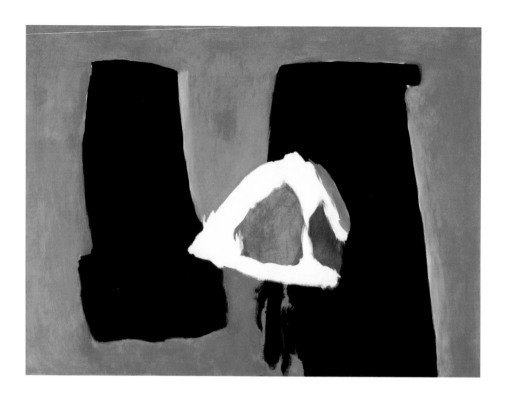

Robert Motherwell's *Afternoon in Barcelona* epitomizes the bold chromatic contrasts and charged gestures that mark the artist's signature canvases. Although nonrepresentational, the imagery evokes natural forms, perhaps scenery viewed during Motherwell's travels in Spain in the late 1950s (the work is part of his *Iberia* series). Indeed the tripartite configuration—which he called a "dolmen," in reference to prehistoric stone megaliths—may have associations with the bull ring in Barcelona. Talking about two other paintings in the same series, he stated: "You would have to know that a Spanish bull ring is made of sand of an ocher color, and that Spanish bulls are very small, quick, and coal black. Both of those coal black, ocher pictures have a bull in them, but you cannot really see the bull. They are an equivalence of the ferocity of the whole encounter." While the angular shapes lend the work a loose structure, the artist's slashing brushwork suggests that his creative process may have been largely spontaneous, particularly as he was influenced by Surrealist automatism, a free-associative technique of drawing or painting thought to better access the subconscious.

Along with Jackson Pollock, Willem de Kooning, and Mark Rothko, Motherwell was a leading figure of the New York School, one whose paintings, drawings, prints, and collages imparted the Surrealists' biomorphic forms and intuitive methods to the grand scale and allover compositions that distinguished Abstract Expressionism. Motherwell was an early theorizer of the movement, promoting its modernist ideals through his activities as a writer, editor, teacher, and lecturer.

Afternoon in Barcelona,
1958. Acrylic and oil on canvas,
54⅛ x 72⅛ in. (137.3 x
183 cm). Gift of Robert and
Jane Meyerhoff 79.35

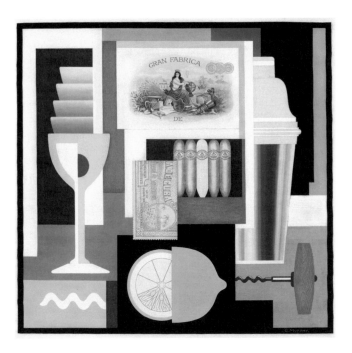

The son of a self-made American millionaire, Gerald Murphy moved to Paris in the fall of 1921 and settled into a glamorous social life with other expatriate Americans: the composer Cole Porter and writers Archibald MacLeish, Ernest Hemingway, John Dos Passos, and F. Scott Fitzgerald. Enthralled by the new art he encountered in the city, he decided to become an artist, studying painting for a few months with Natalia Goncharova, an émigré Russian artist. By 1924 his paintings were being included in important vanguard exhibitions in Paris. What distinguished his art from French Purism, with which it shared smooth surfaces and fastidiously demarcated forms set against abstract shapes, was his magnification of commonplace products in the style of modern magazine advertisements and billboards.

Nowhere is this style more evident than in *Cocktail*, a collage-like presentation of bar accessories together with a trompe-l'oeil cigar box and tax label, all rendered in flat, minute detail and arranged frontally or in profile. Cocktails were considered an American invention, and Murphy was famous for serving them to his guests. The components of the painting are thus representative of Murphy's life in France, which he described as "all somehow an American experience." Murphy stopped painting in 1928 after one of his sons was diagnosed with tuberculosis and by 1934 was back in America running Mark Cross, the family's leather-goods business. During his short career he produced fewer than fifteen paintings, only seven of which survive. Not shown in the United States until 1960, they immediately established Murphy as a central figure of "Jazz Age" modernism.

Cocktail, 1927. Oil and pencil on linen, 29⅛ x 30 in. (73.8 x 76 cm). Purchase with funds from Evelyn and Leonard A. Lauder, Thomas H. Lee, and the Modern Painting and Sculpture Committee 95.188

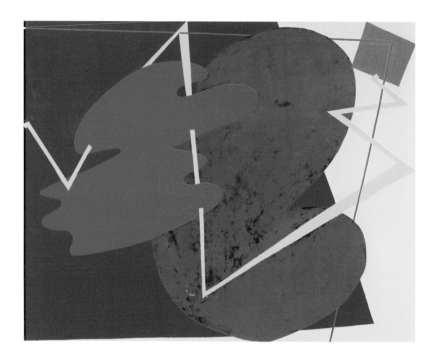

In 1967 Elizabeth Murray left the Midwest and arrived in a New York art world dominated by the cool, spare, and cerebral modes of Minimalism and Conceptualism. Although she experimented in these veins, her preferred medium was painting, then under critical scrutiny and often disdained. Over the course of the next four decades, Murray pioneered a spirited pictorial practice that drew as much from popular art sources such as cartoons as from revered art-historical antecedents, including Cubism, Surrealism, and Abstract Expressionism. The distinction between figuration and abstraction was another divide with which Murray's boldly expressive art readily dispensed, and it similarly ignored the prohibition on high art bearing personal, domestic, or biographical associations. Serious and sensuous at once, Murray's lively, large-scale canvases took shape in a variety of formats, some contoured, layered, fractured, or multipanel.

Children Meeting was executed just as Murray was beginning to consolidate her signature style; in her words, the painting "grew out of a confidence about being able to lay down the colors and put in the goofy shapes that were beginning to emerge. . . . I'd never allowed myself to use that zany purple." This vibrant violet strikes an uneasy balance with the adjacent emerald hue, in turn underscoring other unexpected harmonies—the conjunction of zigzags and rectilinear outlines, for example, or the meeting of hard-edged forms with organic shapes. Murray's central biomorphs, while resolutely abstract, seem simultaneously to take on an embodied presence: perhaps they are the children of the painting's title.

Children Meeting, 1978.
Oil on canvas, 101¼ x 127 in.
(257.2 x 322.6 cm).
Purchase with funds from the
Louis and Bessie Adler
Foundation Inc., Seymour M.
Klein, President 78.34

Elie Nadelman

b. 1882; Warsaw, Poland
d. 1946; Riverdale, NY

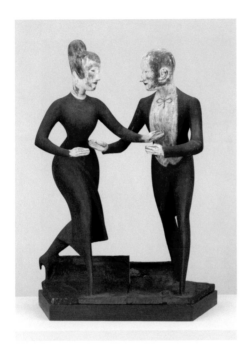

Tango, c. 1920–24. Painted and gessoed cherry, 36 x 25⅝ x 13⅞ in. (91.4 x 65.1 x 35.2 cm). Purchase with funds from the Mr. and Mrs. Arthur G. Altschul Purchase Fund, the Joan and Lester Avnet Purchase Fund, the Edgar William and Bernice Chrysler Garbisch Purchase Fund, the Mrs. Robert C. Graham Purchase Fund in honor of John I. H. Baur, the Mrs. Percy Uris Purchase Fund, and the Henry Schnakenberg Purchase Fund in honor of Juliana Force 88.1a–c

Polish-born Elie Nadelman immigrated to the United States in 1914, having already achieved fame in Paris as a sculptor of sleek, stylized figures and heads inspired by ancient Greek and Roman precedents. In 1920, drawing on the popular entertainments and upper-class society he encountered in America, he commenced a group of figures in wood that included dancers, musicians, and circus performers. *Tango* exemplifies Nadelman's ongoing quest to join classical clarity and order with the abstract values of modernism. Composed of tubular forms and fluid lines, the pair of dancing figures reflects the artist's intent to "employ no other line than the curve, which possesses freshness and force. I compose these curves," he wrote, "so as to bring them in accord or in opposition to one another. In that way, I obtain the life of form, i.e., harmony."

In addition to such formal concerns, *Tango* registers Nadelman's newfound engagement with American culture. The fashionable subject—the Argentine dance that gained popularity in the United States on the eve of World War I—represented a departure from the artist's more resolutely classical imagery. His substitution of raw and painted cherrywood for the bronze or marble he typically used also reflected his burgeoning interest in American folk art, which he avidly collected. The figures of *Tango* nevertheless lack the unbridled sensuality for which the dance was famous, remaining faithful to Nadelman's idealized aesthetic. With their discrete, elongated bodies, elegantly crossed arms, and hands poised to touch, they are suspended between formal rigor and graceful ease, estrangement and freedom, timelessness and contemporaneity.

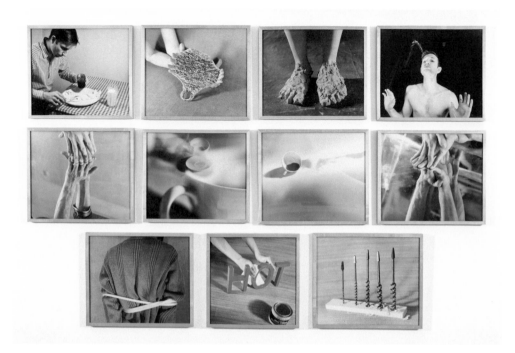

In 1966 Bruce Nauman rented studio space in San Francisco, which for the recent college graduate "raised the fundamental question of what an artist does when left alone in the studio." "My conclusion," he reflected, "was that I was an artist and I was in the studio, then whatever it was I was doing in the studio must be art." The images that constitute the portfolio *Eleven Color Photographs* represent activities and objects in Nauman's studio—often ordinary such as *Cold Coffee Thrown Away*. This literal quality takes on a playful aspect in other photographs, which make visual puns of their title phrases by enacting or staging them: *Bound to Fail* depicts Nauman's arms restrained by rope; *Drill Team* documents a row of drill bits; and *Eating My Words* records him spreading jam on bread shaped into letters.

　　In these photographs, Nauman performs and embodies language, giving it physical form in often comedic ways as in *Self Portrait as a Fountain*, where he

becomes a fountain, spewing water from his mouth. The title of this work also evokes Marcel Duchamp's *Fountain* (1917) and its attendant questioning of what constitutes an aesthetic object—an issue that is also central to Nauman's work. Indeed this group of photographs augurs a number of the concerns of his restlessly inventive and diverse output of the past fifty years: inquiries into the definition of the artistic act, the body as a subject, and the ability of language to shape perception and guide meaning.

Eleven Color Photographs, 1966–67 (printed 1970). Portfolio of eleven chromogenic prints, dimensions variable. Purchase 70.50.1–11

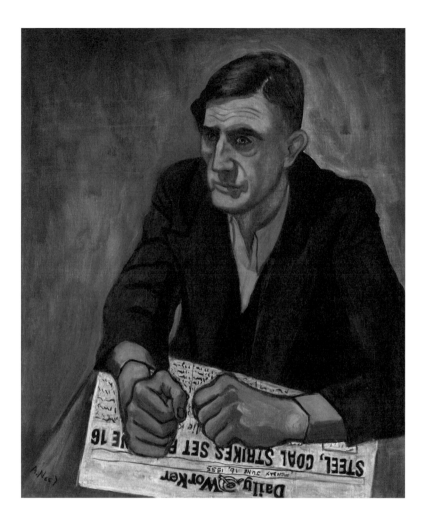

Over the course of a career that stretched from the 1920s to the 1980s, Alice Neel painted hundreds of friends, family members, lovers, artists, art historians, writers, and political activists, believing that "people are the greatest and profoundest key to an era." Seeking to express psychology above absolute physical likeness, she often used exaggerated colors and expressive brushstrokes and eliminated extraneous details in order to capture the inner lives of her subjects.

　　　Neel was a longtime supporter of leftist causes. In the painting *Pat Whalen*, she depicts the Communist activist and union organizer for the longshoreman of Baltimore as a paragon of social justice. Whalen's creased face and stern expression—along with the copy of the *Daily Worker*, the official newspaper of the Communist Party USA, resting beneath his large, clenched fists—suggest both a noble archetype of the blue collar worker and an all-consuming commitment to the working man's cause.

Pat Whalen, 1935. Oil, ink, and newspaper on canvas, 27⅛ x 23⅛ in. (68.9 x 58.7 cm). Gift of Dr. Hartley Neel 81.12

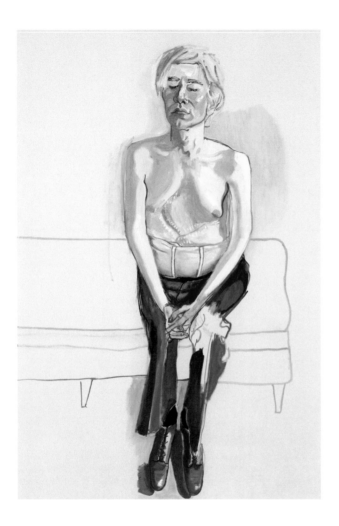

Neel's portrait of Andy Warhol, created more than three decades later, engages an altogether different quarter of American culture. At the time, Warhol was making silkscreen paintings of celebrities and nightlife personalities that in many ways represented the polar opposite of Neel's approach to portraiture. Two years before he sat for Neel, Warhol had been shot by radical feminist Valerie Solanas; here his bare torso is marked by surgical scars that extend from either side of his drooping chest before disappearing beneath the corset he wore after the shooting to support his abdominal muscles. Neel isolates him on a sketchily drawn bench surrounded by empty canvas. By removing the throngs of followers, dark sunglasses, fright wig, and turtlenecks behind which Warhol usually hid, Neel exposes a profoundly vulnerable side of the celebrity artist.

Andy Warhol, 1970.
Oil and acrylic on linen,
60 x 40 in. (152.4 x
101.6 cm). Gift of Timothy
Collins 80.52

Shirin Neshat came to the United States in the mid-1970s to study art and, after completing her BFA and MFA at the University of California, Berkeley, was unable to return home because of the Iranian Revolution. Neshat settled in New York and after a twelve-year absence, returned to her country in the early 1990s. The impact of this visit inspired Neshat's work on an ongoing body of photographs, videos, and films that speak to personal, social, religious, and gender-based issues within Neshat's native culture and beyond.

Between 1998 and 2000, Neshat completed the trilogy of video installations *Turbulent*, *Rapture*, and *Fervor*, collaborating with the Iranian artist and filmmaker Shoja Youssefi Azari and the vocalist and composer Sussan Deyhim. *Rapture* consists of two videos projected on opposing walls. On one screen Neshat depicts a group of men, dressed identically in white shirts, participating in a series of collective rituals within the confines of a seaside fortress. On the second screen women, clothed in black chadors, are assembled in a desert landscape, and eventually make their way to a beach where they launch a small boat that carries six of them out to sea. The sound, composed by Deyhim, creates a mesmerizing effect as the two narratives unfold simultaneously. In this haunting allegorical work, Neshat presents men and women in distinctly different relationships to culture and nature—men appear confined within their culture, and women, by engaging with nature, are ultimately empowered to leave the boundaries of their culturally defined roles.

Stills from *Rapture*, 1999.
Two-channel video installation,
black-and-white, sound;
13 min., dimensions variable.
Purchase with funds from
the Painting and Sculpture
Committee and the Film
and Video Committee 99.86

Louise Nevelson

b. 1899; Kiev, Ukraine
d. 1988; New York, NY

Dawn's Wedding Chapel II, 1959. Painted wood, 115⅞ x 83½ x 10½ in. (294.3 x 212.1 x 26.7 cm) overall. Purchase with funds from the Howard and Jean Lipman Foundation Inc. 70.68a–m

One of the foremost American sculptors of the twentieth century, Louise Nevelson is renowned for her monochromatic assemblages of found or cast fragments, combined in dramatic abstract installations. Trained as an actress, modern dancer, singer, and painter, Nevelson (born in the former Russian Empire) studied with Hans Hofmann and assisted Diego Rivera on WPA murals in New York before taking up sculpture in the mid-1930s. When metal was less available during World War II Nevelson began working with wood, a material she associated with the lumber and building businesses of her father and grandfather. By the early 1950s she had incorporated etching, terra cotta, and stone work into her multifaceted practice, and by 1954 she produced her first series of black-painted landscape sculptures, a breakthrough that would give way to large-scale environments unified by a single color.

One of these, *Dawn's Wedding Feast*, a sprawling installation of Nevelson's first white sculptures, was created for the Museum of Modern Art's 1959 exhibition *Sixteen Americans*. Composed of found wood—stacked boxes, antique chair legs, banister railings, finials, and other architectural fragments—the elements towered against a sixteen-foot-long wall, rose up from large plinths, or hung from the ceiling like totemic stalactites. It represented, in Nevelson's words: "a white wedding cake. A wedding mirror. A pillow . . . a transition to a marriage with the world." After the exhibition closed, the installation was disassembled and recycled into new compositions, a cathartic process Nevelson often employed. Although *Dawn's Wedding Chapel II* was the result of such reconfiguring, it retains the geometric complexity, formal cohesiveness, and elaborate equilibrium of Nevelson's original assemblage.

In the aftermath of World War II, Barnett Newman realized that contemporary painting could not adequately respond to the devastation of the Holocaust or the fear of nuclear weapons. Believing that art faced a "moral crisis" and that as a painter he could no longer condone representational imagery, he argued against the kind of painting that previously "was trying to make the world look beautiful." Concluding in the late 1940s that "the old stuff was . . . no longer meaningful," he rejected looking to the past for inspiration and decided to "start from scratch as if painting didn't exist." His solution was to paint radically reduced, abstract compositions featuring large expanses of color.

The title of *Day One* signals a point of departure for painting and for a new world. Newman covered the canvas with a vast red field bordered by two thin vertical bands. He called these signature lines "zips," painting them freehand or with the help of masking tape. At close range—the distance from which the artist intended his viewers to observe his large works—the painting extends beyond the typical field of vision. Yet by invoking the shared human ability to imagine more than sight apprehends, Newman posits a metaphor for the creative process. He believed that his abstractions communicated a set of moral values because they offered an "assertion of freedom" and a "denial of dogmatic principles." Ultimately, *Day One* professes a new beginning, and the hope that humanity might move forward into a better era.

Day One, 1951–52.
Oil on canvas, 132⅛ x
50⅛ in. (335.6 x 127.3 cm).
Purchase with funds
from the Friends of the
Whitney Museum
of American Art 67.18

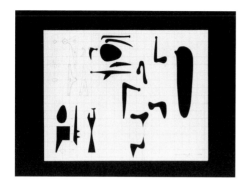

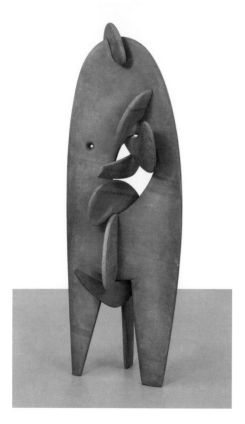

Work Sheets for Sculpture,
1945. Graphite pencil on
cut graph paper mounted on
paper, 17 x 22 in. (43.2 x
55.9 cm). Purchase with funds
from the Howard and Jean
Lipman Foundation Inc. 74.46

Humpty Dumpty, 1946.
Ribbon slate, 59 x 20¾ x
17½ in. (149.9 x 52.7 x
44.5 cm). Purchase 47.7a–e

Over the course of his prolific, six-decade career, Isamu Noguchi explored nearly every available mode of art making. He produced drawings, sculptures, ceramics, and photographs, but also designed stage sets, playgrounds, furniture, and garden landscapes. In 1944 Noguchi began constructing a series of abstract sculptures comprised of flat, interlocking components. His encounter with the organic shapes (or "biomorphs") that Surrealist artists were using to visually evoke dream states and the unconscious influenced his embrace of these curved, subtly anthropomorphic forms.

Noguchi developed a step-by-step process that involved drawing, model making, collage, and enlargement to create his sculptures. *Work Sheets for Sculpture* demonstrates a preliminary stage of this process. Noguchi first sketched shapes suggestive of bones and boomerangs on black paper, cut them out, and then arranged them into small models. This technique allowed the artist to test the configurations' stability and make any adjustments prior to executing the final structures. He then mounted the excised graph paper, which he used to calculate the measurements required for enlarging and transferring elements, onto slabs of slate, marble, or wood. For *Humpty Dumpty*, Noguchi selected ribbon slate and combined the five interlocking units into an upright, freestanding sculpture. Instead of affixing the pieces with adhesive, dowels, or pins, he manipulated properties of balance and gravity. While one segment hangs, another offers crucial support. The result suggests a state of precariousness; removing even one element risks inciting collapse. The work's title underscores the sculpture's fragility: it invokes the familiar children's nursery rhyme of the same name, in which "all the king's horses and all the king's men / couldn't put Humpty together again." Noguchi's interpenetrating sculptures—made in the years during and following World War II—offer a potent reminder of humanity's delicate interconnectedness.

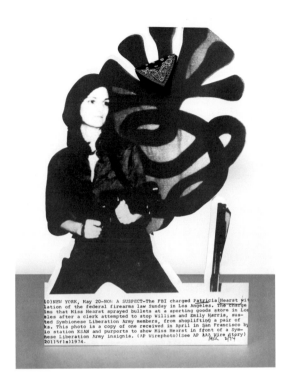

In the 1980s and 1990s Cady Noland created a group of highly influential sculptures, sourcing her iconography and objects from various facets of American culture to reveal the dark side of the American psyche. Among these works were a series of metal sculptures that reproduced newspaper photographs of news figures, including Lee Harvey Oswald and Patty Hearst. *Tanya as a Bandit* is one of two such sculptures to feature Hearst, the newspaper heiress who was kidnapped in 1974 by the self-styled revolutionary group the Symbionese Liberation Army (SLA). During her captivity, she joined their movement and went by the name Tania (given an alternate spelling in the title of this work). Noland's sculpture features an iconic photograph of Hearst gripping a machine gun and standing in front of the SLA's symbol of a seven-headed snake with annotated

newswire text detailing her involvement in a sporting goods store heist running below. Atop the sculpture Noland has placed a bandana—a classic American accessory often associated with cowboys and bandits— tied around two of the snakes' heads. As Noland later explained: "I became interested in psychopaths . . . because they objectify people in order to manipulate them. By extension they represent the extreme embodiment of a culture's proclivities; so psychopathic behavior provides useful highlighted models to use in search of cultural norms. As does celebrity."

Tanya as a Bandit, 1989.
Silkscreen on aluminum, with stand and bandana, 72¼ x 48 x ⅜ in. (183.4 x 121.8 x 1 cm). Edition no. 2/3, 1 AP. Gift of Thea Westreich Wagner and Ethan Wagner 2008.295a–e

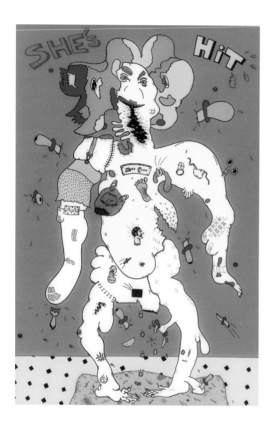

Jim Nutt is among the best known of a small coterie of artists who studied at the School of the Art Institute of Chicago and began exhibiting together in 1965. Calling themselves the Hairy Who, they disbanded by 1968 and are today considered part of the larger, unofficial group of artists referred to as the Chicago Imagists. Inspired by some of the same sources—cartoons, advertisements, pulp magazines—as the Pop art movement then in full flourish in New York, but foregoing the cool ironies of Andy Warhol or Roy Lichtenstein, the Hairy Who produced ribald, fantastical, humorous works of high-key color and exacting craftsmanship. Nutt's figurative work is at once scabrous and learned, synthesizing influences as diverse as European Expressionism and Surrealism with comics and folk art.

The early work *She's Hit* exemplifies what one critic described as "Nutt's frenzied psychopathology of everyday visual life." Its bulbous, epicene figure is misshapen, even abject, a hodgepodge of parts and signifiers that seems to be coalescing and falling apart at the same time. Some elements bespeak a lively period vernacular— tattoos, dyed hair, costume jewelry— while others, including knives and the attack implied by the title phrase, introduce an unsettling violence. Nutt's method, typical of his early paintings, intensifies the work's compositional density and sense of immediacy: he painted on the back side of a transparent plexiglass support, a demanding process that leaves little room for correction or modeling in depth.

She's Hit, 1967. Enamel on wood and plexiglass, 36 x 24 in. (91.4 x 61 cm). Purchase with funds from the Larry Aldrich Foundation Fund 69.101

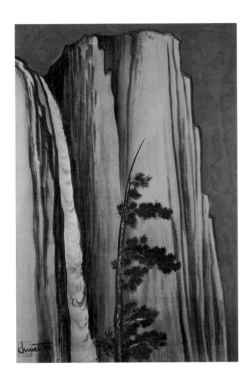

As a young artist in Tokyo, Chiura Obata studied Japanese sumi ink-and-brush painting, a technique he continued to use throughout his life. After moving to San Francisco in 1903, Obata founded the East West Art Society and in 1932 became a professor at the University of California, Berkeley. In the summer of 1927 Obata had traveled from San Francisco to Yosemite and the High Sierra, a trip he described as "the greatest harvest for my whole life and future in painting." Over the course of six weeks of hiking and camping, Obata produced roughly one hundred landscapes in pencil, watercolor, and sumi ink, inspired by the striking natural beauty of the wilderness.

Evening Glow of Yosemite Fall is from the *World Landscape Series "America"*, a portfolio of thirty-five woodblock prints, most made after his watercolors from Yosemite. Obata made the prints in Japan at the Takamizawa Print Works over the course of an eighteen-month period beginning in 1928. He worked with thirty-two wood carvers and eighteen printers, and each image required between 120 and 205 progressive proofs, resulting in an astonishing level of detail in which the hairs from individual brush strokes are faithfully captured. Each print represents the deep impact the distinctly American landscape had on Obata, as filtered through his unique synthesis of Eastern and Western traditions and techniques. Steeped in the Zen tradition, Obata often spoke of the sublime qualities of the natural world and wrote of Yosemite Falls, "This waterfall makes the music of heaven; it is music more inspiring than man-made music."

Evening Glow of Yosemite Fall, 1930, from the portfolio *World Landscape Series "America"*, 1928–30. Woodcut: sheet, 13⅛ x 17⅞ in. (33.3 x 45.4 cm); image, 11 x 15¾ in. (27.9 x 40 cm). Gift of Gyo Obata 2014.280

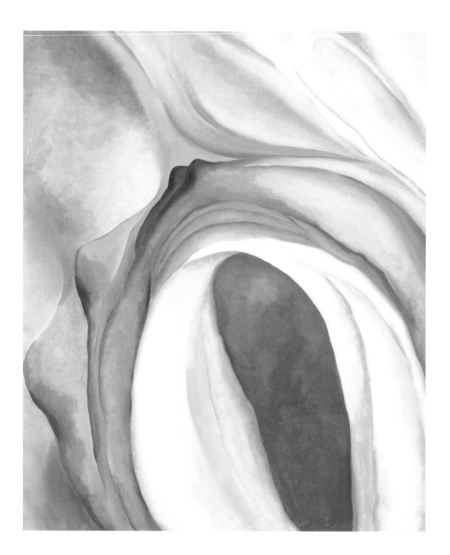

Music, Pink and Blue No. 2,
1918. Oil on canvas, 35 x 30 in.
(88.9 x 76.2 cm). Gift of
Emily Fisher Landau in honor
of Tom Armstrong 91.90

Georgia O'Keeffe used her art to record emotional and sensory experiences, especially her responses to the rhythms and forms of the natural world. Raised on a dairy farm in rural Wisconsin, O'Keeffe attended the Art Students League and Teacher's College at Columbia University in New York, where she trained to be an art teacher. She first came to the attention of the New York art world in the spring of 1916 when her radically abstract charcoal drawings were exhibited at Alfred Stieglitz's pioneering 291 gallery. The artist described the simple, organic motifs of these works, including the spiral form that appears in *No. 8 – Special (Drawing No. 8)*, as vehicles for conveying feelings she could not put into words. "Abstraction," she remarked, "is often the most definite form for the intangible thing in myself that I can only clarify in paint." As O'Keeffe

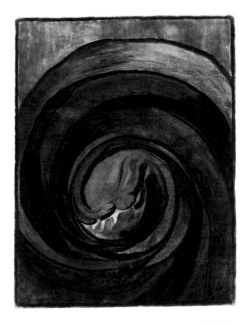

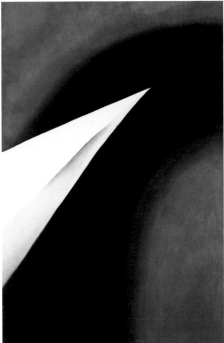

expanded her repertoire in 1918 to include oil, she retained the fluid space and curvilinear motifs of her early charcoals. *Music, Pink and Blue No. 2*, for example, uses gently feathered brushwork and a vibrant palette to evoke the undulating rhythms of nature. Such an approach marked a departure from the fractured geometric language, inspired by European Cubism, which dominated vanguard American painting in the early twentieth century. Yet as the painting's title suggests, O'Keeffe—like many of her modernist colleagues in the United States and Europe—was interested in exploring the correlation between abstract painting and music as nonverbal forms of emotional expression.

Throughout her long and prolific career, O'Keeffe continued to produce highly abstract works, such as the geometric *Black and White*, which she mysteriously described as "a message to a friend." By the mid-1920s, however, she also began painting images with recognizable subjects, earning particular acclaim for her depictions of flowers. In works such as *The White Calico Flower*, O'Keeffe eschewed the traditional figure-ground format of still-life painting, opting instead to dramatically enlarge her botanical subjects so that they oscillate between abstraction and representation. The subject of this painting was not a live specimen, but a cloth flower used in Southwestern mourning rituals. O'Keeffe's use of cropping and magnification in this and other

No. 8 – Special (Drawing No. 8), 1916. Charcoal on paper, 24½ x 18⅞ in. (62.2 x 47.9 cm). Purchase with funds from the Mr. and Mrs. Arthur G. Altschul Purchase Fund 85.52

Black and White, 1930. Oil on canvas, 36 x 24⅛ in. (91.4 x 61.3 cm). Purchase with funds from Mr. and Mrs. R. Crosby Kemper in honor of the Museum's 50th Anniversary 81.9

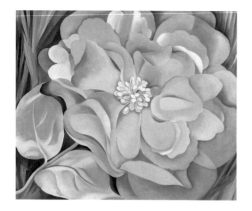

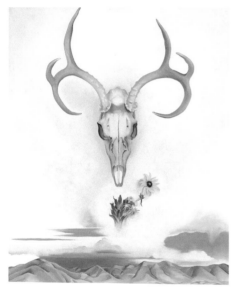

flower compositions reflected her interest in modernist photographic techniques, which she encountered through her close relationships with photographers Paul Strand and Stieglitz, whom she married in 1924. Filling the entire frame of the canvas, O'Keeffe's flowers are neither diminutive nor ephemeral—rather, they are objects of commanding monumentality. Although critics often discussed the flower paintings in sexual terms, O'Keeffe rejected these interpretations, suggesting instead that they were intended to surprise viewers and call attention to the overlooked details of the natural world.

In 1929, O'Keeffe began spending parts of each year working in New Mexico, to which she moved permanently in 1949. She drew inspiration from the stark desert landscape as well as the organic objects she collected there, including animal bones, stones, and feathers. The floating animal skull that appears at the center of *Summer Days* was a motif that O'Keeffe introduced in 1931, when she began painting bones that she had brought back east from her New Mexico sojourns. The desiccated, sun-bleached skull is paired here with—and yet stands in stark contrast to—a group of vibrantly blooming desert wildflowers. Hovering in the clouds over a distant line of red clay hills, the skull and flowers present a distinctive iconography of the American Southwest. And at the same time, with its distorted scale and enigmatic symbols of life and death, the painting demonstrates O'Keeffe's awareness of the incongruous aesthetic juxtapositions employed by Surrealist artists working in Europe and the United States during the same period.

The White Calico Flower, 1931. Oil on canvas, 30¼ x 36¼ in. (76.8 x 92.1 cm). Purchase 32.26

Summer Days, 1936. Oil on canvas, 36⅛ x 30⅛ in. (91.8 x 76.5 cm). Gift of Calvin Klein 94.171

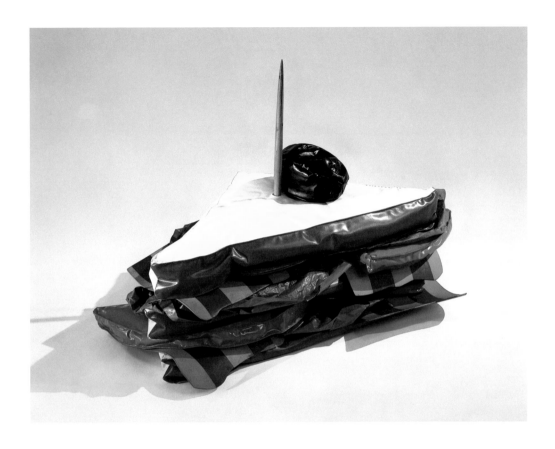

Giant BLT (Bacon, Lettuce, and Tomato Sandwich), 1963. Vinyl, kapok, wood painted with acrylic, and wood, 32 x 39 x 29 in. (81.3 x 99.1 x 73.7 cm). Gift of The American Contemporary Art Foundation Inc., Leonard A. Lauder, President 2002.255a–s

Claes Oldenburg has famously written that he is "for an art that . . . twists and extends and accumulates and spits and drips, and is heavy and coarse and blunt and sweet and stupid as life itself." In this commitment to imbue his art with the energy of "life itself," Oldenburg has frequently turned to commonplace objects as his subject matter, transforming them through unexpected contexts, materials, or scale shifts. In late 1961, he temporarily turned a storefront on Manhattan's Lower East Side into a hybrid studio, gallery, and market, making and selling his sculptural versions of familiar products from nearby businesses, such as food or clothing, and calling the project *The Store.* Produced by molding plaster-dipped muslin over wire and applying bright enamel paint to the mottled surfaces, the sculptures from *The Store*

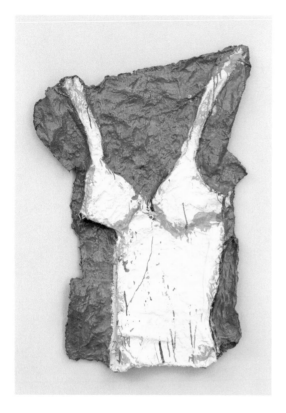
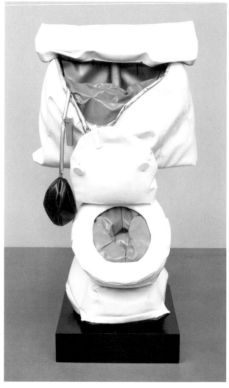

are expressionistic interpretations rather than slick, realistic facsimiles. Works such as *Braselette* imply the human body as much as the commodity. Oldenburg has explained, "I never make representations of bodies, but of things that relate to bodies so that the body sensation is passed along to the spectator either literally or by suggestion."

During this period, Oldenburg was also creating pioneering theatrical performance-art pieces known as Happenings. The elaborate costumes, props, and sets crafted for these performances led to experiments with soft, sewn sculptures. Though the earliest works were in canvas, he discovered that vinyl, an industrial material that had found new upholstery applications in postwar America, provided the desired contrast between hard and

Braselette, 1961. Muslin, plaster, chicken wire, and enamel, 40⅝ x 29⅛ x 4 in. (103.2 x 74 x 10.2 cm). Gift of Howard and Jean Lipman 91.34.5

Soft Toilet, 1966. Wood, vinyl, kapok, wire, and plexiglass on metal stand and painted wood base, 56⅛ x 31⅜ x 30⅛ in. (142.6 x 79.7 x 76.5 cm). 50th Anniversary Gift of Mr. and Mrs. Victor W. Ganz 79.83a–c

Proposed Colossal Monument for Central Park North, N.Y.C.—Teddy Bear, 1965. Wax crayon and watercolor on paper, 24 x 19 in. (61 x 48.3 cm). Gift of the American Contemporary Art Foundation Inc., Leonard A. Lauder, President, in honor of Janie C. Lee 2002.22

Claes Oldenburg and Coosje van Bruggen (b. 1942, Groningen, Netherlands; d. 2009, Los Angeles, CA), *Soft Shuttlecocks, Falling, Number Two*, 1995. Graphite pencil, fabricated chalk, and pastel on paper, 27⅝ x 39⅜ in. (70.2 x 100 cm). Purchase with funds from the Lauder Foundation, Evelyn and Leonard Lauder Fund 99.51

soft, the manufactured and the handmade. *Giant BLT (Bacon, Lettuce, and Tomato Sandwich)*, among his early vinyl works, extended Oldenburg's interest in performance to the object itself: comprised of nineteen individual pieces in varying shapes and textures, it must be assembled like a sandwich to be displayed, provocatively pierced with a wooden toothpick. *Soft Toilet*, produced as part of a group of sculptures of bathroom fixtures (outrageous subject matter at the time), similarly has a subtle performative element. Stuffed with kapok fibers, the sculpture is molded as much by the exterior sewn elements as by gravity (which Oldenburg has called his "favorite form creator") when the pliable vinyl sags and settles over time. Porcelain is thus imagined as a slack, flesh-like substance.

The sandwich and the toilet are defiantly nontraditional artistic subjects. In 1965, Oldenburg began a drawing series that imagined similarly mundane objects as huge public sculptures sited in cities around the globe. In *Proposed Colossal Monument for Central Park North, N.Y.C.—Teddy Bear*, the playful toy masks a political edge; the towering stuffed bear would confront touristic park-goers looking north with a fixed stare that Oldenburg imagined as a subtle rebuke on behalf of Harlem's disenfranchised residents.

Though the Proposed Colossal Monument series began as a speculative exercise, Oldenburg became increasingly interested in realizing large-scale projects. In collaboration with Coosje van Bruggen, with whom he worked from 1976 until her death in 2009, he developed site-specific works all over the world referred to as the Large-Scale Projects. Oldenburg and van Bruggen's drawing *Soft Shuttlecocks, Falling, Number Two*, grew out of their site-specific installation on the lawn of Kansas City's Nelson-Atkins Museum of Art. While the lawn reminded the artists of a tennis court, they selected the shuttlecock rather than a tennis ball because the

feathers related to the museum's extensive collection of Native American feathered headdresses, and because the contrasting features of the shuttlecock's cork and cone provided a wonderfully expressive form. In this drawing the artists imagine two floating shuttlecocks circling each other gracefully in a kind of pas de deux.

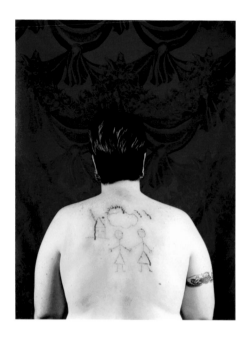

Whether capturing the diversity of the LGBTQ community, the panoramic geometries of Los Angeles freeways, or the abstract beauty of ice-fishing houses in rural Minnesota, Catherine Opie's photographs constitute a rich portrait of contemporary America. Opie first gained attention in the early 1990s for her photographs of transgender women and men, drag queens, "leather dykes," and others who fall outside traditionally assigned gender roles. With their formal composition and vivid, monochromatic backdrops, these images of sexual subcultures use art-historical tropes of photographic and painterly portraiture to cast light on communities unexamined by mainstream America.

Self-Portrait/Cutting is one of the artist's first and occasional self-representations. Opie faces away from the camera; in the center of her back is a stylized line drawing that shows two skirted stick figures in front of a small house. The sun peeks out from behind a fluffy cloud, and two birds fly off in the distance. The crude, childlike drawing has not been rendered in crayon, however, but carved into Opie's flesh with a scalpel. The wounds are fresh, and drips of blood trail down portions of the image. Opie explained that the photograph was about her "dream for a lesbian domestic relationship" and, as the scarified drawing suggests, "the contradictions within that wish." Made on the heels of a difficult split with a long-term partner, the photograph conveys the artist's personal desires and alludes to contested notions of family within the LGBTQ community. The visceral effect of the incised flesh also calls mind the traumatic impact of the AIDS crisis on that community, the force of which was still being felt in 1993.

Self-Portrait/Cutting, 1993. Chromogenic print, 39 x 28⅜ in. (99.1 x 72.1 cm). Edition no. 1/8. Purchase with funds from the Photography Committee 94.64

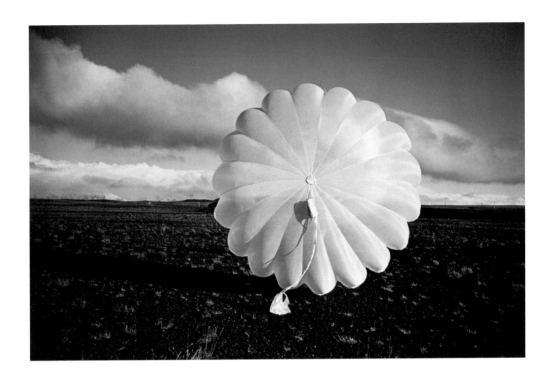

Gabriel Orozco first gained renown in the early 1990s, when he developed an itinerant poststudio practice consisting largely of improvised, site-responsive interventions and became part of a globalized network of artists whose work has been loosely classified as Relational Aesthetics. He is known for engaging his (often urban) surroundings by activating materials he encounters on the street and creating improvised arrangements of found objects. Although such impromptu tableaux are inherently ephemeral, the artist has frequently used them as the basis for photographs that function as autonomous images rather than as mere documents of his original compositions.

Orozco created his four-part photographic series *Parachute in Iceland* in October 1996 for a two-person show with Rirkrit Tiravanija at the Living Art Museum in Reykjavik. The series features a parachute Orozco purchased from an Army-Navy surplus store on New York's Canal Street, photographed within a barren Icelandic landscape. After anchoring its strings to the ground, he released the bright white fabric form and captured it from all four cardinal directions. In *Parachute in Iceland (South)* it is pictured head-on, the taut fabric forming a near perfect circle against the horizon line. The composition recalls the circular motif that has appeared repeatedly in Orozco's work since the early 1990s, while the photograph serves as a record of the artist's site-specific action. As Orozco noted, "Not having a technique that is always the same and not having a proper studio makes me focus on the moment I'm living in and the place I'm living in, which I then try to use to make the work."

Parachute in Iceland (South),
1996. Silver dye bleach
print (Ilfochrome), 12⅜ x
18⅝ in. (31.4 x 47.3 cm).
Edition no. 5/5. Purchase with
funds from Michael Ward
Stout 97.36

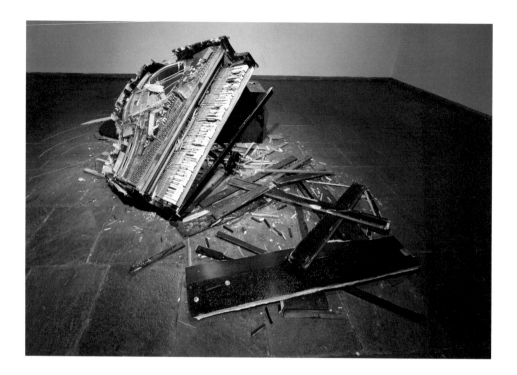

An active member of the New York avant-garde since the early 1960s, Raphael Montañez Ortiz has produced a body of work—in performance, video, film, painting, sculpture, and installation—that he once explained as an attempt to "come to terms with the anguish and anger at the core of man's existence." Ortiz began his studies in architecture at the Pratt Institute but soon turned to fine art, earning a BFA and MFA before completing a PhD at Columbia University's Teachers College in 1982. During this time, Ortiz studied painting with Robert Rauschenberg while developing his own notions of construction and destruction in art and a deep interest in ritual, mysticism, anthropology, and psychology. These interests coalesced with Ortiz's participation in the "Destruction in Art" symposia held in London in 1966 and at New York's Judson Memorial Church in 1968, two notable gatherings of artists, writers, and thinkers associated with Destructivism, an international art movement that drew on Fluxus, Dada, and Futurist traditions.

One of Ortiz's most renowned Destructivist works, *Piano Destruction Concert*, was performed at the Whitney in 1967; the artist created a protective salt circle around a grand piano, which he then destroyed with an axe. In 1996 he re-created the work at the Museum, resulting in a sculptural installation of wooden rubble displayed alongside a video of the performance. At once visceral, mystical, and political, the artist's destructive action was believed to release the potential energy contained inside the object while disrupting the logical order of its form.

Raphael Montañez Ortiz with Monique Ortiz-Arndt, *Humpty Dumpty: Piano Destruction Concert*, 1996. Wood, lacquer, iron, steel, copper, brass, plastic, and felt, and video, color, sound; 34:49 min. Gift of Chon A. Noriega 96.248

Alfonso Ossorio

b. 1916; Manila, Philippines
d. 1990; East Hampton, NY

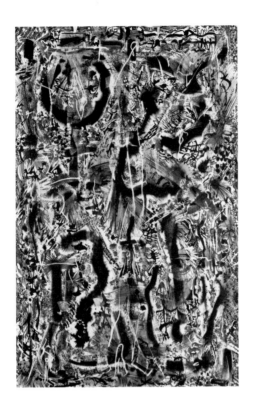

Born of mixed Filipino, Spanish, and Chinese ancestry into a wealthy sugar manufacturing family, Alfonso Ossorio moved to the United States as an adolescent in 1930 and completed his education in fine arts at Harvard University and, subsequently, the Rhode Island School of Design. During his studies, Ossorio created meticulously rendered drawings and watercolors that combined religious symbolism with Surrealist imagery. In the late 1940s he began to explore abstraction, guided by the close friendships he had formed with the Neo-Expressionist and Art Brut pioneer Jean Dubuffet and the Abstract Expressionist painters Clyfford Still and Jackson Pollock, with whom he showed work at the Betty Parsons Gallery in Manhattan.

The influence of these artists is clear in *Number 14–1953*, with its aggressive calligraphic gestures and allover composition. Describing Ossorio's work from this period, Dubuffet wrote: "These paintings no longer present elements treated in a realistic way, but only signs whose meaning has become almost incomprehensible. The figures, when the artist wants any, take on forms so excessively conceptual, so shattered by crushing fragmentation, and so completely removed from any real shapes, that it is impossible to guess their initial significance; they remain, anyway, available to our interpretation." Ossorio created the layered, interlocking areas of color and lines in these works by using a wax resist technique in conjunction with watercolor and ink; however, this technique did not satisfy him for long. He turned away from painting in the late 1950s and began to make assemblages of found objects that he labeled "Congregations."

Number 14–1953, 1953.
Ink and wax on board, 60½ x
38½ in. (153.7 x 97.8 cm).
Purchase 55.8

Since she began painting in the early 1990s, Laura Owens has had a profound interest in texture and unconventional subject matter. Working with found objects, images, and advertisements, she frequently incorporates figurative elements into otherwise abstract compositions, pushing the boundaries of gesture, surface, and layering. Such efforts often lead her to experiment with "unfamiliar formats" as seen in her recent use of digital processes. Owens has said of her expansive approach: "Painting *does things*, and why wouldn't you use all the things it does?"

Untitled features digitally manipulated elements borrowed from a 1970s inspirational poster—including cartoonlike images of a boy and a dog along with the phrase: "When you come to the end of your rope, make a knot, and hang on." Superimposed on the canvas and extending beyond its perimeter is a wood lattice that appears in fragments, as if partially erased. Installed on the wall behind the painting are a book and three additional, smaller paintings. *Untitled* can be shown as it is here with four of the works concealed or all five elements can be presented individually to form a small exhibition. By incorporating hidden elements that are integral to the work, Owens confounds what she calls the "idea of painting within a painting that runs throughout the history of art."

Detail of *Untitled*, 2014. Ink, silkscreen ink, vinyl paint, acrylic, oil, pastel, paper, wood, solvent transfers, stickers, handmade paper, thread, board, and glue on linen and polyester, five parts: 138⅛ x 106½ x 2⅝ in. (350.8 x 270.5 x 6.7 cm) overall. Purchase with funds from Jonathan Sobel 2014.281a–e

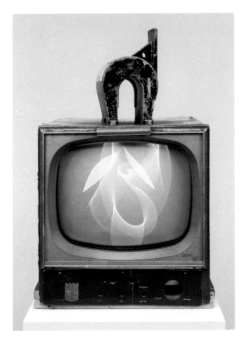

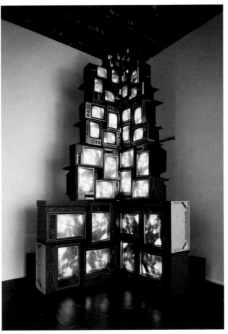

"I wanted to elevate television to an art form that was as highly valued as the music of Johann Sebastian Bach," Nam June Paik once said. Born in Korea, Paik studied twentieth-century music and composition in Japan and Germany before emerging in the early 1960s at the forefront of a critical exploration, through visual art, of the new mass medium of television. *Magnet TV* is one of the pioneering works Paik made utilizing manipulated television sets. In this instance he placed a strong magnet on top of the monitor, where it interferes with the electronic signal; this results in a series of abstract patterns that form on the screen as the magnet is moved. Paik thus transformed the console into a participatory object that subverts the one-way, linear flow of broadcast television.

Paik, whose prolific experimentation also encompassed closed-circuit installations and videotapes, began to create increasingly large, multimonitor sculptural installations in the 1980s. *V-yramid*, a ziggurat of forty television sets of decreasing size positioned atop one another, was made for the artist's retrospective at the Whitney Museum in 1982. The kaleidoscopic, proto-music-video montage that plays on the monitors is recycled material from his single-channel videos *Global Groove* (1973) and *Lake Placid '80* (1982). This footage was produced with video effects generated by the Paik-Abe synthesizer, a video-processing machine Paik had developed with the Japanese engineer Shuya Abe in 1969. In his work Paik embraced both pop culture and the artistic avant-garde; *V-yramid* similarly draws a visual analogy between ancient pyramidal architecture and modern media technology.

V-yramid, 1982. Forty televisions and video, color, sound, 186 ¾ x 85 x 74 in. (474.4 x 215.9 x 188 cm). Purchase with funds from the Lemberg Foundation Inc. in honor of Samuel Lemberg 82.11. Installation view: Whitney Museum, 1982

Magnet TV, 1965. Modified black-and-white television with magnet, 28 ⅜ x 19 ¼ x 24 ½ in. (72.1 x 48.9 x 62.2 cm). Purchase with funds from Dieter Rosenkranz 86.60a–b

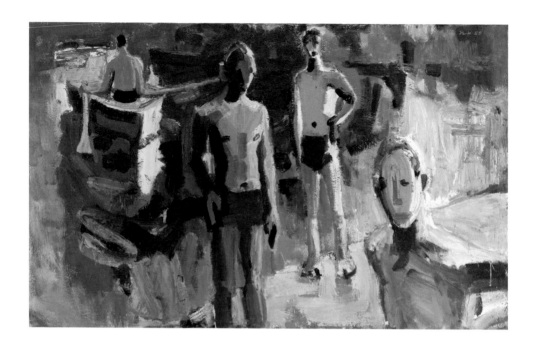

David Park employed strategies associated with abstraction in his painting *Four Men*: broad, rough brushstrokes; passages of built-up paint juxtaposed with less worked areas; and a strikingly frontal composition in which everything feels pressed up against the surface of the picture plane. Indeed, the upper-right and lower-left corners of this grandly scaled canvas verge on total abstraction. The four men's physiques are slablike and their facial features rendered in simplified slashes. While the scene is representational, its meaning is inscrutable; the three men on the beach do not appear to be interacting, and a fourth rows away from the shore, his back turned. If the emotional tenor of the painting is elusive, however, Park's animated brushwork and saturated, jewel-toned palette endow it with a moody lyricism, perhaps even undertones of psychological drama.

The painting's integration of figuration and abstraction was a signal element of Park's important contribution to the history of American art. His earliest work was nonrepresentational, but by 1949 he had abandoned Abstract Expressionism— then the dominant mode of painting in the United States—as overly elitist. His rejection was not complete, however; he imparted action painting's emphasis on spontaneity and unconstrained gestures to depictions of recognizable subject matter, usually figures but also still lifes and interiors. Together with his contemporaries Richard Diebenkorn and Elmer Bischoff, Park was a pioneer of the figurative painting movement that burgeoned in the San Francisco Bay Area in the 1950s and 1960s.

Four Men, 1958. Oil on canvas, 57⅛ x 92⅛ in. (145.1 x 234 cm). Purchase with funds from an anonymous donor 59.27

Gordon Parks

b. 1912; Fort Scott, KS
d. 2006; New York, NY

Gordon Parks's photographs are situated at the intersection of art and journalism and are informed by his profound belief in the capacity of the camera to serve as "a weapon," as he put it, against "poverty, racism, discrimination." Largely self-taught, Parks would make history as the only black member of the Farm Security Administration's photography corps; the first African American staff photographer at *LIFE* magazine, a post he assumed in 1948; and the first African American to direct a major Hollywood film, 1969's *The Learning Tree*, followed two years later by *Shaft*. Alongside fashion and nature photographs, Parks produced portraits of musicians, artists, writers, and politicians, as well as photo-essays on subjects as varied as the daily life of a custodial worker in Washington, DC; civil rights struggles; the Black Panther Party; the *favelas* of Rio de Janeiro; and the plains of his native Kansas.

In 1966 *LIFE* sent Parks to photograph Muhammad Ali during training in Miami. Having recently changed his name from Cassius Clay and declared himself a conscientious objector to the war in Vietnam on religious grounds, the world heavyweight champion was a controversial public figure. Parks's black-and-white photograph of a hunched-over Ali deploys chiaroscuro to emphasize the emblem of the boxer's power: his fists, which, wrapped in white bandages, seem to glow against the dark chair and negative space framed by his legs as the light catches them. Yet Parks's depiction of a private, introspective moment, rather than one of active athleticism, perhaps also alludes to Ali's status as a symbol for the conscience of his times.

Bandaged Hands, Muhammad Ali, 1966. Gelatin silver print, 13⅜ x 9¼ in. (33.8 x 23.5 cm). Edition no. 16/24. Purchase with funds from Joanne Leonhardt Cassullo, The Dorothea L. Leonhardt Fund at The Communities Foundation of Texas Inc., and Michèle Gerber Klein 98.59

Agnes Pelton

b. 1881; Stuttgart, Germany
d. 1961; Cathedral City, CA

Agnes Pelton was among the generation of American modernists in the first decades of the twentieth century who rejected realism in favor of portraying their inner emotional states. Her formative training at Pratt Institute in Brooklyn, under the art educator Arthur Wesley Dow, instilled in her a lifelong appreciation for the importance of abstract relationships and Japanese aesthetic traditions, in particular the balancing of large asymmetrical areas of black and white (*nōtan*, as it was called in Japanese). In her first years as a painter she affiliated with members of the Introspectives group, who used traditional, classical forms to convey romantic, mystical ideas. Two of her "imaginative paintings" in this mode, using single female figures in shallow landscape settings to portray nature's quiet harmonies, were included in the 1913 Armory Show.

By 1926 Pelton's desire to paint "the without seen from within," as she called it, led her to abstraction. For the rest of her life she used the curvilinear, biomorphic shapes of nature to depict the unseen order she believed existed in the world. *Untitled*, with its fairytale imagery and fantastic elements, is among the most narrative of her abstractions, suggesting a processional journey from right to left on a blood-red river that metaphorically ferries viewers from dark void into the light of transcendence and enlightened truth. In the mid-1930s Pelton became aligned with a group of younger abstract painters in New Mexico dedicated to portraying the realm of spiritual awareness. Throughout her career she remained committed to producing depictions of what she called the "inside" of experience.

Untitled, 1931. Oil on canvas, 36¼ x 24¼ in. (91.9 x 61.4 cm). Purchase with funds from the Modern Painting and Sculpture Committee 96.175

OTHERWISE HOW PASS MME. DU PONT WITHOUT A GREETING ?

In Raymond Pettibon's drawings, characters from recent history and pop culture mix with archetypal figures, and a literary sensibility collides with aggressive commentary. Pettibon's drawings demonstrate his voracious appetite for culture both high and low, including politics, film, comics, religion, literature, surfing, and baseball. The artist received a degree in economics from the University of California, Los Angeles, in 1977, around the same time he joined his brother's punk band Black Flag, a now-famed force in the Southern California punk underground. Pettibon cultivated a distinct visual aesthetic that was crude and direct; his bold, black ink drawings combined with provocative texts reflected the energy and angst directed at the conservative agenda of the Reagan era. Language continues to be crucial to Pettibon's practice, and he combines original writing with quotes ranging from film noir to Henry James and Proust. Extraordinarily prolific, he has produced thousands of drawings, which are typically exhibited in large, salon-style installations.

In this drawing from 1996, a stylized rendering of New York's Empire State Building emits dots of light in a night sky. The drawing and caption evoke a bygone era while hinting at romance or social intrigue. The relationship of image to text is characteristically ambiguous: the vaguely anxious query written at the bottom of the work might refer to the wife of Pierre S. du Pont, one of the original financiers of the Empire State Building and a president of the DuPont chemical company, or perhaps to that of his ancestor Pierre Samuel du Pont de Nemours, a friend and correspondent of Thomas Jefferson. Generating a narrative with a minimum of words and image, Pettibon allows almost infinite options for interpretation.

No Title, 1996. Brush and ink on paper, 18⅛ x 10 in. (46 x 25.4 cm). Purchase with funds from the Drawing Committee 97.28.3

Elizabeth Peyton reinvigorated portraiture in the early 1990s with small-scale, stylized paintings depicting historical figures (Marie Antoinette, Napoleon Bonaparte), European royalty (Queen Elizabeth II when she was still a princess, Princess Diana of Wales), and rock stars (Kurt Cobain, Johnny Rotten). These works, which are based on photographs, film stills, paintings, and television, portray her subjects during private, contemplative moments, lending them a quiet intimacy. Later in the decade she incorporated models in her acquaintance, using snapshots of friends, family, and art-world notables, or sketching from life. "I think about how influential some people are in other's lives. So it doesn't matter who they are or how famous they are but rather how beautiful is the way they live their lives and how inspiring they are for others," Peyton has said, explaining her idealized, neo-romantic interpretations of subjects. "And I find

this in people I see frequently as much as in people I never met."

The self-portrait *Live to Ride (E.P.)* is characteristic of what Peyton describes as her "pictures of people," capturing the same androgynous beauty— defined by a waifish figure, disheveled hair, sharp bone structure, translucent skin, and ruby lips—found in many of her renderings. This uncanny visual echoing gives the sense that some of her other portraits may, in fact, be variations on a self-portrait. And while this image possesses Peyton's signature intimacy with the artist languidly resting on a pillow, in contrast to the dreamy, detached gazes of her usual subjects, she stares outward, directly confronting the viewer.

Live to Ride (E.P.), 2003.
Oil on board, 15 x 12 in.
(38.1 x 30.5 cm). Partial and
promised gift of David
Teiger in honor of Chrissie
Iles 2005.41

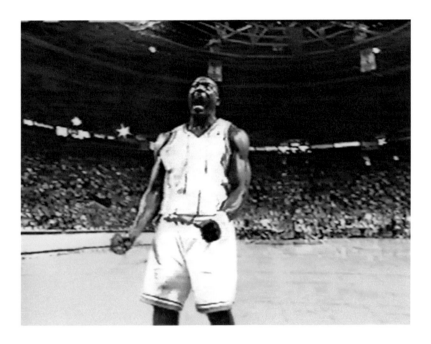

Paul Pfeiffer, who grew up in the Philippines, studied at the San Francisco Art Institute and at Hunter College in New York, and was a participant in the Whitney Museum's Independent Study Program (1997–98), is known for video installations that destabilize the viewing experience. Pfeiffer dissects filmed material into clips, modifies it—for example, by erasing figures or elements—and reconstructs it into brief loops that reframe the original scene's meaning or highlight its iconic nature. Sports, religion, gender identity, and power structures are themes that frequently surface in the work. Pfeiffer's thirty-second video loop *Fragment of a Crucifixion (After Francis Bacon)* features basketball player Larry Johnson, centrally framed in the small projected image and trapped in a silent, triumphant scream that accompanies a quick movement between three different positions. The ball, backboard, and other players have been erased from the image, which frames Johnson in an explosion of flashbulbs in front of an audience that seems distant. The athletic

moment is removed from and transcends its original context, and Johnson's roar thus becomes ambiguous, oscillating between triumph and torment. Pfeiffer's project references the 1950 painting *Fragment of a Crucifixion* by Francis Bacon, in which the scream of a dying creature suspended from a cross becomes the centerpiece of the work. Pfeiffer's *Fragment of a Crucifixion* also has a strong sculptural quality: mounted on a metal armature, the projector emitting the video image becomes a prominent material component, and time itself becomes sculptural in the way it is compressed and formed into a continuously repeating moment.

Still from *Fragment of a Crucifixion (After Francis Bacon)*, 1999. Video, color, silent; 0:30 min., looped; projector; and mounting arm, 20 x 5 x 20 in. (50.8 x 12.7 x 50.8 cm) overall. AP 1/2, edition of 3. Purchase with funds from Melva Bucksbaum and the Film and Video Committee 2000.150

Since the late 1960s Adrian Piper has worked across a range of mediums, including photography, performance, video installation, and text-based projects, to confront thorny social and political issues in American culture such as race and gender. Drawing on her training in philosophy, Piper engages reasoned argument and her own biography to induce audiences to consider their unexamined prejudices and questions of personal identity.

Food for the Spirit, a performative project she conceived in summer 1971, arose as she was obsessively reading Immanuel Kant's *Critique of Pure Reason* (1781) while secluded in her New York loft and following a severely restricted diet. She became so engrossed in her study that she began, as she recounted, to "go to my mirror to peer at myself to make sure I was still there." To counter the feeling that she was disappearing she photographed the reflection of her body, often fully nude, while recording herself reciting the passages from Kant's *Critique* that were "driving [her] to self transcendence." Piper has explained that the ritualistic project helped her "to anchor [herself] in the physical world." Although the taped recitations were inadvertently erased in the mid-1970s, Piper printed and publicly exhibited the fourteen apparitional, black-and-white self-portraits in 1997 as an extension of her conceptual project.

Piper maintains that even when her works contain a confrontational message, the process of establishing trust with her audience "requires a kind of self disclosure." Her installation *Out of the Corner* features a barricade-like configuration of sixteen video monitors arranged on hollow pedestals in which overturned chairs have been placed, their metal legs pointing at the viewer. This phalanx of monitors seems to guard a single monitor that is positioned behind an upended table in the corner of the room and flanked by sixty-four black-and-white images of various black

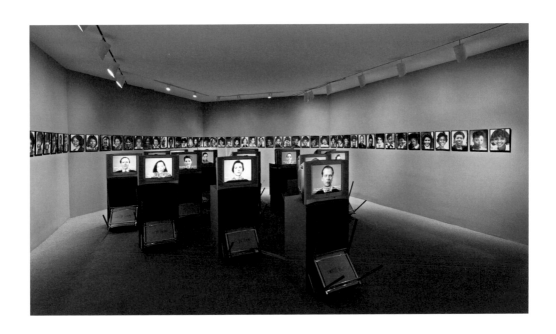

Details of *Food for the Spirit*, 1971 (printed 1997). Fourteen gelatin silver prints, dimensions variable. Edition no. 3/3. Purchase with funds from the Photography Committee 98.28.3a–n

Out of the Corner, 1990. Seventeen-channel video installation, color, sound; 26 min.; sixteen pedestals, table, twenty-three chairs, and sixty-four gelatin silver prints, dimensions variable. Gift of the Peter Norton Family Foundation 94.38. Installation view: Whitney Museum, 2000

women, rephotographed from *Ebony* magazine, on the adjacent walls. On the corner monitor Piper delivers a text on miscegenation, explaining that members of her audience who identify as white may very well have black ancestors. During her monologue, each of the sixteen other monitors—at random and sequential intervals—presents the image of an apparently white man or woman. With the Sister Sledge song "We Are Family" providing a musical backdrop, each of the talking heads recites the same utterance in turn: "Some of my female ancestors were so-called house niggers who were raped by their white slave masters. If you are an American, some of yours probably were, too." The phrase is subtitled beneath the speakers' faces in a variety of foreign languages. This haunting array of skin tones, genders, and languages combines to underscore the socially constructed aspects of race and promote a social consciousness of identity.

A self-taught artist, Horace Pippin was one of the most prominent African American painters of the first half of the twentieth century. Pippin began making drawings while serving in the military during World War I, using his journals to illustrate his experiences fighting in the trenches in France. By the early 1930s, he had shifted to modestly sized paintings on canvas and fabric, as well as cigar boxes and burnt-wood panels that he inscribed with a hot poker, using his left hand to prop up his right arm, which had been partially paralyzed in the war. Living in his hometown of West Chester, Pennsylvania, Pippin portrayed subjects ranging from local interiors and landscapes to portraits of historical figures and scenes inspired by his wartime memories. His pared-down, forthright style and personal approach to these subjects earned him national recognition, especially as folk art traditions garnered new attention in the United States during the 1920s and 1930s.

Many of Pippin's compositions forcefully conveyed his concerns about war and injustice. *The Buffalo Hunt*, one of his earliest canvases, evokes these themes, albeit indirectly. Unlike most of Pippin's landscapes, this composition was not the result of firsthand observation in his native Brandywine Valley. Instead, it represents an imaginary scene in the American West, with buffalos running in deep snow while pursued by a shadowy hunter. The dark, abstracted forms of the buffalos sinking into the stark white ground, together with the heavily falling snow, seem to confirm the hopeless fate of these creatures while also hinting at the cruelty of both nature and humankind.

The Buffalo Hunt, 1933.
Oil on canvas, 21⅜ x
31⅜ in. (54.3 x 79.7 cm).
Purchase 41.27

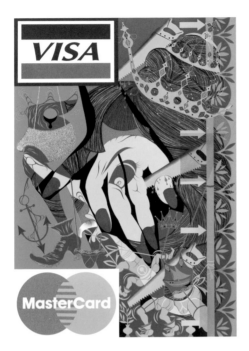

Lari Pittman's paintings present frenetic fields of images, symbols, and patterns layered in intricately interlocking planes. Although their surfaces seem almost mechanical in their perfection, the artist executes the works unassisted, sketching out his compositions in a few sentences then using stencils, masks, and air brushes to create a dense pictorial structure. Pittman attended the California Institute of Arts in the mid-1970s, where he studied with painters Elizabeth Murray and Vija Celmins. He joined members of the influential feminist art program in discussions about the gender bias inherent in art history and in examining works by artists marginalized from the mainstream. He embraced the "decorative" and incorporated explicitly sexual images in his paintings, making reference to gay culture, his own identity as a gay man, and also to his mixed American Protestant and Colombian Roman Catholic background. Aiming to make gregarious paintings that can speak to many different audiences, he produces works encompassing contradictory outlooks and impulses— brash to refined, giddy to despairing. "The work is a record of what the world we live in looks like," Pittman has said.

Pittman exhibited works from his series *A Decorated Chronology of Insistence and Resignation* in the 1993 Whitney Biennial. The series was completed in 1995 and contains more than forty ambitious paintings. In them Pittman layers and juxtaposes cartoonlike renderings of objects and bodies with ornate patterns and corporate logos. In *Untitled #16*, a colorful array of variously scaled fairytale images, both sweet and grotesque, is overlaid at top and bottom with emblems of credit cards, a primary means of accessing enchantment in today's world.

Untitled #16 (A Decorated Chronology of Insistence and Resignation), 1993. Acrylic, enamel, vinyl paint, glitter, and crayon on wood, 84 x 60⅛ in. (213.4 x 152.6 cm). Gift of Peter Norton 93.130

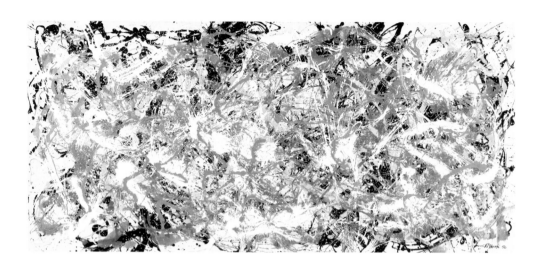

Jackson Pollock "broke the ice," as Willem de Kooning famously declared, clearing the way for an entire generation of abstract artists in the years following World War II. A key figure among the loosely affiliated group referred to as the New York School, he sought a new mode of painting that was both personal and relevant to his time. Pollock had become acquainted with a number of the Surrealists who fled to New York during the war, and their model of psychic automatism, a method that employed spontaneous expression and allowed for manifestations of the unconscious, was particularly important to his artistic progression.

In 1947 Pollock developed the innovative method evinced in *Number 27, 1950* and his other "drip" paintings. He tacked unstretched, unprimed canvas onto the floor of his studio. Then he dipped hardened brushes and wooden stir sticks into cans of enamel or aluminum paint and dripped, flung, and poured liquid pigment directly onto the cloth. "On the floor I am more at ease," Pollock explained. "I feel nearer, more a part of the painting, since this way I can walk around it, work from the four sides and literally be *in* the painting." With gestures at once controlled and improvisatory, he laid down skeins of black lines before adding looping cords of pink, silver, yellow, brown, and white to create an allover composition. The dense, overlapping layers seem to vibrate with energy. Pollock's emphasis on spontaneity and the revelatory quality of his process helped elevate the *act* of painting to a level of importance equal to that of the finished picture. This shift would have a profound influence upon a multitude of artists in succeeding decades.

Number 27, 1950, 1950.
Oil, enamel, and aluminum
paint on canvas, 49 x
106 in. (124.5 x 269.2 cm).
Purchase 53.12

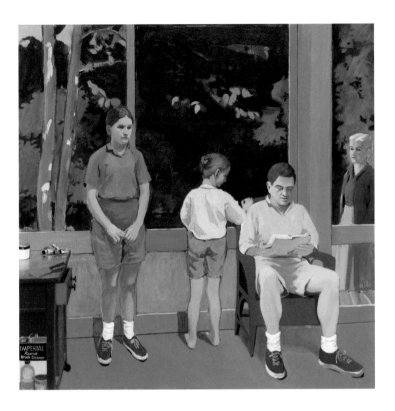

Despite the rise of Abstract Expressionism and Pop art in the decades following World War II, Fairfield Porter remained faithful to a figurative style of painting. This individualistic path accorded with his interest in portraying intimate domestic interiors and exploring light effects—concerns that linked his work to the American Realist tradition of painters such as Thomas Eakins and Edward Hopper. By the early 1960s Porter had expanded the scale of his canvases and increasingly utilized broad areas of color to compose his paintings. In this life-sized composition, the artist portrays four figures on the back porch of his house in Great Spruce Head, Maine, which he used as his studio during the summertime. Inside are two of his children, Kate and Lizzie, and the poet James Schuyler, who lived with the family for twelve years; the artist's wife, Anne, stands outside. The figures do not interact or display emotion, instilling this everyday scene with tension and mystery.

Porter emphasized that he was interested not in narrative elements but, rather, in capturing underlying formal relationships: "When I paint I try not to see the subject as what it is; I try to see only very concrete shapes which have no association except as themselves." This concern is apparent in his attention to the geometric armature of the windows, the rhythm of the four figures across the canvas, and the flattened areas of light. Like all of Porter's canvases, *The Screen Porch* suggests that the distinction between realism and abstraction is not always clear cut.

The Screen Porch, 1964.
Oil on canvas, 80 x 80 in. (203.2 x 203.2 cm).
Lawrence H. Bloedel Bequest 77.1.41

Trained in Mexico City and Buenos Aires, Liliana Porter was drawn to the experimental art scene in New York in the mid-1960s. At a time when Conceptual artists were questioning the definition of art and reacting against Modernism's emphasis on medium specificity, Porter, together with two other Latin American expatriate artists, Luis Camnitzer and José Guillermo Castillo, determined to bring these concerns to printmaking. Their New York Graphic Workshop, founded in 1964, radically reconsidered the print medium, shifting its focus from the age-old craft of printing individual images to championing a broader view in which editioned works became the essence of printmaking. In addition to exploring the relationship between the individual work and the multiple, the Workshop produced unconventional manifestations of the medium, such as inking the sides of stacks of paper and using them to print on paper-based installations.

In Porter's *Arruga y sombra derramada*, a partially excised section of paper that has been wrinkled and then mostly flattened falls over a screenprinted swath of black ink. Here, the relationship between the basic materials of printmaking—paper and ink—is inverted: the ink is printed on one piece of paper and then covered by another. Rather than forming the image, the black ink masquerades as the upper layer's shadow. Porter expressed a conceptual interest in "the representation of something over the thing itself, shadow on shadow, wrinkle on wrinkle." The use of screenprinting here raises questions about the status of images in printmaking and foregrounds the complex exploration of perceptual effects central to Porter's practice, which also extended to photography, video, and installation.

Arruga y sombra derramada, 1970. Screenprint, relief, and cutout: sheet, 31⅛ x 22¼ x ¼ in. (79.1 x 56.5 x 0.6 cm); image, 19¼ x 12⅞ in. (48.7 x 32.7 cm). AP, edition unknown. Purchase with funds from the Print Committee 2011.87

Richard Pousette-Dart was an integral member of the New York School during the early years of Abstract Expressionism. He grew up the son of a painter father and poet mother and, as a child, Pousette-Dart was exposed to his father's collection of African and South Pacific tribal artifacts. These objects no doubt informed his interest in pictographs and other iconography of non-Western art. In the 1940s Pousette-Dart's work made use of calligraphic and biomorphic forms, similar to those of his contemporaries, such as Jackson Pollock, Adolph Gottlieb, and Mark Rothko, with whom he exhibited at the Betty Parsons Gallery. Unlike his colleagues, however, who increasingly privileged aesthetic formalism, Pousette-Dart aspired to a symbolic and spiritual function for his art. He once said, "I strive to express the spiritual nature of the universe. Painting for me is a dynamic balance and wholeness of life; it is mysterious and transcending, yet solid and real."

This "dynamic balance" is evident in *Within the Room*. The loosely flowing geometry appears constantly in flux and yet, as the title suggests, it is contained. One colorful shape transforms into the next as lines meander, connect, and continue. The complex tumble of triangles and semicircles keeps the viewer's eye moving, and yet the composition never descends into chaos. The richly textured organic forms simultaneously evoke two orderly systems that remain mysteries to humankind: the body and the cosmos. *Within the Room* is emblematic of Pousette-Dart's early work in its evocation of a mystical transcendence and synthesis of European Cubist and Surrealist styles.

Within the Room, 1942.
Oil on canvas and wood,
36 x 60 in. (91.4 x 152.4 cm).
50th Anniversary Gift of
the artist 2014.99

At the moment in the 1960s when the sharp edges and industrial materials of Minimalist artists were beginning to define American art, Ken Price introduced a wholly new visual idiom that merged biomorphic interiority, overt sexuality, and the brash color palette of Los Angeles car culture and advertising. In Price's "egg" sculptures from the early 1960s, smooth, skinlike ceramic forms often appear to have been flayed open or pierced by organic protrusions resembling tentacles, entrails, or phalluses. Sculptures from this series, such as the acid yellow, candy-apple green, and iridescent blue *S. L. Green*, were central to securing Price's reputation as one of the most idiosyncratic and seductive object makers of the twentieth century.

That Price achieved this status working on an intimate scale and using the medium of ceramic—a material inherently associated with the qualities of craft and functionality—made his influential contribution to postwar American art all the more extraordinary. A native of Los Angeles, Price studied for a time with the legendary ceramicist Peter Voulkos at Otis College of Art and Design (then the Los Angeles County Art Institute), where he was part of a tight-knit group of young California artists that included Robert Irwin, Larry Bell, and Billy Al Bengston. After moving to New Mexico in 1971, Price worked for many years on sculptures that incorporated or built off of sculpted teacups. As a leitmotif, the teacup implicitly referenced function in Price's work even as he toyed with deconstructing such recognizable forms entirely, creating a unique vocabulary of organic abstractions and amped-up, otherworldly color.

S. L. Green, 1963. Painted ceramic on wood base, 11⅜ x 17⅞ x 10⅞ in. (28.9 x 45.4 x 27.6 cm). Gift of the Howard and Jean Lipman Foundation Inc. 66.35a–b

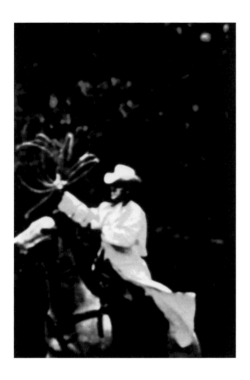

Richard Prince has claimed that his desire to become an artist was born from a pair of posters that hung in his childhood bedroom near Boston. One was an image of Jackson Pollock and the other showed Franz Kline in his Fourteenth Street studio; both images embodied the solitary and machismo attitude often associated with the male-dominated Abstract Expressionist movement of the previous generation. While Prince would not pursue the same type of painterly abstraction, his art explores the fantasy of masculinity and individuality in American culture and, like the work of many artists during the 1970s and 1980s, interrogates the myth of originality associated with modern art.

When Prince arrived in New York in the mid-1970s as an aspiring painter, he earned a living by clipping texts from magazines for staff writers at *Time*. He began rephotographing the remaining images and advertisements for luxury goods and developed a repertoire of strategies—including blurring, cropping, enlarging, and grouping—that enhanced the inherent artifice of the found images. During the early 1980s Prince began photographing advertisements featuring the Marlboro Man, resulting in the series *Cowboys* (1980–84), of which *Untitled (RP82)* is one. In appropriating these images, Prince draws attention to the ways in which corporate advertising and the media construct American identity. In fact, Philip Morris's use of the cowboy and the American West was conceived as a way to popularize filtered cigarettes, which had previously been perceived as feminine, in the wake of growing concern over the long-term effects of smoking. The series perfectly distills the Abstract Expressionist iconography of heroic individualism to which Prince originally aspired, as well as the right-libertarian politics of the Reagan era.

Untitled (RP82) (Cowboys), 1980–84. Chromogenic print, 43⅝ x 29⅜ in. (110.8 x 74.6 cm). Edition no. 2/2. Promised gift of Thea Westreich Wagner and Ethan Wagner P.2011.328

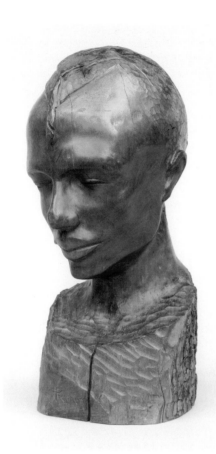

A revered sculptor of the early twentieth century, Nancy Elizabeth Prophet was one of the first African American women to establish a critically recognized career as an artist. After graduating from the Rhode Island School of Design, Prophet moved in 1922 to Paris, where she would remain for the next twelve years. There she found greater freedom from the societal obstacles she encountered in the United States, including opportunities to enter into the traditionally male-dominated field of sculpture. After studying at the École des Beaux-Arts, Prophet began to make portrait busts carved out of wood or stone. Unable to afford the cost of hiring a model, she often sculpted from her imagination, creating portraits of cultural or ethnic types rather than individuals.

Congolaise, Prophet's best-known work, is one of a series of busts she made in the late 1920s and early 1930s focused on African and African American figures. This cherrywood portrait of a Masai warrior reflects Prophet's response to the New Negro Movement in the United States, which exhorted African American artists to study and emulate a wide range of African objects in order to develop a distinctive cultural style. Though inspired by examples of African art Prophet saw firsthand in Paris, *Congolaise* represents a generalized figure (indeed, the work's title refers to the Congolese nation of Central Africa rather than to the East African Masai tribe). By emphasizing the warrior's expansive forehead and serene, contemplative expression, Prophet imbued *Congolaise* with the universal values she sought to associate with African culture: poise, bravery, reason, and intellect.

Congolaise, 1931. Cherry,
16⅞ x 7⅞ x 9¼ in. (42.7 x 20 x 23.5 cm). Purchase 32.83

When Martin Puryear began his career in the late 1960s, he worked in a variety of mediums, including painting, printmaking, and drawing, before shifting to the predominantly abstract sculptures for which he is best known. His lifelong interest in diverse cultures and natural history prompted him to travel, work, and study on several continents. He learned wood craftsmanship techniques while in the Peace Corps in Sierra Leone, printmaking at the Royal Swedish Academy of Arts in Stockholm, and finally honed his artistic practice at Yale University.

The *Ring* series—comprised of approximately thirty wall-mounted, circular wood sculptures that the artist created between 1978 and 1985—calls upon his previous training in two-dimensional methods. The circles, he explained, "are about line," and represent "drawing with wood." Puryear fashioned the forms by bending, gluing, or shaving wood into purposefully imperfect circles. *Ardea* is abstract in composition, yet its title, derived from the scientific name for the genus that includes the great blue heron, suggests a reference to the near-circular curve of that bird's neck. To achieve its arching form, Puryear implemented a technique called lamination that required him to carefully layer thin strips of pine and cedar. Although each *Ring* sculpture is unique, the repetitive format recalls the serial production of Minimalism, the sculptural mode Puryear credits with legitimizing "the power of the simple, single thing." Unlike his predecessors, who championed outsourced fabrication, however, the sculptor in these works balances the fluidity of found organic forms with the individually constructed object. For Puryear, "The physical act of making a work of art is essential."

Ardea, 1981. Casein-painted pine and cedar, 66½ x 1⅛ in. (168.9 x 2.9 cm). Promised gift of Emily Fisher Landau P.2010.222

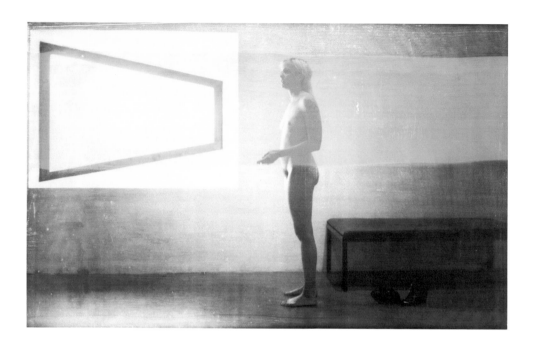

Since 2001 R. H. Quaytman has organized her paintings into "chapters" that are influenced by the place in which they are first displayed. Despite their varying subjects, certain principles remain constant across each series. Quaytman begins with wood panels cut to seven sizes based on the golden ratio (derived by multiplying the smaller dimension by 1.618). Then the artist bevels the edges of the panels to emphasize the picture plane, primes them with gesso, and silkscreens images—photographs, optical patterns, or both—onto their surfaces.

Quaytman conceived of *Distracting Distance, Chapter 16* specifically for the 2010 Whitney Biennial, deriving the compositional starting point from the Museum's former building and permanent collection. The chapter's central motif, the trapezoidal windows designed for the building by architect Marcel Breuer, recurs in several of the twenty-nine total panels. In addition, Quaytman restaged the Whitney's Edward Hopper painting *Woman in the Sun* (1961), a canvas that features a nude figure standing in front of a bedroom window. Quaytman photographed fellow artist K8 Hardy in front of Breuer's angular design, positioned in the profile pose assumed by the model in Hopper's work. The resulting silkscreened images appear on several of the panels. "My idea," Quaytman has explained, "was to set up a series of reflections between the viewer, the space and history of the Whitney, and American painting." Each exhibition offers an opportunity for Quaytman to contribute a new chapter to an ongoing archive, a "book" that the artist has resolved to "continue without end."

Distracting Distance, Chapter 16, 2010. Screenprint and gesso on wood, 24⅝ x 39⅞ in. (62.5 x 101.3 cm). Purchase with funds from the Painting and Sculpture Committee 2010.54

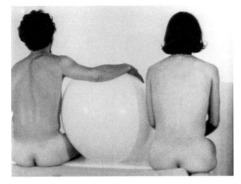

Stills from *Hand Movie* and *Trio Film*, from *Five Easy Pieces*, 1966–69. 8mm and 16mm film transferred to video, black- and-white, silent; 48 min. Purchase with funds from Joanne Leonhardt Cassullo in honor of Ron Clark and the Independent Study Program 2011.91

Yvonne Rainer has worked as a dancer, choreographer, filmmaker, and writer for more than fifty years. In 1962 she cofounded the Judson Dance Theater, a loose collective of choreographers who ushered in the era of postmodern dance through the cooperative efforts of dancers, artists, and musicians. Gathering in the Greenwich Village basement of the Judson Memorial Church, the participants championed pedestrian actions and the use of everyday objects, and they accepted nondancers onto the stage, a space that was not always clearly demarcated from where the audience sat.

Between 1966 and 1969 Rainer made five short 8mm and 16mm black-and-white films. She incorporated them into live multimedia performances, but they were otherwise rarely seen prior to their 2004 release under the overarching title *Five Easy Pieces*. In the opening seconds of Rainer's first film, *Hand Movie*, the back of the dancer's hand appears against a neutral background, filling the camera frame from fingertip at the top to wrist at the bottom edge. Isolated from the rest of her body, the hand's components—wrist, palm, and five fingers—move as a dancer might: it contracts and extends; it stretches, turns, and bends at the joints. The fingers move in isolation, press together, or spread apart. The tendons push against the skin as the hand flexes and disappear when it goes slack. *Hand Movie* emerged from severely limiting circumstances. Rainer made it with the help of fellow dancer William Davis while convalescing in the hospital after a life-threatening illness and surgery. "I was very ill," Rainer explained, "but I could move my hand."

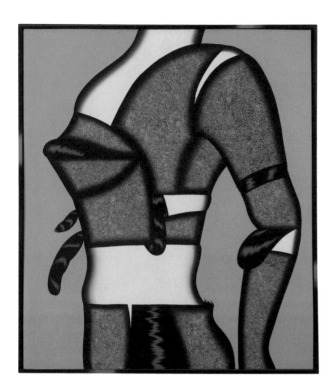

Associated with the Chicago Imagists as well as the Hairy Who group of artists, Christina Ramberg is best known for her discomfiting paintings of female torsos completed in the 1970s. Rendered in profile and tightly cropped by the edges of the canvas to create a sense of voyeuristic intimacy, the disembodied figures are bound, corseted, and bandaged in outfits that variously recall 1950s lingerie, sadomasochistic bondage, or the bionic prosthetics of the future. Recounting the childhood experience of watching her mother dress for parties, Ramberg would wear a foundation garment referred to as a "merry widow," and recalled that "the paintings have a lot to do with this, with watching and realizing that these undergarments totally transform a woman's body. . . . I thought it was fascinating . . . in some ways, I thought it was awful."

In *Istrian River Lady*, a figure wears a long-sleeved bustier covered in what appear to be scales and trimmed with hair. The bustier squeezes the chest to an unnatural point. Soft curves of flesh swell over the hard edges of the outfit, and three loose stitches are visible where a seam is bursting at the figure's shoulder. Ramberg's paintings betray her conflicted reaction to her mother's undergarments: it is unclear whether the garments are sources of power or restraints that limit it. Rejecting readings of her work as either feminist or erotically festishistic, Ramberg shifted her subject in the late 1970s from the recognizable female form to an ambiguous, androgynous cyborg.

Istrian River Lady, 1974. Acrylic on composition board, with wood frame, 35⅜ x 31¼ in. (89.9 x 79.4 cm) overall. Purchase with funds from Mr. and Mrs. Frederic M. Roberts in memory of their son, James Reed Roberts 74.12a–b

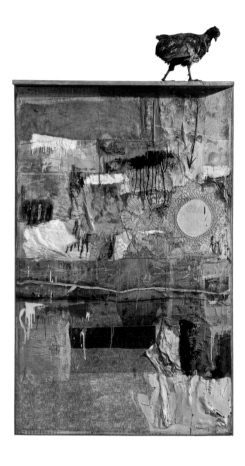

Throughout a career that spanned more than half a century, Robert Rauschenberg remained a relentlessly pioneering figure in American art. Employing a cross-disciplinary approach, he inventively fused painting, sculpture, collage, photography, and printmaking into new, hybrid forms. His interest in using everyday items in his work—perhaps developed in reaction to the formal investigations of his Abstract Expressionist predecessors—led him to incorporate an array of found imagery and objects culled from the world around him. As he famously stated: "Painting relates to both art and life. . . . I try to act in that gap between the two."

In *Yoicks*, created in 1954, the artist layered red paint, fabric, and newspaper, echoing the innovations of early twentieth-century Dada collage and signaling the growing importance of assemblage techniques in the 1950s. That same year Rauschenberg embarked on a body of works referred to as "Combines"—compositions that contain aspects of both painting and sculpture. These explorations began with Combine paintings, which were mounted on the wall, and later shifted to emphatically three-dimensional, freestanding works. In the Combine painting *Satellite* the artist included a stuffed pheasant, delicately perched atop the work, and embedded a pair of socks, among other items, within the composition. "A pair of socks," he later asserted, "is no less suitable to make a painting with than wood, nails, turpentine, oil, and fabric." Although he resisted specific interpretations of these works, Rauschenberg acknowledged that his choice of materials was in part a reflection of postwar American culture: "I was bombarded with TV sets and magazines, by the refuse, by the excess of the world. . . . I thought that if I could paint or make an honest work, it should incorporate all of these elements, which were and are a reality."

In the early 1970s, after relocating from New York to Captiva, Florida,

Satellite, 1955. Oil, fabric, paper, and wood on canvas with taxidermic pheasant, 79⅜ x 43¼ x 5⅝ in. (201.6 x 109.9 x 14.3 cm). Gift of Claire B. Zeisler and purchase with funds from the Mrs. Percy Uris Purchase Fund 91.85

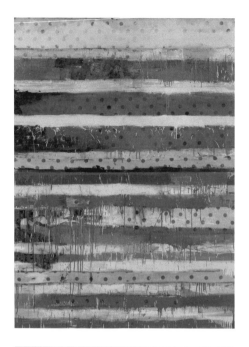

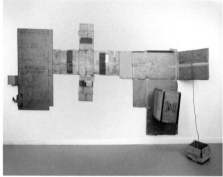

Rauschenberg turned his attention to working with found cardboard boxes. As he later explained: "When I moved to Florida . . . I thought, okay . . . [I] can't be dependent on the surplus and refuse of an urban society. So, what material, no matter where I was in the world, would be available? Cardboard boxes! It was sort of a practical, rational decision." With minimal manipulation and no decorative flourishes, Rauschenberg combined the boxes into a series of wall sculptures called the *Cardboards*. While renewing his long-standing interest in collage-based work, his emphasis on a more straightforward formal engagement with the humble medium connects the work to the approach and modest materials of the Arte Povera artists working in Italy during the late 1960s and early 1970s. *Glass/Channel/Via Panama (Cardboard)* features five wall-mounted and freestanding cartons with lettering and markings denoting their former contents and origins, including "Fragile Glass" and "New York via Panama."

In the *Cardboards*, as with most of his work, Rauschenberg resisted repeating the tropes of earlier movements, as well as his peers' predilection for the Minimalist cube, explaining with his signature wit: "The cardboard was really stubborn and attempted to make me a cubist, and I wouldn't let it happen." The series thus marked yet another period of active experimentation in a prolific career that left an indelible mark on twentieth-century art.

Yoicks, 1954. Enamel on collaged polyester, found paper, and cotton on canvas, 96⅛ x 72⅛ in. (244.2 x 183 cm). Gift of the artist 71.210

Glass/Channel/Via Panama (Cardboard), 1971. Cardboard and rope, 111½ x 185 x 23¼ in. (283.2 x 469.9 x 59.1 cm). Gift of the American Contemporary Art Foundation Inc., Leonard A. Lauder, President, by exchange 2014.299a–e

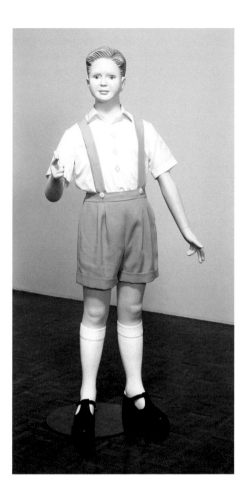

Since the early 1970s, Charles Ray's stylistically varied body of sculptures, photographs, films, and performances has challenged viewers' expectations of artworks and destabilized their perceptions of visual and physical phenomena. The Los Angeles–based artist makes use of humor, provocative subject matter, and surprising distortions of scale, and frequently involves the human body as a central element in his work. He began using himself as a subject in projects while still a student, as in a sculpture from 1973 in which he pinned his own body to a gallery wall with a large wooden plank; in a 1978 performance, he hung from a tree limb.

Ray's sculptures of people and objects often employ significant manipulations of scale to confound art historical traditions as well as social norms, at times sending up stereotypes of middle-class American life. Encountering *Boy*, for example, one is startled by the sculpture's size: uncannily realistic, it looks like an ordinary department-store mannequin, but the child is as tall as a grown male (in fact, he is exactly Ray's height). The boy's adult stance and gesture—reminiscent of a politician or an orator—are incompatible with his youthful visage, knee socks, and short pants, further intensifying the effect of disorientation. At once prepubescent and adult, familiar and enigmatic, innocent and perverse, *Boy* unsettles our sense of space and subjectivity. "You start reading the narrative, reading the story," Ray has explained about his conception of a viewer's interaction with one of his sculptures. "You know what your relationship is to it, even if you don't understand it."

Boy, 1992. Painted fiberglass, steel, and fabric, 71½ x 39¼ x 20½ in. (181.6 x 99.7 x 52.1 cm). Edition of 3. Purchase with funds from Jeffrey Deitch, Bernardo Nadal-Ginard, and Penny and Mike Winton 92.131a–h

A prominent member of the mid-twentieth-century New York avant-garde, Ad Reinhardt distanced himself from his Abstract Expressionist contemporaries by focusing on the formal relationships within a work rather than compositions that emphasize self-expression. His writings, lectures, and artistic output are distinguished by a philosophical meditation on the meaning of abstraction and the virtues of art-for-art's-sake, or, as he termed it, "art-as-art."

Reinhardt often expressed his views in the form of cartoon collages he published in select newspapers and journals. *Museum Landscape* satirizes the art world's liberal use of the term *abstraction* by taking aim at the Whitney Museum's 1950 Annual. Featuring collage elements from a review that declared, "Abstraction Crowned at Whitney Annual," the work depicts, among other elements, finger paints as the medium of Jackson Pollock and Willem de Kooning.

Reinhardt's search for a "pure" abstract art culminated with his "black" paintings. Beginning in 1956 he worked exclusively with five-by-five-foot square canvases featuring dark, matte, hand-painted surfaces. The somber variations of *Abstract Painting*'s nine extraordinarily subtle black-on-black squares are perceptible only through sustained viewing and are lost in reproduction. The only viable experience, Reinhardt felt, was in contemplating the actual painting. In their elimination of subject matter and personal expression, these works not only represented a distilled vision of art but also prefigured the concerns of Minimalists whose work would gain traction in the 1960s and 1970s.

Museum Landscape, 1950.
Collage, pen and ink, brush and ink, acrylic, and graphite pencil on board, 10⅛ x 23⅛ in. (25.6 x 58.6 cm). Gift of the artist 66.141

Abstract Painting, 1960–66.
Oil on linen, 60 x 60⅛ in. (152.4 x 152.7 cm). Purchase with funds from The Lauder Foundation, Leonard and Evelyn Lauder Fund 98.16.3

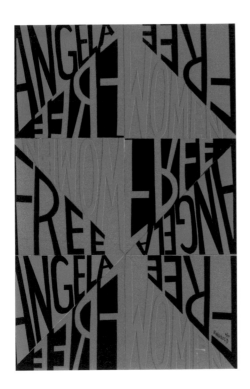

Faith Ringgold began her career as an artist and activist in the mid-1960s with large-scale paintings that bluntly addressed racism and sexism in America. In 1972, after seeing an exhibit of Tibetan *thangkas* hung from dowels, she started painting on unstretched canvases framed in printed fabric. This decisive turn toward the "story quilts" that would epitomize her work in the late 1980s was impelled by her engagement with feminism, her personal history, and her economic circumstances. "Feminist art is soft art, lightweight art, sewing art," Ringgold has defiantly asserted. Like Judy Chicago and other feminist artists in the 1970s, Ringgold was reclaiming traditions of craft for art.

Women Free Angela is a pivotal piece in Ringgold's development, linking the racial discourse of her *Black Light Series* (1969) to the gender-charged paintings of the *Feminist Series* (1972). Ringgold had begun using text in the earlier works, which embraced the black-is-beautiful movement in unstretched paintings rendered in subtle variations of black. Anticipating the triangular stitching in her quilts, the compositions were sometimes divided into chevron shapes, inspired by patterns in African textiles. The bold message of *Women Free Angela* (a collage study for a poster), reflects support for the radical academic Angela Davis, who had been arrested and charged in 1970 in connection with a deadly armed takeover of a California courthouse. The triangulated display of black-nationalist colors, with kaleidoscopic reversals of ground and mirror-image text, suggests the interplay and mutual obligations of individual and collective, as well as racial and sexual liberation movements.

Women Free Angela, 1971. Cut and collaged paper, 29¾ x 19½ in. (75.4 x 49.4 cm). Purchase with funds from the Drawing Committee 2014.68

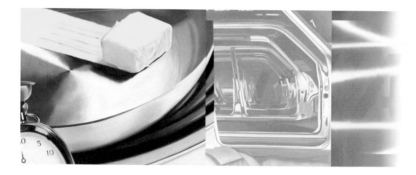

One of the luminaries of Pop art, James Rosenquist came to painting from commercial art: in the late 1950s he worked as a billboard painter in Times Square and other locations around New York. By 1960 he had committed himself to fine art, imparting the heroic scale, stylized forms, and electric hues of his trade to painting.

Rosenquist's iconic works, themselves frequently billboard size, often begin as preparatory collages of reproductions from magazines. Alterations in the shift from mass-media source to oil on canvas might include jarring changes in size and scale and the addition of high-key color, rendering Rosenquist's prosaic subjects—which coalesce, like those of his Pop contemporaries, around domestic, consumerist, and technological themes—strange and startling. The artist's juxtaposition of disparate images across multiple panels intensifies this effect of defamiliarization, placing a burden on the viewer to distill sense and meaning from the disjunctive pictorial syntax.

In *U-Haul-It*, Rosenquist conjoins a panel picturing a pocket watch and a pat of butter melting in a frying pan with another depicting a series of car chassis at a factory and a third showing part of the U-Haul logo as it might appear on the side of a moving van. A range of painterly styles—from exacting illusionism to near abstraction—and the use of three different panel sizes accentuates the jumble of images. Rosenquist's cheerful palette may mask critical implications—a suggested continuum between cozy domesticity and mass production, for example, or the abstracting of corporate logo into gleaming reflection—to say nothing of the note of urgency added by the watch.

U-Haul-It, 1967. Oil on linen, three panels: 60 ⅛ x 169 ¾ in. (152.7 x 431.2 cm) overall. Purchase with funds from Mr. and Mrs. Lester Avnet 68.38a–c

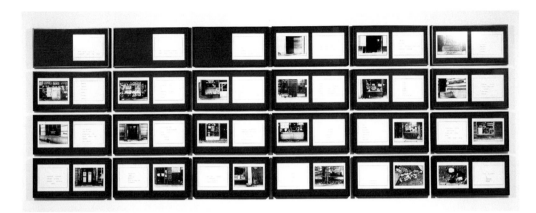

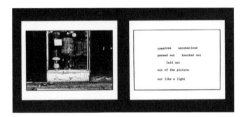

The catalyst for *The Bowery in two inadequate descriptive systems*, Martha Rosler recalled, was a walk in the area of lower Manhattan named in the work's title. A keen investigator of the uses and abuses of documentary photography, Rosler thought of the ubiquitous genre of photographs that captured the downtrodden neighborhood's homeless and alcoholic denizens, and was struck, she said, by "how inadequate the photos were to convey anything about the life there or, even more important, the social position of the men on that street and the circumstances that put them there." To dramatize this deficiency, Rosler paired two kinds of representation, or "descriptive systems," in this work: photography, in the form of black-and-white pictures of unpeopled Bowery storefronts, and language, in images of cards typewritten with assorted synonyms for drunkenness. That neither a photograph of a vacant doorway nor a word such as "sloshed" can comprehensively communicate lived experience is Rosler's

point, and their juxtaposition serves to expose the limits and fault lines in representative modes that are often assumed to be authoritative and transparent. In her words, Rosler intended to "look at the setting and leave the viewer to reimagine the people within."

The plight of the disenfranchised has remained an abiding concern for Rosler, a multidisciplinary artist whose other recurrent themes include the portrayal of women, the culture of public space, and the ideology of modern warfare. Her photographs, videos, installations, performances, and writings are united by their rigorous consideration of the politics of representation: how, and by whom, are contemporary images produced, received, disseminated, and interpreted?

Installation view and detail of *The Bowery in two inadequate descriptive systems*, 1974–75. Forty-five gelatin silver prints mounted on twenty-four backing boards, 11⅞ x 23⅝ in. (30.2 x 60 cm) each. Edition no. 2/5. Purchase with funds from John L. Steffens 93.4a–x

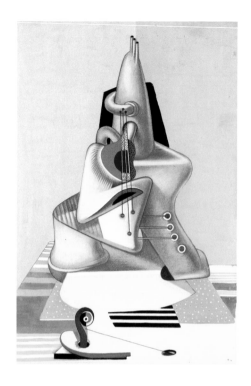

Polish-born, Chicago-trained artist Theodore Roszak embraced the ideals and aesthetic of the Machine Age. During a sojourn in Europe from 1929 to 1931, Roszak was deeply influenced by the utopian commitment to conjoin art and industry promulgated by the Bauhaus, the experimental German art school. Returning to New York, he embarked on a fertile investigation of this idea in an array of media, including painting, drawing, sculpture, lithography, and photography. The sculptures that resulted—and for which Roszak is best known—are streamlined geometric forms produced from industrial materials such as prefabricated metal and plastic. Despite their machine aesthetic, these works remain tied to the natural world, with sinuous or biomorphic elements that evoke figurative forms.

The same is true of Roszak's drawings from the 1930s, including *Metaphysical Structure*, whose title and fantastical imagery recall the artist's interest in the metaphysical compositions of Giorgio de Chirico and the European Surrealists. In this drawing Roszak imagines a contorted pyramidal structure that combines slick industrial elements, including smokestacks and taut cables, together with human forms such as a nose and skinlike surfaces. With its synthesis of abstraction and figuration, the human and the mechanical, the sensual and the austere, *Metaphysical Structure* reflects Roszak's desire to ground all of his art in what he termed "the unique quality of opposing forces." At the same time, this haunting and inventive fusion of man and machine suggests the particular role of drawing, for Roszak, as a tool for "releasing any number of ideas that could not be so readily recorded in any other media."

Metaphysical Structure, 1933.
Crayon, opaque watercolor,
graphite, and ink on paper,
23 x 16⅝ in. (58.4 x 42.2 cm).
Gift of the Theodore Roszak
Estate 83.33.5

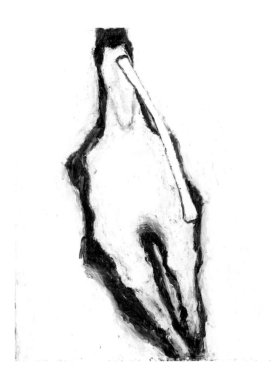

For four decades Susan Rothenberg has depicted animal and human forms in paintings, drawings, and prints that straddle the divide between representation and abstraction. When the young artist began working in the late 1960s, she employed methods and materials associated with Postminimalism, producing process-based works by cutting wire mesh and manipulating lead, and painting geometric abstractions. Dissatisfied with these efforts, she began to ask "if there was anything for [her] to do." In 1974, while sketching on a canvas scrap, an answer intuitively emerged in the shape of a horse outlined in profile and bifurcated by a vertical line.

Rothenberg went on to depict numerous horses—in side view and frontally, stationary and moving—during the following decade, rendering each composition by squeezing paint onto her brush and mixing colors directly on the canvas. The resulting surface texture does not differentiate between the figure and the ground on which it stands or runs. This technique and the recognizable, straightforward subject allowed Rothenberg to "stick to the philosophy of the day—keeping the painting flat and anti-illusionist," while simultaneously allowing her to "use this big, soft, heavy, strong, powerful form."

In *For the Light* the forward-facing beast fills the canvas vertically and charges toward the viewer. Rothenberg wedges a bonelike shape between its head and the picture plane, halting the animal's momentum and reinforcing the materiality of the work. Rothenberg would later break her horses into fragments, and even turn to the human figure, yet she maintains the distinctive style forged in early abstractions of the equine form.

For the Light, 1978–79. Acrylic and vinyl paint on canvas, 105⅛ x 87⅛ in. (267 x 221.3 cm). Purchase with funds from Peggy and Richard Danziger 79.23

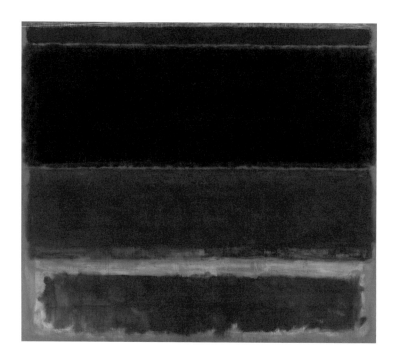

Born in Dvinsk, Russia (now Daugavpils, Latvia), Mark Rothko emigrated at the age of ten to the United States, where he became a leading member of the Abstract Expressionist circle of painters that emerged in New York during the 1940s. In the early years of his career, Rothko painted Surrealist-inflected works in which he used forms derived from primitive totems and mythologies to commune with the epic and tragic events of ancient epochs—which corresponded, he believed, to the horrors and devastation wrought by World War II.

By the late 1940s, Rothko shifted to pure abstraction, filling his canvases with stacked horizontal bands of luminous color in order to express what he described as "basic human emotions—tragedy, ecstasy, doom." He would continue to explore this format in various iterations for the duration of his career. These works came to epitomize the branch of Abstract Expressionist painting known as Color Field—defined by subtly modulated chromatic compositions that were distinct from the agitated gesturalism of painters such as Jackson Pollock and Willem de Kooning. *Four Darks in Red* belongs to a group of dark, somber-toned works from the late 1950s. For these works Rothko painted on an increasingly large scale, a format he also employed in a contemporaneous mural commission (ultimately abandoned) for the Seagram Building in New York. The painting's black and maroon hues, layered in thin, atmospheric veils over a vivid red background, impart a sense of depth and muted radiance that envelops the viewer and commands total emotional and visual engagement.

Four Darks in Red, 1958. Oil on canvas, 101⅞ x 116⅜ in. (258.8 x 295.6 cm). Purchase with funds from the Friends of the Whitney Museum of American Art, Mr. and Mrs. Eugene M. Schwartz, Mrs. Samuel A. Seaver, and Charles Simon 68.9

Ed Ruscha has incorporated popular imagery and text into his paintings, drawings, prints, photographs, artist's books, and films since beginning his career in the early 1960s. These methods have aligned him with Pop and Conceptual art, yet his body of work frustrates easy categorization. For *Large Trademark with Eight Spotlights*, Ruscha amplified the 20th Century Fox film studio trademark to monumental proportions, rendering it, in his words, "Hollywoodized." Most familiar as part of the pre-title sequence that gives way

to a motion picture, the trademark here takes a starring role; the spotlights noted in the work's title likewise emphasizes the importance of branding in popular entertainment. At just over eleven feet long, the painting has a sharp diagonal momentum that provides what Ruscha describes as a "comic comment on the idea of speed and motion in a picture." His dry sense of humor also underscores *Standard Station, Amarillo, Texas*. The photograph was created for the artist's book *Twentysix Gasoline Stations* (1963), a collection of twenty-six images that is purposefully banal and seemingly useless—"a product," the artist explained, "for a non-existent audience." The lackluster company name, "Standard Oil," and the generic quality of the stations' architecture receive their complement in Ruscha's prosaic approach. More interested in information than

Large Trademark with Eight Spotlights, 1962. Oil, house paint, ink, and graphite pencil on canvas, 67 x 133⅛ in. (170.2 x 338.1 cm). Purchase with funds from the Mrs. Percy Uris Purchase Fund 85.41

Standard Station, Amarillo, Texas, 1962, from *Twentysix Gasoline Stations*, 1963. Gelatin silver print, 5 x 5⅛ in. (12.7 x 13 cm). Purchase with funds from The Leonard and Evelyn Lauder Foundation and Diane and Thomas Tuft 2004.461

aesthetics, he described himself as "doing photographs without being a photographer." Ironically, Ruscha's snapshot aesthetic later became the "standard" for many Conceptual artists.

Lion in Oil displays the artist's ongoing fascination with language's potential to both clarify and confuse. The juxtaposition of the mirrored letters of its title—a palindrome—with the image of an impossibly symmetrical mountain range becomes increasingly strange with prolonged viewing. Ruscha painted the phrase in an invented typeface he calls "Boy Scout Utility Modern," designed so that its style "doesn't say anything." The signpost-like lettering is extremely legible, but the words add up to nonsense, presenting the viewer with an odd combination of precision and obscurity. The highly detailed but ultimately fictional mountain range plays a similar role, providing what Ruscha calls an "anonymous backdrop for the drama of words." The enduring ambiguity in Ruscha's work is fitting for an artist who from the beginning has opined: "art has to be something that makes you scratch your head."

Lion in Oil, 2002.
Acrylic on canvas with tape,
64¼ x 72⅛ in. (163.2 x
183.2 cm). Promised gift of
the Fisher Landau Center
for Art P.2010.330

In 1953, while studying jazz in New York, Robert Ryman began a seven-year stint as a guard at the Museum of Modern Art, and soon undertook an artistic self-education by examining how the paintings on view there were "put together." Ryman's subsequent sixty-year career could be characterized as an autodidactic study of the elements of painting: while sticking nearly exclusively to a pared-down grammar of white paint, abstract forms, and square formats, he has experimented extensively with hues of white; paint types (oil, enamel, latex); shape, size, texture, and density of marks; support types (canvas, metal, paper, fiberglass, wood); and means of attaching support to walls (stretchers, fasteners, tape).

　　Ryman's stated concern with the question of how rather than what to paint is exemplified by his refusal to scrape away or overpaint, instead preserving each stroke exactly as it is applied. Eschewing image, narrative, or symbolism, *Untitled* makes its subject the subtle behaviors, and aesthetic pleasures, of the overlapping, noodle-like white marks wriggling in multiple directions; the glimpses of greens, blacks, oranges, and yellows that emerge from underneath; and even the exposed edges of the linen support and the lines of the signature at lower right. Though Ryman began painting during the heyday of "heroic" gestural Abstract Expressionism, the sensuous marks of *Untitled* do not fetishize the artist's touch. Yet neither does the painting operate purely conceptually. Quite the opposite: with each white painting, Ryman encounters again the basic problem of how to paint, and demonstrates anew the potentially inexhaustible possibilities of applying pigment to a flat surface.

Untitled, 1962. Oil on linen, 69½ x 69½ in. (176.5 x 176.5 cm). Gift of the American Contemporary Art Foundation Inc., Leonard A. Lauder, President 2002.263

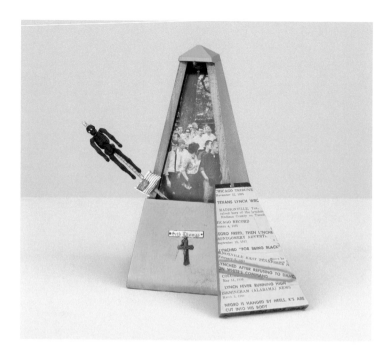

Working in assemblage, installation, and printmaking, Betye Saar has spent much of her life transforming discarded objects. Her work combines a shamanistic sensibility and social conscience with the lineage of Dada and Surrealist collage. A 1967 exhibition of Joseph Cornell's assemblage boxes had a profound impact on Saar, conveying the idea that a new context for an object could alter its meaning. This transformative ability of assemblage surfaces in Saar's political sculptures from the late 1960s and early 1970s, which make use of objects and photographs portraying degrading stereotypes of African Americans. Saar used images of pervasive cultural constructs such as Aunt Jemima and Little Black Sambo in order to access a painful but still relevant part of history, while at the same time reclaiming and re-empowering these iconic figures.

I've Got Rhythm confronts racism by presenting fragments of its history. Here, the image of a tap-dancing, tambourine-playing minstrel is pasted to the exterior of a metronome inside of which are collaged a photograph of a white crowd standing under a tree and newspaper headlines about lynchings. The artist has circled one that reads: "Lynched After Refusing to Dance on White's Command." A black skeleton and an American flag are attached to the metronome's arm. The metronome and allusion to George Gershwin's popular jazz standard in the title asks viewers to consider the legacy of racial oppression embedded in the stereotype of the minstrel. By juxtaposing these references to entertainment with evidence of racial violence, the artist exposes the stereotype as a more insidious and long-lasting form of oppression.

I've Got Rhythm, 1972.
Mechanical metronome with wood case, plastic toy, American flag pin, paint, and paper collage, 8⅝ x 4½ x 4½ in. (21.7 x 11.3 x 11.3 cm). Purchase with funds from the Painting and Sculpture Committee 99.87a–b

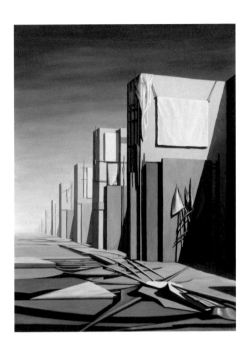

Born into a wealthy family in upstate New York, Kay Sage had a peripatetic childhood and spent much of her adult life in Italy and France. In Paris she joined the circle of Surrealist painters working there during the late 1930s. Following the outbreak of World War II, Sage returned to the United States and married fellow Surrealist Yves Tanguy, settling in rural Woodbury, Connecticut. By the end of the war, she adopted architectural imagery as the signature subject of her mature paintings, which depict imaginary psychic landscapes.

No Passing—like many of her canvases—portrays a barren, otherworldly realm, here populated by windowless monoliths that in turn are covered with smaller rectangular slabs and lattice-like constructions resembling scaffolding. Receding infinitely into the distance, these fantastical structures are painted in a meticulous realist style—a hallmark Surrealist technique for invoking an uncanny sense of disjuncture. The flaglike objects that lean against the buildings and are strewn on the ground hint at a mysterious activity or ritual that was suddenly abandoned, leaving the scene eerily devoid of human presence. The painting's mood of unease and melancholy is reinforced by Sage's muted tones of gray, green, and blue, a palette influenced by the early Renaissance frescoes she had encountered during her years in Italy. *No Passing* may depict a world under construction, or a scene of postapocalyptic desolation, but it is impossible to know for certain. Enigmatic and impenetrable, the painting fulfills the admonitory warning of its title.

No Passing, 1954. Oil on linen,
51¼ x 38 in. (130.2 x 96.5 cm).
Purchase 55.10

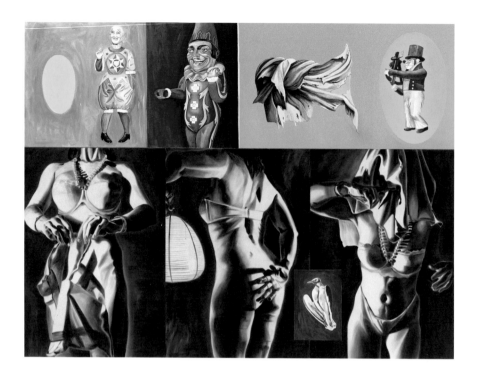

David Salle's paintings are inspired by a medley of popular and art historical sources that he juxtaposes to startling, and often provocative, effect, in a manner evoking film montage. The rectangular compartments that subdivide *Sextant in Dogtown* contain a pastiche of painterly styles and subjects. Jester-like characters are adjacent to scantily clad female figures; black-and-white panels counterpoise brightly colored ones. Confronted with disjunctive images and no evident narrative or overarching motif, we are left to forge connections and surmise meaning. For example, extracting the connection between a large bird and a half-dressed woman is rendered additionally complex for the viewer by the multiple vantage points available. Here, we are at once looking at the woman, are looked at by the clowns, and observe the cartographer in the upper right-hand corner looking. The act of seeing—or not seeing—is indeed thematized: in two frames, the woman's head is truncated above the neck, while in a third it is cloaked.

Salle's work straddles two of the most significant movements in American art of the late 1970s and 1980s—the resurgence of figurative painting, one shared with artists such as Eric Fischl and Francesco Clemente, and the use of appropriated imagery by the group of artists referred to as the Pictures Generation, including Cindy Sherman and Richard Prince. Salle's paintings, drawings, photographs, and films of the past three decades represent by turns an indictment and a celebration of our fast-paced, consumerist, image-saturated, postmodern age.

Sextant in Dogtown,
1987. Oil and acrylic on canvas,
five panels: 96¼ x 126¼ in.
(244.3 x 320.7 cm) overall.
Purchase with funds from the
Painting and Sculpture
Committee 88.8a–e

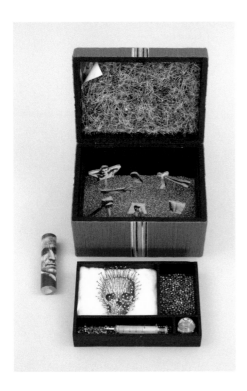

Since the late 1950s Lucas Samaras has demonstrated an insatiable desire to experiment. He has produced work in traditional mediums such as painting, drawing, sculpture, and photography but has also created book art, reconfigured furniture, and sewn tapestries. His enormous output ranges in scale from three-inch Polaroids manipulated by hand to room-sized, mirrored installations.

Samaras made the first of his numerous sculptural boxes in 1960. He was drawn to the form because it offered an artistic "category of its own" that combines aspects of painting, sculpture, and architecture. Although he initially constructed these mysterious and compelling objects out of found items such as cigar boxes, Samaras soon began producing custom designs with removable components. When closed, the brightly-hued, yarn-covered *Box #42* resembles a sewing kit or storage container for treasured items. Once opened, it reveals a glittering array of contrasting content: sharp items and soft, the playful alongside the menacing. A spiked, pin-covered skull rests on a bed of cotton; a toy globe is placed next to a syringe. Beneath the upper tray Samaras propped wooden sticks topped with cutout photographs of nude figures. These dismembered, eroticized paper dolls poke out from a bed of multicolored beads. In addition, the artist's self-portrait— a frequent element in his work—appears affixed to a dowel. Samaras's boxes evoke reliquaries yet house no overt religious content. Instead, by acknowledging the danger present in the ordinary and the pleasure found in the harmful, they reveal his persistent fascination with transforming everyday objects. The act of making, Samaras has explained, "is a ritual, almost a religious act."

Box #42, 1965. Wood box with yarn, straight pins, nails, cut-and-pasted paper, glass beads, rhinestones, wood sticks, metal hardware, cotton, metal globe, and glass syringe, 17⅛ x 14¼ x 12⅜ in. (43.5 x 36.2 x 31.4 cm). Gift of Howard and Jean Lipman 74.97a–m

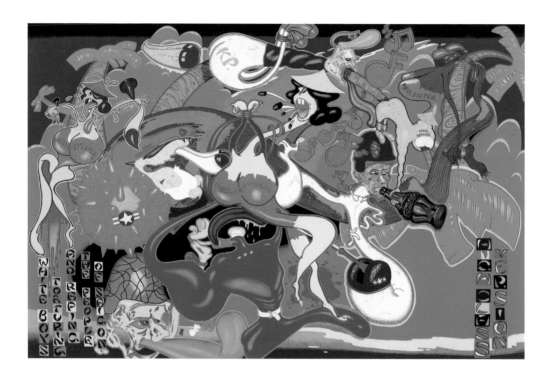

Upon his return to the United States from Paris in the mid-1960s, Peter Saul's painting took a darkly political turn, aiming a fiercely critical eye at the American establishment. He conceived of his work as a response to what he saw as the apolitical nature of much American painting at that time. Saul's subjects from this period include the execution of Ethel and Julius Rosenberg for espionage; American consumerism; and the racism, spectacularized bloodlust, and violent misogyny that played out in the context of the Vietnam War.

Saigon is a melee of extreme violence enacted by and on grotesquely caricatured protagonists, presented on the vast scale of history painting. In it, Vietnamese women with distended, pneumatic breasts are defiled by whistling, Coke-swigging GIs with similarly distorted bodies. The subject of the painting, outlined on the left-hand side of the picture— "White Boys Torturing and Raping the People of Saigon"—came from Saul's imagination and was shaped by the regular news reports from Vietnam and the rhetoric of antiwar activism in the San Francisco Bay Area rather than first-hand experience of the war. The saturated colors and bulging forms show the influence of popular cartoons and psychedelic art, but Saul was also linked at the time with American funk, Pop art, and European new realism. Although he has stated that he was unaware of the work of artists such as Roberto Matta and Max Ernst, Saigon might also be linked to Surrealism in its darkly sexual content and its dreamlike compositional structure.

Saigon, 1967. Acrylic, oil, enamel, and ink on canvas, 93¼ x 142¼ in. (236.9 x 361.3 cm). Purchase with funds from the Friends of the Whitney Museum of American Art 69.103

A seminal figure in the development of non-object-based art in the postwar era, Carolee Schneemann scrutinizes the dominant structures of society through her provocative, celebratory, and sensorial art. Her multidisciplinary practice—which includes performance, installation, film, video, painting, drawing, and writing—has dealt frankly with sexuality, taboos, gender, and the body alongside deeply researched topics such as anthropology, myth, symbolism, and art history. Originally trained as a painter, Schneemann's early Abstract Expressionist paintings were an important influence on her first performance works, scatological and gestural events she termed "Kinetic Theater," which combined performance and installation and developed alongside Fluxus and Happenings.

Her most famous of these works was *Meat Joy*, which was choreographed for nine performers—four men wearing only briefs coupled with four bikini-clad women (including the artist), and a "serving maid" who introduced raw meat and other items into their orgiastic action. It was first performed in 1964 at the Festival of Free Expression in Paris and then at Dennison Hall in London and the Judson Memorial Church in New York. In Schneemann's own words, *"Meat Joy* has the character of an erotic rite: excessive, indulgent, a celebration of flesh as material: raw fish, chickens, sausages, wet paint, transparent plastic, rope brushes, paper scrap. Its propulsion is toward the ecstatic—shifting and turning between tenderness, wilderness, precision, abandon: qualities which could at any moment be sensual, comic, joyous, repellent." Schneemann edited the 16mm documentation of these three performances into a distinct experimental film by incorporating pop music, slow motion, montage editing, and poetic voice-over to create a dizzying and exuberant vision of the experience. It remains an essential, groundbreaking example of early feminist art.

Still from *Meat Joy*, 1964.
16mm film transferred to video, color, sound; 10:35 min.
Purchase with funds from
Randy Slifka 2009.126

Garnering critical attention from the outset of her career, Dana Schutz is known for cartoonish figures and narrative-infused compositions that draw upon the history of painting. Often depicting dystopic scenarios, though with wit and humor, Schutz's paintings have featured "self-eaters"—figures who devour their own hands, arms, chests, and even faces—as well as a character named Frank, whom the artist imagines in a scenario in which she is the last painter alive and he the last man on Earth. Alluding to the works of René Magritte, Pablo Picasso, and Philip Guston, many of Schutz's compositions can be interpreted as investigations of what painting means today—bodies being broken apart, dissected, augmented, digested, and reassembled evoke the very process of constructing a painting. Likewise, her pointed references to celebrity, technology, history, and current events bring to light the varied topics painting can address in the twenty-first century.

Her 2012 drawing *Building the Boat While Sailing* shares its title with a large-scale painting she made prior to the work on paper. The figures in both are busily engaged in various activities, from useful actions like sawing wood to less industrious ones like squirting water from one's mouth. Schutz based the overall composition on Théodore Géricault's *The Raft of the Medusa*, an iconic early nineteenth-century painting of a shipwreck featuring—not unlike her own work—living and dead bodies in various states of distress.

Building the Boat While Sailing, 2012. Ink on paper, 72⅛ x 96 in. (183.2 x 243.8 cm). Purchase with funds from the Drawing Committee 2013.33

George Segal

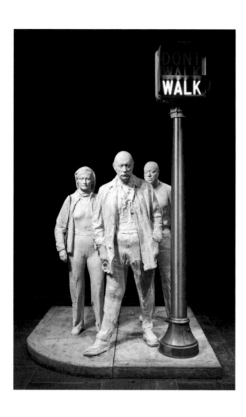

Walk, Don't Walk, 1976.
Plaster, cement, metal, painted
wood, and electric light,
109⅛ x 72 x 74⅜ in. (277.2 x
182.9 x 188.9 cm) overall.
Purchase with funds
from the Louis and Bessie
Adler Foundation Inc.,
Seymour M. Klein, President;
the Gilman Foundation
Inc.; the Howard and Jean
Lipman Foundation Inc.;
and the National Endowment
for the Arts 79.4a–f

George Segal began his career as a figurative painter, but by 1958 he started to work his figures in three dimensions, bringing them off the canvas and into the space of life. In 1961 he began experimenting with a new type of medical bandage meant for setting bones, which he dipped into wet plaster and wrapped onto live models. After removing the dried bandage molds, Segal was left with hollow, life-sized white sculptural forms, which he soon began integrating into architectural scenes to create tableaux with scavenged materials. Later, around 1970, he began to fill the molds with plaster or bronze, creating figures whose surfaces preserved the rough bandage textures.

Although in select ensembles Segal referenced historic and politically charged events, including the Holocaust and the civil rights movement, he primarily chose subjects drawn from daily life. In *Walk, Don't Walk* three anonymous figures stand on a concrete sidewalk. They are positioned in close proximity to one another but do not interact. In observing city dwellers prior to making this sculpture, Segal noted how "people moving around seem to be in some kind of hypnotic dream state. They seem to be programmed." The ghostly bodies of Segal's sculptural figures seem momentarily frozen, instinctively negotiating this typical urban scene. Segal became intrigued with the craftsmanship and monumentality of New York's street signs in preparing this work, and the device here is a functioning example. It faces outward, implicating viewers in the narrative of the scene: they momentarily become pedestrians across the street from the sculpted figures, also waiting for the light to change.

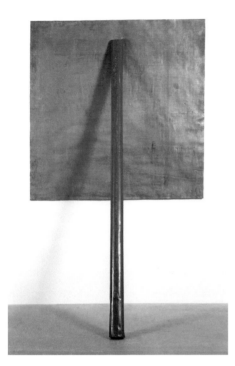

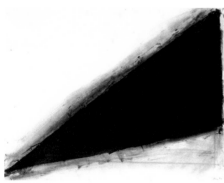

Prop, 1968 (refabricated 2007). Lead antimony and steel, 89½ x 60 x 54 in. (227.3 x 152.4 x 137.2 cm). Purchase with funds from the Howard and Jean Lipman Foundation Inc. 69.20a–b

Untitled, 1972–73. Oil stick on paper, 37⅞ x 50 in. (96.2 x 127 cm). Purchase with funds from Susan Morse Hilles 74.10

Throughout a career that has spanned nearly half a century and ranged across mediums such as sculpture, drawing, experimental film, video, and large-scale public art, Richard Serra has insisted that the elements essential to any work of art include the qualities inherent in the materials used and the process of its making. In 1968 Serra executed numerous sculptures comprised of manipulated lead. These works realize in three dimensions a set of written instructions the artist began compiling the previous year. The list, which includes the verbs "to scatter, to roll, to fold, to spill" as well as select nouns suggesting terms "of context, of tension, of gravity," signals both the undertaking of these works and the conditions within which they exist. For example, the sculpture *Prop* enacts the verb in its title: a large, rolled-up lead tube props up a square lead sheet placed against the wall. *Prop* operates in the specific "context" of the museum gallery, suspended in a state of "tension" as the two elements resist "gravity."

The drawings Serra has made since the early 1960s, executed in charcoal, lithographic crayon, or oil stick applied to paper, linen, or cut canvas affixed directly to the wall, operate not as preparatory sketches for his sculptures but as independent objects. *Untitled*, one of the first drawings he made using a paint stick (oil paint hardened with wax), features a densely applied black triangle inscribed within the rectangle of the white paper. Despite the variety of pigments and application techniques he has utilized in drawings that vary from sketchbook-sized renderings to large-scale, site-specific installations, Serra consistently works in black. The color, he has argued, "is a property, not a quality," one that allows him to explore the relationship of forms both to and in space.

Ben Shahn

b. 1898; Kaunas, Lithuania
d. 1969; New York, NY

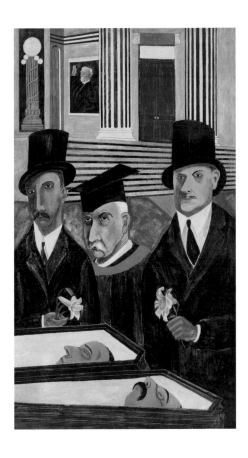

Ben Shahn rose to prominence as a leading proponent of Social Realism, a style that responded to the social, economic, and political conditions of the Great Depression. In both paintings and photographs he portrayed the hardships of poverty and protested the era's social injustices.
The Passion of Sacco and Vanzetti belongs to a series of twenty-three works that Shahn based on the controversial trial of Italian immigrants Nicola Sacco and Bartolomeo Vanzetti, who in 1921, despite weak evidence, were found guilty of killing two men during the robbery of a Massachusetts shoe factory. In 1927, after years of legal appeals, the presiding judge, Webster Thayer, sentenced the two men to death, and the decision—which many believed reflected bias against their ethnic background and anarchist beliefs—was met with worldwide protests.

First exhibited in 1932, Shahn's *Sacco and Vanzetti* series launched his career. Each image represents an episode from the story in a pared-down, graphic style that conveys a sense of directness and immediacy. Here, the three members of the Lowell Committee, a group appointed to investigate the bias charges, stand over the coffins of the men whose fate they sealed by affirming the verdict's legitimacy—the white lilies they hold seem like an empty gesture. Behind them, Judge Thayer is visible through a window, his right hand raised as if taking an oath. The allusion in the title to the Passion of Christ suggests that the work is a broader meditation on martyrdom and injustice. As Shahn remarked, "I was living through another crucifixion. Here was something to paint!"

The Passion of Sacco and Vanzetti, 1931–32. Tempera and gouache on canvas, 84 x 48 in. (213.4 x 121.9 cm). Gift of Edith and Milton Lowenthal in memory of Juliana Force 49.22

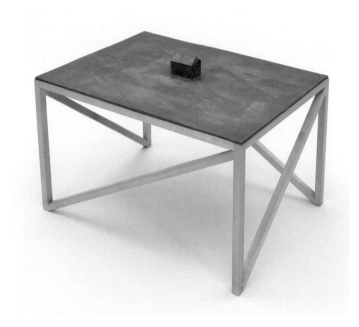

When Joel Shapiro began showing his sculptures in the 1970s, they bucked prevailing trends: they were small rather than large in scale; figurative rather than abstract; compositionally condensed, solid, and deliberate rather than variable, open-field, and contingent; and classic rather than experimental in material. *Untitled (House on Field)* belongs to a body of diminutive bronze, iron, plaster, and wood sculptures he made of simple geometric forms such as chairs, tables, houses, and ladders. Usually placed directly on the floor, sometimes positioned teetering on their sides as if knocked over, these are touchingly vulnerable sculptures.

In *Untitled (House on Field)* the featureless house is fused to a surrounding bronze plane and placed atop a raised wooden pedestal, yet the remoteness and unapproachability of this structure, set within a seemingly vast field, speaks with just as much pathos as its floor-bound counterparts. Home registers both as a formal, architectural notation and as the locus of emotional projections and institutional formations, particularly those concerned with memories of childhood. As Shapiro explained: "This house is not engaged so much with the space that it actually occupies, but functions in a much more psychologically determined space instead. It is removed. It is very sentimental. It gives a real sense of isolation." The replicative method of casting serves to further underscore the theme of memory. Following these early works, which stressed the interaction between an interior, associative, and imaginative space and the real space a sculpture occupies, Shapiro increasingly focused on the latter with running, tumbling, and gesticulating stick figures composed of conjoining cubic rectangles.

Untitled (House on Field), 1975–76. Bronze and wood, 20⅝ x 28⅞ x 21⅝ in. (52.2 x 73.2 x 54.8 cm). Edition no. 1/2. Purchase with funds from Mrs. Oscar Kolin 76.22a–b

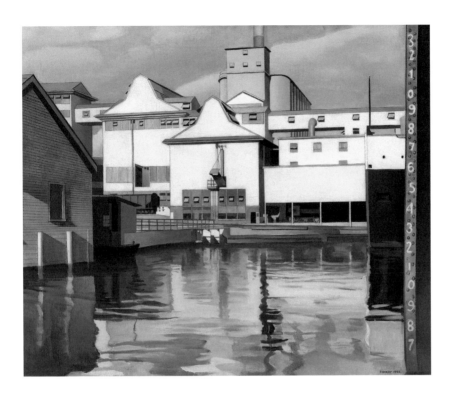

Charles Sheeler was a leading exponent of the innovative modernist style that arose after World War I in the United States and came to be known as Precisionism. Artists associated with the movement fused a planar geometry developed from European Cubism with an interest in uniquely American subjects, often celebrating industry and a Machine Age aesthetic. Sheeler worked across artistic mediums and developed a versatile, complex practice in which his vision was expressed with equal artistic command and intellectual rigor, masterfully devising compositions of modern, geometric form from America's burgeoning urban and industrial landscapes.

In 1927, Sheeler was commissioned to photograph the Ford Motor Company's massive new automobile manufacturing facility in Dearborn, Michigan, on the Rouge River. Sheeler was fascinated by the mechanized totality of the environment, and his photographic images of the facility's machines and architecture became justly celebrated. This fascination persisted beyond the photographic assignment, and in subsequent years he embarked on a series of paintings and drawings based on the complex. In the painting *River Rouge Plant*, Sheeler focuses on the section of the facility that processed coal into fuel; in the foreground are a boat slip and the bows of two ships that carried the coal. Sheeler captures the scene—its whitewashed buildings depopulated and waters motionless—with a lucidity and sereneness that confounds our expectations of heavy industry. "It may be true," he remarked, "that our factories are our substitute for religious expression."

River Rouge Plant, 1932.
Oil and pencil on canvas,
20⅜ x 24⅜ in. (51.8 x
61.9 cm). Purchase 32.43

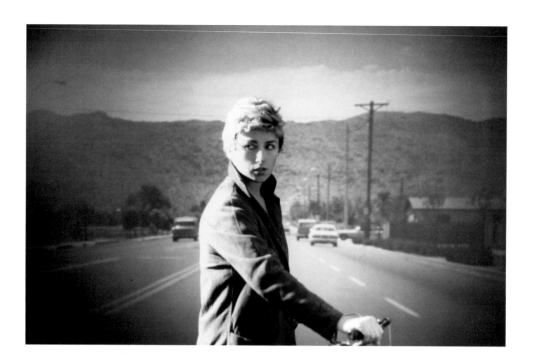

Untitled #66, 1980.
Chromogenic print, 15⅜ x
23½ in. (39.1 x 59.7 cm).
Edition no. 5/5. Gift of Barbara
and Eugene Schwartz 88.50.1

Untitled, 2008. Chromogenic
print, with frame, 63¾ x
57¼ in. (161.9 x 145.4 cm).
Edition no. 5/6. Purchase with
funds from the Painting
and Sculpture Committee and
the Photography Committee
2009.46a–b

One of the most important artists of her
generation, Cindy Sherman has produced
a provocative body of photographic
work that addresses—and complicates—
themes of gender, sexuality, and class,
particularly as they intersect with codes
of representation and spectatorship. She
first gained notice for her groundbreaking
Untitled Film Stills, a series of sixty-
nine black-and-white photographs made
between 1977 and 1980 that feature
the artist as model. Inhabiting a different
role in each image, Sherman alters
her clothing, hair, and makeup and adjusts
staging and lighting to convey generic
female characters and narrative conventions
from old B-movies or foreign films. In the
related series *Rear Screen Projections*,
she used color images for the first
time and employed projected slides as
backgrounds for her characters. For
example, in *Untitled #66* Sherman poses in
front of a grainy image of a highway exterior
as a young woman in some sort of trouble;
on the lam or plotting an escape,

she undoubtedly conceals a secret. Demonstrating the facility with which photography transmits clichés of narrative and identity, Sherman shows equally how convincingly, for all its artifice, the medium functions to convey truths.

In subsequent series Sherman has portrayed female subjects from a range of visual genres, including magazine centerfolds, fashion spreads, horror films, and history paintings. In a 2008 suite of large-scale photographs, she masquerades as an assortment of dowagers or aging socialites. The fancy jewels worn by the matron in an untitled image from the series suggest that she may be about to ascend the staircase to attend a party or charity event. Her heavy makeup and world-weary mien belie the age that her dyed hair and strapless gown attempt to mask. Here again, Sherman incisively probes the conditions under which contemporary identity is constructed, represented, and perceived.

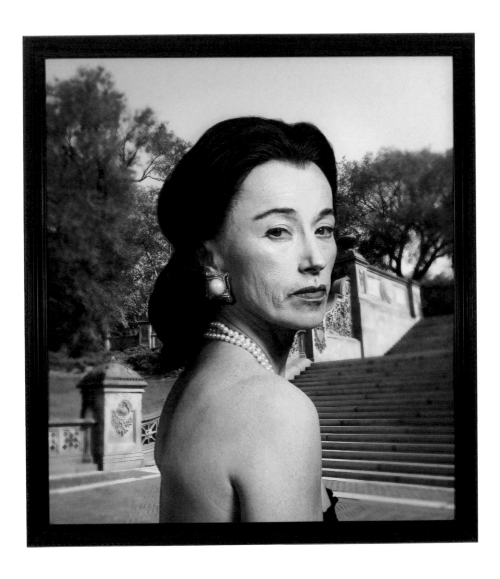

Paul Sietsema's body of work encompasses drawing, sculpture, and film and explores the nature of representation itself. Conceptual yet deeply engaged with material, Sietsema's projects often involve the meticulous crafting of objects or models that are then represented in projected films. For his film *Empire*, Sietsema built architectural models, including one of the living room of the art critic Clement Greenberg—known for his formalist approach to art and emphasis on the purity of mediums—as it appeared in a 1964 *Vogue* photo spread. The strict adherence to prescribed forms embodied by the art hanging in Greenberg's living room is juxtaposed with the gilded pomp and decorum of the other model Sietsema built, of an eighteenth-century Rococo royal salon. Sietsema creates an entire landscape of books, images, histories, and bodies of knowledge for these two spaces and then combines and weaves them into a structure that becomes both the material and subject of the film.

Questions about the mediation of material, information, and their cultural context play a central role in Sietsema's artistic practice. In *Empire* such questions are mirrored in the spatial uncertainties the artist creates for the viewer through his skillful play with scale. Using black-and-white and red-tinted negative images, *Empire* creates a network of references and allusions that explore systems of power and visual styles. The 1964 image, for example, which evokes Greenberg's art-historical reign, was shot the same year as Andy Warhol's iconic eight-hour film *Empire*, while the making of Sietsema's film coincides with Michael Hardt and Antonio Negri's influential 2000 theoretical book *Empire*, which investigated new forms of imperialism.

Stills from *Empire*, 2002.
16mm film, black-and-white
and color, silent; 24 min.
Edition no. 5/7, 2 AP. Purchase
with funds from the Film and
Video Committee and
the Contemporary Painting
and Sculpture Committee
2003.211

Through her art and writings, Amy Sillman has played a significant role in the resurgence of American painting since the mid-1990s and in the artistic discourse that surrounds it. Although known primarily for her large-scale oil paintings—works at once rigorous and playful that hover between abstraction and figuration, executed in surprising color palettes—drawing is a crucial part of the way she works. "I think the core of my practice is completely drawing," she has said. Sillman has explored language and image in this medium and, more recently, has used contemporary technology such as the iPhone to make drawings that she then translates into animated films.

Untitled April Drawing 3, Version 2 and *Version 3* were part of a group of more than a dozen drawings on which Sillman worked serially, one leading to another in an instinctive process of formal experimentation. In her oil paintings Sillman works through many stages, each successive reworking responding to previous gestures and strokes yet leading to a final composition that may look nothing like the one with which she began. The more naked medium of drawing lays this process bare so that we can see how her compositional tinkerings progress from one sheet to the next. Here, the faucet/phallic shape becomes pinched and tightened into two separate forms, while the background shapes sharpen from washy curves into thinner, darker lines. Many of the traditional dichotomies associated with working in two dimensions—line/color, figure/ground, flatness/space—play out lyrically before us in these two works.

Untitled April Drawing 3, Version 2, 2014. Mixed media on paper, 30 x 23¼ in. (76.2 x 59.1 cm). Purchase with funds from the Drawing Committee 2014.145

Untitled April Drawing 3, Version 3, 2014. Mixed media on paper, 30 x 23¼ in. (76.2 x 59.1 cm). Purchase with funds from the Drawing Committee 2014.146

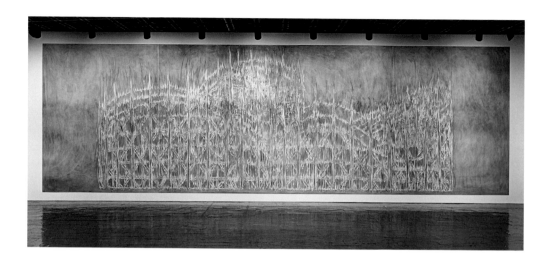

Ghoster is one of Gary Simmons's signature "erasure drawings," made by applying chalk to a surface that resembles an outsized blackboard. Its smudges and blurs evoke the traces left on a blackboard after it has been wiped clean. Yet the invocation of erasure is not simply literal; Simmons ties this series of works to the way that memory functions—combining, modifying, and indeed erasing various elements from the past. His title is a blend of the words *ghost* and *roller coaster*, and the massive image of lattices and curves was inspired by various wooden roller coasters of the artist's youth, including the Cyclone at Coney Island. Simmons's support, occasioned in part by abandoned blackboards he found in an old schoolhouse where he kept a studio in the late 1980s, adds an additional layer of historical weight. Although typically drawn directly on the surface of a wall, the installation pictured here was made by Simmons on four wood panels to facilitate future display.

Simmons's art, which encompasses painting, drawing, sculpture, photography, video, and site-specific installation, often takes the idea of disappearance and loss as a central concern. His subjects have included bygone themes, including the historic roller coasters of *Ghoster*

and images of ancient ships or moonshine distilleries, as well as cultural and racial stereotypes, as embodied in references to Ku Klux Klan gowns, rap songs, and blaxploitation films. "I wanted to show how we can attempt to erase a stereotype, but the image won't easily go away," Simmons has explained. "It persists." The erasure drawings manifest this persistence in an affecting visual form.

Ghoster, 1996. Chalkboard paint and chalk on wall, dimensions variable. Purchase with funds from the Contemporary Painting and Sculpture Committee 97.100. Installation view: Whitney Museum, 2009

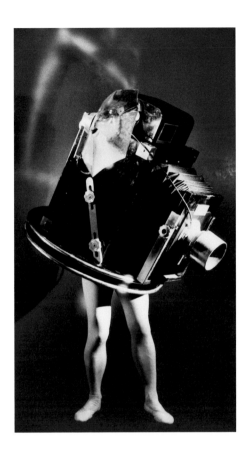

Photographer and filmmaker Laurie Simmons emerged as one of the artists of the Pictures Generation alongside Sarah Charlesworth, Barbara Kruger, Louise Lawler, and Cindy Sherman. Named after the landmark exhibition in 1979, these artists challenged, and continue to challenge, the function of images and photography in society by questioning the role that images play, rather than their ability to function as documents. She has said: "I wanted to make pictures that were psychological, political, subversive. Images from my subconscious that could inform." Simmons's first series set female figurines inside of dollhouses, depicting domestic spaces and using them to critique representations of women by the media. She continued this work with inanimate subjects, including toy cowboys and ventriloquist dummies.

In the late 1980s Simmons began working on her *Walking Objects* series. A life-sized costumed camera in the 1978 movie *The Wiz* triggered a childhood memory of a 1950s cigarette advertisement featuring dancing Chesterfield cigarette boxes. Borrowing the original movie costume, Simmons convinced her friend and mentor, fellow photographer Jimmy De Sana, to don the costume and pose for a series of photographs printed at life-size. De Sana had been diagnosed with AIDS two years earlier, and he struggled under the weight of the costume. After making *Walking Camera*, Simmons had her sister pose as an oversized walking purse. The series continued, including myriad disparate objects such as guns, houses, and cakes, but all subsequent images were made with doll and mannequin legs. While the spotlit, surreal, and often sardonic photographs in the series would become iconic for challenging the representation of women as "objects" in art history, *Walking Camera II (Jimmy the Camera)* stands apart as a portrait of Simmons's now departed friend.

Walking Camera II (Jimmy the Camera), 1987. Gelatin silver print, 82⅞ x 47½ in. (210.5 x 120.7 cm). Edition of 5. Purchase with funds from the Photography Committee 94.107

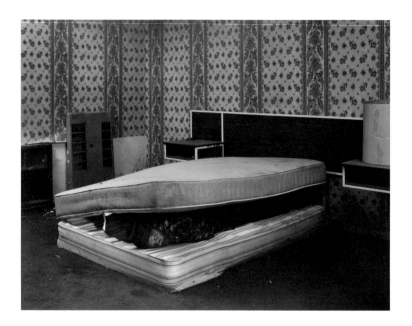

Taryn Simon investigates photography from within, employing the medium to probe its various uses and abuses. Her projects of the past decade, which are extensive in means and scope, have integrated photographs, text, and elements of graphic design in inventorying, among other subjects, contraband items seized by airport authorities, bloodlines that connect hundreds of people around the world, and birds in James Bond films. With a taxonomic approach, Simon plumbs the internal contradictions of the photographic medium, exploring it as a mode of both corroboration and concealment, truthtelling and obfuscation, cohesiveness and fragmentation.

The man named Larry Mayes who is featured in Simon's 2002 work was identified by a rape victim as one of her attackers on the basis of a photograph; he was consequently imprisoned for nearly twenty years, even though no biological evidence had tied him to the crime. The work is one of fifty that comprise Simon's early project *The Innocents*, for which the artist photographed men who had been convicted of violent crimes, and who were imprisoned and then later exonerated through DNA evidence. Simon learned that mistaken identification, often made through photographic images of suspects, was a frequent cause of wrongful conviction. *The Innocents*, as she has explained, "stresses the cost of ignoring the limitations of photography and minimizing the context in which photographic images are presented." Each subject was photographed at a site significant to his experience; Larry Mayes, his gaze at once defiant and resigned, is posing here in the decrepit Indiana hotel room where he was arrested for a crime he did not commit.

LARRY MAYES *Scene of arrest, The Royal Inn, Gary, Indiana, Police found Mayes hiding beneath a mattress in this room, Served 18.5 years of an 80-year sentence for Rape, Robbery and Unlawful Deviate Conduct*, 2002, from the series *The Innocents*. Edition no. 2/5. Chromogenic print, 48 x 62 in. (121.9 x 157.5 cm). Purchase with funds from the Photography Committee 2005.31

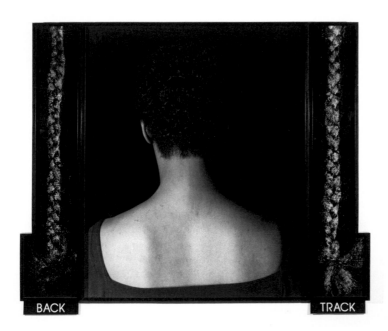

After receiving a BFA from the School of Visual Arts, New York, and an MFA from the University of California, San Diego, Lorna Simpson began in the mid-1980s to produce works combining photographs and text that draw on aspects of Conceptual art to consider themes of race, gender, and identity. Although they engage broader contexts of historical memory and visual culture, Simpson's photo-text tableaux resist easy explication, relying instead on viewers' interpretations to untangle their enigmatic syntheses of image and language.

 2 Tracks, for example, seems to set forth a narrative in its juxtaposition of a photograph of the shoulders and close-cropped head of an African American woman, seen from the back; a pair of flanking photographs of long braids of black hair; and the words *back* and *track,* on accompanying plaques. But the relationship between these components remains unclear. The words have literal correlates (the subject's back and the tracklike braids), but the phrase *backtrack*, with its

connotations of reversal and regression, provokes consideration of additional meanings as African American hair, a favored motif of the artist's, takes on loaded significance. Simpson frequently pictures her subjects from behind or crops or fragments her images—challenging the presumed objectivity of the photographic medium—and she often invokes systems of counting, indexing, or classification only to violate the order of these typologies. Both formal strategies heighten the ambiguity of her combinations of photographs and text.

 In the 1990s Simpson began creating large-scale, multipanel photographic works on felt. Her practice in recent years furthers her examination of contemporary identity in the mediums of drawing, film, and video.

2 Tracks, 1990. Three gelatin silver prints with frames and two plastic plaques, 48⅞ x 62⅝ in. (124.1 x 159.1 cm) overall. Edition no. 4/4. Gift of Raymond J. Learsy and Gabriella De Ferrari 91.59.4a–e

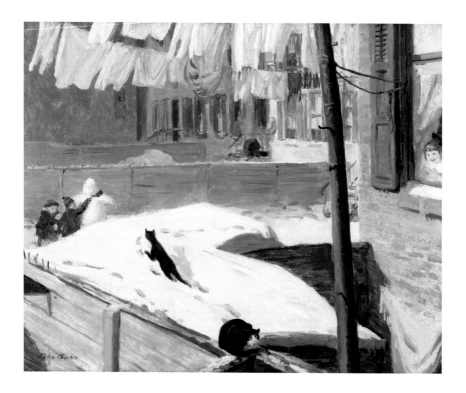

One of the foremost urban realists of the early twentieth century, John Sloan was captivated by the vibrant pulse of everyday working-class life. After pursuing a successful career as a commercial newspaper artist in Philadelphia, Sloan followed his friends Robert Henri, George Luks, Everett Shinn, and William Glackens to New York in 1904. There, he harnessed the skills he had learned from newspaper work—the ability to memorize characteristic details and sketch quickly on the street—to paint impressionistic images of squalid tenements, streets and storefronts, parks, restaurants, and bustling crowds. To critics, these commonplace subjects were inappropriate for art, but to Sloan and his circle—whose dark palette and gritty subject matter earned them the nickname the Ashcan School—they were quintessentially American.

Backyards, Greenwich Village was painted not long after Sloan relocated his studio and apartment to West Fourth Street in Greenwich Village, where he immersed himself in the neighborhood's flourishing bohemian community. Sloan especially loved to capture his subjects unawares, as in this scene of two children building a snowman in the ramshackle backyard seen from the artist's apartment window. The pair is supervised by a nearby cat, while another young child, in turn, observes the entire scene from an upstairs window, creating an interplay of gazes that modulates the viewer's own entry into the image. By portraying such ordinary, seemingly unremarkable moments with his exuberant brushwork and keen eye for detail, Sloan invested them with a sense of freshness and immediacy, suffused with the democratic idealism of the Progressive Era.

Backyards, Greenwich Village, 1914. Oil on canvas, 26 x 32 in. (66 x 81.3 cm). Purchase 36.153

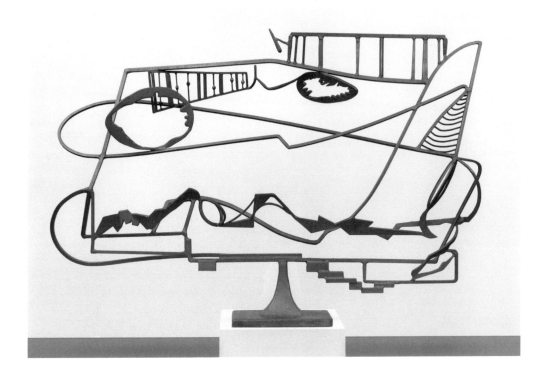

Hudson River Landscape,
1951. Welded painted
steel and stainless steel,
48¾ x 72⅛ x 17⅜ in.
(123.8 x 183.2 x 44.1 cm).
Purchase 54.14

David Smith, one of the most prominent
and celebrated American sculptors
of the twentieth century, is known primarily
for the welded steel abstractions
he executed throughout his nearly four-
decade-long career. Although he trained
as a painter in the late 1920s, Smith
also produced numerous drawings and
photographs, moving fluidly between
two and three dimensions, and between
positive and negative space.

Smith configured his first welded
metal sculpture in 1933 after seeing
reproductions of constructions by Pablo
Picasso and Julio González from the
late 1920s. For such works, a welder, using
either a torch or an electrical current,
fuses metal pieces with an additional steel
rod. Both the modern material and
the modern process appealed to Smith,
who saw the late-nineteenth-century
invention as freed from the weight of art
history. He derived *Hudson River*

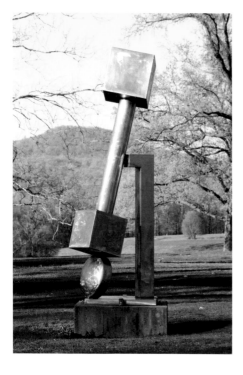

Eng No. 6, 1952. Tempera and oil on paper, 29⅞ x 42¼ in. (75.9 x 107.3 cm). Purchase with funds from Agnes Gund and an anonymous donor 79.43

Cubi XXI, 1964. Stainless steel, 119½ x 41½ x 40⅞ in. (303.5 x 105.4 x 103.8 cm). Gift of The Lipman Family Foundation, jointly owned by the Whitney Museum of American Art, New York, and Storm King Art Center, Mountainville, New York 2011.168

Landscape, a lyrical, open-frame sculpture, from sketches made while riding the train between his home in Bolton Landing, in upstate New York, and New York, in particular the seventy-five-mile stretch between Albany and Poughkeepsie. "Later," Smith recalled, "while drawing, I shook a quart bottle of India ink and it flew over my hand. It looked like my river landscape. I placed my hand on paper. From the image that remained, I travelled with the landscape, drawing other landscapes and their objects, with additions, deductions, directives, which flashed unrecognized into the drawing, elements of which are in the sculpture. Is my sculpture the Hudson River? Or is it the travel and the vision? Or does it matter? The sculpture exists on its own; it is an entity." Smith's sculptural process, often described as "drawing in space," relates closely to his works made on paper. These he executed nearly every day using ink, tempera, and oil. The bright red color featured in Eng No. 6 echoes the artist's desire to merge painting and sculpture, which he explored in polychrome three-dimensional works. Indeed, he described his drawings as "studies for sculpture, sometimes what sculpture is, sometimes what sculpture can never be."

Smith began his last series, titled Cubi, in 1961. He configured this group of twenty-eight monumental stainless steel sculptures from prefabricated, hollow geometric components. Cubi XXI aggregates cubic, rectangular, cylindrical, and tubular elements. The Cubi seem at once balanced and unstable; they convey a sense of action even in their solidity. This is due in large part to their burnished surfaces, which Smith achieved using a circular sander. His sweeping, arching movements produced a brushstroke effect on the polished surface. When positioned outside, the Cubi catch and reflect changing light conditions, reminding the viewer that forms interact with, depend upon, and alter the space around them.

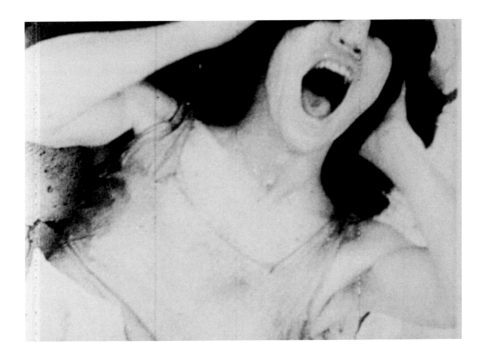

Best known as a pioneer of American avant-garde film and performance art, Jack Smith also created photographs, writings, and drawings, all of which defied existing conventions of art, theater, sexuality, and taste. A denizen of New York's downtown scene and lover of Hollywood Golden Age cinema, Smith advocated for what he called "secret-flix"— genre pictures that exude kitsch sensibilities and do not aspire to high cinematic art. For Smith, these low-budget films, horror movies, and musicals prioritized imagery over narrative, an inversion he valued even at the expense of technical finesse. Drawn to orientalist fantasies, the films of B-movie actress Maria Montez, and trash aesthetics, Smith created visually dense works for an audience he fondly called "the scum of Baghdad."

Smith's 1962 film, *Flaming Creatures,* is imbued with a libidinal decadence— for which it would be placed at the center of a 1964 obscenity trial—and premiered on the cusp of the sexual revolution of the 1960s. In one scene a group of ambiguously gendered characters—men in drag and women—continuously apply lipstick as a mock radio commercial for "indelible lipstick" is heard; later a tangled confusion of bodies—limbs, genitalia, hands, breasts— writhes in either ecstasy or pain as dry plaster rains from above. With portions of the film over- or underexposed (it was shot on outdated stock), *Flaming Creatures* subsumes both traditional technique and plot by bounding forward out of sheer energy and visual innovation.

Still from *Flaming Creatures*, 1962–63. 16mm film, black-and-white, sound; 43 min. Edition no. 1/10. Gift of Gladstone Gallery, New York 2010.209

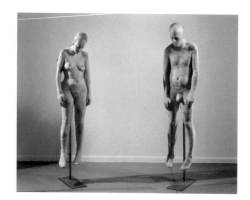

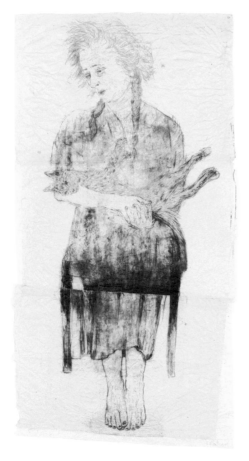

Since the 1980s Kiki Smith has focused her art on the human body, creating transgressive, often disturbing works that deal with themes related to the life cycle—reproduction, decay, mortality, and regeneration—as well as the role of women in society. Smith's work often aims to undermine customary modes of perceiving the human body. As she remarked, "Most of the functions of the body are hidden or separated from society; . . . we separate our bodies from our lives." In her hand-wrought sculptures Smith explores corporeal textures and functions using nontraditional materials such as hair, latex, beeswax, glass, and porcelain. *Untitled*, one of Smith's earliest large-scale wax sculptures, consists of two life-sized figures, a man and a woman, suspended from metal poles as though exhibited in a natural history museum or other site of public display. Although life-giving secretions—milk and semen—drip from the woman and man, respectively, the two figures hang lifelessly, the areas of red-tinted wax gruesomely visible beneath the outer layers of their skin suggesting internal damage or dissolution.

Often, Smith fuses her interest in the body with themes drawn from the Bible and ancient mythology, as in *Pieta*. This drawing, a self-portrait of the artist holding her deceased cat Ginzer, is based on Christian depictions of the grieving Virgin Mary cradling the dead Christ in her arms—a subject known as the *pietà*, from the Italian word for *pity* or *devotion*. Here, Smith uses the familiar art-historical representation to memorialize her own grief and experience of loss. The delicate, slightly crinkled Nepalese paper on which the drawing is rendered emphasizes the fragility of life and the intimate bond between the artist and her beloved pet.

Untitled, 1990. Beeswax and microcrystalline wax figures on metal stands, 78 x 71½ x 21¼ in. (198.1 x 181.6 x 54 cm). Purchase with funds from the Painting and Sculpture Committee 91.13a–d

Pieta, 1999. Ink and graphite pencil on paper, 55¼ x 30⅜ in. (140.3 x 77.2 cm). Purchase with funds from the Drawing Committee 2001.151

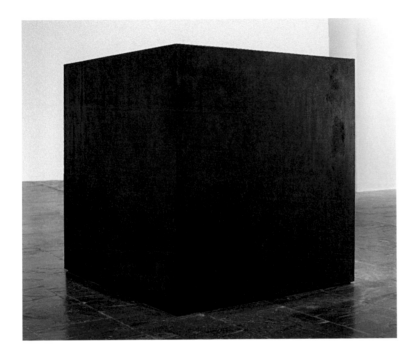

Tony Smith produced abstract, geometric, and mathematically derived paintings, drawings, architectural designs, and—beginning in the late 1950s—sculptures, the work for which he is best known. Smith studied painting and architecture in the 1930s and, following an apprenticeship under Frank Lloyd Wright, designed private residences for twenty years. He considered form, scale, mass, and voids as essential components of his architectural work, and while these same considerations surfaced in his two-dimensional paintings, they proved fundamental to the sculptures.

Although Smith's peers in the 1950s were first-generation Abstract Expressionist artists such as Jackson Pollock, his commitment to modular, regularized, and industrially fabricated units anticipated the concerns and methods of the Minimalist sculptors of the 1960s. To make *Die*, a six-foot, hollow steel cube raised slightly off the floor to reveal all twelve of its edges, Smith gave his specifications to fabricators at a welding company. As he explained,

"I just picked up the phone and ordered it." Unlike the younger Minimalist artists, however, Smith did not reject allusive references. He derived *Die*'s shape and size from ancient sources, including a description by the Greek writer Herodotus of a cubic chapel carved from a single stone, and studies by the Roman architect Vetruvius of ideal human proportions.

The sculpture's evocative title suggests an unmarked die or, more morbidly, the act of dying. The dimensions, as he suggested, point to the latter: "Six foot box. Six foot under." Yet Smith was primarily concerned with the living viewer's perceptual and bodily experience of *Die*. Its scale, he felt, should register as smaller than a monument but larger than an object.

Die, 1962. Steel, 72⅜ x 72⅜ x 72⅜ in. (183.8 x 183.8 x 183.8 cm). Edition of 3. Purchase with funds from the Louis and Bessie Adler Foundation Inc., James Block, The Sondra and Charles Gilman Jr. Foundation Inc., Penny and Mike Winton, and the Painting and Sculpture Committee 89.6

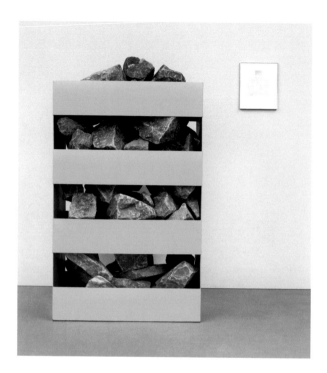

While remembered chiefly for his pioneering earthworks, Robert Smithson's earliest artistic endeavors, created between 1957 and 1963, were two-dimensional—paintings, drawings, woodcuts, and collages that often suggested mythological, literary, or religious themes. By the mid-1960s Smithson started producing his first mature works—principally sculptures and theoretical writings—which consistently challenged ideas about what materials may constitute art, where it could be located, and how its relationship to institutions might be configured.

In 1968 Smithson began to make what he called "non-sites": works in which natural materials such as rocks, sand, and gravel—from an outdoor geographic or geological "site"—were transferred, contained, and presented indoors, in a gallery or museum. *Non-site (Palisades—Edgewater, N.J.)* consists of a slatted aluminum box filled with rocks salvaged from an area near a former trolley line in the artist's native New Jersey. "Instead of putting a work of art on some land, some land is put into the work of art," he wrote in the sculpture's component text panel. This particular site interested Smithson for its illustration of a central preoccupation of his art: the thermodynamic principle of entropy, or the tendency of any system to lose energy over time. "What was once a straight track has become a path of rocky crags—the site has lost its system." Smithson's fascination with entropy also underpins his earthworks, large-scale, site-specific interventions in the natural environment, some of which were underway when he died in a plane crash at age thirty-five.

Non-site (Palisades—Edgewater, N.J.), 1968. Enamel on aluminum with stones and ink on paper, 63½ x 36 x 26 in. (161.3 x 91.4 x 66 cm) and 11⅛ x 8½ in. (33.3. x 21.6 cm). Purchase with funds from the Howard and Jean Lipman Foundation Inc. 69.6a–b

Nancy Spero's distinctive form of politically engaged art combines a wide-ranging social and cultural critique with craft-based techniques, historical references, poetic and personal text, and a loose figurative style. Trained at the Art Institute of Chicago and the École des Beaux-Arts in Paris, Spero began to produce work that was pointedly political in 1965, during the height of the Vietnam War. By the end of the 1960s she had also become active in the Art Workers Coalition and Women Artists in Revolution, groups that protested the discriminatory practices of New York cultural institutions. Throughout the 1970s, Spero's work increasingly reflected feminist concerns, portraying the protagonists of history with female figures, or referencing personal experience through text-based compositions.

Hours of the Night—comprising eleven nine-foot-high, hand-printed and collaged paper panels—is a textual work that recalls a manuscript or scroll, though it eludes linear reading. Phrases such as *shoot out* and *body count* suggest the violence and grim political climate that followed the United States' withdrawal from Vietnam in 1973. Textual fragments such as *smoke lick* and *knife cut* hint at more personal events: a fire that damaged Spero's New York apartment the year the work was made, and a stabbing that injured her husband, the artist Leon Golub. *Hours of the Night* might suggest a catalogue of night terrors or racing thoughts, but Spero described the piece in more optimistic terms. The work, she stated, was inspired by the Ancient Egyptian *Book of the Dead*, in which the sun god Ra "travels the underworld each night, but emerges triumphant at dawn each day. This continual battle affirms the future—and the celebration of life."

Hours of the Night, 1974.
Relief print and collage with opaque watercolor and acrylic on joined paper, eleven parts: 116¼ x 298½ in. (295.3 x 758.2 cm) overall. Purchase with funds from the Painting and Sculpture Committee 2007.25a–k

An artist and writer, Frances Stark draws inspiration from her professional and personal life as well as from literature, music, and pop culture. Her work is infused with humor and wit, often of a self-deprecating variety in which the pressures of life and making art become generative subject matter. Mining topics both common and erudite, and often incorporating text into her work, Stark has featured her children and pet cats in videos, created abstract compositions utilizing quotations from writers such as Robert Musil and Samuel Beckett, and participated in Internet sex chats that developed into the script for an animated video. Often, the act of production—or, even more so, the hesitancy and procrastination that precedes making—is emphasized in her works, becoming a self-referential source of inspiration itself.

Stark's collage *Push* depicts the door to the artist's Los Angeles studio and a stream of mail passing through it. The barrage of bills, exhibition announcement cards, and junk mail—all of which are physically incorporated into the drawing—represents the outside world interfering with the contemplative space of the artist's work environment. Rather than letting the mail become another item on her to-do list, Stark turns a tedious chore into a work that directly conflates the competing concerns of art and life. Known for her use of double entendres and wordplay, Stark has titled the work after the ubiquitous door sign but also as an allusion to the act of refusal. *Push* forces the extraneous out of the studio and returns it to the world.

Push, 2006. Collage, acrylic, tape, and graphite pencil on panel, 80 x 91¼ in. (203.2 x 231.8 cm). Purchase with funds from the Drawing Committee and partial gift of Tina Petra 2009.132

Edward Steichen was one of the most important American photographers of the early twentieth century. A contemporary of Alfred Stieglitz and F. Holland Day, Steichen began his career as a painter and a photographer in the atmospheric and painterly style of Pictorialism. Following service in World War I as an aerial photographer, Steichen abandoned painting and began to develop a more modernist approach to photography, presenting his subjects with greater volume, scale, and clarity of form. At the age of forty-four, after receiving recognition among artistic circles in the United States and Europe, he began a career in the commercial world.

From 1923 to 1937 Steichen worked as chief photographer for Condé Nast Publications, photographing actors, writers, artists, and statesmen for *Vanity Fair* and fashion and society figures for *Vogue*.

Paul Robeson as the Emperor Jones depicts Robeson as Brutus Jones in the 1933 film adaptation of Eugene O'Neill's *The Emperor Jones*. Steichen portrays the compelling strength of the Jones character as well as the powerful presence of Robeson, an actor, singer, scholar, and political and social rights activist. The dramatic, abstract framing of Robeson and the starkly contrasting light and shadow are hallmarks of Steichen's influential style. Yet it is Steichen's ability to "awaken a genuine response" in his subjects that made him one of the greatest portrait photographers of his day.

Paul Robeson as the Emperor Jones, 1933. Gelatin silver print, 10 x 8 in. (25.4 x 20.3 cm). Gift of Richard and Jackie Hollander in memory of Ellyn Hollander 2012.240

Pat Steir has defied stylistic categorization throughout her long career, persisting instead in systematically dissecting the traditional techniques of art, including mark-making gestures such as brushstrokes and paint drips, in much of her work. Beginning with her pivotal 1985–86 "Wave" paintings, she has used the inherent liquidity of wet paint as the basis for several series. Steir's *September Evening Waterfall* began with the impulse to create a work in which the paintbrush never touched the canvas. She was also responding to what she felt were the clichés of Abstract Expressionism—as embodied by Jackson Pollock's drip paintings—and wanted to make a painting that merged those clichés in a fresh way.

In *September Evening Waterfall*, which Steir made in a single day in September, she embraced techniques of pouring, dripping, splashing, and flicking a single color of white paint, mixing in more or less turpentine to create a range of consistencies and transparencies, the deep blue-black ground discernable through the thinner rivulets. The liquid paint in essence becomes the subject it is depicting as gravity pulls the paint downward, echoing the waterfall of the title, and much is left to chance and accident. As Steir said: "What I can do is limited by what I know. But I'd rather do more than what I know. So chance becomes part of the work and can help form a better painting. I rely on chance rather than showing how smart I am. Who cares how smart I am!" The finished painting is a composition balanced between order and chaos, control and accident.

September Evening Waterfall, 1991. Oil on canvas, 114⅜ x 103 in. (290.5 x 261.6 cm). Gift of an anonymous donor 2001.322

Die Fahne hoch!, 1959. Enamel on canvas, 121⅝ x 72⅞ in. (308.9 x 185.1 cm). Gift of Mr. and Mrs. Eugene M. Schwartz and purchase with funds from the John I. H. Baur Purchase Fund; the Charles and Anita Blatt Fund; Peter M. Brant; B. H. Friedman; the Gilman Foundation Inc.; Susan Morse Hilles; The Lauder Foundation; Frances and Sydney Lewis; the Albert A. List Fund; Philip Morris Incorporated; Sandra Payson; Mr. and Mrs. Albrecht Saalfield; Mrs. Percy Uris; Warner Communications Inc.; and the National Endowment for the Arts 75.22

In 1959, shortly after graduating from Princeton University, twenty-three-year-old Frank Stella embarked on a radical group of works that have come to be known as the *Black Paintings*. Like the other paintings in the series, *Die Fahne hoch!* consists of a stark geometric pattern of uniform black stripes—a dramatic departure from the gesturalism of Abstract Expressionist painting then in vogue. Further distinctive features include the deep stretcher on which the work is mounted, which allows the painting to assert its presence as a physical object; and the white lines, which turn out not to be applied but rather the bare canvas left exposed between areas of black pigment. Rejecting personal expression and illusionistic representation in favor of reductive intellectual structures, the Black Paintings redefined painting as a literal, object-based practice and anticipated the emergence of Minimalism during the 1960s. As Stella remarked: "My painting is based on the fact that only what can be seen there is there. It is really an object. . . . What you see is what you see." Nonetheless, *Die Fahne hoch!* is not devoid of allusion. The work's provocative German title, meaning "the banner raised," comes from the marching anthem of the Nazi Party, linking the cruciform structure and dark austerity of the large-scale canvas to a remembrance of that period. The title may also be a reference to Stella's contemporary Jasper Johns, whose American flag paintings, begun just a few years prior, paved the way for Stella to raise his own aesthetic banner.

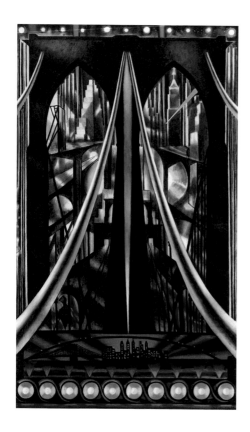

Believing that an artist should "not confine himself to any schools or representation," Joseph Stella engaged in parallel experiments with a lyrical, symbolic style of abstraction and a bold geometric aesthetic inspired by modern industry. After encountering the Futurist artists of his native Italy (he emigrated to New York at the age of nineteen), Stella sought to use their faceted and planar imagery to capture the technological marvels of his adopted country. He turned to an icon of American engineering: the Brooklyn Bridge. For Stella, as for many other artists in the early twentieth century, the bridge epitomized the confluence of American cultural and industrial achievement. He first depicted the structure in 1918 and returned to it throughout his career. In *The Brooklyn Bridge: Variation on an Old Theme*, painted in the final years of his life, Stella portrays the bridge as a modern-day altar, using crisp geometries to instill the structure with solidity and dynamism. The image's massive upper section represents the bridge's soaring cables and majestic Gothic arches in a jewel-toned palette that evokes the impression of light filtering through a stained-glass window. The work's horizontal lower portion, which contains a miniature panoramic view of the bridge and the city skyline, is reminiscent of the predella format of Renaissance altarpieces. Indeed, Stella perceived the bridge as a potent spiritual symbol—it was, for him, a "shrine containing all the efforts of the new civilization, *America*."

The Brooklyn Bridge: Variation on an Old Theme, 1939. Oil on canvas, 70¼ x 42¼ in. (178.4 x 107.3 cm). Purchase 42.15

A painter, poet, and designer, Florine Stettheimer was a central figure in the modernist avant-garde circles of New York between the two world wars. She began her formal training at the Art Students League in 1892 and continued studying art in Europe, where she absorbed Symbolist and Post-impressionist styles and developed a unique figuration that drew on the ornamentality of Art Deco patterns. With war impending, Stettheimer returned to New York in 1914 and soon began hosting a salon with her two sisters in their Upper West Side apartment. The salon cultivated a vibrant community of artists, literati, and European expatriates, many of whom appear in Stettheimer's portraits, including Marcel Duchamp, Man Ray, Charles Demuth, Edward Steichen, and Carl Van Vechten.

Stettheimer created fantastic urban scenes in a decorative style that was, in many ways, opposed to the abstract and geometric forms prevalent in the 1920s and 1930s. *Sun*, for example, depicts an airy riverside promenade or rooftop with a towering bouquet of flowers radiating from its center. Rendered in curvaceous lines and intense, saturated colors, the flowers are a powerful focus of the scene and, with "Florine" written on the bow that snakes around the bouquet like a vine, suggest a stand-in for the artist herself. Indeed, Stettheimer picked a bouquet of flowers for herself each year on her birthday, and flowers often appear in her work as a kind of self-portraiture. Because she exhibited her paintings only rarely during her lifetime and refused to sell any, Stettheimer remained in relative obscurity for much of the twentieth century.

Sun, 1931. Oil on canvas, with painted wood frame, 43⅝ x 31¾ in. (110.8 x 80.6 cm) overall. Purchase 73.36a–b

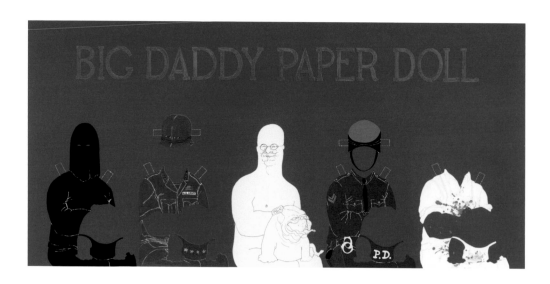

Painter, poet, and political activist May Stevens imbues her work with a sociopolitical consciousness. In the wake of the civil rights movement and the Vietnam War, Stevens developed a symbolic figure that would feature prominently in much of her work of the late 1960s and early 1970s: Big Daddy. According to Stevens, Big Daddy is modeled after her father, "who represented to me an authoritarian and closed attitude . . . towards culture, towards politics, towards Black people and towards Jews. He was a person who had stopped thinking when he was twenty and hadn't opened his mind to anything since."

 Big Daddy Paper Doll features the outline of a naked, bespectacled, and mustachioed man holding a bulldog in his lap. Exuding a sexual and militarized dominance, his head appears bullet-shaped and phallic. His wrinkly features echo those of his canine companion, a visual allusion implying bestial alpha-male instincts. Stevens presents him as a mere paper doll with four potential guises—a masked executioner, an army sergeant, a policeman, and a butcher with a bloodstained apron, each one a manifestation of violence and power. Presenting these roles as interchangeable costumes hints that the same white patriarchal spirit runs through a wide range of American institutions. The representation of Big Daddy as a paper doll, a widely available commercial product, also ties the painting's style and content to Pop art, and asks the viewer to consider how authoritarian mindsets are being packaged and sold to the American public.

Big Daddy Paper Doll, 1969. Opaque watercolor, pen and ink, and graphite pencil on paper, 27 x 41⅛ in. (68.6 x 104.5 cm). Gift of Leonard Bocour 69.129

Songs of the Sky B3, 1923,
from the series *Equivalent*.
Gelatin silver print, 4½ x
3½ in. (11.4 x 8.9 cm).
Promised gift of Sondra
Gilman Gonzalez-Falla and
Celso Gonzalez-Falla
to the Whitney Museum
of American Art, New
York, and the Gilman and
Gonzalez-Falla Arts
Foundation P.2014.105

In 1922 Alfred Stieglitz—the influential photographer who played a seminal role in defining and promoting modern art in the early twentieth century—began to document the sky at his family estate on Lake George in New York. He eventually produced more than two hundred images, including *Songs of the Sky B3*, for the series, which came to be called *Equivalent*. The small size of these prints, made with a handheld Graflex camera, contrasts with their expansive subject. Light, the very substance of photography, is foregrounded here, expressing the tension between the transitory and the eternal that underlies photographic practice.

This series was a departure for Stieglitz, who spent much of his career advocating for "straight photography" through the numerous institutions he developed. These included the magazine *Camera Work* and a succession of important galleries in which he championed the work of fellow photographers such as Edward Steichen and Paul Strand along with the paintings of European and American modernists—including his wife, Georgia O'Keeffe, whose painterly abstractions of nature may have influenced the *Equivalent* series.

In this early print from the series, wisps of woolen white-and-gray clouds frame a slice of piercing light against a darkened sky. The viewer's eye is drawn to the soft, curving shapes of the dissipating clouds, which, disconnected from everyday experience, are meant to suggest an "equivalence" between one's thoughts and nature. "Several people feel I have photographed God," Stieglitz wrote to the poet Hart Crane in 1923. By connecting his inner life to the natural world, Stieglitz imbues a cross-section of the sky with spiritual depth through a rhythm of abstracted forms.

During the 1940s Clyfford Still began to paint large-scale, expansive abstractions that evoked the vast landscapes he encountered during his youth in Washington State and Alberta, Canada. In canvases such as *Untitled* he used jagged, interlocking planes of thickly layered paint that recall the craggy forms of mountains and caverns, or the conjunction of earth and sky, while remaining resolutely abstract and mysterious. Like many of Still's works, *Untitled* is impressively scaled—more than nine feet high and twelve feet long—and utilizes a palette of deep blacks animated by swaths of vibrant color, balanced by large areas of seemingly bare canvas.

With works such as *Untitled*, Still became linked to the Abstract Expressionist painters who rose to prominence during the 1950s, especially artists such as Mark Rothko and Barnett Newman, who similarly composed their works from fields of color. However, Still eschewed associations with any movement. Believing that participation in the commercial activities of the art world compromised the integrity of the artist and his work, he conceived of himself as an outsider and carefully controlled the exhibition and sale of his paintings. Likewise, he made ambitious claims for his canvases as a critique of modern consumer culture, describing them as "an assault upon the concept of the picture as a value object . . . a repudiation of the mechanistic ethic and technological rationale of our culture." The counterpoint to Still's rejection of modern values was his evocation of the sublime and timeless drama of the natural world. With its serrated forms, immense scale, and brooding palette, *Untitled* conveys awe—and perhaps unease—at nature's dynamism and magnitude.

Untitled, 1956. Oil on canvas, 113⅛ x 147¼ in. (287.3 x 374 cm). Gift of The American Contemporary Art Foundation Inc., Leonard A. Lauder, President 2002.265

Since the outset of his career in the 1980s, Rudolf Stingel has consistently sought to broaden the possibilities of painting. He moves freely among styles and genres, flouting the barriers between handmade and mechanically made, abstract and representational. He has often worked at the intersection of painting and architecture: in 2013 he covered the interior of a Venetian palazzo in a digitally printed facsimile of an antique carpet. For his solo exhibition at the Whitney in 2007, he installed foil-covered insulation on the walls and invited viewers to draw on and incise into it. Many of Stingel's "paintings" record action on a surface—a condition that the artist seems to indicate is the essential requirement of the medium.

In 2005 Stingel began working in a photorealistic style, using other artists' photographs as a starting point. His subjects have since included many self-portraits from various points in his life, as well as portraits of his long-time gallerist Paula Cooper and paintings of religious statuary. *Untitled (After Sam)* is a from a self-portrait series based on photographs taken by the artist Sam Samore. Moody and monumental in scale, the image juxtaposes an intense emotional weight with a cold, mechanical method of rendering. Once Stingel sets the composition, his studio assistants produce the work according to a strict system that recalls paint-by-numbers. Stingel acknowledges shared authorship, downplaying his own artist's "hand." By questioning where exactly the artfulness resides in the process of making art, Stingel has produced a body of work that evades typical definitions of the creative act.

Untitled (After Sam), 2005–6. Oil on canvas, 139½ x 188 in. (354.3 x 477.5 cm). Purchase with funds from the Painting and Sculpture Committee 2006.105

The central element of Jessica Stockholder's untitled 1995 work—a rattan Papasan chair—is quotidian enough, but its commonplace presence serves primarily as a base for the motley assortment of objects and materials the artist has added to and around it. The chair's function as a place to sit has been nullified, as it is occupied by a plastic tub and large stretch of velvet. The work's placement on a wheeled trolley, and its inclusion of a light fixture, impart an aspect of unpredictability and movement. As with many of her works, the piece is anchored to the wall, fixing it in space, in this case by a bright pink electrical cord. All of the components— the chair itself and the grid of yarn skeins on the wall behind—are surfaces upon which Stockholder applies paint. As she explained: "Color drives me. I make art to play with color, to see it work. . . . I experience color as sculptural, as something that collects onto things and takes up space, a physical event existing next to physical objects."

Stockholder's sculptures, assemblages, site-specific installations, paintings, and prints make use of ordinary, often nonart materials in extraordinary ways. Each component, from laundry baskets to bowling balls, extension cords, and refrigerators, brings its own associations and histories, while simultaneously engendering fresh resonances when combined with the other items. Evocative and surprising, Stockholder's work engages both the intellect and feeling: "I work with color, form, and composition," she explained, "exploring the links between emotive and thoughtful response."

, 1995. Wicker chair, plastic tub, light fixture with bulb, acrylic and oil paint, plastic, fabric, concrete, resin, wood, wheels, acrylic yarn, glass, and cookie in resin, 71½ x 63 x 50 in. (181.6 x 160 x 127 cm) overall. Gift of the Jack E. Chachkes Estate by exchange and purchase with funds from the Peter Norton Family Foundation and Linda and Ronald F. Daitz 95.182a–e

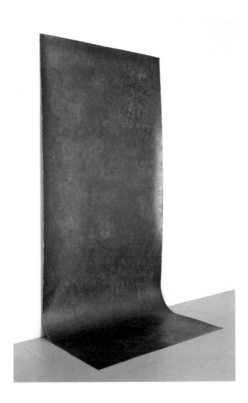

The earth's physicality has fascinated Michelle Stuart since childhood. Her work often examines landscape as both a metaphor for memory and the sense of place we seek as human beings. Like other artists associated with the movement known as Land art, Stuart has investigated sites as a symbolic abstraction—a concept she understood well from her work as a cartographer in the mid-1960s. Her piece *#28 Moray Hill* challenges traditional ideas of drawing and its boundaries by combining performative gestures with found materials.

This large, scrolling sheet of paper is scaled to the body and extends down the wall, creating a dimensional presence and invoking actual terrain, as if one might enter into it. Through size, proportion, and shape, the artist alludes to the way in which we inhabit the landscape. The title refers to the location where Stuart found the rocks and earth, which she then used as both a medium and a drawing instrument. Using muslin-backed paper allowed her to aggressively smash these materials into the sheet without tearing it. This technique resulted in a pitted surface, indexing the site used to make the piece, while mimicking dirt and earth more generally. Stuart added aluminum powder to create a sheen, so the work's visual qualities change depending on lighting and viewing angle. This drawing is part of a group of related works that Stuart created in a similar format using the same special paper, all of which reveal her experimental approaches to materials and process while referencing the earth both literally and metaphorically.

#28 Moray Hill, 1974.
Graphite, earth, and rocks on muslin-mounted paper,
144 x 62 in. (365.8 x 157.5 cm).
Purchase with funds from the Painting and Sculpture Committee, the Drawing Committee, Steven and Ann Ames, Greg S. Feldman, Martin Hale Jr., Elizabeth Kabler, Donna Rosen, and Fern Kaye Tessler 2014.108

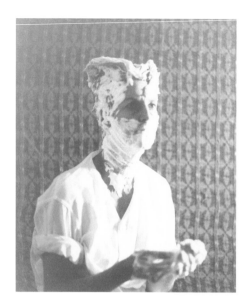

In the mid-1960s the artist Sturtevant (born Elaine Sturtevant) began to make "repetitions" of recent paintings, sculptures, and installations by contemporaries such as Jasper Johns, Claes Oldenburg, and Andy Warhol. Although she mimicked her fellow artists' subjects and methods, Sturtevant was not simply cloning the work of others but rather underscoring her belief in the conceptual underpinnings of art. Indeed, her project questions how art is made, institutionally contextualized, and monetarily valued. "The brutal truth of the work," Sturtevant has explained, "is that it is not copy"; rather, "the push and shove of the work is the leap from image to concept."

Sturtevant has reimagined numerous works by Marcel Duchamp, an artist whose "readymade" sculptures helped to spearhead conceptually based art making. For *Duchamp Man Ray Portrait*, she restaged the 1924 portrait photograph *Duchamp with Shaving Lather for Monte Carlo Bond*, taken by the artist's frequent collaborator Man Ray. Duchamp's neck and face are coated in soapsuds in that image, and his lathered hair, pulled back from his forehead into two stiff spikes, resembles the winged helmet of Mercury, the Roman messenger god. Assuming the guise of Duchamp-as-Mercury, Sturtevant not only re-creates the earlier image but also echoes the fluidity of Duchamp's ambiguously gendered self-representations, in which he frequently appeared disguised as his female alter ego, Rrose Sélavy. Although she consistently emphasized the idea over the object, Sturtevant never neglected the material basis of each work she made. As a result, her maneuvers paradoxically call upon audiences to look more closely at what they think they already know.

Duchamp Man Ray Portrait,
1966. Gelatin silver print,
8⅝ x 7¼ in. (21.9 x 18.4 cm).
Gift of Sascha S. Bauer
and Kristen Dickey 2013.102

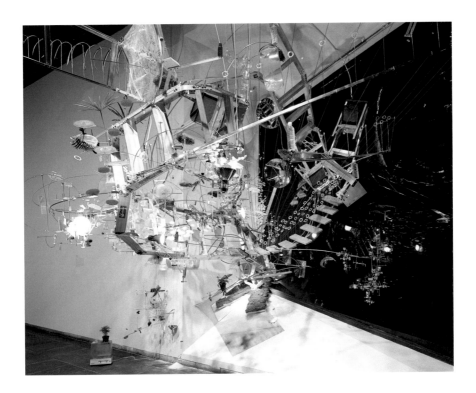

Sarah Sze created *Strange Attractor* for a specific site—the area in front of the massive window on the fourth floor of the Whitney Museum's Marcel Breuer–designed building—as part of the 2000 Biennial exhibition. Intended to be viewed both in the gallery and from Madison Avenue, seventy-five feet below, the sculptural installation veritably explodes into space, its hundreds of parts radiating in multiple directions, extending up even past the open grid of the ceiling. The work has an additional local resonance: Sze sourced all of the materials used in its making from the neighborhood around the Museum. They are ordinary objects—aspirin tablets, plastic spoons, balsa wood, metal ladders, and paper tickets—similar to items found in the artist's other intricate, architecturally scaled constructions.

 Other elements render the arrangement dynamic: mirrors cause volleys of reflection; small whirring fans set bits of paper in motion; a humidifier dispenses steam; and water flows through a set of clear plastic tubes. These activities lend the work qualities of a delicate, organic ecosystem, in which interdependent parts change over time. (Sze's title is a mathematical term, describing the pattern of behavior in a chaotic system.) Yet, in spite of the work's subtle motion and initial sense of unruliness, *Strange Attractor* registers a finely calibrated equilibrium. Sze's installations are precisely planned and configured; as she has explained: "My sculpture is an intersection of painterly ideas about composition and architectural ideas about the use and structure of space."

Strange Attractor, 2000. Mixed media, dimensions variable. Gift of Marianne Boesky, Ed Cohen, and Adam Sender 2001.1. Installation view: Whitney Museum, 2000

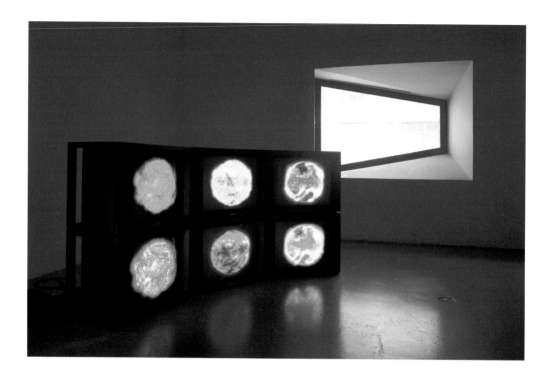

Since the early 1990s Diana Thater has been producing complex video installations—nonnarrative moving images in layered, room-sized projections and architectural interventions—that investigate the relationship of time and space to the subjective experience of viewing. Thater's approach developed from an engagement with media theory, literature, science, art history, Hollywood cinema, and experimental filmmaking, all of which she studied at New York University and, later, at the Art Center College of Design in Pasadena, California, where she received her MFA. She also has cited a deep interest in the notion of beauty as an underlying principle for much of her art making, as reflected in her use of video imagery drawn from the natural world—primarily plants, animals, and the solar system.

Six-Color Video Wall, for example, uses footage taken by NASA satellites of the sun at various stages of the day to deconstruct the basic six-color spectrum of video light; Thater presents both the original imagery photographed in red, blue, and green, as well as in its complementary color set of cyan, magenta, and yellow, which the artist generated in postproduction. The six cube monitors are displayed in a gallery flooded with mauve and deep blue light filtered from windows covered with colored theatrical gels, creating a volumetric and immersive environment. As Thater explained, "I wanted to make a vehicle for thinking about space. I want people to go into that . . . purple volume that I have made and experience a very complex relationship between their body and space."

Six-Color Video Wall, 2000. Six-channel video installation, color, silent, with six monitors and six colored gel filters; dimensions variable. Purchase with funds from the Contemporary Committee and the Film and Video Committee 2000.193. Installation view: Whitney Museum, 2001

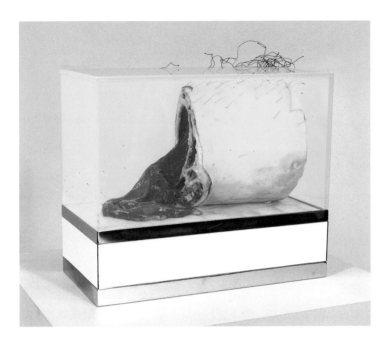

Paul Thek was one of the most prescient artists to emerge during the 1960s, yet his work remained largely unrecognized for decades. Having begun his career as a painter, Thek traveled in 1963 with the photographer Peter Hujar to Palermo, Italy, where he visited the Catacombs and observed the accumulations of skeletons there, openly displayed in boxes. A lapsed Catholic, he found the sight unforgettable, and the trip precipitated a turning point in his art.

On his return to New York, however, Thek was confronted with a sculptural practice completely at odds with his thinking about the body and mortality. Interest in the figure and materiality had been superseded by the industrially produced sculpture of the prevailing Minimalist style. In reaction Thek embarked on a series of works he later named *Technological Reliquaries*, sculptures that directly imitated body parts, which he encased in plexiglass boxes. *Untitled* is a replica of a tubular section of flesh, with what looks like blood and bodily fluids oozing out at one end.

A facsimile of fat and skin encases the surface, covered with nylon-monofilament "hairs" that protrude through the chartreuse container. "My work is insulting to our sense of the humane," Thek wrote of these pieces, and "insulting to art history in terms of subject matter, the way some of the abstractionists insulted history in a formal, plastic way."

Thek lived in Europe for much of the 1970s, organizing collaborative theatrical installations. The impact that his *Technological Reliquaries* and installations had on sculptors such as Mike Kelley and Robert Gober in the 1980s has led to the posthumous recognition of Thek's art.

Untitled, 1966, from the series *Technological Reliquaries*, 1964–67. Wax, paint, polymer resin, nylon monofilament, wire, plaster, plywood, melamine laminate, rhodium-plated bronze, and acrylic, 14 x 15⅛ x 7½ in. (35.6 x 38.4 x 19.1 cm). Purchase with funds from the Painting and Sculpture Committee 93.14

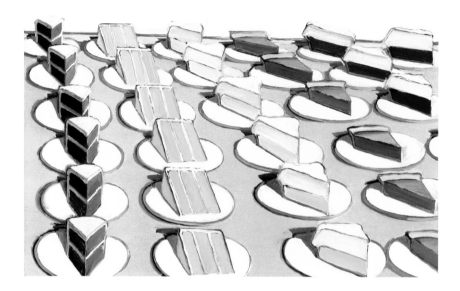

Wayne Thiebaud's works from the early 1960s are often linked with Pop art by virtue of their depiction of quotidian American subjects, including gumball machines, soda bottles, hot dogs, and delicatessen counters. Painted from memory and imagination rather than direct observation, these canvases recall the time Thiebaud spent working in restaurants. Around 1959 he became interested in the formal properties of the shapes he encountered in daily life, such as the triangles and circles in *Pie Counter* and the planes upon which they sit. His style resists the flattening graphic approach of other Pop artists, however, and he has remained resolutely devoted to painting.

In *Pie Counter* Thiebaud renders the tempting textures of sponge, frosting, and meringue in luscious, thick strokes of oil paint. The rows of standardized slices evoke the mass production of food in the postwar period, while their chromatic

outlines and bold shadows harness the visual language of advertising, the legacy perhaps of Thiebaud's experience as a graphic designer. *Pie Counter* stops short of critique of mass consumer culture, however. It also conveys a sense of nostalgia for what the artist has described as "a visual memory in fragmented circumstances [that] were always poetic to me." As such, the painting might be read as a traditional still life, with its presentation of food a metaphor for transience: "The pies that we now see," Thiebaud has explained, "are not going to be around forever. We are merely used to the idea that things do not change."

Pie Counter, 1963. Oil on canvas, 29⅞ x 36 in. (75.9 x 91.4 cm). Purchase with funds from the Larry Aldrich Foundation Fund 64.11

After devoting herself full time to painting in 1960, at the age of sixty-nine, Alma Thomas rose to prominence as a Color Field abstractionist. The first graduate of the fine arts program at Howard University in Washington, DC, in 1924, Thomas had spent thirty-five years as an art teacher in the city's public schools. During her years as a teacher she was active in the Washington arts community and took classes at American University, where she first began to paint abstractions. With vibrant canvases such as *Mars Dust* Thomas forged a link to the thriving community of abstractionists known as the Washington Color School—which included the painters Morris Louis, Kenneth Noland, and Sam Gilliam. Like these artists, Thomas turned to acrylic paint and used her large-scale canvases to explore experimental techniques. Unlike them, however, Thomas rooted her images in nature, especially the abstract patterns created by the interaction of light and earth.

In *Mars Dust* the lyrical, allover surface of dappled red brushstrokes conjures the massive dust storms created by the iron-rich soil of Mars, which are fueled by the heat of the sun and often envelop the planet for weeks or months. These atmospheric phenomena were first observed at close range during NASA's 1971–72 space mission, events that Thomas avidly followed. In *Mars Dust* the luminous cobalt underlayer adds to the shimmering effect of the inch-long red strokes, which the artist created by using an elastic band as her guide. The year she painted this image, Thomas became the first African American woman to be accorded a solo exhibition at the Whitney Museum.

Mars Dust, 1972. Acrylic on canvas, 69¼ x 57⅛ in. (175.9 x 145.1 cm). Purchase with funds from The Hament Corporation 72.58

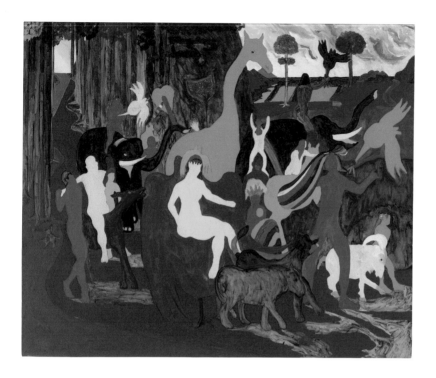

Bob Thompson's painting career was brief but prolific. He began showing his work in 1959 and over the next seven years completed several hundred canvases. During this time he developed a style that combined the imagery of Old Master painting with an explosive chromatic palette. In *Triumph of Bacchus* Thompson borrowed compositional elements from Renaissance depictions of this mythological subject, exchanging the descriptive clarity of the originals for a vividly hued arrangement by alternating passages of flatly applied and loosely brushed color. In modernizing these historical sources, Thompson participated in the jazz idiom practiced by his contemporaries, who based their improvisations on a thorough understanding of preexisting styles. Saxophonist Steve Lacy, a friend of Thompson's, referred to the artist as "jazz himself," explaining that "the way he painted was like jazz—taking liberties with colors."

Thompson also updated the symbolism in his mythological paintings, often using avian imagery to represent various states of the soul. Here a massive winged creature replaces Bacchus's triumphal chariot, and the processioners hold birds in their hands. In the ancient story, Ariadne falls in love with Bacchus only after the duplicitous Theseus abandons her. In this work the birds can be interpreted as embracing Bacchus and the joy of the present while, by tethering birds from flight, Ariadne remains anchored to Theseus and her past. Thompson admired how Renaissance artists could "relate" to and "educate the public." His canvases perform a similar function by merging reverence for these painters with a desire to depict his experience of modern life.

Triumph of Bacchus, 1964. Oil on canvas, 60¼ x 72⅛ in. (153 x 183.2 cm). Purchase with funds from the Painting and Sculpture Committee and The Lauder Foundation, Leonard and Evelyn Lauder Fund 98.19

Rirkrit Tiravanija came to prominence in the 1990s and is closely associated with relational aesthetics, a term used to characterize a generation of artists whose works have highlighted the social context of art and human relationships and given rise to new ways of conceiving art and its relationship to the gallery or museum. The son of a Thai diplomat, Tiravanija studied in Canada and the United States, including at the Whitney Independent Study Program, and has taken the social aspect of art to its logical extreme. His works have involved various actions set in exhibition spaces, such as cooking and serving Thai curry, re-creating a replica of his apartment and leaving it open day and night to visitors, building a pirate broadcasting station, and setting up a professional recording studio for anyone to use.

Untitled 2008–2011 (the map of the land of feeling) I–III is an ambitious project that makes use of a range of printing techniques. Across its three sheets, which together extend some eighty-four feet in length, Tiravanija draws on his personal history, presenting successive images of his passports across the years that document two decades of his international travels, as well as city plans and maps from places he visited. The work charts both time and space, including illustrations of archaeological labyrinths, symbols of movement, and renderings of ships to represent Christopher Columbus and Zheng He, a Chinese admiral who sailed around the world before European explorers. Additional depictions of a urinal and a pot of mussels respectively reference Marcel Duchamp and Marcel Broodthaers, two significant artistic inspirations for Tiravanija.

Detail of *untitled 2008–2011 (the map of the land of feeling) I–III*, 2008–11. Inkjet print, offset lithograph, screenprint, and collage; inkjet print, screenprint, and collage; and inkjet print, screenprint, and collage, three parts: 36 x 334½ in. (91.4 x 849.6 cm) each. Edition no. 10/40. Purchase with funds from the Print Committee 2012.6a–c

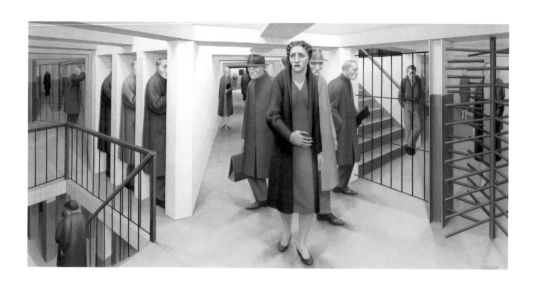

A leader in the Symbolic Realism movement—a group that included his close friends, the painters Paul Cadmus and Jared French—George Tooker is known for works featuring dreamlike imagery, androgynous figures, a sense of suppressed homoeroticism, and examinations of the troubled relationship between society and the self. Tooker's deliberate, intellectual method of art making seldom resulted in more than four paintings a year. His medium was egg tempera, a Renaissance-era material he embraced while he was studying with Reginald Marsh at the Art Students League of New York in the early 1940s. Egg tempera's long drying time allowed Tooker to work slowly, building up fine layers of pigment through which the white of the gesso ground emanates, lending his paintings a distinctive luminosity.

Tooker considered his works from the period in which *The Subway* was created to be "paintings of protest." He was frustrated and saddened by the social injustices and dehumanization of contemporary urban society, and the resulting isolation of the individual. *The Subway*—one of the painter's most vehement statements against the oppression and loneliness of city life—

employs multiple vanishing points and repetition of strong vertical elements to create an imagined world that is at once familiar and uncanny. Instead of looking at each other, the painting's commuters stare watchfully and with dread into the station's sterile, overlit, and claustrophobic corridors and stairwells, which seemingly lead nowhere. The painting gives visual form to Cold War America's existential despair, suspending the city's inhabitants in a modern purgatory.

The Subway, 1950. Tempera on composition board, 18½ x 36½ in. (47 x 92.7 cm). Purchase with funds from the Juliana Force Purchase Award 50.23

Bill Traylor was born into slavery on a plantation in southern Alabama and after the Civil War remained on the farm as a sharecropper until approximately 1928, when he found himself isolated, when, as he explained, the "white folks had died and [his] children scattered." He moved to nearby Montgomery, spending nights sleeping in a funeral parlor and days sitting outside the local pool hall in the city's lively black business district. There, at age eighty-five, he began to sketch on pieces of cardboard, creating more than 1,200 drawings that depict recollections of his Benton years and observations from the streets of Montgomery. The drawings caught the attention of Charles Shannon, a young white artist who furnished Traylor with art supplies and purchased or safeguarded many of the works, giving them descriptive titles.

For Traylor, drawing was a visual form of storytelling. In *Man in Blue House with Rooster* a figure sits on a chair in the doorway of a house with his feet elevated against the doorframe and head tipped back, a cigarette in hand; a rooster stands at the crest of the roof. The composition is unusual for Traylor. The house, with its strong red outline, fills almost two-thirds of the page; more commonly, his scenes appear to float in a dreamlike world. Traylor often depicted scenes of animals interacting with human figures, and the bird is a recurring symbol in his work. His images have been understood variously as political commentaries on race relations in the Jim Crow South, representations of African spiritualism passed along by slaves, visual manifestations of blues music, or more personal narratives.

Man in Blue House with Rooster, 1939–42. Opaque watercolor and graphite pencil on board, 15¾ x 11¾ in. (40 x 29.8 cm). Purchase with funds from the Drawing Committee 95.176

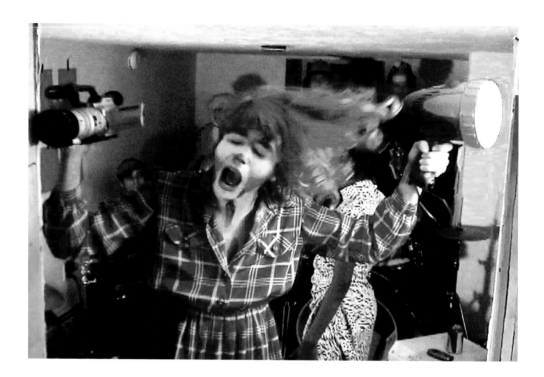

Ryan Trecartin's distinctive video aesthetic absorbs and reconfigures the visual and linguistic clutter of technology, culture, consumerism, psychology, and identity at the beginning of the new millennium. These frenzied, nonlinear narratives are the product of an artist who came of age alongside the Internet; the works' manic pace and fluid structure reflect Trecartin's acute understanding of media and its social machinations.

Trecartin studied film, video, and animation at the Rhode Island School of Design, where he graduated in 2004. His senior thesis project, *A Family Finds Entertainment*, remains one of his most celebrated videos. It features the artist as the lead among a cast of friends and performers—including his longtime collaborator Lizzie Fitch— who move through highly stylized sets, wear eccentric costumes, and recite fragmented declarative lines in a mix of dialects. In the spirit of experimental filmmakers such as Jack Smith and John Waters, Trecartin's sensibility borders on camp. The video begins as a young girl named Lisa defiantly confronts her mother while a seemingly imaginary friend (played by Trecartin) looks on. The narrative quickly diverts from this "real" world into a fantastic inner cosmos, depicted through colorful animations and lo-fi computer editing tricks. In this parallel universe, a character named Skippy journeys alongside others—hybrids of gender and class types—that become his adopted family. Skippy and these androgynous and polysexual personalities work through adolescent social mores that culminate in an orgiastic party ending in fireworks.

Still from *A Family Finds Entertainment*, 2004. Video, color, sound; 41:12 min. Gift of an anonymous donor 2006.110

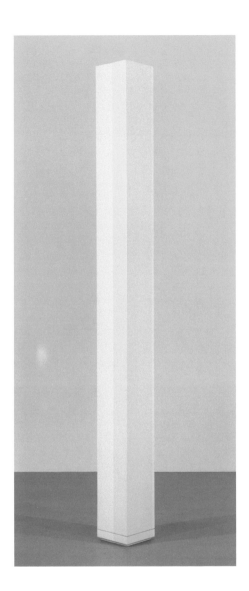

After a period in which she made representational sculpture, in 1961 Anne Truitt broke new ground with a simple painted wood structure resembling a fence picket. That work, appropriately titled *First*, and the boxlike sculptures that immediately followed were often associated with grave markers. By the late 1960s Truitt had established the parameters that would characterize most of her sculptural work for the next four decades: narrow, vertical shapes painted with bands and stripes of color. Her palette was diverse, and the harmonies and contrasts between these color variants led to the association of her stele-like sculptures— often otherwise classed as Minimalist— with the Color Field painters of the previous generation. Truitt, however, eschewed connections with either abstract movement, often giving her sculptures evocative titles and relating them to funerary sculpture, the human body, and questions of the individual's place in the universe. Indeed, she declared: "I have never allowed myself . . . to be called a minimalist. Because minimal art is characterized by nonreferentiality. I've struggled all my life to get maximum meaning in the simplest possible form."

For *Triad* Truitt covered a prefabricated wood structure with layers and layers of paint, laboriously sanding between each application to achieve a polished finish that nearly obliterates the trace of brushstrokes altogether. The title for this slender column, *Triad*, may describe the sculpture's three distinct planes of color: vertical stripes of beige and peach, and a thin horizontal orange band that draws the eye downward, anchoring the sculpture much like the bass note in a harmonic musical triad.

Triad, 1977. Acrylic on wood, 90⅝ x 8 x 8 in. (230.2 x 20.3 x 20.3 cm). Gift of Ann and Gilbert Kinney 2006.33

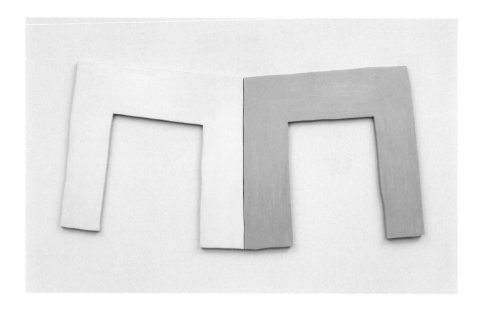

Richard Tuttle's first solo exhibition, at the prestigious Betty Parsons Gallery in 1965, consisted of painted constructions such as *Drift III*, a conjoined pair of plywood forms whose wobbly contours attest to the inexact hand-drawn lines of their paper templates. The work hovers between image and object, organic and geometric, and seems to be adrift on the wall, the pale green and mauve units weightlessly lingering like grace notes. Although Tuttle usually avoids identifying the sources for his work, he has explained that the *Drift* series reminds him of the colored cloud formations he observed while briefly serving in the United States Air Force. The title evokes not the clouds themselves but their wandering movements as they respond to natural forces.

Tuttle's ten-year survey exhibition at the Whitney in 1975 garnered a host of negative reviews from the conservative art establishment, whose vituperation focused on the works' minuteness and offhanded presentation; one critic complained that after seeing the exhibition he was compelled to examine the hairline cracks in the gallery wall. But Tuttle's art is driven by such dramas as hairline cracks, creases in fabric, or a wavering graphite trace precisely because they sensitize the viewer's eye.

Since then Tuttle has gained a reputation as an artist of poetry and quietude, even of disappearance, because his work is slight in scale if not always small in size, and made from humble, ephemeral materials such as rope, cardboard, twigs, and florist's wire. The artist has said that he considers the installation of delicate objects like *Drift III*, which often lie in the middle of the gallery floor or hang awkwardly high or low on the wall, to be "the other half of the work."

Drift III, 1965. Painted wood, 26 ¼ x 53 ⅛ x 1 ¼ in. (66.7 x 134.9 x 3.2 cm). Purchase with funds from Mr. and Mrs. William A. Marsteller and the Painting and Sculpture Committee 83.18a–b

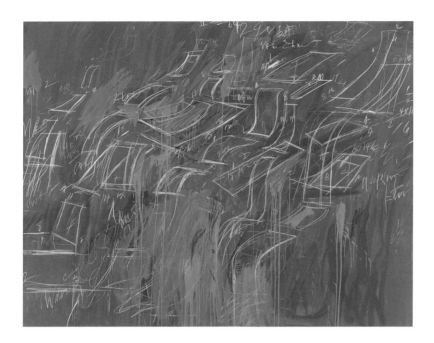

When Cy Twombly began painting in the early 1950s, he shared with Abstract Expressionists a commitment to nonrepresentational subjects and allover compositions that filled large-scale canvases. Yet instead of using the broad, gestural brushstrokes common to the then-dominant style, Twombly covered his surfaces with quick lines and graffiti-like marks reminiscent of handwriting. Beginning in 1957 he made Rome his primary home, with frequent trips back to the United States, and created drawings, collages, and sculptures that merge cultural references—Greek and Roman mythology, ancient ruins of the Mediterranean, or Western literature— with his idiosyncratic approach to mark making and construction throughout the next five decades. As he once explained, "Generally speaking my art has evolved out of the interest in symbols abstracted . . . and a deeply aesthetic sense of eroded or ancient surfaces of time."

In 1966 Twombly began a cycle of paintings and drawings with gray grounds onto which he made repetitive markings in white crayon—abstracted, lyrical, sometimes frenetic scrawls and marginalia. Often described as his "blackboard paintings" because of their resemblance to chalked lessons that have been partially erased, this format dominated his output until the early 1970s. In *Untitled* overlapping outlines of rectangles, rendered in loose perspective, flow diagonally from the top right to the bottom left of the large canvas, as if cascading down a waterfall. Letters, numerals and fractions punctuate the palimpsest-like surface, and the words *water chart* can barely be discerned at the top right. Yet Twomby's canvases defy easy interpretation or impersonation. As the French theorist and critic Roland Barthes wrote, Twomby's line "is inimitable. (If you try to imitate it what you do will be neither his nor yours.)"

Untitled, 1968. Oil and crayon on canvas, 79 x 103⅜ in. (200.7 x 262.6 cm). Purchase with funds from Mr. and Mrs. Rudolph B. Schulhof 69.29

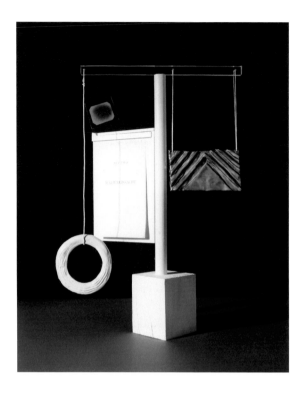

Since the mid-2000s, Sara VanDerBeek has been testing the relationship between photography and sculpture by creating physical arrangements to be captured by the camera. Incorporating into her compositions printed matter and small items suspended by string, and more recently classical sculpture and architectural elements, VanDerBeek examines the fugitive nature of memory and its evocation through objects and their settings. Her use of repeating geometric forms alludes to the sculpture of Constantin Brancusi and makes reference to the legacy of modernism. She challenged the notion of a linear progression of artistic exploration in photographs she made in Detroit and New Orleans, two cities in which past glories and present failures stand in stark relief. Speaking of the architectural elements she examined in New Orleans's Lower Ninth Ward, VanDerBeek has said, "I felt when looking down upon them for the first time that these foundations retained in their surfaces the entire history of our civilization."

Walpurgisnacht depicts objects suspended from an armature of wood and plexiglass. Featuring geometric forms such as a roughly painted torus and a rectangular solid with chevrons, the photograph also incorporates a book page that serves as a counterpoint point to the rest of the arrangement. The page presents the title of act two of Edward Albee's *Who's Afraid of Virginia Woolf?*. Dramatically lit from the left, the overall composition juxtaposes ideal forms with the insinuation of unbridled menace. This is reinforced by the allusion to Albee's play in which the characters turn on each other with particular malevolence in the second act.

Walpurgisnacht, 2007.
Chromogenic print, 19½ x
15½ in. (49.5 x 39.4 cm).
Edition no. 2/3, 2 AP. Purchase
with funds from Joanne
Leonhardt Casullo 2007.138

A pioneer of video art, Bill Viola is known for his technical and artistic mastery of the medium and for a body of work that traverses the visual language of painting, electronic art, and cinema. While studying painting and music at Syracuse University in the late 1960s and early 1970s, Viola discovered video and experimented in his early work with its unique properties. In time he would move from single-channel videotapes to explorations of large-scale projected imagery and immersive soundscapes in groundbreaking gallery-based installations that helped to redefine video as an art form.

Throughout his career, Viola has embraced aspects of spirituality, from Zen Buddhism to Sufi mysticism. By manipulating the experience of time in his videos, he often evokes a state of transcendence or altered consciousness. Each of the five projected images in the operatic *Five Angels for the Millennium*—titled "Departing Angel," "Birth Angel," "Fire Angel," "Ascending Angel," and "Creation Angel"—depicts an aquatic scene with a figure emerging from or descending into the water. As Viola has explained: "The human figure arrives intermittently as a powerful explosion of light and sound that interrupts an otherwise peaceful, nocturnal underwater landscape. Because the sequences run in slow motion, and are further altered by running backwards and forwards or right-side-up and upside-down, the image is read in unexpected ways, and the disorientation becomes an essential aspect of the work's theme." The sensorial effect is overwhelming as Viola invites the viewer to consider how art might produce a ritualistic, sacred, or symbolic experience.

"Departing Angel" from *Five Angels for the Millennium*, 2001. Five-channel video installation, color, sound; 94½ x 126 in. (240 x 320 cm) each projection. Edition no. 2/3. Purchased jointly by the Whitney Museum of American Art, New York, with funds from Leonard A. Lauder; Tate, London, with funds from Lynn Forester de Rothschild; and the Centre Pompidou, Paris, with funds from Lily Safra 2004.27

Since rising to prominence in the mid-1990s, Kara Walker has used silhouette cutouts as a signature element in her large-scale tableaux and projections. Yet her appropriation of this popular nineteenth-century portrait technique diverges starkly from its genteel roots. Drawing on sources that include American slave narratives, the literature of the antebellum South, and minstrel shows, her works examine racist and sexist stereotypes as well as issues of identity, narrative representation, violence, and desire. Walker has likened placing the viewer in the center of these historical retellings to "creating a monster that swallows you."

In *Mistress Demanded Swift and Dramatic Empathetic Reaction Which We Obliged Her*, paper cutouts and colored gels are cast from an overhead projector onto the wall of a dark room. The images call to mind historical attractions such as shadow puppetry and silent-era animation techniques pioneered by German artist Lotte Reiniger. Instead of fairy tales, however, Walker's projection reveals a gruesome scene in which a small African American girl plunges a machete into the abdomen of a bound "mistress." An onlooker's head is trapped in a grotesque metal contraption, and his hands and feet are in shackles. Although the scene seemingly represents a slave rebellion or escape, nothing in it suggests redemption. Rather, Walker's hard-hitting depictions aim to confront us with imagery that, as she has put it, undermines "all our fine-tuned, well-adjusted cultural beliefs."

Each of the fifteen prints in her portfolio *Harper's Pictorial History of the*

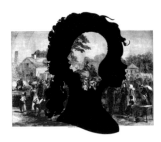

Civil War (Annotated), features a lithographic enlargement of an illustration from a popular history book published by *Harper's Weekly* in 1866 that Walker has "annotated" with screenprinted silhouettes. The placement and contours of the silhouettes often highlight particular elements of the original imagery. *Exodus of Confederates from Atlanta* features a silhouette outline within a silhouette that calls attention to an African American boy piling up belongings for white civilian evacuees. In *Alabama Loyalists Greeting the Federal Gun-Boats*, an oversized silhouette of a woman becomes part of the action; she appears to have been knocked down by Union supporters rushing to greet the northern warships. Although Walker's interventions obscure much of the detail in the source imagery, they foreground an African American presence that had been minimized or ignored in the originals, underscoring an ongoing bias in popular media representations of newsworthy events. As she has explained, "as long as there are people saying 'Hey, you don't belong here' to others, it only seems realistic to continue investigating the terrain of racism."

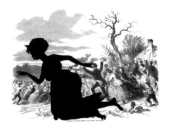

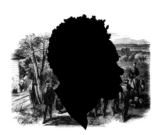

Mistress Demanded Swift and Dramatic Empathetic Reaction Which We Obliged Her, 2000. Cut paper and projection on wall, 144 x 204 x 300 in. (365.8 x 518.2 x 762 cm) overall. Purchase with funds from the Contemporary Painting and Sculpture Committee 2001.228

Exodus of Confederates From Atlanta, *Alabama Loyalists Greeting the Federal Gun-Boats*, and *Confederate Prisoners Being Conducted from Jonesborough to Atlanta*, from the portfolio *Harper's Pictorial History of the Civil War (Annotated)*, 2005. Photolithograph and screenprint: sheet, 39 x 53 in. (99.1 x 134.6 cm) each; image, dimensions variable. Edition 2/35. Purchase with funds from the Print Committee 2005.91.4, 2005.91.9, and 2005.91.11

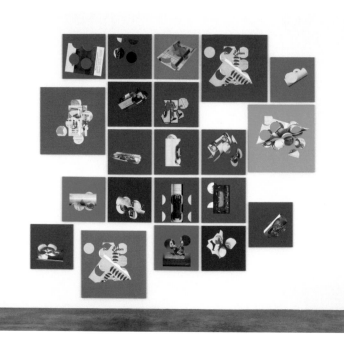

Kelley Walker mines the legacy of appropriation, from the work of Pop artists to that of the Pictures Generation, by utilizing photographs that have appeared in the press, in advertising, and in his own works or those of other artists, to highlight the ways images are transformed through circulation and dissemination. He frequently employs diverse tools and methods to create his works—including scanners, Photoshop, and silkscreen techniques, as well as applications of nontraditional materials such as toothpaste and chocolate.

For *Untitled*, Walker lifted advertising campaigns for the Volkswagen Beetle produced in the 1950s and 1960s, perforated them, and then used Rhino, a three-dimensional modeling program, to torque, twist, fold, and otherwise manipulate the layouts. The technology, as he has explained it, adopts biological nuances: "The forms are generated by cross breeding Photoshop/Mac with PC; Volkswagen Bug with Rhino program, creating a hybrid language. This generates architecturally 3-D spatial configurations where image becomes skin and the Rhino program becomes the nerves."

The resulting forms are then silkscreened, using hand pressure, onto painted medium-density fiberboard panels, which he has arranged in a precise configuration. Walker's reinvention of the found imagery through processes of appropriation, digital manipulation, and manual printing parallels the efforts of the irreverent and transformative American ad campaign itself, which made the Volkswagen Beetle, produced by a German company previously associated with the Nazi Party, into a postwar icon of American cool. According to Walker, "The work encompasses over a hundred years of compressed history."

Untitled, 2013. Screenprint with acrylic ink on medium-density fiberboard, twenty-one parts: 94 x 104 in. (238.8 x 264.2 cm) overall. Purchase with funds from the Painting and Sculpture Committee 2014.152a–u

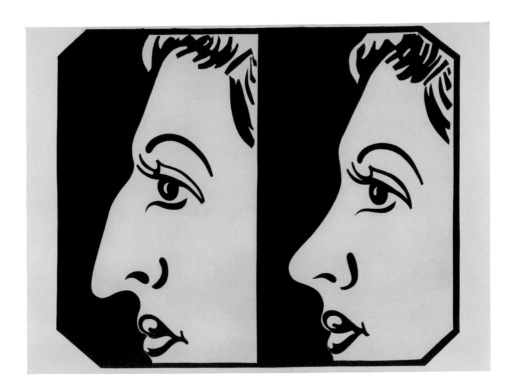

Before and After, 4, 1962.
Acrylic and graphite pencil
on linen, 72⅛ x 99¾ in.
(183.2 x 253.4 cm). Purchase
with funds from Charles
Simon 71.226

More than any other artist of his generation, Andy Warhol understood how photographic images reflect and shape the way we see the world. Working across multiple mediums—painting, drawing, printmaking, photography, film, video, and installation—he pushed beyond the boundaries by which each is defined, his art and name becoming synonymous with Pop. But his influence extended far beyond the 1960s: indeed, Warhol's work foreshadows the ease and ubiquity with which we create and consume images in the digital era.

Born Andrew Warhola and raised in Pittsburgh, Warhol attended the Carnegie Institute of Technology and received his BFA in 1949. That same year he moved to New York, where he became a highly successful commercial illustrator, drawing advertisements for shoes and designing window displays for department stores. In the early 1960s he decided to concentrate on making fine art. Appropriating an image

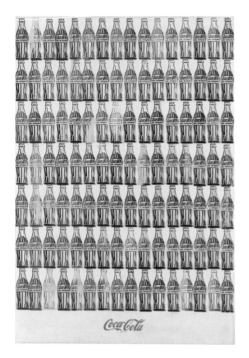

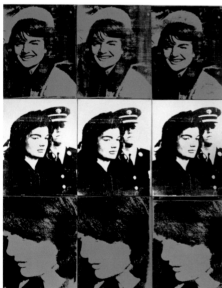

from a *National Enquirer* ad for plastic surgery (Warhol previously had plastic surgery on his own nose), he made four different paintings titled *Before and After*. Although he painted these works by hand, Warhol used an opaque projector to enlarge the ad and trace it onto the canvas—one of the techniques he employed as a commercial illustrator. Unlike his Abstract Expressionist forebears, Warhol wanted to achieve an art that could be "noncommittal, anonymous," and so he progressively eliminated evidence of the brush in each variation of the subject until all visible traces of the artist's hand were removed from *Before and After, 4*. From the start, Warhol selected images that were familiar but could be interpreted in multiple ways. For instance, *Before and After, 4* references the transformational powers of plastic surgery as well as the assimilating desire to conform to expected notions of beauty.

Green Coca-Cola Bottles signals Warhol's shift toward the processes of mechanical reproduction. Here he created a single woodblock stamp to imprint a grid of 112 signature silhouettes of Coca-Cola bottles, but within a year he would shift to the more efficient silkscreen technique for which he became famous. The rows in this painting might suggest an assembly line as well as a grocery store shelf, or anticipate the linear and modular configurations of

Green Coca-Cola Bottles, 1962. Acrylic, screenprint, and graphite pencil on canvas, 82¾ x 57⅛ in. (210.2 x 145.1 cm). Purchase with funds from the Friends of the Whitney Museum of American Art 68.25

Nine Jackies, 1964. Acrylic, oil, and screenprint on linen, 60⅜ x 48¼ in. (153.4 x 122.6 cm). Gift of The American Contemporary Art Foundation Inc., Leonard A. Lauder, President 2002.273

Birmingham Race Riot, from the portfolio *Ten Works by Ten Painters*, 1964. Screenprint, 20 x 24 in. (50.8 x 61 cm). Edition no. 102/500. Transfer from the Frances Mulhall Achilles Library, Special Collections, Whitney Museum of American Art 96.53.5

Rorschach, 1984. Acrylic on linen, 164⅛ x 115⅛ in. (416.9 x 292.4 cm). Purchase with funds from the Contemporary Painting and Sculpture Committee, the John I. H. Baur Purchase Fund, the Wilfred P. and Rose J. Cohen Purchase Fund, Mrs. Melva Bucksbaum, and Linda and Harry Macklowe 96.279

imagery of silkscreened paintings Warhol made on this and similar subjects, this screenprint features a single image that he cropped to maximize its dramatic effect.

Warhol also created his own photographs—employing Polaroid cameras as well as strips of cheap black-and-white photo-booth images—to use as source material for his paintings. His sitters included celebrities, socialites, and artists, as well as habitués of the Factory, his New York studio.

By the late 1970s Warhol began experimenting with abstraction, in what was seen by many as a puzzling move by an artist famous for his representational imagery. *Rorschach* was made by painting onto one vertical half of the canvas, then folding and imprinting it onto the other half (a blotting technique he had evolved years earlier as a college student). In its reference to the Rorschach test, which analyzes a subject's perceptions of an inkblot, the painting is a potent reminder of Warhol's understanding of the mutability of the visual image and of art itself.

Minimalism. This serial arrangement of the bottles, in combination with the conspicuous placement of the logo, underscores Warhol's summation of the democratizing effect of such products: "A Coke is a Coke," he explained, "and no amount of money can get you a better Coke than the one the bum on the corner is drinking."

Warhol selected subjects that had an immediacy and relevance to contemporary culture for his silkscreen paintings, often using images culled from the news. The nine blue and gray canvases of *Nine Jackies* feature three different photographs of Jacqueline Kennedy from events surrounding the assassination of her husband, President John F. Kennedy. Arranged in rows, the first image was taken in Dallas just prior to the assassination; the second during his funeral; and the third as Lyndon B. Johnson was being sworn in as president on Air Force One. The filmic nature of the arrangement emphasizes the stillness of the images; frozen in time and presented out of temporal sequence, they impart a sense of the public's grief and confusion. It is a history painting in which the story has gone horribly wrong.

Birmingham Race Riot was similarly based on photographic imagery, here specifically from a 1963 *LIFE* magazine spread showing peaceful civil rights protesters being attacked by police with dogs and water hoses. Unlike the repeated

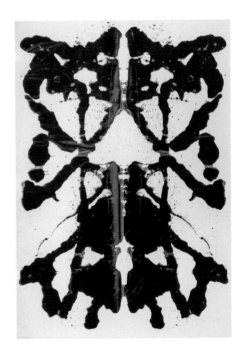

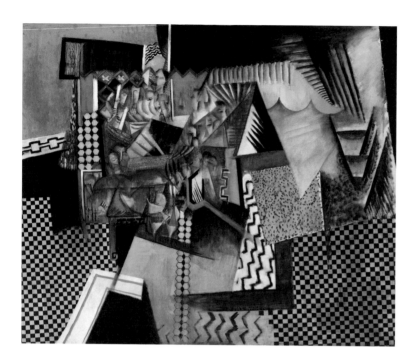

For Max Weber, who came to the United States as a young boy from Bialystok (part of the former Russian Empire), the collision of different cultures was the defining feature of modern American life. *Chinese Restaurant*, one of Weber's most important works, focuses on this theme, fusing together influences from vanguard modernism, folk art, and everyday life. During time spent in Paris from 1905 to 1908, where he was acquainted with Pablo Picasso, Henri Rousseau, and other important figures, Weber became deeply immersed in modern European artistic developments, well before their transport across the Atlantic. Indeed, he became one of the key figures to introduce Cubism to America, through his art as well as his involvement in the avant-garde circle surrounding New York photographer and gallerist Alfred Stieglitz.

In *Chinese Restaurant* Weber combines the fractured forms of Cubism, geometric motifs drawn from Russian and Native American folk traditions, and first-hand observation to create a kaleidoscopic, abstracted impression of a Chinese restaurant in New York. The rhythmic interplay of overlapping forms evokes the restaurant's hustle-bustle energy, while the patterned planar sections conjure details that were hallmarks of these elaborately ornamented establishments—a checkered floor, a scrolled table leg, and the red-black-and-gold color scheme. Amid these elements are forms suggesting hurried waiters and seated customers—"flickers here and there in fitting place of a hand, an eye, or drooping head," in Weber's words. Through the inventive stylistic synthesis he used to portray this distinctly modern subject, Weber captured the dynamism and diversity of urban America in the early twentieth century.

Chinese Restaurant, 1915.
Oil, charcoal, and collaged
paper on linen, 40 x
48⅛ in. (101.6 x 122.2 cm).
Purchase 31.382

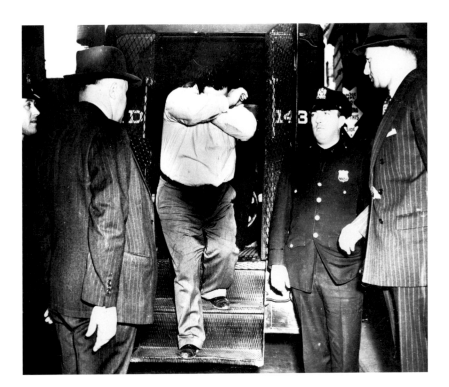

Arthur Fellig, the photojournalist who went by the name Weegee, elevated tabloid news photography to an art form. Working as a freelance news photographer in New York from 1935 to 1947, he revealed the dark underbelly of the city— violent crime scenes, arrests, fires, and other urban mayhem. Although the primary intention of Weegee's work was documentary, his photographs betray an aesthetic consideration and psychological content that transcend the reportorial.

Weegee unflinchingly captured the events and individuals involved, but also included the raw reactions of people at the perimeter of the scene, including officials, relatives of the subjects, and bystanders. In addition to appearing regularly in New York daily newspapers and in syndication throughout the country, Weegee's "film noir" portrayals of New York life and its menagerie of disparate city dwellers were published in two popular books in this period: *Naked City* (1945) and *Weegee's People* (1946).

Member of Murder Inc. Got the Chair displays many classic elements of Weegee's brash style. The flashbulb's sudden white glare catches the intense moment when an accused murderer descends from a police wagon and hides his face, while the placid expressions on nearby officials strangely contrast with the gruesome and sensational scope of the story. The "Murder Inc." of the title references the name given by the press to the notorious Brooklyn-based ring of hit men that operated within organized crime. The group was eventually disbanded as many of its members, like the gangster in this news shot, were sentenced to the electric chair.

*Member of Murder Inc.
Got the Chair*, 1937. Gelatin silver print, 6 7/8 x 8 3/8 in. (17.5 x 21.3 cm). Gift of Denise Rich 96.90.7

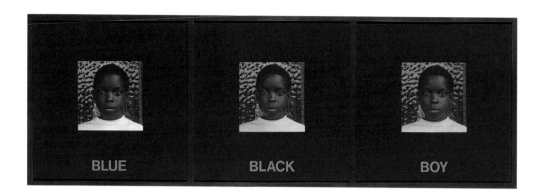

Over the course of more than thirty years, artist Carrie Mae Weems has produced a provocative body of work that addresses complex legacies of race, gender, and class in the United States. She often combines text with images in her projects, a process that allows her to catalogue and interpret her own experiences as well as those of others. By blending documentary, autobiography, and storytelling techniques, Weems conveys what she has called "real facts, by real people."

Blue Black Boy features three identical photographs of an African American child which were shot in black-and-white film and then printed and hand-dyed a deep blue. The young sitter faces the viewer directly, almost as if in the style of a mug shot, and beneath the successive repetitions of his visage Weems has printed the words *BLUE*, *BLACK*, and *BOY* to signal the tint of the photographs, the darkness of his skin, and his gender, even as they open onto other meanings. This triptych is part of the larger photographic series *Colored People*, from 1987–90. Other works in the series, such as *Golden Yella Girl,* and *Red Bone Boy,* are toned with corresponding colored dyes. Reclaiming the term *colored people*, the artist celebrates the rich variety of skin color that is encompassed by the simplistic term *black*, while also critiquing the values ascribed within the African American community to pigmentation variances. Weem's process of "coloring"

the prints also underscores the artificiality of such visual distinctions among people. Weems has explained that in *Colored People*, as well as in other works, she has aimed to "intertwine themes" of identity and history, and to represent them with "overtones of humor and sadness, loss and redemption."

Blue Black Boy, 1987–90, from the series *Colored People*, 1987–90. Three toned gelatin silver prints with transfer type and frame, 16⅞ x 49½ in. (42.9 x 125.7 cm) overall. AP, edition unknown. Purchase with funds from the Photography Committee 2001.257a–d

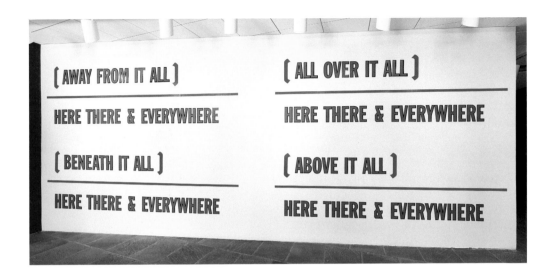

Lawrence Weiner played a key role in the development of Conceptual art, a movement that emphasized the idea of an artwork over its material form and questioned the structures through which art is created, presented, and distributed. His earliest artistic undertakings were sculptural, and in the mid-1960s he exhibited a series of propeller-shaped canvases at Seth Siegelaub Contemporary Art. From 1968 on, however, language has been the primary component, and his text-based works, which often describe procedures, propositions, or actions, have embraced a wide range of formats: paintings, sculptures, films, videos, records, compact discs, posters, books, wall installations, and even a website. Varied in form and context, these works are connected in their supposition that the majority of our experiences— even the activity of seeing—are mediated by language.

HERE THERE & EVERYWHERE is presented as a chorus and refrain: parenthetical statements pertaining to direction (such as BENEATH IT ALL and ABOVE IT ALL) are each followed by the general declaration HERE THERE & EVERYWHERE (a ready descriptor of where one might encounter Weiner's work). Following from his belief that viewers are integral to the creation of any given work's meaning—and indeed to its very status as art—Weiner does not need to do the lettering himself, and allows the work to be installed in a variety of configurations and color palettes at the discretion of a curator. The Whitney has installed this work in various ways: on a single wall, on the glass window at the front of the Museum's former uptown home, and placed on the four panes of a revolving door.

HERE THERE & EVERYWHERE, 1989. Language + the materials referred to, dimensions variable. Purchase with funds from the Contemporary Painting and Sculpture Committee 94.136. Installation view: Whitney Museum, 2011

Trained in conceptual and video art at the California Institute of the Arts, James Welling taught himself photography on a second-hand camera and photographic processing before moving to New York in 1978. There, in 1980, he began to produce photographs of crumpled pieces of aluminum foil, torn from a large roll borrowed from the restaurant at which he worked, sometimes painting the surface of the foil in black and emphasizing the shadows through dramatic lighting. He developed the photographs as very dark contact prints, the same size as the negative from his four-by-five-inch view camera, in order to draw a direct link between object and image. The result is what Welling has termed "obscure looking pictures," characterized by a densely textured field of light and shadow: three dimensions depicted in two.

Although Welling terms these works "abstract photographs," he acknowledges that "a photograph can never really be abstract because it's always of something." The works seem nonrepresentational and give no clue as to orientation, yet evocative titles such as *The Wayfarer 1980* point to the pictures' potential to carry meaning or narrative, and Welling has described them as "glittering, emotional landscapes of an unknown dimension." The aluminum foil works thus explore both the material and conceptual properties of photography itself, highlighting the way in which it allows meaning to be created in the mind of the viewer.

The Wayfarer 1980,
1980. Gelatin silver print,
3¾ x 4¾ in. (9.5 x 12.1 cm).
Purchase with funds
from the Photography
Committee 96.29

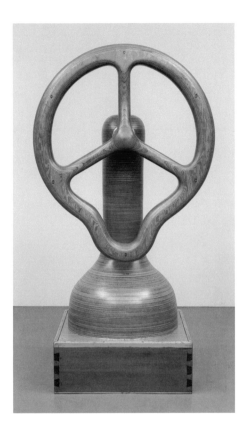

H. C. Westermann's singular body of work draws on a range of cultural and personal signifiers—including military insignias, nautical motifs, comic books, folk art, and literature—to portray a critical and darkly humorous vision of mid-twentieth-century America. His energetic drawings and masterfully crafted sculptures incorporate formal aspects of Surrealism, Expressionism, Pop art, New Imagism, and Funk sensibilities, yet they refuse any such easy classification.

In 1942 Westermann enlisted in the Marine Corps, serving as an anti-aircraft gunner on the USS *Enterprise*. After the war, he briefly traveled with the USO as an acrobat before enrolling through the GI Bill in the School of the Art Institute of Chicago. Just three years into his studies, in 1950, he enlisted again as an infantryman in the Korean War, a second tour of duty that would have a profound effect on the artist; his subsequent work is characterized by an existential rumination brought about by the trauma of war and the contradictions of postwar society.

Antimobile embodies the sense of futility Westermann found in America's so-called industrial progress. The seamless craftsmanship of the work, its finish, and the clever engineering of its functional axle mechanism are in conflict with the incongruous form of the wheel itself, detached from any vessel and seemingly warped or melting. As Westermann explained, "Everything is on wheels nowadays . . . a hundred million cars . . . and everything turns and it's all a bunch of junk. . . . I wanted to make something that was just completely anti-wheel, anti-mobile."

Antimobile, 1966. Laminated plywood, 67⅜ x 36⅜ x 27⅝ in. (171.1 x 92.4 x 70.2 cm). Purchase with funds from the Howard and Jean Lipman Foundation Inc. and exchange 69.4a–b

Edward Weston

b. 1886; Highland Park, IL
d. 1958; Carmel, CA

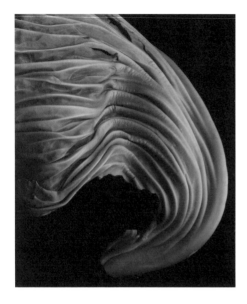

Cabbage Leaf, 1931. Gelatin silver print, 9¼ x 7½ in. (23.5 x 19.1 cm). Edition no. 3/50. Promised gift of Sondra Gilman Gonzalez-Falla and Celso Gonzalez-Falla to the Whitney Museum of American Art, New York, and the Gilman and Gonzalez-Falla Arts Foundation P.2014.113

An innovator who created some of the most enduring photographic images of the twentieth century, Edward Weston was a leader in transitioning art photography from soft-focused Pictorialism to a sharp-focused modernism. In 1932, to distinguish their unique brand of "straight photography" from that of their contemporaries, he and his circle of San Francisco Bay Area photographers—including, among others, Imogen Cunningham—formed Group f.64, named for their preferred camera setting, which places foreground and background in focus simultaneously.

Capturing images of nudes and the sand dunes at Oceano, California, as well as the rocky terrain around Point Lobos near his Carmel residence with this characteristic resolution of detail and depth of field, Weston became identified most closely with the American West, whose landscapes he documented on travels he made throughout the region. "The camera," Weston once noted, "should be used for a recording of life, for rendering the very substance and quintessence of the thing itself, whether it be polished steel or palpitating flesh."

Weston's 1929–33 close-ups of vegetables isolated against black backgrounds are among his most well-known photographs. Without any guide to scale or contextual clues, the subject of his quintessential image *Cabbage Leaf* can be interpreted as ripples of sand or draped fabric. Likewise, his nudes, sand dunes, sweeping landscapes, and coastal scenes, with their classic forms, abstract shapes, and underlying sensuality, illuminate ambiguities and point to the interchangeability of subject matter, whereby vegetables can be read as animals or minerals. Lush detail, dynamic contrasts of light and shadow, and exquisite compositions shot directly from life are Weston's signature elements, which also set the standards for the genre.

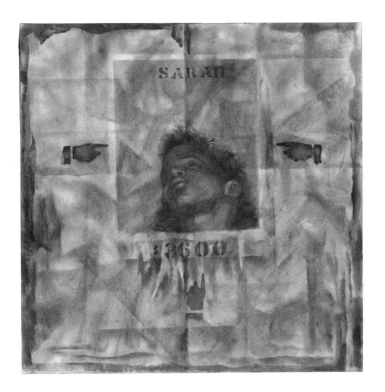

Charles White's paintings, drawings, and prints are characterized by an unwavering dedication to representing the history and experience of African Americans. Among his best-known works is a mural commission he created in Chicago in 1939–40 for the Works Progress Administration. He remained committed to a social realist style of figurative painting into the postwar era, when abstraction dominated the mainstream art world. White's socially conscious portraits portray both celebrated civil rights activists, such as Harriet Tubman and Frederick Douglass, and archetypal everyday community figures, including mothers and laborers, as venerable, valiant subjects.

White began his *Wanted Poster Series* in the late 1960s, after coming across reproductions of pre–Civil War posters that advertised slave auctions or economic rewards for the return of runaway slaves, thereby assigning a specific monetary value to their lives. Against an abstract, sepia-toned background recalling creased and timeworn parchment, *Wanted Poster Series #4* presents a cropped image of a contemporary girl; the letters stenciled near the top of her picture identify her as "Sarah," while the sum printed below it, "$3600," indifferently assesses her worth as if she were a slave. As White explained: "During the past decade the black people of this country have waged a heroic militant struggle for their fundamental rights. As a result they have on numerous occasions been jailed or in some instances become fugitives. I see many parallels between the period of slavery and now. Thus in a series of works, still continuing, I made this point."

Wanted Poster Series #4,
1969. Oil on paper, 29⅜ x
29¼ in. (74.6 x 74.3 cm).
Purchase with funds from
The Hament Corporation 70.41

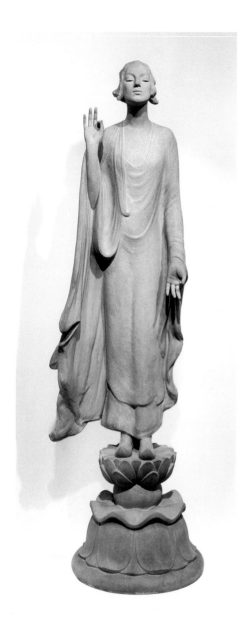

As a daughter of Cornelius Vanderbilt II, the richest man in the United States at the turn of the century, Gertrude Vanderbilt Whitney was born into tremendous wealth and privilege. She defied social expectations, however, by becoming a sculptor and the foremost patron of American art in the early twentieth century—activities that ultimately would lead her to found the Whitney Museum. Not long after marrying Harry Payne Whitney, scion of one of New York's wealthiest families, she embarked on art studies and later rented a studio in New York's Greenwich Village, far from uptown society, to begin working as a sculptor. Whitney received several major public commissions during her lifetime, including a memorial to the *Titanic* victims in Washington, DC; a World War I memorial in Brittany, France; and a monument to William F. "Buffalo Bill" Cody in Cody, Wyoming.

Chinoise, one of her early successes, is a more intimate and personal work. As an antidote to the highly prescribed confines of her life as a socialite, Whitney loved to dress up in elaborate and fanciful costumes by designers such as Léon Bakst. In *Chinoise* she commemorates this pastime, depicting herself in a flowing Asian-style robe, her gaze serene as she stands atop a lotus blossom. This whimsical self-portrait was displayed prominently in the Whitney Museum after it opened to the public in 1931. Over time, the sculpture became a kind of personal emblem—indeed, so closely associated with her that Florine Stettheimer included it in her iconic 1942 painting *The Cathedrals of Art* as a ghostly symbol of Whitney, who died the same year.

Chinoise, 1914. Limestone,
61 x 20¼ x 17 in. (154.9 x
51.4 x 43.2 cm). Gift of the
artist 31.79

Shortly after graduating from Cooper Union in 1964, Jack Whitten met Willem de Kooning, Franz Kline, and other lions of Abstract Expressionism. Galvanized, like many of his contemporaries, by that idiom, he produced gestural, expressive paintings in the 1960s that were often inspired by the tumultuous sociopolitical events of the decade. Whitten's work became more abstract and process-based in the 1970s: he began manipulating layers of wet paint on canvas with implements that included Afro combs, carpenters' saws, rakes, and squeegees (including one specially devised squeegee that was twelve feet long). The artist explained that his technique was "a physical way of getting light into the painted surface without relying on the mixture of color."

Beta Group Number One, from this period, is a field of black and white, mostly regular, finely ridged lines. However, incident and accident rupture the geometric uniformity: lines veer off in diagonal directions; certain strands are thicker than others; lighter blotches reveal areas where paint is distributed more thinly. Whitten here imparts the action painters' esteem for chance to the rigor of contemporaneous geometric abstraction and even Minimalism, achieving a composition that, despite its reductive palette, seems to pulsate with energy. While emphatically palpable, this painting also evokes other, less immediately material mediums—from black-and-white photography to scratchy film leader to television static. Such experimentation with surface effect grew bolder in the 1980s, and by the 1990s Whitten was incorporating bits of hardened acrylic into his canvases, using them like mosaics. His works, which also include drawings and collages, often pay tribute to deceased family members and friends and memorialize traumatic events.

Beta Group Number One, 1975. Acrylic on canvas, 40⅜ x 68¼ in. (102.6 x 173.4 cm). Gift of Flora Miller Biddle 94.27

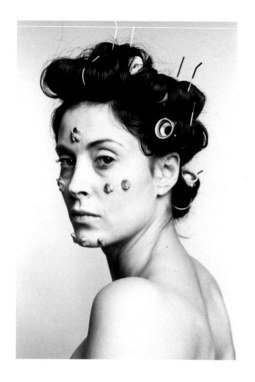

"I have been concerned with the creation of a formal imagery that is specifically female," wrote Hannah Wilke in 1976, describing "a new language that fuses mind and body into erotic objects that are nameable and at the same time quite abstract." Wilke—an innovative artist who worked in sculpture, photography, drawing, performance, installation, and other mediums—is perhaps best known for her *S.O.S. Starification Object Series,* from 1974. The photographs, taken by Les Wollam in Wilke's studio, depict the artist topless in various guises, her face and torso adorned with pieces of chewing gum sculpted into labial forms.

With Wilke posed sensuously, looking at the camera over her shoulder, *S.O.S. Starification Object Series* (Curlers), one image from the series, could be mistaken for a women's beauty advertisement; however, the seductive nature of the image is negated by the unseemly "stars" stuck to her forehead, cheeks, and chin. The title of the series refers to both the Morse code distress signal and to the starring role in which the artist places herself as the object of the camera's focus. It is also a word play, a pun on *scarification*, referring to ancient tribal rituals and the complicated relationship between pain, disfiguration, and contemporary notions of female beauty and power. Wilke's work gained attention amid the feminist movement of the 1970s, yet it also became the target of feminist disdain. Her highly erotic self-portraits were seen by some as reinforcing the very objectification of women that she set out to challenge. In response to the criticisms, Wilke created a poster featuring a photograph from the *S.O.S.* series framed by the text "Marxism and Art: Beware of Fascist Feminism," which she hung throughout SoHo in New York on the opening night of a solo show of her work in 1977.

S.O.S. Starification Object Series (Curlers), 1974. Gelatin silver print, 40 x 27 in. (101.6 x 68.6 cm). Purchase with funds from the Photography Committee and partial gift of Marsie, Emanuelle, Damon, and Andrew Scharlatt 2005.33

Rooted within the technical precision with which Christopher Williams constructs his photographs is a conceptual practice that investigates the medium of color photography itself and the role that it plays in creating social and cultural meaning. *Kodak Three Point Reflection Guide © 1968 Eastman Kodak Company, 1968 (Meiko Laughing), Vancouver, B.C., April 6, 2005* is part of a series that belongs to a vast photographic project titled *Die Welt ist schön* (The world is beautiful) that Williams embarked upon in the late 1980s and that included several other series also devoted to specific brands of film, such as Kodak, Fuji, and AGFA. Although not a stock commercial photograph, this image has been carefully staged to appear like one: the cheerful model is set against a plain studio backdrop and her gaze seems fixed on the middle distance, while the image includes an Eastman Kodak color bar, used to help publishers achieve the correct hues in print. The work is made using Kodak film, processing chemicals, and photographic paper, but Williams references the company visually, too: the yellow color of the towels wrapped around Meiko's head and body is calibrated exactly to match the dominant hue of Kodak's packaging, a shade that Williams has suggested connotes "warmth, sunshine, spring, domestic bliss." Color photography is thus linked intimately with the artifice of advertising and consumer culture that shaped the world in 2005 just as it did in 1968, allowing for the precise construction of beauty and the manipulation of emotions as well as images.

Kodak Three Point Reflection Guide © 1968 Eastman Kodak Company, 1968 (Meiko Laughing), Vancouver, B.C., April 6, 2005, 2005. Chromogenic print, 18¼ x 22⅝ in. (46.4 x 57.5 cm). Edition of 10. Purchase with funds from the Photography Committee 2006.31

For conceptual artist Fred Wilson, the museum is not just a place to visit or exhibit his work; it is also his palette and his subject. His work challenges the social codes that structure our experience of museums and exposes the historical misconceptions and implicit biases with respect to nonwhite cultures that underpin the practices of Western institutions. Wilson is perhaps best known for his museum projects in which he appropriates curatorial methods and strategies to rearrange and recontextualize existing collections, creating gallery installations that bring to light new histories, meanings, and artistic interpretations for the objects.

In *Guarded View* four headless black mannequins, feet planted firmly apart, are dressed as museum guards. Each figure wears a uniform, dating to the early 1990s, from one of four New York art museums: the Jewish Museum, the Metropolitan Museum of Art, the Whitney Museum, and the Museum of Modern Art. The mannequins underscore the institutional and public anonymity in which security personnel, often the only people of color present in the museum galleries, are tasked with protecting art and the public while remaining out of view. Having worked as a guard in his college museum, Wilson recognized what it felt like to be ignored by museum visitors: "When you are a museum guard, you are on display like everything else. You are standing there. You are silent. People walk by you. But unlike the artwork, you are invisible." He challenges this dynamic by placing these ordinarily unnoticed figures at the center of our attention.

Guarded View, 1991. Wood, paint, steel, and fabric, four parts: dimensions variable. Gift of the Peter Norton Family Foundation 97.84a–d

Garry Winogrand, born and raised in New York, spent most of his career photographing the visual cacophony of his native city. Each day, the photographer would spend hours strolling its busy sidewalks and parks, shooting a dozen rolls of black-and-white film that captured the possibilities and anxieties of daily life in postwar America. Winogrand used a 35mm camera that enabled him to produce snapshot-like photographs quickly and freely. In 1967 curator John Szarkowski selected Winogrand, along with Diane Arbus and Lee Friedlander, for the influential exhibition *New Documents* at the Museum of Modern Art, noting that these artists used documentary photography for "personal ends" rather than as a tool of social reform.

 New York City appears to be a candid encounter with a woman eating an ice cream cone on a sidewalk. In fact, outtakes reveal that Winogrand interacted with his subject, moving around her in order to crop out her male companion and to slyly reveal his own reflection in the store window. The photograph became the cover image for his 1975 monograph *Women Are Beautiful*, featuring eighty-four pictures of women in a variety of situations and places in and around New York. These images capture the styles, activities, and gestures that accompanied the second-wave feminism and sexual liberation of the era. Of his subjects, Winogrand noted: "I respond to their energies, how they stand and move their bodies and faces. In the end, the photographs are descriptions of poses or attitudes that give an idea, a hint of their energies."

New York City, 1968 (printed 1981), from the portfolio *Women Are Beautiful*, 1981. Gelatin silver print, 8⅞ x 13⅛ in. (22.5 x 33.3 cm). Edition no. 48/80. Gift of Barbara and Eugene Schwartz 91.93.1

Jackie Winsor's sculptures inflect the primary geometric language of Minimalism with a singular aesthetic that derives from handmade processes, human scale, and ordinary and organic materials. Initially trained as a painter, Winsor began making three-dimensional works in the late 1960s using rope, nails, wood, bricks, and copper wire, often crafting their forms via repetitive, manual actions such as wrapping, stacking, and hammering. These materials and techniques aligned with a Postminimalist interest in process and duration, but also derived from Winsor's upbringing on the coast of Newfoundland, where her engineer father built houses.

In *Cement Piece*, which was included in the 1977 Whitney Biennial, Winsor constructed a three-foot cube from wood lath and wire-reinforced concrete. Small square portals cut into the center of each of its six sides allow viewers to peer into the center of the form. Winsor's use of the cube, a shape that dominates her sculpture from the mid-1970s to mid-1980s, was in part inspired by a dream in which she dug into a spot of light on her studio wall until she broke through to the adjacent space. As the dream suggests, the "neutral" form of the cube allowed her to address relationships between positive and negative space. For Winsor, the cube-shaped sculptures focus on "creating a balance between the physical grid and an intangible grid—bringing openness and airiness into the pieces and still retaining their solidity." They take on a monumental Minimalist form, only to open it up and reveal its interior.

Cement Piece, 1976–77.
Wire, cement, wood, and nails,
36 x 36 x 36 in. (91.4 x 91.4 x
91.4 cm). Purchase with funds
from the Louis and Bessie
Adler Foundation Inc.,
Seymour M. Klein, President;
Mr. and Mrs. Robert M.
Meltzer; and Mrs. Nicholas
Millhouse 80.7

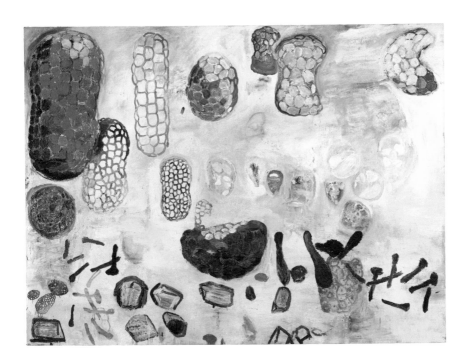

For the past four decades Terry Winters has delved into organic abstraction in painting, drawing, and printmaking. His earliest canvases, from the mid-1970s—allover compositions filled with thick and clearly recognizable brushstrokes—adhered to the monochrome formats championed by postwar artists. A shift toward quasi-representational imagery occurred in 1980, when his interest in the material qualities of paint led him to depict the crystalline structures of the minerals from which his pigments—many of which he ground himself—were composed. By the early 1980s Winters began incorporating schematically rendered biological imagery into his canvases, evocative of pollen, ova, cells, and other indeterminate organic material.

In *Good Government* Winters applied paint in thinly layered strokes or heavily impastoed sections, using tools that ranged from traditional brushes to rags to palette knives. The large forms at the top resemble honeycombs and molecular chains, while the smaller black shapes positioned along the bottom conjure plant spores or enlarged chromosomes, signaling the fundamental structures of life. The title alludes to one of Ambrogio Lorenzetti's fourteenth-century frescoes, *Allegory of Good Government*, which Winters saw in Siena, Italy, prior to beginning the canvas; but it also refers to his compositional process. Winters recalled how when the painting began to cohere, it reminded him "of those charts you would see in elementary school about good government, where all the different things were all working together." Despite Winters's identifiable references and scientific imagery, the painting ultimately remains open to interpretation. "The image has a life of its own," he has stated; "the image itself is an organism."

Good Government, 1984.
Oil on linen, 101¼ x 136¼ in.
(257.2 x 346.1 cm).
Purchase with funds from
The Mnuchin Foundation
and the Painting and
Sculpture Committee 85.15

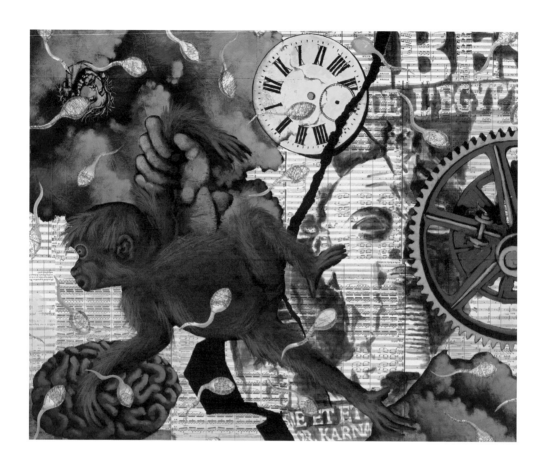

Fear of Monkeys/Evolution,
1988. Acrylic and opaque
watercolor on cut papers,
24¼ x 29⅜ in. (61.6 x
74.6 cm). Gift of Steven
Johnson and Walter Sudol
2001.309

Untitled, 1989. Three gelatin
silver prints, 30½ x 24¾ in.
(77.5 x 62.9 cm) each.
Purchase with funds from
the Robert Mapplethorpe
Foundation and the
Photography Committee
2007.122a–e

One Day, This Kid . . . ,
1990. Photostat, 29¾ x
40⅛ in. (75.6 x 101.9 cm).
Edition of 10. Purchase
with funds from the Print
Committee 2002.183

In an artistic practice spanning photography,
painting, collage, sculpture, film, and
writing, David Wojnarowicz distilled his
moral fury into a powerful weapon
amid the political and social turbulence
of the 1980s—addressing in particular
the devastation of the AIDS epidemic,
homophobic politicians and policy, and the
institutionalized apathy and loss of
spirituality he saw in American society.
His work was shaped and propelled
by the violence and marginalization he
had experienced: as a child, growing up in
suburban New Jersey with an abusive,
alcoholic father; as a teenager hustling
on New York's streets; and, later, as
a gay man living with (and eventually dying
from) AIDS. He emerged in the early
1980s as a leading figure of the loosely

defined East Village scene of galleries, clubs, and alternative art spaces, and collaborated widely with his peers, including Kiki Smith and Peter Hujar, who was Wojnarowicz's close friend and mentor until Hujar's death in 1987.

In paintings and sculptures from the mid-1980s Wojnarowicz developed a visual language built upon the principle of collage, using found posters and images, maps, stencils, and paint to build up layered, often cacophonous surfaces. *Fear of Monkeys/Evolution* combines imagery drawn from an intricate, personal web of symbols to which he would frequently return: a monkey (symbol of the possible origin of the HIV virus), a clock face without hands (a reference to mortality and the loss of time), and sperm shapes cut out from a map (signifying desire, reproduction, and/or contagion), among other elements arranged across torn sheets of music. Often recalling states of reverie or dreaming, his paintings present an anxious, teeming vision, "like

fragmented mirrors of what I perceive to be the world."

In the late 1980s Wojnarowicz increasingly moved away from painting and toward photography, a medium he had used since the 1970s. *Untitled*, a triptych of images he made of Hujar just after his death, presents vignettes of his friend and mentor's body—a haunting document of loss, tenderness, and intimacy, and an attempt to reverse the invisibility of AIDS-related deaths. "History is made and preserved by and for particular classes of people," he wrote. "A camera in some hands can preserve an alternate history."

Wojnarowicz's writings were another means of telling such alternate stories; like much of his work, they offer reflexive accounts of desire, fear, and anger, narratives of experience marked by "the sensation of being an observer of my own life as it occurs." He often incorporated his writings into works that hinge on the relation of text and image. *One Day This Kid . . .* relies on a concise formal economy: a grainy image of Wojnarowicz as a child, set within a text that outlines what he saw the future holding for a queer person—loss of political rights, dispossession, and abuse. An icon of activism and queer identity, the work telegraphs Wojnarowicz's uncompromising commitment to claiming visibility within a society that had rejected him.

One day this kid will get larger. One day this kid will come to know something that causes a sensation equivalent to the separation of the earth from its axis. One day this kid will reach a point where he senses a division that isn't mathematical. One day this kid will feel something stir in his heart and throat and mouth. One day this kid will find something in his mind and body and soul that makes him hungry. One day this kid will do something that causes men who wear the uniforms of priests and rabbis, men who inhabit certain stone buildings, to call for his death. One day politicians will enact legislation against this kid. One day families will give false information to their children and each child will pass that information down generationally to their families and that information will be designed to make existence intolerable for this kid. One day this kid will begin to experience all this activity in his environment and that activity and information will compel him to commit suicide or submit to danger in hopes of being murdered or submit to silence and invisibility. Or one day this kid will talk. When he begins to talk, men who develop a fear of this kid will attempt to silence him with strangling, fists, prison, suffocation, rape, intimidation, drugging, ropes, guns, laws, menace, roving gangs, bottles, knives, religion, decapitation, and immolation by fire. Doctors will pronounce this kid curable as if his brain were a virus. This kid will lose his constitutional rights against the government's invasion of his privacy. This kid will be faced with electro-shock, drugs, and conditioning therapies in laboratories tended by psychologists and research scientists. He will be subject to loss of home, civil rights, jobs, and all conceivable freedoms. All this will begin to happen in one or two years when he discovers he desires to place his naked body on the naked body of another boy.

During the last decade, Jordan Wolfson has created a powerful yet enigmatic body of work that delves deep into the libidinal subconscious of our society and consumer culture. While studying sculpture at the Rhode Island School of Design in the early 2000s, the budding artist began making videos that, like those of his contemporary Cory Arcangel, precociously combine the legacies of Conceptual and Pop art with new visual technologies.

Con Leche mines the icons and ruins of the American Dream to surreal effect. The film installation features an army of animated Diet Coke bottles filled with milk *(con leche)* that traverse the empty streets of real-life Detroit. The graffiti covering the abandoned buildings provides a formal counterpart to the hand-drawn soldiers, which hauntingly recall the magic brooms in the 1940 Walt Disney classic *Fantasia*. The video image itself is constantly skewed, just as the artist shifts and subverts any reading of these layered images.

Wolfson has paired the video with a longer and continuously out-of-sync soundtrack featuring a woman's voice that recites information gathered from common Internet searches: "How do I know if I'm gay?," "reincarnation," "Kate Moss cocaine," "Is diet soda bad for you?" and "cell phone." The resultant verbal stream is interrupted by the artist's own voice, giving directions to his narrator: "Can you pause, please?" "Please lower your voice." Wolfson reveals himself to be the creator of this world, but refuses to endow it with a specific meaning. "I like the viewers to do the interpretive legwork," he has said.

Stills from *Con Leche*, 2009.
Video, color, sound; 14:57 min.
(video), 22:41 min. (audio),
looped. AP 1/2, edition of 5.
Gift of Brooke Garber Neidich
and Daniel Neidich 2010.154

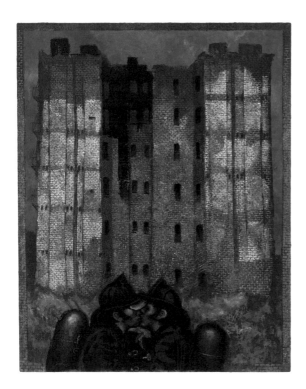

In 1978 Martin Wong moved from California to New York's Lower East Side, then a vibrant community of predominantly Puerto Rican immigrants and known by its Nuyorican name, "Loisaida." Raised in San Francisco's Chinatown district by parents who had themselves immigrated to the United States from China, Wong studied ceramics and participated in experimental performance groups in the San Francisco Bay Area before turning to painting. His canvases, often marked by their earthy palettes, lively social interactions, and brick backdrops, reflected his urban environment and gave visibility to groups underrepresented in both the society and art of the time, including recent immigrants and the gay community (Wong was openly gay). The physical architecture of the neighborhood constantly looms behind this very human subject matter: especially tenement buildings similar to the one Wong himself lived in, whose windows sometimes reveal interior lives and whose walls often bear traces of graffiti.

One of Wong's most iconic works, *Big Heat* presents a profound meditation on both the ravages and poignancies of life. In the foreground two firemen—an ongoing fascination of the artist's—share a tender kiss as the specter of a massive, partially charred tenement building looms in the background. The building is embellished with bright patches of paint used to buff over graffiti, an urban, vernacular art form that Wong supported and collected in earnest. Wong nourished graffiti artists by buying their work, and shortly after he tested positive for HIV he donated his extensive collection of graffiti art to the Museum of the City of New York.

Big Heat, 1988. Acrylic on linen, 60⅛ x 48⅛ in. (152.7 x 122.2 cm). Purchase with funds from the Painting and Sculpture Committee 99.89

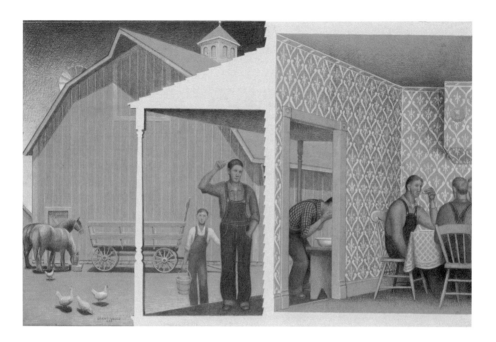

Grant Wood advocated for art based on what he called "an American way of looking at things." Along with Thomas Hart Benton and John Steuart Curry, he was one of the primary artists associated with Regionalism, an approach to painting marked by an emphatically realist approach as well as by subject matter drawn from rural American life and its landscapes—epitomized by Wood's iconic painting *American Gothic* (1930). Though he lived in his native Iowa for most of his life, his early travels to Europe were formative; a 1928 stay in Munich left him deeply impressed by the precision and lucidity of Northern Renaissance art. During this time, Wood developed the visual vocabulary that would sustain him for the rest of his career: simplified but finely delineated treatment of forms, flattened areas of color and pattern, and saturated color and tone that border on the uncanny.

 Dinner for Threshers is a finely worked study for the left part of a painting of the same name that depicts the midday meal during threshing season, when farmers would join together in communal labor. Two men prepare to enter the house, washing their hands and combing their hair; the remaining parts of the full image depict a long table lined with farmers and a kitchen where women prepare the meal. While the subject derived from Wood's memories of his childhood in rural Iowa, he drew on the visual conventions of religious painting to represent this microcosm of idealized community, endowing a mundane moment with the meaningful air of ritual.

Dinner for Threshers
(left section), 1933. Graphite pencil, opaque watercolor, and colored pencil on paper, 24⅛ x 33 in. (61.3 x 83.8 cm). Purchase 33.79.1

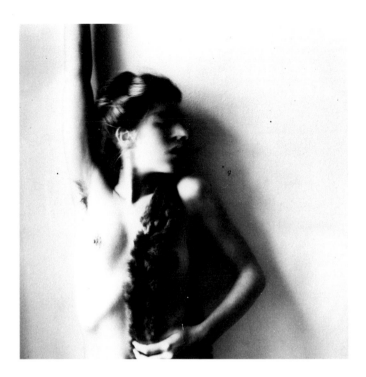

As a student at the Rhode Island School of Design in the late 1970s, Francesca Woodman developed an experimental photographic practice rooted in performative self-portraiture. Taking her own body as her primary subject and favoring dilapidated interiors as settings, Woodman would position herself behind scraps of peeling wallpaper, within glass casements, or posed among taxidermy, alternately nude or clothed in vintage dresses.

After completing her undergraduate degree, Woodman moved to New York and sought commercial work as a fashion photographer. During a residency at the MacDowell Colony in July 1980, she began to experiment with outdoor settings and materials found in nature. *Untitled (MacDowell Colony, Peterborough, New Hampshire)* shows the artist from the waist up with one arm raised and a fox fur draped over the opposite shoulder, her face partially blurred as it turns aside. Juxtaposing her own skin and hair with those of plants and animals, she explores the echoing forms and contrasting textures of her subjects. Like many of the objects that comprise Woodman's visual vocabulary—which contains a litany of references to Surrealism and Gothic literature—the fox fur is charged with erotic symbolism. In one of her last works, a fur is wrapped tightly around the artist's neck in a more menacing gesture as she gazes directly into the camera. Woodman committed suicide in 1981 at the age of twenty-two. Although her work did not garner much recognition during her lifetime, Woodman's brief but prolific career gained much posthumous attention after a 1986 exhibition of her photographs.

Untitled (MacDowell Colony, Peterborough, New Hampshire), 1980. Gelatin silver print, 9½ x 9½ in. (24 x 24 cm). Purchase with funds from the Robert Mapplethorpe Foundation and Hadley Fisher 2008.176

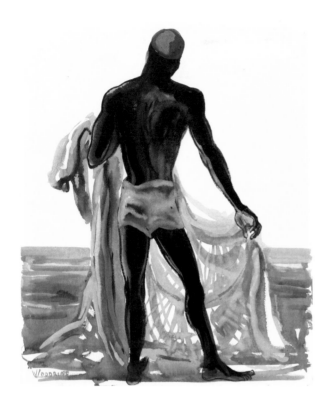

Among the most prominent African American painters of the twentieth century, Hale Aspacio Woodruff developed a wide stylistic range that included Impressionist-inspired landscapes, social realism, modernist murals, and Abstract Expressionism. Raised in Tennessee and educated at the John Herron Art Institute in Indianapolis, the painter was encouraged early in his career by influential figures in African American art and culture—Countee Cullen, William Scott, and Walter White. After winning a prize in 1926 from the Harmon Foundation, which supported black American artists, Woodruff spent four years in France working, studying, and traveling.

This luminous watercolor was almost certainly executed during the summer of 1930, when the artist was based in the Provence village of Cagnes-sur-Mer. Another sheet of a fisherman drawn the same year indicates, in an inscription, the artist also visited Tunisia that summer, and this is perhaps the location captured here. The scene is from everyday life in a port city, but the statuesque body places the work in the long Western tradition of idealized nudes. This heroic presentation of a black body would have had political connotations for an African American artist at the time, given the contemporary New Negro movement, as well as the pervasiveness of racist imagery in American visual culture. It also foreshadows Woodruff's Amistad Murals, a monumental narrative cycle in which the expressive black male body took center stage.

Fisherman, c. 1930.
Transparent and opaque watercolor on paper,
18 x 14⅞ in. (45.7 x 37.8 cm).
Purchase with funds from the Drawing Committee and partial gift of Auldlyn Higgins Williams and E. T. Williams Jr. 2013.119

When Christopher Wool began his painting career in the early 1980s, the field was in a moment of crisis. As a powerful faction of artists and thinkers refuted painting's relevance, demanding a more self-conscious approach to images and representation, Wool responded by critiquing the medium from within, exploring the mechanics of its processes. Often drawing inspiration from hardware stores rather than art shops, Wool has employed a range of devices in the service of painting, from rubber stamps and stencils to screens and spray paint, working principally with black enamel on chalky white aluminum panels. As he later reflected, he became "more interested in 'how to paint it' than 'what to paint.'"

Untitled belongs to Wool's groundbreaking series known as the "word paintings," begun in 1987. These hand-stenciled works—which followed "pattern paintings" made with incised decorative rollers and "drip paintings" that exploited the physical properties of paint—showcase single words or found texts as sequences of letters, spaced in gridlike formation across the white ground. Here, the declarative *RUN DOG RUN DOG RUN*, a play on the simple repetitions of classic *Dick and Jane* books, becomes a compositional exercise. As bold block letters run in nonstop, breathless progression, they are transformed into incomprehensible utterances. Their linguistic integrity broken, the words read as images. While the use of stencil suggests precision and uniformity, imperfections abound, as black paint leaks into white ground and white "touch-ups" roll into black. This tension between perfunctory process and human touch highlights a central paradox of Wool's practice: a negotiation between an aesthetic of calculation and one of immediacy.

Untitled, 1990. Enamel on aluminum, 107⅞ x 71¾ in. (274 x 182.2 cm). Purchase with funds from the Painting and Sculpture Committee 91.2

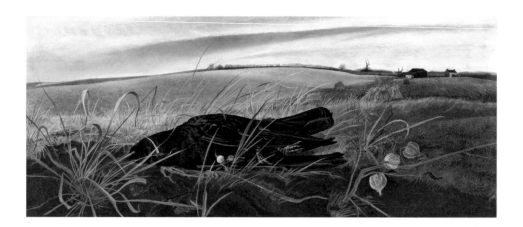

Andrew Wyeth established himself as a master of realism amid the ascendancy of abstraction during the 1940s, remaining faithful to his meticulous depictions of rural America for more than sixty years. His subjects were the immediate surroundings of his modest life—family, friends, and, above all, the landscapes of his hometown of Chadds Ford, Pennsylvania, and his summer retreat in Cushing, Maine. *Winter Fields*, an early canvas painted before Wyeth began to incorporate figures into his work, portrays a crow lying lifeless in a desiccated field. The only signs of life are two houses visible on the horizon in the far distance. Completed at the height of World War II, this somber, bleak scene may have been intended to evoke the casualties occurring in the battlefields of Europe or to reference the Revolutionary War dead of the Brandywine battlefield adjacent to the farm.

To bolster the authenticity of the imagery, Wyeth made two sketches prior to painting *Winter Field*: one of the dead crow, which he found near his Chadds Ford studio, and another of the spindly clump of grass at the lower left. Yet despite the composition's extraordinary detail, it subtly distorts reality. The rendering of the bird and foreground grasses is so painstaking as to seem exaggerated,

creating a compression of the pictorial space toward the canvas surface. This effect is underscored by the equally sharp focus of the elements in the far distance, which defies visual logic and engenders an uncanny feeling not entirely out of step with contemporaneous Surrealist works, despite the artist's desire to distance himself from such practices.

Winter Fields, 1942.
Tempera on composition
board, 17 ⅜ x 41 in. (44.1 x
104.1 cm). Gift of Mr. and
Mrs. Benno C. Schmidt in
memory of Mr. Josiah
Marvel, first owner of this
picture 77.91

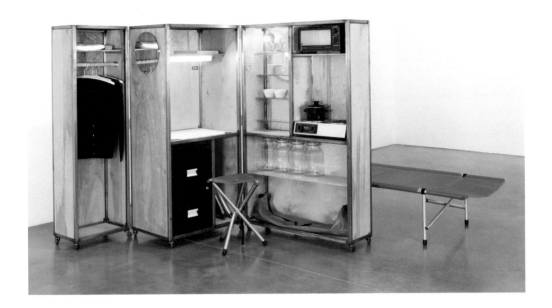

Andrea Zittel has produced a body of work that fuses the functional and the aesthetic, probing the intersection of art, design, and architecture. Since 1990 she has created a range of objects, including clothing, furniture, carpets, living compartments, and, perhaps most notably, moveable "wagon stations" and vehicles. As Zittel has explained, "Home furniture, clothing, food all become the sites of investigation in an ongoing endeavor to better understand human nature and the social construction of needs." Zittel functions as the "one-woman corporation" A–Z Enterprise, now based at a desert compound in Joshua Tree, California. Throughout Zittel has insisted that she is creating art, not design objects.

A to Z 1993 Living Unit is an early example of the functional living environments Zittel created at the outset of her enterprise. These *units* are modular, portable structures that allow for storage, a modest kitchen, and a place to sleep—the essentials of daily life. Inspired by the limitations of her two-hundred-square-foot studio in Brooklyn

in the early 1990s, and grappling with how to best utilize the limited space, Zittel began work on these structures, which could be customized to meet individual needs. Interested in what she describes as the "fine line between freedom and control, and how people often feel liberated by parameters," Zittel's units reference Bauhaus design while simultaneously providing a streamlined solution for everyday living.

A to Z 1993 Living Unit, 1993. Steel, wood, mirror, four hangers, sweater, towel, soap container, calendar, filing cabinet, pencils, two notepads, folding seat, folding bed, four glass jars, two ceramic cups, two glasses, two ceramic bowls, digital clock, electric lighting system, hot plate, pot, and toaster oven, open: dimensions variable, closed: 62¾ x 40 x 30 in. (159.4 x 101.6 x 76.2 cm). Purchase with funds from the Painting and Sculpture Committee and partial gift of Jay Jopling 2014.293a–e

Acknowledgments

Dana Miller

The very nature of a publication based on the Museum's collection is collaborative, and I am deeply indebted to all of those who worked on this book and those who work with the collection. My first thanks go to Adam D. Weinberg, the Whitney's Alice Pratt Brown Director. It is almost impossible to imagine a director being more supportive than Adam has been of this handbook. From the beginning, he gave this project his full attention and, in addition to authoring an astute and insightful essay, he spent hours poring over the lists of artists and works with us as well as advising on the final selection. No one felt the pain of excluding artists from this book more acutely than Adam.

Each of my colleagues in the Curatorial Department, which is led by the inestimable and enormously encouraging Donna De Salvo, Chief Curator and Deputy Director for Programs, made sizeable contributions to this volume, helping to select the artists and works included as well as authoring texts. Their efforts have broadened and deepened the scholarship on the collection in immeasurable ways for years to come. Those curators are as follows: Donna De Salvo, Chief Curator and Deputy Director for Programs; Carter E. Foster, Steven and Ann Ames Curator of Drawings; Barbara Haskell, Curator; Chrissie Iles, Anne and Joel Ehrenkranz Curator; David Kiehl, Nancy and Fred Poses Curator; Christopher Lew, Associate Curator; Jane Panetta, Assistant Curator; Christiane Paul, Adjunct Curator of New Media Arts; Scott Rothkopf, Nancy and Steve Crown Family Curator and Associate Director of Programs; Jay Sanders, Curator and Curator of Performance; Carrie Springer, Assistant Curator; Elisabeth Sussman, Curator and Sondra Gilman Curator of Photography; Catherine Taft, Assistant Curator, New Building Project. Claire K. Henry, Laura Phipps, and Elisabeth Sherman, Senior Curatorial Assistants, also contributed texts, as did Mia Curran, who, in her role as Curatorial Assistant, New Building Project, lent essential organizational aid throughout the gestation of this project. My partners on the team responsible for the inaugural installation, Carter, Scott, Catherine, Jane, and Mia—expertly led by Donna—also provided enormous help conceptualizing this publication in its early stages.

I owe an enormous debt of gratitude to the twenty of other authors, the full list of which is on page 426, for their wonderful contributions. Many of these authors are former Whitney colleagues or part of what we consider the Whitney's extended family, and I am pleased we could reel them back in for this occasion.

At the Museum, my heartfelt thanks go to the Publications Department, in particular Beth Huseman, Director, whose care and attention to the larger project and the smaller details has no comparison. As coordinators of this project, Jacob Horn and Diana Kamin adeptly managed countless details. Diana provided essential research and functioned as a clearing house and sounding board for all image-related issues. Beth Turk worked tirelessly on the captions and text, and my mind rests easier because of her high editorial standards. Anita Duquette, Manager of Rights and Reproductions, assembled numerous images on extremely tight deadlines. In the Graphic Design Department, Hilary Greenbaum, Director, was responsible for the handsome book design and worked patiently with us as lists were finalized and adapted gracefully as changes arose. Without the exactitude and expertise of each one of these individuals, this book would not have been possible.

Nerissa Dominguez Vales and Sue Medlicott brought their careful eye and depth of printing and production knowledge to this volume. Janet Jenkins deserves many thanks for her patience and stellar editing of the majority of texts in this volume. Gratitude also goes to Amanda Glesmann, Thea Hetzner, Sarah McFadden, Gail Spilsbury, and David Updike for their meticulous editing.

The care and feeding of the collection involves a immense number of people, and I have had the great pleasure and privilege to work with an extraordinary team of colleagues in other departments at the Museum. Numerous staff members have helped to shape this book through their work with the art objects, the archival files, and the object reproductions. Carol Mancusi Ungaro, Melva Bucksbaum Associate Director for Conservation and Research, and her fantastic team in conservation have ensured that the works were all in suitable condition for photography and helped with many aspects of the media research. Farris Wahbeh, Director of Research Resources, and Christa Molinaro, Permanent Collection Documentation Manager, were incredibly helpful, facilitating access to archival materials and offering their cataloguing expertise. Adrienne Rooney, Curatorial Assistant; Catherine Taft; and Diana Kamin, took on much of the curatorial research for this project, delving into the object files or reaching out to studios and galleries to request information. In numerous cases, incorrect dates or titles have been corrected and missing information filled in for the first time. I owe the three of them a huge debt of gratitude. Barbi Spieler, Head Registrar, Permanent Collection; Joshua Rosenblatt, Head Preparator; Abigail Hoover, Associate Registrar and Project Manager CDI; and Chris Ketchie, Associate Preparator and Warehouse Manager, alongside the rest of the registration and exhibitions team helped throughout this process, whether installing a Robert Morris felt work specifically for photography or matching a Pantone paint chip to the Anne Truitt sculpture so it could be properly color proofed. There was literally no request that went unheeded. Many of the photographs in this book were taken as part of the extensive and multiyear Collection Documentation Initiative (CDI), which was overseen by Christy Putnam, Associate Director for Exhibitions and Collections Management. I am grateful to the entire CDI team, in particular Robert Gerhardt, Digital Photographer, and Denis Suspitsyn, Digital Imaging Specialist, for producing such beautiful images.

Others at the Museum who provided essential assistance are those in the Frances Mulhall Achilles Library who helped facilitate the archival research, including Carol Rusk, former Benjamin and Irma Weiss Librarian; Ivy Blackman, Library Manager; and Kristen Liepert, Archives Manager. Kathryn Potts, Associate Director, Helena Rubinstein Chair of Education, and Dina Helal, Manager of Education Resources, immediately understood the importance of parsing the term "American" and buoyed this research in innumerable ways. Hillary Strong, Director of Institutional Advancement, and Ann Holcomb, Assistant Director of Foundation and Government Relations, secured funding for the book. A special thank-you goes to Emily Russell, Director of Curatorial Affairs, who functions as both the backbone and the safety net of our department. Over the past several years we have been ably assisted by interns on various aspects of this project, and I thank them all for their work, Yae-Jin Ha, in particular.

Our enormous gratitude goes to the National Endowment for the Arts for recognizing the significance of this publication and providing commensurate support.

The basis for this entire effort is the collection, and we are indebted to the foresight of our colleagues and predecessors at the Whitney for providing such a strong foundation upon which to begin, as well as to the many donors and patrons who enabled us to build the Museum's holdings into the trove that it is today. And lastly, I want to thank all the artists in the Whitney's collection, for they provide the raison d'être for such a project.

The entries in this volume were written by Mia Curran, Curatorial Assistant, New Building Project (pp. 65, 71, 101, 236, 239, 277–78, 292, 295, 320, 383, 408, 410); Donna De Salvo, Chief Curator and Deputy Director for Programs (pp. 395–97); Carter E. Foster, Steven and Ann Ames Curator of Drawing (pp. 102, 111, 142, 181–84, 204, 208, 349, 373, 420); Barbara Haskell, Curator (pp. 69, 121, 167–68, 273, 300); Claire K. Henry, Senior Curatorial Assistant (pp. 82, 382); Chrissie Iles, Anne and Joel Ehrenkranz Curator (pp. 137, 197); David Kiehl, Nancy and Fred Poses Curator (p. 214); Christopher Lew, Associate Curator (pp. 340, 357, 362, 381, 388, 394); Dana Miller, Curator, Permanent Collection (pp. 57, 88, 113–14, 164, 175, 255); Jane Panetta, Assistant Curator (pp. 75, 76, 89, 92, 105, 132, 192, 261, 296, 321–22, 423); Christiane Paul, Adjunct Curator of New Media Arts (pp. 38, 44, 108, 173, 180, 235, 249, 303, 348); Laura Phipps, Senior Curatorial Assistant (pp. 55, 125, 140, 201, 266); Scott Rothkopf, Nancy and Steve Crown Family Curator and Associate Director of Programs (pp. 209, 231–32); Jay Sanders, Curator and Curator of Performance (pp. 100, 165–66); Elisabeth Sherman, Senior Curatorial Assistant (pp. 48, 118, 141, 169, 224, 283, 351); Carrie Springer, Assistant Curator (pp. 143, 155, 279, 363); Elisabeth Sussman, Curator and Sondra Gilman Curator of Photography (pp. 43, 146, 202–3, 257, 377); Catherine Taft, Assistant Curator, New Building Project (pp. 40, 47, 67, 77, 90, 91, 223, 233, 252, 258, 265, 268, 271, 280, 294, 339, 367, 376, 384, 403), at the Whitney Museum of American Art, New York, and the following curators, art historians, and writers: Ani Boyajian (pp. 104, 159, 213, 364, 399, 404); Lucy Bradnock (pp. 81, 107, 120, 149, 156, 191, 205, 338, 378, 402, 409); Cathleen Chaffee (pp. 312, 385); Lori Cole (pp. 210, 369); Kim Conaty (pp. 36, 172, 421); Stacy Goergen (pp. 59, 93, 163, 178, 302); Jennie Goldstein (pp. 41, 45, 46, 49, 70, 84–86, 94, 126, 136, 139, 147, 148, 176–77, 185, 194–95, 200, 211, 225, 229, 237, 256, 264, 270, 281, 282, 304–5, 308, 315, 318, 319, 329, 331–32, 337, 341, 342, 355–56, 359, 374, 380, 387, 400, 413); Henriette Huldisch (pp. 259, 297, 392–93); Frances Jacobus-Parker (pp. 39, 51, 52, 152, 160, 222, 226, 238, 262, 412); Martha Joseph (pp. 187, 193, 240, 285, 310, 311, 324, 334, 368, 389); Diana Kamin (pp. 171, 289–91); Anna Katz (pp. 42, 50, 74, 117, 153, 218, 299, 333, 344, 386); Sasha Nicholas (pp. 58, 61, 66, 68, 79, 80, 83, 103, 106, 109–10, 116, 122, 124, 127, 135, 145, 151, 158, 174, 190, 196, 221, 244, 245, 251, 253, 269, 275, 286–88, 306, 309, 314, 328, 330, 335, 343, 354, 358, 361, 365, 366, 370, 379, 398, 406, 422); Daniel Palmer (pp. 73, 123); Nicholas Robbins (pp. 56, 87, 130, 414–15, 418); Beau Rutland (pp. 254, 417); Drew Sawyer (pp. 63, 78, 96, 99, 112, 133, 138, 179, 217, 234, 263, 313, 411, 416); Susan Thompson (pp. 293, 405, 419); Mamie Tinkler (pp. 60, 144, 157, 207, 215, 260, 301, 307, 325, 371); Lisa Turvey (pp. 37, 53, 54, 62, 64, 72, 95, 97, 98, 115, 119, 131, 134, 150, 154, 161, 162, 170, 186, 198–99, 206, 212, 216, 219, 220, 227, 228, 230, 241, 246, 247, 248, 250, 267, 272, 274, 276, 284, 298, 323, 326, 327, 336, 346–47, 350, 352, 353, 360, 373, 275, 401, 407).

Whitney Museum of American Art
Board of Trustees

Chairman Emeritus
Leonard A. Lauder

Honorary Chairman
Flora Miller Biddle

Co-Chairmen
Robert J. Hurst
Brooke Garber Neidich

President
Neil G. Bluhm

Vice Chairmen
Melva Bucksbaum
Warren B. Kanders
Scott Resnick
Laurie M. Tisch

Vice Presidents
Pamella G. DeVos
Beth Rudin DeWoody
Susan K. Hess
Paul C. Schorr, IV
Fern Kaye Tessler

Secretary
Nancy Carrington Crown

Treasurer
Richard M. DeMartini

Alice Pratt Brown Director
Adam D. Weinberg

Steven Ames
J. Darius Bikoff
David Carey
Joanne Leonhardt Cassullo
Richard M. Chang
Henry Cornell
Fiona Irving Donovan
Fairfax N. Dorn
Lise Evans
Victor F. Ganzi
Henry Louis Gates, Jr.
Philip H. Geier, Jr.
Robert B. Goergen
Sondra Gilman Gonzalez-Falla
James A. Gordon
Anne Dias Griffin
George S. Kaufman
Emily Fisher Landau
Raymond J. Learsy
Jonathan O. Lee
Miyoung Lee
Thomas H. Lee
Raymond J. McGuire
Peter Norton
John C. Phelan
Nancy Poses
Donna Perret Rosen
Richard D. Segal
Jonathan S. Sobel
Anne-Cecilie Engell Speyer
Thomas E. Tuft
Fred Wilson
David W. Zalaznick

Honorary Trustees
Joel S. Ehrenkranz
Gilbert C. Maurer

Founder
Gertrude Vanderbilt Whitney

As of December 11, 2014

Alison Abreu-Garcia, Jay Abu-Hamda, Stephanie Adams, Adrienne Alston, Martha Alvarez-LaRose, Amanda Angel, Marilou Aquino, Emily Arensman, Morgan Arenson, Kristina Arike, I. D. Aruede, Bernadette Baker, John Balestrieri, Wendy Barbee-Lowell, Courtney Bassett, Caroline Beasley, Michelle Bedford, Justine Benith, Harry Benjamin, Nathalie Berger, Jeffrey Bergstrom, Caitlin Bermingham, Stephanie Birmingham, Ivy Blackman, Hillary Blass, Richard Bloes, Alexandra Bono, Sarah Braselton, Keri Bronk, Cristine Brooks, Algernon Brown, Douglas Burnham, Ron Burrell, Garfield Burton, Anne Byrd, Jocelyn Cabral, Pablo Caines, Margaret Cannie, Amanda Carrasco, Christina Cataldo, Inde Cheong, Ramon Cintron, Randy Clark, Ron Clark, Heather Cox, Kenneth Cronan, Monica Crozier, Mia Curran, Regine David, Donna De Salvo, Margo Delidow, Lauren DiLoreto, John Donovan, Lisa Dowd, Anita Duquette, Raquel Echanique, Alvin Eubanks, Seth Fogelman, Carter Foster, Samuel Franks, Murlin Frederick, Annie French, Donald Garlington, Anthony Gennari, Larissa Gentile, Claudia Gerbracht, Robert Gerhardt, Francesca Grassi, Hilary Greenbaum, Cassandra Guan, Peter Guss, Stewart Hacker, Jill Hamilton, Adrian Hardwicke, Greta Hartenstein, Barbara Haskell, Maura Heffner, Dina Helal, Peter Henderson, Claire Henry, Jennifer Heslin, Megan Heuer, Ann Holcomb, Nicholas S. Holmes, Abigail Hoover, Jacob Horn, Ayyub Howard, Sarah Hromack, Karen Huang, Sarah Humphreville, Beth Huseman, Chrissie Iles, Carlos Jacobo, Julia Johnson, Dolores Joseph, Vinnie Kanhai, Chris Ketchie, David Kiehl, Thomas Killie, Mo Kim, Kathleen Koehler, Irene Koo, Tom Kraft, Eunice Lee, Sang Soo Lee, Kristen Leipert, Monica Leon, Jen Leventhal, Jeffrey Levine, Christopher Lew, Danielle Linzer, Kelley Loftus, Robert Lomblad, Emma Lott, Kevin Lu, Doug Madill, Trista Mallory, Elyse Mallouk, Carol Mancusi-Ungaro, Louis Manners, Anna Martin, Heather Maxson, Patricia McGeean, Michael McQuilkin,

Sandra Meadows, Sarah Meller, Bridget Mendoza, Graham Miles, Dana Miller, David Miller, Christie Mitchell, Christa Molinaro, Michael Moriah, Victor Moscoso, Eleonora Nagy, Ruben Negron, Randy Nelson, Lloyd Newell, Carlos Noboa, Pauline Noyes, Thomas Nunes, Brianna O'Brien Lowndes, Rose O'Neill-Suspitsyna, Suzanna Okie, Nelson Ortiz, Jane Panetta, Christiane Paul, Ailen Pedraza, Jessica Pepe, Jason Phillips, Laura Phipps, Angelo Pikoulas, Mary Potter, Kathryn Potts, Linda Priest, Vincent Punch, Christy Putnam, Julie Rega, Gregory Reynolds, Emanuel Riley, Felix Rivera, Jeffrey Robinson, Georgianna Rodriguez, Gina Rogak, Justin Romeo, Adrienne Rooney, Joshua Rosenblatt, Jamie Rosenfeld, Amy Roth, Scott Rothkopf, Sara Rubenson, Emily Russell, Edward Salas, Angelina Salerno, Leo Sanchez, Jay Sanders, Galina Sapozhnikova, Lynn Schatz, Peter Scott, Michelle Sealey, David Selimoski, Jason Senquiz, Elisabeth Sherman, Kasey Sherrick, Sasha Silcox, Matt Skopek, Joel Snyder, Michele Snyder, Stephen Soba, Barbi Spieler, Carrie Springer, John Stanley, Mark Steigelman, Minerva Stella, Betty Stolpen, Hillary Strong, Emily Sufrin, Emilie Sullivan, Denis Suspitsyn, Elisabeth Sussman, Hannah Swihart, Catherine Taft, Kean Tan, Ellen Tepfer, Latasha Thomas, Phyllis Thorpe, Ana Torres, Beth Turk, Lauren Turner, Ray Vega, Snigdha Verma, Eric Vermilion, Billie Rae Vinson, Farris Wahbeh, Robert Wainstein, Adam D. Weinberg, Alexandra Wheeler, Andrew Wojtek, Laura Wright, Sefkia Zekiroski, Kayla Zemsky

As of December 16, 2014

Photography credits
Image courtesy 303 Gallery: p. 207; images courtesy Andrea Rosen Gallery: pp. 24, 150, 261, 423; image courtesy Arsenal—Institute for Film & Video Art: p. 82; photograph by Lance Brewer: p. 423; image © Center for Creative Photography, The University of Arizona Foundation/Art Resource, NY: p. 404; image © Condé Nast: p. 363; image courtesy The Conner Family Trust and Kohn Gallery: p. 100 (top); image courtesy Corbett vs. Dempsey: p. 169; performed by Josh Coxx: p. 389; photograph by Ellen Crozier: p. 289; image courtesy David Kordansky Gallery: p. 219; image courtesy David Zwirner Gallery: p. 416; image © 2014 Sherry Turner DeCarava: p. 112; images courtesy Electronic Arts Intermix (EAI): pp. 48, 67, 81, 197, 233, 257 (bottom), 339, 384; image courtesy the Estate of Stan Brakhage and Fred Camper (www.fredcamper.com): p. 77; images courtesy The Felix Gonzalez-Torres Foundation: pp. 24, 150; image courtesy Fraenkel Gallery: p. 37; image courtesy Gavin Brown's Enterprise: pp. 296, 302; photograph by Herbert Gehr: p. 13; images courtesy Gladstone Gallery: pp. 279, 357; image courtesy Gladstone Gallery, Blum & Poe, and neugerriemschneider: p. 228; courtesy the artist, Greene Naftali Gallery: p. 93; photograph by Samuel H. Gottscho: p. 12; photograph by George Hirose: p. 375; image © 1931, 2015 The Imogen Cunningham Trust: p. 104; image courtesy Jan Mot: p. 216; photograph © Karin Jobst: p. 6; courtesy Leslie Tonkonow Artworks + Projects: p. 373; photograph by Ralph Lieberman: p. 176; photograph by F.S. Lincoln: p. 13 (top); image courtesy Maccarone, and David Zwirner Gallery: p. 74; image courtesy Mary Boone Gallery: p. 209; Marion Goodman Gallery: p. 187; image courtesy Matthew Marks Gallery: p. 185; photograph by Helaine Messer: p. 18; image courtesy Miguel Abreu Gallery: p. 118; image courtesy Mike Kelley Foundation for the Arts: p. 203; photograph by Peter Moore, © Barbara Moore: p. 297 (bottom); photograph © Museum Associates/LACMA: p. 173; photographs by Tim Nighswander/Imaging4Art: pp. 146 (bottom), 192, 212, 315, 332; photograph by Fredrik Nilsen: p. 376; image courtesy Gyo Obata: p. 285; photograph by Göran Örtegren: p. 203; image courtesy Pace Gallery: p. 289; image courtesy Picture Palace Pictures: p. 134; images courtesy Paula Cooper Gallery: pp. 249, 394; photograph by Kira Perov: p. 389; photograph by Steven Probert: p. 394; image courtesy Regen Projects: p. 348; courtesy the Robert Rauschenberg Foundation: p. 322 (bottom); image courtesy Sadie Coles HQ: p. 416; photograph by Timothy Schenck: 22; courtesy Sikemma Jenkins & Company: p. 392; photograph by Steichen/Vanity Fair: p. 363; photograph by Glenn Steigelman: p. 322 (bottom); photograph by Jean de Strelecki: p. 9; photograph by Ezra Stoller, © Esto: pp. 14 (top), 18 (top); courtesy Storm King Art Center: p. 356; photographs by Jeffrey Sturges: pp. 118, 373; image courtesy Tanya Leighton Gallery: p. 170; photograph by Jerry L. Thompson: p. 356; image © Time-Life, Inc., Getty Images: pp. 13, 73; image courtesy Tribolite-Arts DAC: p. 134; photograph © 1991 Jeanne Trudeau: p. 19; images courtesy Video Data Bank: pp. 215, 319; courtesy Bill Viola Studio LLC: p. 389; images © Walker Evans Archive, The Metropolitan Museum of Art: pp. 133, 227 (top); photograph by Weegee (Arthur Feelig)/International Center of Photography/Getty Images: p. 399; images courtesy their respective artists: pp. 55 (bottom), 63, 108, 118, 134, 140, 187, 216, 258, 264, 296, 303, 416.

Reproduction credits
The copyrights in selected works illustrated in this volume are held by the artists, their successors, or the applicable owners. For detailed reproduction credits and copyright information regarding these works, please visit whitney.org/HandbookCredits.

Copyright © 2015 by the Whitney Museum
of American Art, New York.

All rights reserved. This book may not
be reproduced, in whole or in part, including
illustrations, in any form (beyond that
copying permitted by Sections 107 and 108
of the U.S. Copyright Law and except
by reviewers for the public press), without
written permission from the publishers.

Whitney Museum of American Art
99 Gansevoort Street
New York, NY 10014
whitney.org

Distributed by
Yale University Press
302 Temple Street
P.O. Box 209040
New Haven, CT 06520
yalebooks.com/art

Generous funding for this publication
has been provided by the
National Endowment for the Arts.

ART WORKS.
arts.gov

Project manager
Beth Huseman

Project coordinators
Jacob Horn and Diana Kamin

Editors
Janet Jenkins, with Amanda Glesmann,
Thea Hetzner, Sarah McFadden,
Gail Spilsbury, Beth Turk, and David Updike

Curatorial research
Sarah Humphreville, Diana Kamin,
Adrienne Rooney, and Catherine Taft

Publication research
Jacob Horn

Designer
Hilary Greenbaum

Production
The Production Department

Proofreader
Kerrie Maynes

Separations
Altaimage, New York

Printing and binding
Printing Express, Ltd., Hong Kong

Set in Neue Haas Grotesk
Printed on 115gsm NPI Kasadaka

Note to the reader

The birth and death locations provided for artists reflect the current national borders and place names. Unless otherwise noted, all works are in the collection of the Whitney Museum of American Art, New York.

Library of Congress Cataloging-in-Publication Data:
Whitney Museum of American Art, author.
Whitney Museum of American Art : handbook of the collection / edited by Dana Miller ; with an introduction by Adam D. Weinberg.
pages cm

ISBN 978-0-300-21183-2

1. Whitney Museum of American Art—Catalogs. 2. Art—New York (State)—New York—Catalogs. I. Miller, Dana, editor. II. Weinberg, Adam D., writer of introduction. III. Title.

N618A645 2015
709.73'0747471—DC23

2014042984

Printed and bound in Hong Kong
10 9 8 7 6 5 4 3 2 1

Cover illustrations

Front, clockwise from top left: Alexander Calder, *Big Red*, 1959 (p. 86); Edward Hopper, *Seven A.M.*, 1948 (p. 183); Jack Goldstein, still from *Metro-Goldwyn-Mayer*, 1975 (p. 148); Willem de Kooning, *Woman and Bicycle*, 1952–53 (p. 111); Hannah Wilke, *S.O.S. Starification Object Series* (Curlers), 1974 (p. 408); Asco, *Decoy Gang War Victim*, 1974 (printed 2011) (p. 47). Back, clockwise from top left: Yayoi Kusama, *Accumulation*, c. 1963 (p. 214); Jean-Michel Basquiat, *Hollywood Africans*, 1983 (p. 57); Alice Neel, *Andy Warhol*, 1970 (p. 278); Robert Heinecken, Detail of *Inaugural Excerpt Videograms*, 1981 (p. 172); Peter Hujar, *Candy Darling on Her Deathbed*, 1973 (p. 186); Georgia O'Keeffe, *Music, Pink and Blue No. 2*, 1918 (p. 286).

Cover reproduction credits

Front, clockwise from top left: Alexander Calder, © 2015 The Calder Foundation/Artists Rights Society (ARS), New York; Edward Hopper, © Whitney Museum of American Art; Jack Goldstein, © courtesy Galerie Buchholz, Berlin/Cologne, and the Estate of Jack Goldstein; Willem de Kooning, © 2015 The Willem de Kooning Foundation/Artists Rights Society (ARS), New York; Hannah Wilke, photograph © 2015 Marsie, Emanuelle, Damon, and Andrew Scharlatt/Licensed by VAGA, New York; Asco, © 1974, Harry Gamboa Jr. Back, clockwise from top left: Yayoi Kusama, © Yayoi Kusama; Jean-Michel Basquiat, © 2015 The Estate of Jean-Michel Basquiat/ADAGP, Paris/ARS, New York; Alice Neel, © The Estate of Alice Neel, courtesy David Zwirner, New York/London; Robert Heinecken, © 2015 The Robert Heinecken Trust; Peter Hujar, © 1987 The Peter Hujar Archive LLC, courtesy Pace/MacGill Gallery, New York, and Fraenkel Gallery, San Francisco; Georgia O'Keeffe, © 2015 Georgia O'Keeffe Museum/Artists Rights Society (ARS), New York.